THE OPEN STUDIO

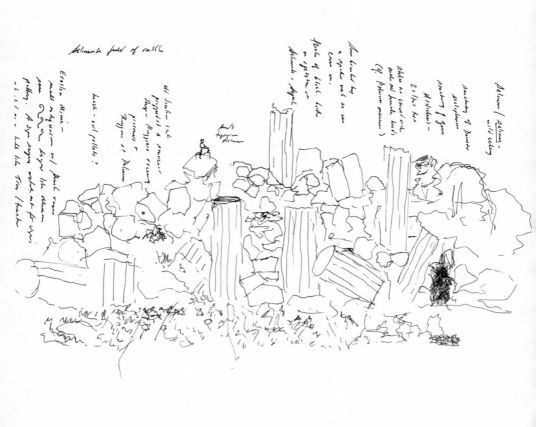

THE OPEN STUDIO

ESSAYS ON ART AND AESTHETICS

SUSAN STEWART

The University of Chicago Press
Chicago and London

Susan Stewart is professor of English at Princeton University and a former MacArthur Fellow. She is the author of four books of poems; the most recent, *Columbarium* (paperback edition available spring 2005), received the 2003 National Book Critics Circle Award for poetry. Stewart has also written many works of literary and art criticism, including *On Longing. Poetry and the Fate of the Senses*, published in 2002, won both the Christian Gauss Award of the Phi Beta Kappa Society and the Truman Capote Award for Literary Criticism.

The University of Chicago Press, Chicago 60637
The University of Chicago Press, Ltd., London
© 2005 by The University of Chicago
All rights reserved. Published 2005
Printed in the United States of America

14 13 12 11 10 09 08 07 06 05 1 2 3 4 5
ISBN: 0-226-77446-5 (cloth)

ISBN: 0-226-77447-3 (paper)

Library of Congress Cataloging-in-Publication Data
Stewart, Susan.
 The open studio : essays on art and aesthetics / Susan Stewart.
 p. cm.
 Includes bibliographical references and index.
 ISBN 0-226-77446-5 (cloth : alk. paper)—ISBN 0-226-77447-3 (pbk. : alk. paper)
 1. Art. 2. Aesthetics. I. Title.
 N7445.2.S74 2005
 701′.1—dc22
 2004007019

Frontispiece: Sketch of a field of rubble at Selinunte, Sicily (March 2000), from museum and travel notebooks. Courtesy of the author.

⊚ The paper used in this publication meets the minimum requirements of the American National Standard for Information Sciences—Permanence of Paper for Printed Library Materials, ANSI Z39.48-1992.

CONTENTS

ACKNOWLEDGMENTS

I would like to acknowledge my debt and extend my thanks to those artists, curators, conference planners, and editors who invited me to write these essays or work on other collaborative projects: Ann Hamilton, Hugh Davies, Lynne Cooke, Claudia Gould, Ingrid Schaffner, John Elderfield, Maitena de Elguezabal, Tacita Dean, Ralph Rugoff, Richard Torchia, Patrick Murphy, Anne and Patrick Poirier, Juliana Engberg, Mary Kordak, Robin Jaffee Frank, Jock Reynolds, Noemi Cohen, Helena Tatay, William Kentridge, Charles Altieri, Peter Flaccus, Edward Hirsch, Malcolm Baker, and John Brewer. Teaching aesthetics with Alan Singer at the Tyler School of Art in Rome from 1988 to 1997 influenced my thinking throughout the writing of these essays, as did the practices of our students and of the many artists, writers, and filmmakers who visited our program, often as a result of the generous efforts of Pia Candinas and Brunella Antomarini.

This book is dedicated to the memory of Sam Walker, printmaker, and to my sons Jacob and Sam Stewart-Halevy and their imaginary third-floor museum.

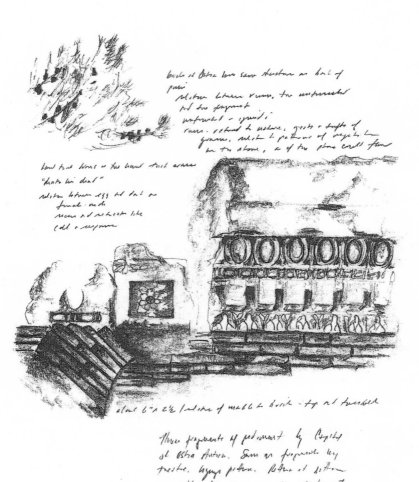

INTRODUCTION

QVISQVIS HVC ACCEDIS
QVOD TIBI HORRIDVM VIDETVR
MIHI AMAENVM EST
SI PLACET, MANEAS
SI TAEDET, ABEAS
VTRVMQVE GRATVM

[To whoever enters here: what seems horrid to you is pleasant to me; if you like it, stay, if it bores you, leave; it's all the same to me.]
 —Inscription on the garden wall at the Villa Farnesina

Thursday mornings, though I can't remember why—it must have been the opening hours—I often walked to the Farnesina. I'd take the Lungotevere, crossing at the Ponte Sisto, then follow the rumble of the Via Lungara traffic, and find my way at last through the high black gates that banked a sudden stillness—the flat garden with its cedars, laurels, and bergamot trees, songbirds and oranges flashing spots of color, sometimes an intense fleck of sunlight breaking through into the deep green quiet shade of it. And then inside: bored attendants, dust-covered guidebooks, and the sound of an electric hand drill somewhere in the building—that music of Rome's endless cycle of restoration and decay. I'd pass through the dining hall where the guests had thrown their gold spoons and knives out the open window and into the Tiber. Or so they thought: a net had been strung below, and all would be hoisted up again by the morning. Saving waits for waste as waste

awaits all rescue: Agostino Chigi had once held the crown of the pope himself as collateral for a debt.

Then up the front stairs and through the halls, past Queen Christina's room with its bed like a cave, then down the back stairs until, finally, the great Sala of Galatea. A wall of windows on one side threw sunlight across the three remaining walls. There—draped with painted garlands of leafy beets, grapes, daisies, pineapples, onions, and cattails—was the whole vast array: Galatea pulled in her chariot by dolphins in a vision Raffaello said came completely from his imagination; the intense realism of the enormous monochromatic portrait head; Dughet's amorphous and gently craggy landscapes; the cramped giant Polyphemus with his profile like a geological formation and his heel splashing in the sea. No nostalgia there even before the restoration: a pulsing wall, refusing the very idea of fading.

All art is contemporary in this sense; every use of the form lives on in later uses of the form and beyond the sequences of historiography. The frescoes were completed in 1519. Less than ten years later Rome was sacked, the Lansquenets had put another pope to flight; someone wrote a graffito between columns at the villa: "1528—why shouldn't I laugh?" Yet even now in the Sala of Galatea the pagan gods endure, the monstrous is distinguished from the perfect, the monochromatic from color, drawing from painting, the finished from the sketch, three dimensions from two, the view of an observer who is moving from the view of an observer who is fixed, animation from stasis, narrative from the immediacy of emotional expression, the room from the garden, the fruits on a table from the fruits in a picture—the painted ceiling's constellations are locked above the viewer and well below the constellations that turn above the world.

Some works of art and some places where works of art exist call us back over and again in ways we cannot explain or explain away. They survive in the translation of one era to the next or in the smaller sphere of changes that make up our own lives. We go to them without a particular reason and come away renewed by their particulars. Their very resistance as things of the past makes them of value to the present and future. A pineapple is still a pineapple; a cattail still looks like a cattail; and the stories of Galatea and Polyphemus can be learned from frescoes as well as brought to them by a recognizing knowledge.

I have gathered here most of my occasional writing on art from 1987 to the present under the title *The Open Studio*, for I'd like to indicate some of the open and reciprocal relations between visual pleasure and thinking that led me to write them. They are records of studio conversations and reading, of walking, talking, and looking in museums and exhibitions, and of the

afterlife of those experiences in the solitude of my own study. During this period, many artists and curators have asked me to write or speak on works of art. I've never had an interest in reviewing art solely for the purpose of making positive and negative judgments—a task vital to culture, but not a task for me. However, when I have known works well, I have readily turned to these projects of "essaying," or trying without preconceived aims, to understand the intentions of individual artists, both living and dead, and the consequent decisions they have made. Such intentions and decisions have helped me understand works of art by giving me a glimpse of the limits of my understanding.

Barnett Newman, who himself took on the tasks of both making and writing about art, is credited with the well-known quip that "artists need critics as much as birds need ornithologists." But artists and critics can speak with one another, and recall and imagine and change one another, in ways that, so far, birds and ornithologists cannot. Many of the works of installation, process, and environmental art addressed here have disappeared or are recorded in photographs that render them necessarily partially. I have used my essays as a way of remembering and thinking about such works— yet without setting out to memorialize them, for they continue to exist as a potential, vibrant force in the minds of those living artists who made them.

The years represented by these essays are years of major changes in the public functions of museums and exhibitions. "Blockbuster" shows devoted to artists—most often painters—from Cézanne to Gerhard Richter have flourished, as have museum shops and restaurants and what is sometimes called museum tourism. In the United States, museums have been tied to commercial aims from their inception, as the history I've drawn here of Charles Willson Peale's endeavors in part illuminates. Yet in recent decades curators have sought new ways of organizing traveling exhibitions through collaborative and independent projects often unified by theme. And many artists have struggled to come to terms with the economics of the art commodity system by producing works that are ephemeral, experiential, or recyclable. Others have organized communal projects that involve the public as makers, as well as receivers, of art.

Each of these developments has had, I believe, both negative and positive outcomes: the blockbuster show can trivialize the history of individual artworks and artistic careers while it elevates the public estimation of artistic achievement and disseminates knowledge of art throughout a broader social sphere. The decentralization of art exhibitions can disperse attention and promote novelty over the estimation of individual works; yet it also can give a new creative impulse to curatorship, provide fresh ways of thinking

about relations between artists and historical periods, and like the mega-show, reach a far-ranging audience. Works of installation and process art can result in a denigration of the permanent art object or end up fetishizing their own documentary records and remains; yet they also can alter perceptual habits and profoundly transform our relations to our senses and to objects more generally.

These years of mass public attention to painting in museum contexts paradoxically have also been noteworthy for a decline in painting at international exhibitions of contemporary art. Video and digital artworks and new developments in photography have come to dominate such international shows, and these developments intersect with the projects of several of the artists I consider. Such electronic media often produce an intentionally anachronistic frame for reconsidering techniques of early film, painting, handcrafts, and other arts that rely on tactility as counters to technological abstraction.

The living artists I discuss work in many media and with many different aims. As I think of these aims more particularly, they include among them such disparate goals as altering perception, creating sanctuaries of beauty, elegizing and consecrating forms of life, transforming socially received categories of power, or simply following a conceptual concern arising from private experience. Thomas Schütte and Hans-Peter Feldmann, for example, are contemporary German artists whose work has little in common. Schütte follows in the tradition of polymathic makers, forging original forms out of steel, ceramics, wood, watercolor, cloth, and other materials and creating installations and models that propose new kinds of space and means of apprehension. Feldmann, in contrast, works with mostly two-dimensional visual materials and familiar received objects that are deeply embedded in cultural frames of reception. In common with the work of other postmodern artists, his pieces call upon receivers to complete their meanings with knowledge brought from popular culture and media. The British filmmaker and painter Tacita Dean creates an art haunted by coincidence and the intersections between her life and the lives of others. She suffuses chance with meaning and gives us a sense of how the random can lend significance to whatever purposes we might intend. The South African artist William Kentridge works in printmaking, film, and theater, though an ethics of drawing informs everything he does. Kentridge's drawing practices, undertaken by hand and in a carefully slowed temporality, serve as a critique of violence and unthought technological development. The Scottish writer and artist Ian Hamilton Finlay, whose garden I study here, has made historical mem-

ory another kind of resistance to the state. Finlay and the French artists Anne and Patrick Poirier are concerned in different ways with what can be called a neo-neo-classicism and the relations of ruin to history. In linking the avant-garde and the classical, they reveal history as a task of memory and selection that is often attached to utopian political values. In contrast, the American Ann Hamilton's installations summon all the senses and engage their audiences along paths of perceptual surprise. Hamilton's works are studies in the threshold between language and intelligibility where a realm of thought feeling can be experienced.

I have organized these essays retrospectively. The most recent pieces, "To Take a Chance" and "On the Art of the Future," outline some of the relations between aesthetics and ethics. They grow directly from concerns that have emerged during my studies of individual works and historical problems in the philosophy of art. I suggest that art is an open project, prior to other cultural forms, and vital to our ability to acknowledge other persons. I believe that art therefore might serve as the basis for a global and secular humanism founded in whatever is universal in sense experience and the intelligibility of emotional expression. In contrast, the earliest work here, and thus the final essay, is a kind of journal entry, a brief meditation on the work of Lucien Freud and the experience of visiting his 1987 show with my then six-year-old eldest son. Whereas some of the pieces are brief sketches of the practices of artists I have known and whose work I have wanted to think through, others are public talks demanding rather sweeping surveys of a particular cultural moment or a theme in art history. In a lecture commissioned by the curators at the Museum of Modern Art in New York as they embarked on plans for their new building in 1997, I took their invitation to provide an alternative history of modernism as an occasion to explore the interdependence of abstraction and figuration.

I have not included all my writings on art from this period. I am grateful to have had an opportunity to deliver the keynote address at the Melbourne Biennial, Signs of Life, in 1999, which gave me an opportunity to experience firsthand a wide and international range of new artworks, but I have not been able to address these works in depth and so have not reprinted those remarks. And a number of these essays have been either modified or abridged radically from their original length because they turned out to be, often literally, drafts for my long-term study of the history of poetic forms, recently published as *Poetry and the Fate of the Senses*. There nevertheless remains some redundancy among the pieces here, which I have allowed to stand if individual artworks were illuminated from varying perspectives.

These essays overall are frequently concerned with art as an alterna-

tive model of time. By "alternative" I intend to distinguish the experience of art from the experience of everyday life and to mark the possibilities for reversibility and intensification that the time of artworks can offer us. Readers familiar with contemporary art might keep in mind the extraordinary range of temporality implied by environmental artists like Andy Goldsworthy and utopian artists like the partners Arakawa and Madeline Gins. In Goldsworthy's projects ephemerality is the root of beauty. Consider, for example, the simple, temporary elegance of his "rain shadows," which are made as the artist lies down during a rainstorm, waits a bit, and then rises to document the dry pattern his body has left on the ground. Goldsworthy's subtle and impermanent alterations of material nature make our lived experience of time potentially eternal as they also are a vivid demonstration of what an unalienated relation to nature might be.

Announcing "We have decided not to die," Madeline Gins and Arakawa build constructions of what they call "reversible destiny." These works, including the architectural project they have presented since 1975 under that name, are intended to produce new physical experiences in their viewer-receivers—experiences of compression, infinity, inversion, opening, and reversal that the artists contend will gradually modify the human senses. This project of "new sensations" could be said to have its basis in the future-oriented passages of the *Economic and Philosophic Manuscripts of 1844*, where Marx imagines how new senses might eventually develop under social conditions constructed in accordance with humanist needs and values. Underlying these aspirations is the truth that experiences of art call us to modify our bodily behavior as well as our thinking, and hence that works of art are inherently transforming.

The forms I have considered here include installation art, portrait miniatures, early American collecting practices, painting, doll making, sculpture, music boxes, gardening, drawing, film, animation, and photography. Some of my studies have involved historical or archival research and are designed to be scholarly contributions; others resemble prose poems in their attempt to get closer to the particular reality of particular works. I have been preoccupied, because of my past projects, with issues of monumentality and minuteness, collecting, and archiving works of art, and with the connections between the traditional fine arts and the making of objects. Even more often, I have been drawn to works as a way of understanding the circumstances of my historical moment and thereby opening my practice as a poet to the art of my generation.

As I discuss in the opening essay, art continues to be under a threat today from two forms of "end of art" arguments: the first one stemming from

Plato's critique of art's authenticity, the second stemming from Hegel's championing of speculation over sensuality. As philosophers are busy proclaiming the death of art, artists go on making it—nor, by the way, do they seem interested in proclaiming the death of philosophy. As soon as a form seems to have disappeared—say, encaustic painting or needlecrafts or even painting on canvas itself—a revival and transformation is on the horizon. My tendency to "read" the works I consider here in relation to literary and historical allusion has been an unavoidable bias, but the conversation between visual artists and poets is always inflected by a knowledge of the limits of linguistic understanding. And just as a poet is struck by the ineffable dimension of visual experience, so is a visual artist conscious of the rebuslike aspect of visual choices, continually informed by memories of language and language's capacity for escaping the bounds of the material.

CHAPTER 1

TO TAKE A CHANCE

What kinds of chance does art involve? Chance composition has never struck me as convincing, since the kind of chance staged under such terms is a rather sentimental version of the overwhelming forces actual contingency brings to bear upon the making of artworks. A throw of the dice, it seems, could never abolish chance. This argument can be made on the basis of notions from nature, theology, or the unconscious—any will suffice.

At a closer look, I also have wondered how an example like John Cage's *sortes* consultation of the *I Ching* or the cutups of William Burroughs and Jackson MacLow truly exemplified composition by chance, since these artists worked within a finite domain of materials according to rules laden with much determining intention. When Cage would say that in the nature of chance composition is the contention that all answers answer all questions, or when he and others would claim that there was a certain selflessness in exercising chance composition, the ethics involved seemed paradoxically to arise from a determining, even colossal, willfulness.

My reaction stems somewhat from my conviction that art is not an experiment—for what would be the purpose of beginning to make art by controlling the uniformity of its objects and the circumstances of its method? If the function of experimentation is to replicate results, how could such replication be a motivation for art? But lately I have been thinking that my bias has kept me from taking seriously what might be important in the relation chance bears to composition.

As an example that raises some of these questions, let's consider a recent artwork that is also a collection. One day in 1985 the artist Tom Whiteside found on the ground in a Philadelphia neighborhood a playing card de-

picting the three of clubs. He decided to use it to begin a collection of a full deck of cards, all of which, he decided, would have to be serendipitously found in his path. He set down a rule that if he encountered more than one card on the ground, he would allow himself to take only two from the given site. It took four years for Whiteside to complete a deck of fifty-four cards —the usual fifty-two plus two jokers.

This meant that the world of chance encounters could not include the world of intended consumption—a card had to appear as the world so often appears, randomly and without attribution. What "counted" was the general identity common to all playing cards, regardless of their membership in a particular deck or kind of deck. No other quality of a card would be relevant, including its overall condition. In other words, "quality" was not a quality of the object. And the ongoing construction of the projected deck overrode the significance of any duplicate cards—thus, as in any obsession, a process was constructed for making the bulk of phenomena *not* count, while the selected phenomena became overdetermined.

The process of making this work was intentional, but open-ended in time and space. The collector lived in a state of constant suspense and anticipation—the cards to be used appeared without prediction and yet were selected nevertheless by an individual agency. In this sense, the collection was somewhat like children's car-trip games of "collecting" license plates from all fifty states or looking for letters of the alphabet in sequence on roadside signs. But Whiteside was gathering actual objects. The collection was like a bouquet, a whole larger than the sum of its parts. Yet it also was not like a bouquet, because it subscribed to a finite rule and system for its organization as a complete deck. In the end, it was created with regard to a future apprehension by those outside the collector's agency.

I thought of Hannah Arendt's comment that "to be alive means to live in a world that preceded one's own arrival and will survive one's own departure. On this level of sheer being alive, appearance and disappearance, as they follow upon each other, are the primordial events, which as such mark out time."[1] Like all artworks that create alternative models of time, these cards were removed from realms of accident or disappearance and placed in realms of intention and appearance—and so reversed the finitude of our lived experience of time. That they and their maker will disappear (just as either might outlast the other, depending upon equally open circumstances) is part of what they encounter as appearance. In running the risk of never being completed within the lifetime of its maker, this collection took on the stakes of finitude in a particularly compelling way, but one we can only infer retrospectively once the collection is complete.

Some collections may be made in a race against time; this one seemed to be made in a walk with time. Because it was impossible to predict where or when one of the necessary parts of this collection might be filled, it unfolded within the space of everyday experience, and made that space something like the "infinite stochastic space" model of the cosmos. Thinking of this analogy, I have wondered if this work about intersection and coincidence did not in fact reverberate to the largest possible sphere of coincidence between lived experience and the total environment—that is, the noumenal environment beyond human senses, imagination, and understanding. The way in which we cannot answer this question repeats the circumstance of searchingness under which the deck of cards was gathered.

Here we see that openness to chance in composition is not the same as following "chance" procedures. And further questions arise. Are both openness to chance in composition and chance procedures aspects of collecting and of any art-making that is based upon collecting? All art is based upon the gathering and arrangement of materials, from those traditional arts forged from the raw materials of nature to salvage crafts to modernist readymades and collages. And this gathering, whether for the purposes of art-making or collecting, will proceed under terms of chance or luck. But the more cognitive and material resources a collector has (ranging from the Internet to traveling assistants who enable him or her to be in more than one place at a time), the less opportune and the more determined will be the collection. I would argue that the less luck, the less art—that the creative process is shut down by too much determination, shut down at the start of making and shut down at the start of reception.

Of course, my response is tied to the persistence of Romantic, particularly Kantian, ideas of the symbol and organic form, and an inherent conflict between the aesthetic and the purely cognitive. On the most powerful level, such ideas have to do with the status of the "unconditioned legislation with regard to ends" that for Kant is what human beings are—an end in themselves, with human being as the highest end of creation.

As early as Edward Young's 1759 "Conjectures on Original Composition," we find a negative comparison between composition by rule and the inspiration of genius. Modernist ideas of chance procedures in truth simply invert this negative comparison as a way of critiquing the supposed spontaneity of inspiration and at the same time acknowledging the socially structured aspects of consciousness and their displacement of individual intention. Yet if we look closely at Kant's discussion of genius, he emphasizes the rather contrary dual nature of the productions of artistic genius as being both original and exemplary or rule-producing—this is how "genius is

the talent that gives the rule to art."[2] It is something within the subject or maker that gives this rule to art—an aspect of his or her nature that cannot be brought forward by the will or articulated prior to production. Nevertheless, according to Kant's notion of a purposiveness without a purpose, the finished work has something about it that can be grasped and followed according to rules: "for something in it must be thought of as an end, otherwise one cannot ascribe its product to any art at all; it would be a mere product of chance."[3] Such a work without end would be the cards Tom Whiteside did not pick up, including those that never crossed his path.

As art-making involves the animation of some aspect of human nature, so might the impulse to collecting be viewed as involving an animation of external matter. Making and collecting art both produce a dynamic relation between prior and later activities of ordering and gathering. But animation produces anxiety about containment, and both collections and artworks share a teleology toward finality of form.

Let me then simply list some remaining questions: do collecting and art-making take separate paths on the way to finality of form? A finished artwork cannot be added to or subtracted from—is this true of a finished collection? Does a collection create a whole that overwhelms its parts, or do its parts persist under quantifiable terms? At what point in the history of art, the history of aesthetics, and the history of consumption do art-making and collecting part or join ways? And if collections involve the arrangement of things but not the representation of things, and artworks also use things but transform them into representations of things, then what happens when an artwork becomes part of a collection or a collection is formed into an artwork?

Perhaps, in the end, we have rediscovered some of the differences between games and play under other terms. Games involve fixed rules and fixed outcomes. In play the rules are set out at the start and specific to the emerging actions of the players; the end is a matter of consensus, an often arbitrary stopping point. If chance composition works like a game, composing while remaining open to chance works like play. The stakes for making works of art are quite high. You're either in the game or you're not, and it's always possible to start again. In play, however, to stop too early is a frustration; to go over too far is a ruination.

ON THE ART OF THE FUTURE

Does the concept of art do useful work, or is it now primarily a defensive political gesture?—this is the question we've been asked to consider. It suggests a separation between the concept and practice of art that I would like to take up and then reimagine in terms that separate the ongoing work of individual artists from the path of art as a whole. I assume the question raises the specter of "a defensive political gesture" because of the attack on art from within aesthetics—the death- or end-of-art argument we have inherited from Hegel—and the attack on art from without aesthetics—the ideological suspicion of art we have inherited from Plato, a suspicion that continues to underlie attacks on art from the standpoint of religion and the state.

I'd like to address both the internal and external attacks on art, and to talk about a collective framework for the arts in what I hope are neither defensive nor merely political terms by considering art's relation to ethics. My argument finds its source in the relation between aesthetics and *aesthesis*, or sense apprehension, and in the deep formal analogy between the face-to-face encounter between persons and the face-to-face encounter with artworks. To put my aims simply, I am interested in preserving persons from totalitarian systems of social control, including systems of nonconsensual time and technological development, and preserving artworks from speculative allegory. I believe that this task requires concepts of persons and art that strive toward the most general universality without a prior outcome in mind—hence a universality that precedes cultural choice-making. I imagine the ground for this precultural choice-making to be nature and the by-now-common concern for the future of nature. This concern is inseparable

from our acknowledgment of finality of form in the world and a concern for living things coterminous with our own finite being. Following directly from Kant, I'll suggest that art is a domain for the exercise of nonteleological judgments—hence art's deep commitment to a practice that is truly practice, and that such aesthetic judgments provide a nonteleological paradigm for the ongoing work of ethics. In this way I'd like to pursue a concept of art that addresses the real consequences of metaphysical beliefs for thought and perception and that considers transformed conditions of thought and perception as occasions for transforming relations between persons.

So let's follow Kant in saying that art is a practice for its own sake and then ask what a practice for its own sake might be *for*. I believe that many of us who make and write about art have forgotten to ask such a question because we have not been patient enough to separate the two strands of the following formulation: at one level, instances of art practice can be in themselves and for themselves; at another level, the long historical development of art can have consequences that are not dependent upon the outcomes of particular works, either in their creation or reception.

To continue to confuse the particular activities of artists with the broader function of art in the development of human culture is to ignore artworks in their specificity and to foreclose the possible work of art in general. If function is indeed met by this long historical trajectory, then individual works, as Kant surmised, need not themselves bear the burden of purpose. Such works would precede cultural understandings of purpose and not be in pursuit of them. I see no reason to presume art is a cultural production; such a presumption tends toward a representative function for art and masks the ways in which culture is itself an aesthetic production. Separating the situation of individual artworks from the history of art in general also means that the demand to reconcile theory and practice is unnecessary, perhaps even untenable. As any working artist knows, art practice that proceeds under the shadow of theory is doomed to be mere allegory; and as any working aesthetician knows, theories of art bound to particular historical practices are doomed to apologetics. Here I am merely recapitulating, under other terms, Kant's well-known axiom that "concepts without percepts are empty; percepts without concepts are blind." For art to be of any use at all to us, there must be a tension between the actual circumstances of perception and the continuity of conceptual habits. Art theory has demanded of us a reverence for such habits as "things of the past" approaching a reverence for nature. And art theory has also, rather paradoxically, demanded of us an overthrowing of such habits, also as "things of the past," a demand in the shadow of the planned obsolescence of commodity culture. Yet whether

theory demands reverence or denigration, the result is the same: a declaration of the death of art. Jay Bernstein has suggested helpfully in this regard that philosophy's constantly renewed announcement of the death of art can be read as a response to art's unstated assertion, by means of its animation of sense particulars, of the limits of philosophy.[1]

We reach this fulcrum between the demands of art theory and art practice via another conceptual habit: the tendency when talking about aesthetics to conclude with "productive tensions," or "necessary dialectics," or notions of "interplay." Such a tendency seems to me to resolve the real tensions between sensual particulars and abstraction as if thought were the sole sphere of aesthetic experience. Instead I want to propose that what the practice of art in general might be for is the carrying forward of a practice of ethical encounters between persons. I say "might be" because I am viewing the history of art in a way that emphasizes such encounters, and I am going to suggest that art offers a potential sanctuary, a *secular* sanctuary, for such encounters in the future. Such an ethics is by definition both hypothetical and incomplete and yet perpetually realized under the finite circumstances of particular encounters—features it shares with aesthetics. I take seriously here the outcomes of art as a *purposeless* practice. This purposelessness is at the heart of what makes art a possible ethical sanctuary; far from removing art from the spheres of political power and importance, art's hypothetical and incomplete aspects are vital to both its conceptual freedom and its capacity to bear an ethical orientation.[2]

To say that art-making is a practice indicates from the outset that the task of art is unfinished. Individual works will necessarily exhibit finality of form, but the task of art in general is incomplete. Something continues to call for art, something in the experience of those who make it and something in the experience of those who seek to apprehend it. Nature produces beauty without human intervention, but not artworks, and no artwork can be completed without reception. Our metaphors for these recurring openings to art as a summons to apprehension—*to call, to speak, to hear, to touch*—reveal the etymology of aesthetics in sense experience that draws on intersubjective apprehension and the continuity between such experiences and face-to-face encounters with other persons.

Aesthetic judgments and ethical choices take place as face-to-face experiences. Such encounters may involve the immediate presence of others, or they may involve a retrospective or projective imagining of such presence. The persistence of the face-to-face relation in the structure of aesthetics and ethics provides a deep and formal analogy. This similarity in form is why the relation between aesthetics and ethics cannot be reduced to the mere

conveyance of ethical themes by works of art. Nor can pleasure and the sen-
suous apprehension of persons be banished from ethics.

Our meetings with artworks are embedded in the meanings and conven-
tions we bring to encounters with other persons, and all nonmonumental
art is a means of figuration in this sense. Yet, specifically, this meeting with
an artwork that is in itself and for itself is analogous to that free ethical
stance in which persons are encountered in themselves and for themselves
—without prior determination of outcome or goal. When we consider an
artwork as something meant, it is the intentions and actions of individual
persons that we seek to recover and come to understand in a project of im-
plicit mutuality and heightened responsiveness or intensity.

Face-to-face forms have a capacity to change or move us, perhaps be-
cause of their propinquity and because of the incipient tactility such close
conditions imply. With such propinquity comes the possibility, and hence
the necessity for refusal, of injurability—that refusal underlying the as-
sumptions of ongoingness and reciprocity tacit to all face-to-face, first-
person, and conversational encounters. We can separate ourselves concep-
tually and sensually from monumental and spectacular works of art, but the
intimacy and affect of face-to-face works stems from our human scale and
biological experience,[3] just as the absence of such a scale in our meetings
with certain other phenomena, including some works of art, is the basis for
our intuition of the sublimity of what is supersensible. But face-to-face com-
munication is not sublime: it relies upon frontality and reversibility, involv-
ing frames of reciprocity that neither sublimity nor the conventional, irre-
versible time system of social life can accommodate.[4]

Human facial expressions may be said to offer temporal depth rather
than spatial limitlessness. Within a finite material frame, the human face can
proffer an indeterminate range of expressions, including impassivity, that
reveal and conceal meanings to a receiver and move between spontaneity
and volition on the part of the maker. When considered in light of animal
expression more generally, human expressions are unique in the range and
complexity of meanings they produce. When we turn toward another's fa-
cial expressions, and when we perceive what is alive about another person,
we encounter the simultaneous underdetermination and overdetermination
characteristic of symbols more generally. Recent work on animal calls and
other forms of acknowledgment indicates such calls and expressions are far
less likely to be unbidden responses to pain than to be intended and inter-
subjective.[5] And recent work on facial agnosia, the absence or loss of the
ability to remember and recognize faces, indicates that the way we recog-
nize faces in general is separate from the way we recognize individual faces.[6]

From the presentation of the newborn as headfirst to the fixing of the death mask at the entrance to the house, the acknowledgment of the face is inseparable from the claim to personhood—the person who inhabits space and undergoes time.

The Greek *prosôpon* and the Latin *persona* indicate the individual living human countenance and the fixed visage of the mask at once and so incorporate the living and contemplated forms of the face from the perspectives of bearer and beholder. The face is individual and unique as well as the site of an indeterminate expression that is open to a universal intelligibility. This universality is based in nature, that is, in human nature, and is why such indeterminacy is open to interpretation and the discernment of a hierarchy of particulars to be received as the consequences of intention.

Let's consider, then, some of the ways in which our apprehension of other persons in face-to-face encounters, involving both individuation and indeterminacy, is aligned to our apprehension of aesthetic objects. Kant's *Critique of Judgment* offers a paradigm for aesthetic experience as an encounter between persons and forms that is in truth an encounter between persons—the maker and the receiver. Though implied in the two analytics, this paradigm is most clearly laid out in sections 46–50 as part of the discussion of the production and reception of artworks proper, rather than the earlier discussion of the beautiful that emphasizes the beholding of natural phenomena. In sections 46–50, Kant holds that artistic genius cannot describe how it brings about its products, but rather gives an unanticipated rule to art, just as nature does, on its own terms—that is, a rule that is inferred only retrospectively and so a rule that requires the participation of another person—the person who receives the work. Kant further explains that although every artwork requires some purpose or intention in order to be art at all, this cannot be a teleological purpose, for such a purpose would not be adequate to the outcome of the artwork.

Following Alexander Baumgarten's earlier writings on the complex and confused elements of aesthetic representation, Kant goes on to develop a theory of symbolization and overdetermination: works of art present "aesthetical ideas," which he describes as "occasioning much thought, without however any definite thought, that is any concept of the understanding, that is capable of being adequate to it."[7] Here every artwork confronts us with its integrity as a form and with its existence as the outcome of a prior intention. Engaged with the work, we can only move backward from its particulars to inferences of that intention. And those particulars cannot be readily absorbed within the concepts we already have in mind; they resist such integration, just as the artwork as a whole resists any prior determi-

nation we might bring to it. In apprehending the work we do not diminish it or explain it away; we only continue to enrich our apprehension, to challenge our usual habits of making the world intelligible.

The individual, the unique, the indeterminate are adjectives describing both the face of the other and the work of art. Kant's aesthetics continually emphasizes the nonteleological encounter. We cannot decide before our engagement with particular artworks what they are *for*, what purpose or purposes they might or will serve. This emphasis on the nonteleological encounter readily can be compared to a similar emphasis in the controversial and often extreme ethics of Emmanuel Levinas. Levinas describes ethics as "first philosophy." By this he means ethics, and not ontology, is prior—and particularly that ethics is prior to the legislating rules of morality. Using, in fact, Kant's terminology, Levinas describes morality as already overly interested in existing concepts and outcomes such as those of property. In contrast with morality's predeterminations, ethics is characterized by disinterestedness—a form of vigilant passivity toward the face of the other.

In an interview in 1986, Levinas summarized the basis of his ethics in the face-to-face as follows: "The approach to the face is the most basic mode of responsibility. As such, the face of the other is verticality and uprightness; it spells a relation of rectitude . . . it is the other before death, looking through and exposing death. Secondly, the face is the other who asks me not to let him die alone, as if to do so were to become an accomplice in his death." [8] Levinas's ethics of the face-to-face requires the perceiver to be held *hostage* to the requirements of the other, an extreme ethical demand that admits of, and can be seen to compensate for, the asymmetry between the relationship we bear to our own death and the death of others. It is only our own death that we will ever come to know, and whatever that knowledge proffers will unfold literally, in the end of intersubjective acknowledgment. Levinas himself famously rejects a notion of intersubjectivity, for he fears the narcissistic projection of our subjectivity onto the being of others, a projection that erases the particularity and indeed whatever is incommunicable in the existence of others. But I believe this position is also unnecessarily extreme, since we are able to recognize the common human position of others without projecting upon them the features of our own interiority, just as the way we recognize faces in general is separate physiologically from the way we recognize particular faces.

The extremity of Levinas's position in many ways recapitulates the sacrificial logic of the human relation to the gods, and indeed is rooted in a theology that envisions the human face as a vehicle for knowing the divine. Therefore I would like to retrieve from his ethics a secular and intersub-

jective potential. Such an individuality must be an outcome of not merely the perception of particulars, but the recognition of temporal existence, a recognition of an ongoing interest that overflows the moment of apprehension. Individuality resists its own allegorization by the fact of death and by its structural, and universal, embeddedness in the temporality of intersubjective relations. We should remember that we cannot perceive our three-dimensionality, or what is alive about ourselves, and we cannot see our own faces—we continually require the affirmation of others to testify that we are living forms occupying space.

There are, then, a number of links between Kant's aesthetics and Levinas's ethics—the nonteleological, the asymmetry inherent in reception, the imbalance between the underdetermination of received intention and the overdetermination of consequences, the requirement of an affirmation or recognition of being. But I must stop for a moment here and remark that what is equally striking is that Levinas's *aesthetics* and Kant's *ethics* are not at all useful for our purposes. In Levinas's most well-known statement on aesthetics, his essay, "Reality and Its Shadow," he wrote, "To say that an image is an idol [a semblance of existing] is to affirm that every image is in the last analysis plastic, and that every artwork is in the end a statue—a stoppage of time, or rather its delay behind itself." [9] This is a strangely static account of visual art, and he goes on to present a Platonic denigration of aesthetic form, claiming that only a reasoned criticism might restore art to meaning.

And as Levinas's aesthetics here blocks any particularity or specificity of form and so blocks our ability to recognize the acts of creation of which the work is an expression, so does Kant's ethics constantly turn away from particularity to the general rule, as it offers a hypothetical and universalized morality that is self-deluding in its abstraction and ease of application. Nevertheless, Kant sets out, in his discussion of "the beautiful as a symbol of morality," some of the structural relations between the beautiful and the moral: that both please without interest in the sense that moral interest does not precede judgment; that both involve freedom, of imagination in the case of the beautiful, of the will in the case of the moral; that both link the subjective with the universal but without prior determination. [10] What if we then took our cue from this structural analogy and proposed a particular, yet equally hypothetical, ethics as practiced or modeled in aesthetic experience? Such an ethics would be volitional and reciprocal and would bind its responsibilities to the contingent particulars of the form in time and space. Art's full array of sensual resources makes it of more usefulness as a sphere of such hypothetical encounters than the discourse conventions of ordinary

speech or action, which cannot accommodate the unsaid, the undone, or the merely imagined and so limit us to realms of manifestation. I am suggesting, in other words, that we revise our usual sense of sublimation—it is life that might seek to be adequate to the capaciousness of our experiences of art.

Following Levinas's "first philosophy" and Kant's version of the aesthetic encounter, such an ethics would be prior to the law and would provide a preparation for conduct that ensures such conduct will not be based merely on either convention or the spontaneity of individual desire. Kant's ethics remains bound to the imperatives of preexisting convention, but his aesthetics models a way of yoking our subjectivity to a universal disinterestedness that suspends its outcome. Thus what remains of value for thinking of a Kantian *aesthetics* in relation to a Levinasian *ethics* are the requirements of disinterestedness and temporal commitment, a suspension of teleology, and ethical specificity.

So long as those who make art have taken as their task the finer and finer articulation of preexisting meanings, either the meanings of religion or the meanings of social and perceptual habit, they have not been able truly to revise the possibilities of relations between persons. Artists have often decided to ornament or supplement such meanings, or they have merely inverted them in an attempt at transcendent values in the style of the avant-garde, and so such meanings have become petrified.[11] Rilke, for one, was preoccupied with the limitations of art when its fear of external authority resulted in a compulsion to concretize: he wrote, "Fearful of the invisible tribunals of an oppressive faith, men had sought refuge in these visible forms, had escaped from the unknown to this concrete embodiment."[12] For Rilke the long development of plastic art followed a path of finding more and more concrete forms of realization and animation. Along this path, realism emerged as the accumulated history of conventions for forming adequations of reality. Literally creating a life of their own, realist conventions were formed in the shadow of an absent and terrible figure who, omnipresent, prohibits its own figuration.

But the consequences of realism's concreteness have been mixed. Realist technological innovations became redundant as early as the photograph if not the perspective device, and this paradoxically redundant progress has not ended as we enter an era of various kinds of simulation of human form. Labor-saving artistic devices, when applied to aims of realism, are sadly caught in a paradox of short-circuiting their own value, since they limit the possibilities of intention in making and of the inference of intention in reception. However, even when artists have limited themselves to repeating preexisting meanings or merely made concrete the most familiar conventions

of perception, artworks have also been apprehended as made things, as the intended creations of others and so creations individuated and taken up in face-to-face relations. In this sense, art gradually has led the way in delivering the task of meaning into the sphere of individuals. As human culture has begun to turn from the sphere of moral law to the sphere of ethical choice-making, aesthetic experience has taken some responsibility for the task of anthropomorphization by which we represent ourselves to ourselves.

Although realism, like various forms of narcissism, may be driven by a desire for "matching" or mirroring, the face-to-face encounter with an artwork is an unfolding series of asymmetries. As there is a projection of the situation of the beholder or listener into the arrangements of the form, there is also an asymmetry between the particulars of the work and the assumptions or concepts brought to it from prior experiences of all kinds, including those of works of art. There is an asymmetry between the intentions of the maker and the consequences effected in the receiver. There is an asymmetry of volition to the extent that the free engagement of the maker is a constraint upon the voluntary passivity of the receiver, just as the active retrospection of the receiver reframes the intentions of the maker. Spatial asymmetry has its counterpart in belatedness in time. All works of art are destined to a belated reception, and more often than not such works are gifts of the dead that have outlived their makers.

At first we may think of how this belatedness makes the face-to-face relation with the artwork merely a compensatory substitute for the encounter with living persons. Yet Levinas has described the ethical encounter, even when in the presence of the other, in analogous terms of belatedness. He describes how "the relationship with the other is *time*: it is an untotalizable diachrony in which one moment pursues another without ever being able to retrieve it, to catch up with it, or coincide with it. The nonsimultaneous and nonpresent are my primary rapport with the other in time. This means that the other is forever beyond me, irreducible to the synchrony of the same. The temporality of the interhuman opens up the meaning of otherness and the otherness of meaning." [13] The belatedness of this relation with the other is an opportunity to extend interpretation under the finite circumstances of ethical needs.

In aesthetic experience, the receiver faces up to consequences as she infers the other's intention. In ethical experience, the receiver faces up to her own intention as she infers consequences. What is the result of these asymmetries if not our abiding sense of the uniqueness of the position of the beholder and the beheld? In his 1995 essays on alterity and transcendence, Levinas wrote that in representation "we have thought, approaching even

the uniqueness of the unique that is expressed in the face, in the same way as visible and plastic forms. Uniqueness of the *one of a kind*—or uniqueness having broken with all kinds—in the sense of the loved one being unique for the one who loves. A uniqueness that, to the one who loves, immediately means fear for the death of the loved one." [14]

Like language, artworks can make nonbeing present and so open up the sphere of being to what is not, including nonsimultaneity in time. But artworks are materially finite; their aesthetical ideas are manifested within their finality of form, just as the fleetingness of facial expression is manifested within the finite frame of our mortality. Artworks and persons inhabit a materiality vulnerable to decay and dissolution. They require acts of physical care as well as acts of disinterested engagement in order to continue, and they are finite nonetheless. They literally bear meaning, and once they are materially gone, they exist only if they are carried on in the para-life of reproduction and other forms of description; their uniqueness can no longer be experienced without mediation.

If the face-to-face, the volitional, and temporal asymmetry broadly link aesthetics and ethics as kinds of reflective judgment, then what are the particular consequences for an art practice that intends toward the other without seeking to stereotype or totalize the representational field? Every gesture toward articulation is countered by the inevitability of disappearance. Within the realm of visual art, for example, to think only in terms of what has been made visible, or to go even more astray and think of visual representation as only based in what is available to sight, is to miss the long tradition of representing the invisible and the limits of vision by plastic means. As Levinas mentions, the notion that recognition has ethical priority over description is as well deeply tied to attitudes toward iconicity and the tension between iconophilism and iconoclasm.

Whenever art makes visible, it does so by referring to the invisible from which the visible emerges. The unsaid can be withheld by the will; silence is volitional and interstitial, a temporal aberration and an outcome of acts of attention. But the invisible, to which we can only refer by means of metonymy, cannot be withheld and cannot be brought under attention. The invisible is the source of all visibility and never visible: this paradox is commensurate to the farthest poles of our seeing. At its most external limit, seeing cannot look at the sun that is its source; at its most internal limit, seeing cannot look at its own mechanism. We cannot look at the sun and we cannot look at our own eyes and faces.

The sun is the source of all images and at the same time the most powerful force of iconoclasm. To try to see the sun or look at it sustainedly is to

risk blindness; we seek a view of it through mediated glances, as we know our own eyes and faces only through the mediation of the responses of others. This mediation has a peripheral quality. We glance at the sun at the edge of our vision, or watch the horizon of its emergence and disappearance at sunrise and sunset. In the traditions of the Greeks, in many folkloric traditions, and in the Judeo-Christian scriptures, to look on the gods can cause disaster. Consequently, the encounter with the gods takes on the material qualities of the encounter with the sun—a surfeit of sensation results in deprivation.[15]

In the context of religious belief, our view of ourselves is curtailed in comparison to the view the gods might have, and we anxiously establish and internalize our sense of what the divine view might be by adherence to perceptual habit. But in the context of a secular ethics, we might instead seek images that move between the iconoclastic power of the source of light and the impossibility of self-seeing. An iconoclasm that refuses to totalize the human image inevitably will be joined to a need to disseminate and multiply such images given the infinite variety of human forms. Otherwise, as in the theological turn of Levinas, we will once again mistake human making as something divine.

Blockage accompanies vision; deprivation is the partner of sensation: these truths lead me to argue that realism's domination of aesthetic theory has itself kept us from recognizing an equally powerful historical tendency toward iconoclasm, iconicity, and iconoclastic withdrawal from the sensory manifold. Following some of the arguments of Alain Besançon, we can recognize that the iconophile's attitudes toward optical plenitude and totality are invariably accompanied by specific gestures within the work, acknowledging the limits of representation and foregrounding the haunting of the visual field by forces of invisibility.[16] In a secular context, foremost among these invisible forces are light, wind, and time.

Kant had characterized space as the realm of the external, just as he held that time is the dominant form of internal consciousness. It would be difficult to underestimate the great transformation modernism effected in our view of this spatial world. After modernism, the external became a source of abstraction as it had been under Mosaic law and in Byzantine and Islamic art; no longer was the external world merely a trove of concrete particulars. Although this begins as a problem of visual art, abstraction in all the arts produces synesthesia. And because sight and hearing are senses across distance, synesthetic works linking touch to sight and hearing inevitably bring forward a correlation between proximity and aesthetic value.

The movement toward abstraction, the breakup of surface into discrete

material particulars, the simultaneous juxtaposition of otherwise nonsi-
multaneous materials, the flattening of the picture plane and revival of an
anamorphic relation to the viewer, the introduction of circumscribing out-
lines, the use of monochromism and borrowings of written symbols, the
disruption of melodic or narrative expectations—when we think of the spe-
cific formal innovations of modern art, we see the vivid influence of Byzan-
tine art and its efforts both to avoid a totalizing presentation and to find,
out of a love for the image that is tactually as well as visually proximate, a
way to disseminate access to the divine. The icon maker borrows the ab-
straction of metaphor and at the same time uses the tactility of glinting and
glittering and absorbent surfaces. His techniques express a refusal of per-
ceptual illusion within a theology that rejects the material by showing its
merely material status. These techniques are at once inseparable from the
power of the glint in the living eye of the beholder,[17] from the desire for an-
imation, and from the experience of glimpsing and anthropomorphizing the
sun: its glittering, glistening, and absorbent effects, its transformation of the
edges and boundaries of entities, the repetitions evoked by the sun's after-
images, its facticity and abstraction at once.

The modernist break with the concretization of realism continues as the
art of our time begins to turn to new configurations of temporality and to
counter any totalizing representation of the human figure. Such an empha-
sis on abstraction and invisibility transforms Kant's division between space
and time. The figure of spatial orientation and location who is the measure
of spatial scale becomes the figure of temporal experience—an inner expe-
rience that cannot be reified by conventions of single-point perspective. The
figure is revealed as a being of internal consciousness as well as external
form. As modernism wrested the nontotalizability of representation from
the gods and placed it in the realm of external nature, the next great trans-
formation in the ethics of aesthetic practice will be, I believe, an ethical ac-
knowledgment of what cannot be totalized in the representation of other
persons and a recognition of indeterminacy in the encounter between mak-
ers and receivers.

This approach to a general concept of art leaves a number of questions
that I have left unanswered: How in practice *does* the experience of specific
artworks carry over into ethical decision-making? Are works of art based
in spectatorship and voyeurism doomed to the absorption of persons into
a-priori systems? How is art-making also productively *counter* to contin-
gent nature and hence bound up with decisions about technology?—for ex-
ample, the conditions necessary for the practice of art by women have only
been available by means of technological interventions in our biological

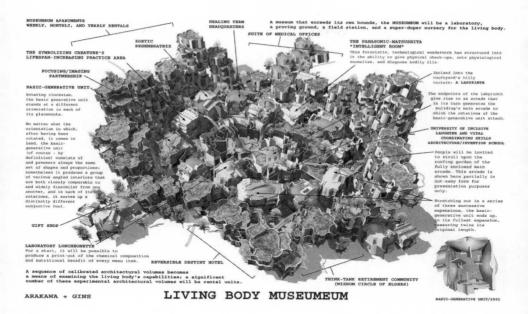

destiny of the kind artists like Arakawa and Madeline Gins now imagine as antidotes to death itself.[18] Which raises a final question about art's relation to an alienating technological determinism and the absorptive social coordination of time: can art continue to serve as an alternative to, and not merely a negation of, such alienating forms? It is my hope that it will—and that it is by means of artistic practices, and not merely through the refinement of aesthetic theory, that this might happen.

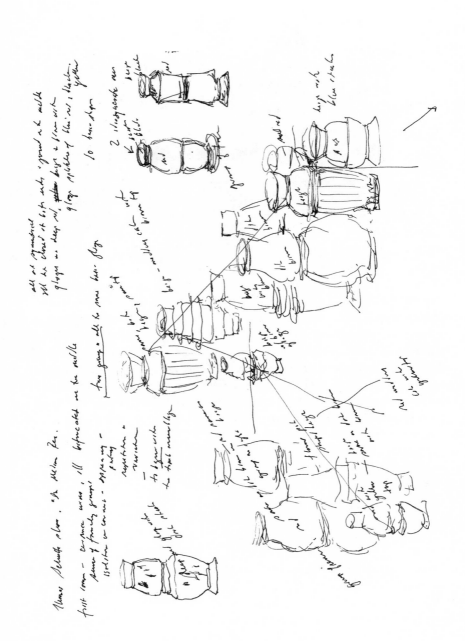

CHAPTER 3

THOMAS SCHÜTTE
In Medias Res

In medias res: "into the middle of things" is how Horace's famous rule to the young poet or maker is usually translated—to begin in the middle of the action, immersed in its density, whether the narrative be an epic, a drama, or other work of fiction. From this vantage, the poet can work forward or backward in time, establish causality after the fact, and bring consequence up against its instantiating moment. A mobility in time is made possible by beginning in this way, and beginnings of artworks acquire an independence from the contingency of real or experienced time, the time of existence and the time of history. But Horace's *De Arte Poetica* in fact presents this dictum in a broader and more intriguing frame:

> semper ad eventum festinat et in medias res
> non secus ac notas auditorem rapit, et quae
> desperat tractata nitescere posse, relinquit.

> [Ever he hastens to the issue, and hurries his hearer into the story's
> midst, as if already known, and what he fears he cannot make attractive
> with his touch he abandons.] [1]

In this fuller context, the mandate to begin in the middle of things is a mandate to try by every means to move the listener, the one who attends or hears the poet's words. The listener is addressed "as though" he or she knew the narrative beforehand and this prior knowledge is a resource for the poet, who therefore may act with greater freedom in presenting the nar-

rative in a new order. But the listener's prior knowledge also asserts a demand, for the poet must make such history worthwhile and what escapes the poet's powers cannot be deliberated upon and recaptured; the poet must move on, abandoning what is beyond her creative resources.

In Medias Res is the title of the third in a series of installations Thomas Schütte has made at Dia in 1999–2000. Yet Horace's dictum underlies much of his approach to art-making in general. Schütte's work enters into the narrative of its own historical moment with an immediacy of response, an approach of intervention or eruption in circumstance. Without a recognizable signature in material, ambiance, or theme, Schütte both revives the figure of the polymathic great artist moving between two-dimensional and three-dimensional forms from Michelangelo to Bruce Nauman and at the same time rejects, with a characteristic modesty, self-effacement and deliberately erring practice, the model of mastery such an artist might claim. Schütte plays in the "fields" of modeling, sculpture, ceramics, watercolor, painting, architecture, and what might be called theatricality or scene-setting. Materials are a means to expression for him, and his expression centers not upon the self but rather upon a continuing project of apprehending and representing his encounters with others. In his earlier work, with its models evocative of vast civic spaces and public forms of architecture, the encounter emphasized an abstract relation to the social. In the 1980s and '90s his work has moved into a close and provocative consideration of human emotion and human figuration, a concern that culminates in the particulars of *In Medias Res*.

In Plato's *Symposium*, the wise woman Diotima describes how all humans seek to immortalize themselves through form or the process of producing forms. Some try to do so by begetting children, she says, but others "are more creative in their souls than in their bodies . . . Homer and Hesiod and other great poets [created] children . . . which have preserved their memory and given them everlasting glory." [2] Any artist whose aim is a representation of life is pulled at once into the terrible economy of the overdetermination of nature and the underdetermination of death. To be awed and overwhelmed by the great panoply of the given world from without and to know the shattering and revelatory experience of childbirth from within are experiences that transform the limits between the inside and the outside of consciousness; to think on the pain of others and to imagine the otherness of our own deaths is to find ourselves withdrawn into an inarticulate privacy. In *In Medias Res*, Thomas Schütte has staked an ambitious and ultimately successful claim to represent the birth and death of individuals as

universal processes of nature. He places us "in the middle" of life, a vantage from which we discover death and memory at the center of the artist's task.

Schütte orders the viewer's progress through four discrete spaces in *In Medias Res*: the first room holds a complex arrangement of ceramic vases of nearly human scale (they are three to five feet in height); the second is a long hall-like space exhibiting seventy ceramic studies, human figures on rectangular slabs approximately the size of cutting blocks, arranged on open steel shelving. This room also exhibits three watercolors: one, visible as one enters, of a knotted cloth; and two more works, visible as one leaves, of knotted socks. As the viewer faces the shelved studies, he or she must turn away from a third large room where four monumental steel sculptures of female forms each appear on a large steel table. Once the viewer enters this third room, four of Schütte's "self-portraits in a shaving mirror" are visible, two on either side of the opening to the room. And beyond the long hall of ceramic studies, the viewer enters another room to the left, where two enormous ceramic sculptures of the head of the art dealer and artist Konrad Fischer are displayed on high wooden pedestals in the center of the space. The heads themselves are several times larger than they would be in life, and the features of each countenance are bandaged about by winding sheets. Fischer's Düsseldorf gallery played an important role in fostering international art of the postwar period, especially minimalism, conceptualism, and *arte povera*. Fusing developments in the aesthetics of installation art with the pragmatics of gallery exhibition, Fischer developed his space as an often improvisatory extension of the artwork—and artists reciprocally created new works specifically to be shown by him and his wife, Dorothee. Fischer saw his gallery as not merely a commercial enterprise but rather an effort to, in his own words, "keep the family informed." [3] These monumental portrait heads are in fact funerary monuments, completed in Fischer's memory after his death in November of 1996. The walls of this room also display four more of Schütte's shaving self-portraits and ten flower paintings.

The narrative constructed by movement through the space is a carefully articulated sequence of entry, transition, arrival, transition, and arrival, for it is necessary to return to the "hall" of ceramic studies in order to view either the "steel women" who are their monumental counterparts or the ceramic effigies of Fischer. In order to leave the space, one has to retrace one's steps, to traverse the hall of studies and end again in the place of beginning, the room of ceramic urns. The viewer is always at a middle point in this sense; the dynamic is one of entry and transit back to exit as a transforma-

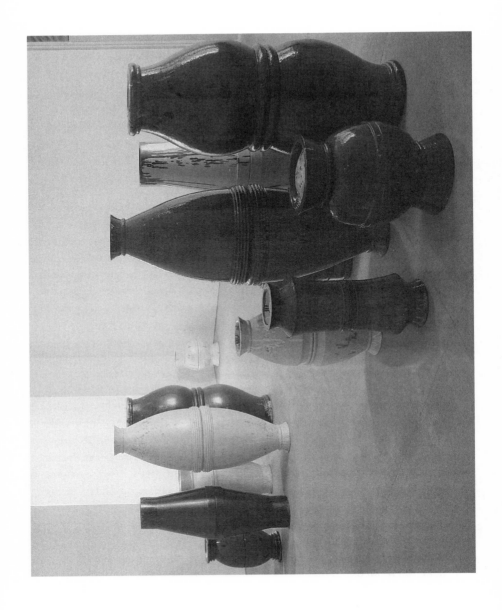

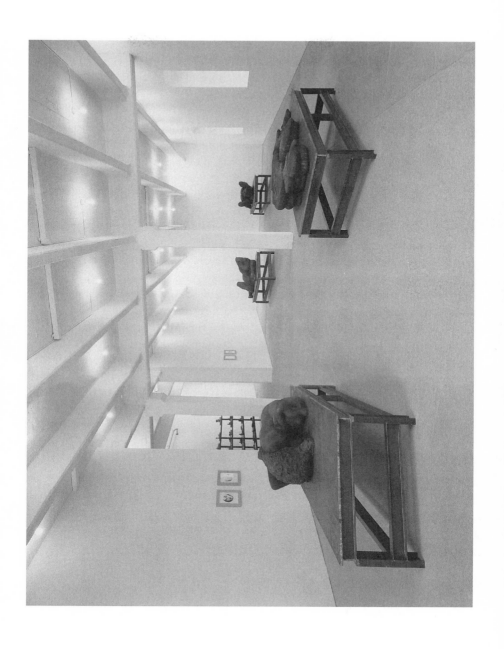

tion of entry. This structural movement through the work as a whole is what
is temporally continuous to the work: in each of the individual "rooms," the
viewer's attention is called away from such linear movement and drawn to
absorption in the materials and works at hand.

The ceramic urns of the first room share certain features: they are all cir-
cular, vertically symmetrical, and clearly bifurcated by a "joint" that is usu-
ally in the middle; they also are closed at both ends, which adds to the im-
pression that they might contain something. The eighteen forms are in fact
variations on ten basic shapes; two of the shapes only appear once. None
are duplicates, however, because of the variation in the glazes, which involve
a finite and repeated palette of deep red, beige, brown, turquoise, black, and
yellow. The glazes are marked by streaks, striations, speckles, and various
other surface effects. Two urns stand off in diagonal corners by themselves;
the others are in groups of four, five, and seven. The shadows of the vessels
mix on the floor; moreover, the forms themselves are positioned in such
proximity that the viewer must move around one in order to see another,
and none can be viewed in its entirety without interference from another.

With their closed ends and central seams, the urns are evocative of Rus-
sian nesting dolls, and like other nearly human-sized figures, such as those
of the Sicilian puppet theater or the terracotta figures from the Mausoleum
of Qin Shihuangdi (220–210 B.C.), they bear a remarkable quality of pres-
ence. By being slightly smaller than those persons we encounter in our every-
day existence, they seem to have receded against a horizon of time past. And
of course these urns bring to mind cinerary urns and individual tombs.
However, because Schütte has arranged them in distinctive groups, giving
a relational meaning of individuality to the two that are not grouped, one
immediately sees each vessel in its "family" relation.

This resonant "familiarity" of the inanimate object of course calls to
mind Fischer's insistent emphasis upon the family of artists as the ultimate
aggregation of individuals, as well as a number of issues out of Wittgen-
stein's work on image-making, picture-making, and resemblance. Indeed,
Schütte's vessels call up the specific terms of the explorations of Wittgen-
stein's *Brown Book*: shape, color, faces, and facing; the "lighter" and
"darker"; the given and the volitional; things and "kinds of things"; the ex-
pression of character and inference of emotion. In Wittgenstein's thinking
there is a gradual transition from the realm of apprehending purely formal
qualities of things to that of recognizing, and responding to, human inten-
tion.[4] Schütte's vessels are linked to a similar aim, for whereas our first ap-
prehension of the objects in the room involves issues of quantity (how many
are there? how many groups are displayed?), we then begin to ask how

many *kinds* there are, and what these vessels might evoke or imply—*how* we are seeing them.

In the history of Schütte's own work, the vessels have a clear line of descent from his 1992 piece *Die Fremden* (The strangers). This was a group of large terracotta figures arranged in three family groups and accompanied by sacks or urns similar in form to those of *In Medias Res*. The figures of *Die Fremden* themselves were heads and torsos attached to urnlike bases and glazed in bright colors. They had closed eyes and downcast heads and were placed eventually on the portico of the former Roten Palais of the Landgrafen von Hessen in Kassel, now a large department store. There they gave testimony to those refugees who so often suffered displacement and migration in the 1990s and consequently met with persecution in German cities. Schütte said of these "strangers," "They all have their individual history of growing and so on, the figures were even given names at the factory. The idea was to make lifesize clay figures, people as precious big vases. No negative molds, no plaster or metal casting or steel skeletons were used, nothing like this I wanted." [5]

Whereas it was important to Schütte that these figures could only be viewed from a distance and from below, the ceramic vessels of *In Medias Res* can only be viewed immediately and in a circular way. The vessels appear like caskets or containers evoking the absent strangers; they mark their passing as they also fill the space with a presence that is *as* or *like* their referents. The faceless vessels of *In Medias Res* are literally "counters" in an arrangement speaking to the connection between the familiar and the strange, the living and the dead, the recognizable and the mutely unintelligible in a world where a face-to-face relation appears as a relation between persons and things.

The second hall-like room of ceramic studies on shelves is continuous with the first room in that the primary materials, the terracotta and the colored glazes, are the same. But the steel shelving and the random or arbitrary placement of the seventy studies make this experience one of passage and transition rather than compelling the studied circulation of terms required by the first room. The arrangement of the studies was determined not by Schütte himself but by the Dia staff members who assembled the shelving and unpacked the works; the artist asked them at this point to determine the order of the placement.

Facing the shelves, one reads from left to right and finds it impossible to read from top to bottom. The highest shelf, at seventy-six inches, is placed above the view of even the tallest visitors, and the only works that can be seen with any clarity of perspective are those at eye level and below. Not

much bigger than the page of legal-sized photocopy paper on which I have drafted this essay, the terracotta slabs that serve as "bases" for these works are almost all rectangular in shape (three are round), though of slightly varying sizes. The "figured" female nude forms, who are prostrate in gestures suggesting anguish, submission, death, or sleep, display a range of relations to the slablike bases: they seem alternatively to rise and recede in varying degrees from their grounds. They are often so torqued that they appear knotted, and one of the most striking studies evokes the knotted cloth Schütte has used elsewhere in his work, here echoing as well the forms depicted in the installation's three watercolors. The knotting indicates the volitional activity by which the artist can reveal the inward as he also represses the surface of appearances, creating an entirely new configuration out of the elements to hand. Significantly, the first watercolor, with its image and black shadow, is intelligible as a knotted *something*; it is only as one leaves the space that the paired watercolors on the far wall are revealed by their titles as knotted socks.

One of the ceramic studies is simply a rectangular base with a hole; in another a snake emerges from a hole. Throughout, the viewer has a sense of the chthonic origins of these works, both in the sense that the human figure arises from the earth of its base and in the literal sense that these terracotta images (like the urns in the previous room, we retrospectively realize) are made from earth itself. The figures seem both fallen (there is in fact a representation of an apple on one of the slabs) and emergent. Ranging from minimal relief that is almost recessed into the slab on the one hand to nearly upright forms on the other, they are all nevertheless bound to their bases, as we are bound to the gravity of earth and derive our own gravity from the necessity of death's magnetic earthward pull. Grounding, gravity, table, block, shambles—the base is always evident here, whereas it was hidden by the poised and determined posture of the urns in the previous room.

The terracotta studies are "finished" with what looks like a slapdash application of glazes. They have a quick and urgent effect in their modeling as well, resembling the "bozzetti" of baroque sculptors, those terracotta studies of uneven levels of finish with the marks of hand- and fingerprints appearing over and under the surfaces. But it is the glazes that most clearly give evidence of a technique wherein what the artist despairs of treating effectively "he abandons." There is an irony in the way bronzing and gilding have been used in some of these radically unfinished works, and the dripping glazes spill over the surfaces of both sculpture and base with a seeming lack of discrimination, as if they were mistakes on purpose undermining the integrity of the object and emphasizing at the same time the volitional and

made aspects of the form. The maker's spontaneity seems to be driven by a force outside himself. The viewer notices a compelling necessity, an urge to move or be born or recede that seems attributable to the forms themselves, now lying in abandonment on storage shelves like carapaces of a flown intention.

Yet of course the true outcome of these studies is "revealed" in the monumental sculptures of the third room. Here the terracotta bases are transformed into mammoth steel tables (ninety-eight by forty-nine inches), and the torqued female figures are four great giantesses in poses that seem less reclining than knotted, earth-born, struggling, and receding into the very ground of the table. The sculptures are six or seven times larger than the ceramic studies. Whereas the perspective was either too close or too far in viewing the seventy studies, here the women lie, for the female viewer of average height, just at waist level. The view is both completely open (the figures are like specimens laid out for viewing) and completely occluded in that the relations between the back and front of the body and the inside and outside areas of flesh are knotted by the poses themselves. Suggestive most obviously of the bulging and heavily weighted nudes of Aristide Maillol, these figures nevertheless have nothing in common with the poised frontality of such sculptures. The experience of seeing Schütte's figures is closer to that of tracing the quick erotic line drawings of Pablo Picasso. From one angle, the back of a head looks like the top of an acorn, and from another, the face of this head is so recessed that it resembles a vulva; the breasts of a figure look like the bulls' testicles worn by Diana of Ephesus, and protrusions like horns erupt; viewed from the back, the pressure of a heel can be seen in the left buttock, like the presence of hand on flesh in Bernini's *Rape of Persephone*. One figure seems to have been sliced into a planar surface. Breasts, navels, protrusions, and recessions are evident, and yet the hands and feet are stylized abstractions. Hence the chthonic and primordial earthbound quality of the form is emphasized over any idea of an animated will. Another figure conceals the suggestion of an individual face under something like a corrugated mudslide of hair: she seems of the four the most unbalanced, as if she were slightly tilted to one side and might tumble over.

The steel tables have been polished and sanded, but the sculptures are coated with a patina that makes them corrode, and the rust readily spreads from sculptures to tables. The studies' concern with effects of relief and recession is here continued, as the "relief" of the glazing is now replaced by the recession of corrosion. Whereas it is the forces of nature that usually wear down art, here it is art that corrodes the world as it is itself corroded. Everything seems to be breaking back down into the earth—the most cor-

roded sculpture is the one with the abraded planar surface. It seems at once taken further into a state of inert mineral life and yet the most nascent of the four figures.

The face-to-face encounter that is not possible with the monumental torqued physicality of these sculptures is, however, brought forward with great immediacy by the four self-portraits flanking the exit to the room. In making these works Schütte, who is nearsighted, removes his glasses to paint himself as reflected in a shaving mirror. The circular frame of the mirror is the edge of the portrait. These four portraits are separated from the four "shaving" portraits displayed in the final, fourth, room of the installation, but are necessarily read temporally as "earlier" than the remaining four works. They are striking representations of eyes and hands made by eyes and hands. And the productive tautology of self-making and self-scrutiny is emphasized in this further aspect of their circularity. Here a depiction of the left hand within the frame implies that the right hand is the hand of the maker: in a portrait in the final room, the right hand is portrayed. Is Schütte claiming an ambidexterity and facile mastery of the watercolor? Or is he presenting an image that is in truth a memory or fiction? In any case the time of the viewer, the time of the image, the time of painting/making are all distinct and articulated from one another. The portraits, with their intense and melancholy self-scrutiny, recall the great shaving self-portraits of Pierre Bonnard's late years. As with the dripping glazes, the materials here are presented in a consciously catechrestic fashion. The watercolors drip beyond the edge of the shaving mirror's circle: a black spot on the chin of one of the images might be a spot on the face, a spot in the mirror, or a mark on the paper. This watery and glassy medium of reflection resists certainty as surely as the tactile density of the terracotta forms roots them to the earth.

The fourth room of the installation can also be read as the point of departure for reentry, since leaving the installation requires passing the shelves of studies again—this time with the studies on the right side of the body—and passing in reverse fashion through the first room of ceramic vases. Thus there are two terminal points (the room of monumental female figures and this fourth room) that are also "middles" in the trajectory of entering and exiting. As a knot reconfigures "ends" within a twisted circuit and moves interiors into exteriors and exteriors into interiors, so does this nonlinear and recursive structure of viewing require a reconsideration of ends and means. The fourth room also stands in vivid thematic contrast with the room of monumental female figures, for here there is no anonymity or universality. The great bound ceramic heads on pediments are clearly effigies

of Fischer, the flower paintings on the walls are specifically titled and dated, and the shaving portraits show specific differences in Schütte's daily appearance. His long sideburns in one portrait and disheveled look in others are reminiscent of mourning practices of refusing to cut the hair or beard and covering mirrors with dark cloths. But they also speak to another passage in Horace's *Ars Poetica* about the artist's search to escape the very artifice of art:

> Ingenium misera quia fortunatius arte
> credit et excludit sanos Helicone poetas
> Democritus, bona pars non unguis ponere curat,
> non barbam, secreta petit loca, balnea vitat.
> nanciscetur enim pretium nomenque poetae,
> si tribus Anticyris caput insanabile numquam
> tonsori Licino commiserit.

> [Because Democritus believes that native talent is a greater boon than
> wretched art, and shuts out from Helicon poets in their sober senses, a
> goodly number take no pains to pare their nails or to shave their beards;
> they haunt lonely places and shun the baths—for surely one will win
> the esteem and name of poet if he never entrusts to the barber Licinus a
> head that three Anticyras cannot cure.][6]

Anticyra, a town on the Corinthian gulf, was famous in the ancient world for its profusion of hellebore, the standard cure for insanity. In the progression of the fourth room's self-portraits, there is surely something of this classical idea of the coincidence of grief's derangement, great artistic concentration, and a refusal to compose the appearance of the body.

The ceramic heads are distinctly contrasted in color. The head first visible as one enters the room bears a livid glaze of red and beige; the second is blue-green. The red head lies on a triangular pedestal of dark smooth wood; the blue head lies on a blue quilted and padded cloth, of the type used by moving companies, that is folded over a rectangle of unfinished plywood. The cloth that binds the faces, although identical, appears in the first image as a bandage and in the second as a winding sheet because of associations suggested by the glazes. The first head seems on fire with pain, the second frozen in mortification. There is a terrible and moving quality of "on" and "off"—of too much response to the world and too little—in the dynamic between the two effigies.

The ten flower paintings, in the same watercolor palette as the knotted

socks and shaving portraits, are hung along three of the walls of the room. They necessarily are reminiscent of the elegaic tradition of the flower catalogue. Here all the flowers are cut, and all are represented by single blossoms. The palette is orange and gray and black and yellow, with black dominating the backgrounds. A day lily looks as if its color had bled into the paper, a rose has torn petals and bears the inscription Happy New Year. An iris is inscribed Back to Earth, and the yellowing of tulip foliage expresses the spent state of the flower. Flowers in their ephemerality have long been linked to the wasting of human life; here the flowers are in a state of decay and return to earth, as each image is dated as a memorial to a beloved, departed friend: the earliest works here are December 1997; the most recent, December 1999. There is a pattern to the cycle of mourning—an anniversary is like the revival and ensuing death of the flower.

In Medias Res continues many of the concerns of Schütte's earlier work. The given spatial terms of the exhibition space are modified in order to rethink the trajectory of aesthetic experience. The relations between painting and sculpture are emphasized, as are themes of modeling or miniaturization. Yet in this work Schütte also takes on the most basic and elemental questions about the artist's means for representing life. The range of materials in the installation brings forward all the elements: earth transformed into terracotta; water transformed into watercolor; fire employed in steel and evoked in the cinerary urns; air at work in the corrosion of rust. Spatial arrangements are readily apprehended as temporal arrangements as well. In the first room of ceramic urns, the viewer must take time in order to discern and separate the genealogies and assemblies of forms into families. In the room of models, the viewer can see the panoply of slabs and figures, yet he or she is constantly pulled to look at the works both individually and in the groupings of three or four elements on each shelf. The four monumental female forms must be approached as dynamic and unified works overall and yet also can be examined as discrete landscapes, for the crevices and marks of the patina differentiate their surfaces into beautiful and complex patterns.

Each room also prohibits certain views. The urns recede behind each other and their bases cannot be moved or seen. The models on the top shelf, or perhaps the top two shelves for many viewers, are too high to be seen. The monumental figures cannot be taken in at once but rather must be circled and viewed from changing angles. They are too low to see without bending, just as it is impossible to view fully the two monumental ceramic heads in the fourth room without standing on our toes. And the watercolors in each room compel the viewer's full attention, drawing him or her away from the domain of objects and into a realm of reflecting two-

dimensionality of great psychological depth. What we most readily see in the world is just beneath us or face to face with us: the watercolors are in this "position of the person," yet pose certain metaphysical knots of interpretation.

We are, in looking at these watercolors, looking at a representation of an image in a mirror, which the artist is painting by removing his glasses and so sacrificing any larger or distanced perspective for a close view of self-analysis. But the close view is limited to the immediacy of time, and when such works appear as a series they show the ephemerality of states of being and self-knowledge as surely as the "portraits" of cut flowers show their immanent death. And whereas the shaving portraits and the ceramic heads of Konrad Fischer speak to an irreducible individuality, so do the monumental female forms appear as types or positions of identity rather than singularities. Even the two urns that appear singly in the corners of the first room and the two urns that have no resemblance to the other forms are endowed with their individuality only by means of formal relations in space and shape to the other urns. One can only be a "black sheep" if there is a family with which to argue.

All things come from and return to the earth in the narrative of *In Medias Res*, but what is truly "in medias res" is life itself. Forms of life are shared collectively and universally, yet experienced and known as a matter of self-consciousness—as death is experienced—only individually. In their path-breaking critique, "The Culture Industry: Enlightenment as Mass Deception," Max Horkheimer and Theodor Adorno crucially linked the promotion of mass consciousness in the fascist era to the promotion of mass consciousness in postwar commodity cultures. Central to their argument was the idea that mass culture produces an illusion of individuation ("you are what you buy"; "it is so *you*") indistinguishable from the forces of illusory identification between the individual and the collective central to fascist psychology. The culture industry commodifies the spectacle of suffering and turns the recognition of death into a variation on sentimentality. Horkheimer and Adorno wrote, "Once the opposition of the individual to society was its substance. It glorified 'the bravery and freedom of emotion before a powerful enemy, an exalted affliction, a dreadful problem,' as Nietzsche had written in *The Twilight of the Gods*." But, they continued, "Today tragedy has melted away into the nothingness of that false identity of society and individual, whose terror still shows for a moment in the empty semblance of the tragic . . . this liquidation of tragedy confirms the abolition of the individual." [7]

In Medias Res can be read as bearing the particular death of a particu-

lar individual at its "middle." Konrad Fischer, at the age of fifty-seven, was cut down in the midst of the action of life. This death is not incomprehensible; rather, it is framed, bandaged, and bound about by the "winding sheets" of the flower catalogue and the grief-stricken face of the one who recognizes the death: the artist himself, who asks us to read in his own face the recognition by which all death is made significant. Fischer promoted and protected the artist in an age that otherwise relentlessly capitalizes upon the brand name of the artist's reputation and just as relentlessly reifies the artist's signature and materials within a system of planned obsolescence. Out of this middle, unraveling from this knot, is the ground or context of all tragic recognition—the place of the other between strangeness and familiarity, the birth of the vessel of the soul out of the configurations of the historical moment and social place of origin, and the emergence of all human life out of the four elements. Moving forward and backward in time—out of death's aftermath, into birth and decay, into memory and recognition, and returning the way we came—we enter into a narrative that is "as if" already known and is transformed by the distance between that "as if" and the experience. The return is transformed by the means of departure. Meanwhile the artist has moved on and will be waiting to move us again.

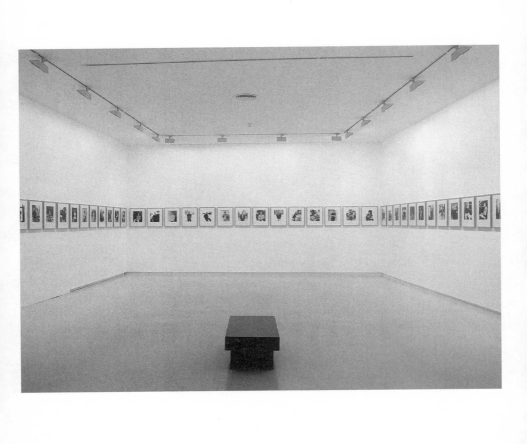

CHAPTER 4

HANS-PETER FELDMANN

Why is it impossible to describe the faces of those we love and yet almost
never difficult to recognize them? Even when we have last seen such faces a
few hours or perhaps minutes ago, we often cannot imagine how to describe
them. And even when they are long absent from us or absent forever, re-
ceded within the shadows of the dead, we know them readily in images and
can glimpse or recall them as well in the faces of others.

I would like to understand how this strange difference, the difference
between the difficulty of representing and the ease of recognizing beloved
faces, has something to do with what visual art has been and is and will be
able to become. With its emphasis on small-scale apprehension, valences of
anonymity and familiarity, repetition, fragmentation, and temporal change,
Hans-Peter Feldmann's work helps us imagine art's potential as an ethical
force in an age of secularization and continues an iconoclastic impulse to-
ward recognition at the expense of description that has been submerged,
but never disappeared, within the history of Western art.

At the heart of Feldmann's practice as an artist is the idea of the ephem-
eral. It is not simply that he seeks a kind of antimonumentality, or that, as
has often been noted, he is reacting against the gallery system and the com-
modification of his art. He also shrinks the sphere of creation and appre-
hension to the world at hand, the world of the momentary, daily, and per-
sonal whose meaning is fleeting, idiosyncratic, and yet profound—the true
measure of existence under the pressure of forces of unmaking. He shows
that the familiarity of images is specific to individual consciousnesses and
thus, in his scale of values, places the activities of individual perceivers ahead
of any qualities borne by inherent aspects of the artifact.

Photography is a deception concealing the temporal fleetingness of perception, and in Feldmann's work the sheer bombardment of visual images photography has plastered on every surface of our world becomes a kind of second nature—wherever we turn, we see an image of something that escapes us, as in an earlier era we had contended that the phenomenal masked the noumenal. Thus his art does not remind us of nature but is, rather, a way of remembering images themselves; or, we might say, a way of remembering ourselves seeing images. Feldmann indicates this cultural manifold by clotting his work with pictures, emphasizing their redundancy and partialness, their naiveté and seeming absence of agency, refusing them what might be called visual integrity. And then he sorts, organizes, and reframes them so that they speak to an individual will and desire and take place within lived temporality once again.

Whether they are on the scale of a tiny stamp or a series of billboards, by refusing to caption or explain them with words, he returns them to conditions of overdetermination and visual fantasy. The experience of his art can be compared to witnessing the unscrolling of an endless home movie in which, somehow, nothing has been excluded. Here the concept of the "coloring" of emotion is particularly apt in relation to Feldmann's transformations of the given world. When in his *Sonntagsbilder* he bleeds familiar images of a couple holding hands in front of a sunset, a kitten, or waterfall; or when he adds color to black-and-white photocopies of images of children holding dogs; or paints plaster models of classical sculptures, the effect is one of emotional supplement and minute attentiveness, much like that of the "features" and Sunday supplements of the daily newspaper. He also evokes the practices of children when they color, although I would say he alludes to the early stages of such a practice—when children give attention to what most interests them, rather than following rules of matching the colors of nature to the colors of art.

Feldmann himself has expressed a disinterest in the aesthetic, and indeed in certain periods his career has been devoted to an explicitly reactive and ironic political practice of art-making. Much of this work undermines the status of the figure of the artist himself: by surrendering gallery space to unknown local artists, or sending pornographic photographs of himself to his associates, or issuing invitations to exhibitions that did not exist, or most dramatically, withdrawing for ten years into an artistic silence, he played with setting limits of distance and propinquity between the creation and reception of his work. In his more recent work, *Aesthetic Studies*, he has exhibited everyday practical objects—pencils, tools, glasses—on pedestals, and in doing so does not seek the formal apotheosis of a Duchampian ready-

made so much as insist that even on a pedestal such an object retains its use value. But I see his overall project as one devoted to restoring the mystery and profundity of the face-to-face relation to the apprehension of images, and it is difficult in this sense to conceive of his project as outside the aesthetic tradition.

Feldmann's work that most strongly testifies to this possibility are his recent pieces emphasizing the lives of individual persons through sequential images: his album *Portrait* where photographs of a woman's life are arranged in chronological order; *Holidays*, an album devoted to one hundred snapshots from a couple's vacations over many years; a smaller booklet, *Africa*, that assembles photographs and documents that have been required for emigrants passing from Africa to Europe. On another scale, his 1993 work *The Dead* chronicles the death of every person from terrorism and the state response to terrorism over a twenty-six-year period. And his most recent work, *100 Years*, is a collection of 101 portraits of his circle of family members and associates, ranging from eight weeks to one hundred years old and arranged in sequence according to age. We can say that we come to know something thereby of every age, whereas we know very little about the persons represented. The allegory of "the ages of man" is realized, as all allegories are realized, only at the expense of certain particulars. And those particulars thereby come to mind—untotalizable, endless, and sublime. Recurring in Feldmann's work is the contrast between the reifying portraits of state documents, where identification is reduced to whatever can be made manifest and material, and the intimate fleetingness of the snapshot, where life takes priority over its arrangement.

A similar effect of indeterminacy and even ineffability is evoked in both his early piece *All of a Woman's Clothes* and his recent sequence *L'amore*. *All of a Woman's Clothes* is a sequence of centered black-and-white images of every item of a woman's clothing at a particular moment of time, with the sequence arranged from undergarments to outer garments. It is the opposite of a striptease; a proleptic ghost of a presence is what is bracketed before the first photograph begins. In *L'amore*, six photographs show a white woman and a black man posing individually before the same backgrounds: a flowerbed, a bedroom, a bed. Like Feldmann's impromptu tourist snapshots, *L'amore* displays a historically determined spontaneity. The duality of the images charmingly illustrates the principle of all photographs produced by couples who want to be alone: one must take the picture while the other is in the picture—and it charmingly illustrates as well what Lacan has called "the lover's complaint": *you never look at me from the place from which I see you.*[1]

In the Middle Ages, an average person may have come to meet fewer than twenty other people in the course of his or her life. As recently as my great-grandparents' generation, the typical person may have had only one photograph taken of himself or herself during a lifetime. But now the often photographed inhabitants of First-World countries may "see" a hundred people and hundreds of images in the course of an ordinary day—that is to say, of course they do not see these phenomena, and forgetting is an important device for maintaining significance in such a world. To apprehend someone face to face is not the same as merely being in the same visual field. And to apprehend an image tactually, to encounter it within a certain context intended by the artist, is to meet face to face with the consequence of that intention. Feldmann continues into our image-soaked era the long trajectory of the relation between our concept of person and the persona—or Latin term *per-sonare*, the mask through which the voice of an actor or agent will sound with its important connection to the image of the dead. In his history of the development of the concept of a person in the West, Marcel Mauss describes how in ancient Rome the *imago*, or wax death mask of the face, was attached to the cognomen, the right of name and family. Then the dual sense of the person as a role and inner, intimate conscience arose under Stoic philosophy, the Christian concept of the soul, and the modern concept of the psychological self. A paradigm of inner feeling and outward expression develops wherein the individuality of the inner self is the ground of all rights and receptivity regarding expression. Mauss summarizes this history as follows: "From a mere masquerade to the mask, from a role to a person, to a name, to an individual, from the last to a being with metaphysical and ethical values, from the latter to a fundamental form of thought and action—that is the route we have covered."[2] This is thereby the history of the modern notion of the person, one who is the subject of experiences and maker of choices, one whose existence is in itself and for itself.

I would argue that of even more importance than visual apprehension in Feldmann's work is the gesture of binding that is indicated by this holding together of the inner and outer life of persons by means of thought and action. The binding of images into books, photographs into albums, works into sequential relations and narrative plots is indicative of the binding that unifies the practice of the artist as an analogy to the unifying practices of anyone's being. In his collections and books, Feldmann exercises a salvage craft wherein the ephemeral is gathered by fantasy, reverie, and, eventually, memory. Thus the ordinary and the everyday become objects of beauty not merely because of their inherent formal aspects, but because they are put to human use in forms of human expression.

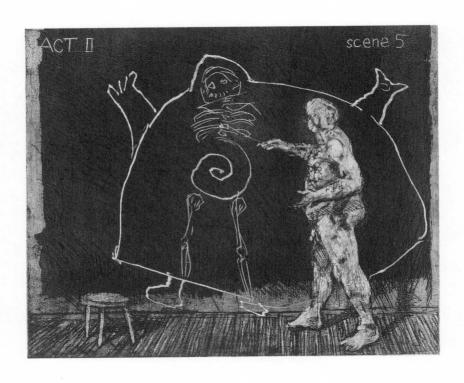

WILLIAM KENTRIDGE

I. A Messenger

One by one, across the plains and sea and hills to the palace of the Atridae, the torches are lit to bring the news from Troy. The watchman stands anxiously in the dark, pining for the moment when he can watch the night sky as an emblem of itself, without an expectation of the sudden human light that brings the obligations of history. A messenger eventually will burst on the scene, and there and then will narrate the truths of suffering, murder, and treachery that have remained in every sense *ob-scene*, hidden from view and hence all the more necessary as a narrated knowledge. The messenger must urgently and patiently unfold his testimony, detailing and quoting and inferring cause. And then, at the end of his message, he must move back from his narration of horror and brutality to conclude with some aphorism, some sense-making principle as a counter to the ineffable or absurd: "Every man must learn not to be too trustful" (line 1616), says the messenger of Euripides' *Helen*. "The noblest thing a man can have is a humble and quiet heart that reveres the gods. I think that is also the wisest thing for a man to possess, if he will but use it" (line 1150), says the messenger of his *The Bacchae*.

The messenger speeches of classical tragedy are prototypes for an authentic documentary art. They break from the limitations of both the subjective speech of individual figures and the collective and abstract lament of the chorus; in messengers' speeches first-person perspective is harnessed to the interests of moral continuity. In form the messenger's speech effects a great reversal of figure/ground relations: first asserting the claims of the

trauma of memory against the forgetfulness of present-centered existence, then reframing the particular facts of the trauma within a discourse of truth and virtue. The authenticity, beauty, symmetry, and skilled likenesses of the messenger's speech only have moral authority because of this final transformation of what is individual into what is universal. Without that transformation, such facts remain objects too sensational in their detail and too cold in their indifference to be of human use.

Few living artists understand more vividly than the South African artist William Kentridge the difficulties and responsibilities that accompany such relations between figure and ground. No stranger to tragedy in life and on the stage, he truly has served as a messenger of the ob-scene and has taken on the burden of drawing ethical conclusions from historical events that are often overwhelmingly evil. His is an art not only of politics, as it has often been viewed, but also of theodicy that considers with great deliberation the problems involved in witnessing, telling, and concluding in the face of unremitting state violence. A merely political art acquires its sanction from external sources of authority and power. Kentridge has resolutely refused to do this; every sanction of his art grows from the terms of its own creation.

What this means in actual practice emerges from a simple point that the artist himself has made over and over again: he *draws*. And after he draws, he animates, reproduces, and transforms each drawing. His task is not simply to represent, detail, or delineate the facts of suffering: rather, he draws from such a content as surely as clear water is drawn by patience from a dark well, or as pain is drawn away from the body by healing. Kentridge draws with charcoal, and his dominant palette of black and white is literally graced by occasional touches of blue that signify water and water's ambiguous, sensual fluidity and capacity to renew. His method is urgent, but he will not skip a step. Every drawing is a gesture against the ready-made, simultaneous, and quickly consumed facility of photographic imagery. He reveals how drawing is a hermeneutic advance upon photography's mode of representation, just as history writing is a hermeneutic advance upon the random details of mere chroniclism. The most obvious fact of drawing—that it unfolds in time and records that unfolding—acquires a profound significance here as a counternarrative, an alternative speed, another opportunity to examine experience in a context in which violence has obliterated the possibilities of perspective and hence made the view of history unbearable.

When Kentridge works at the speed of his hand and eye, the drawing itself is evidence of his first-person witness, a trace of his presence and se-

quence of judgments. In this way, his drawings are something like courtroom drawings: they slow down publicity and serve as a form of witnessing that admits its limits from the outset and prefers the impediment to ease of execution. Kentridge's dominant internal perspectives involve examinations of the very problems of figure and ground that provide the context for his work: figures gazing upon crowds, emerging from crowds, stranded by crowds; views from above, below, and, significantly, the rearview mirror and frames inside frames; an architecture of confinement and repetitive institutional spaces placed amidst a denuded and desolate landscape. Within the frame, the hand is often mediated by a weapon, the voice by a megaphone, the eye by a mirror or window; but outside the frame a free hand is what draws them. The mind and hand and eye of the artist loom over these scenes of history. The work of the hand is transparent; it retraces its steps and reveals its erasures to accumulate a history of layers and tangles and cross-references that are also cross-purposes.

Like the disappearing view from the rearview mirror, history is run backward as a way of reattempting a path forward. As the images of the camera are superseded by hand-drawn images, so in his films are the sounds of everyday speech superseded by a recurring choral music. The history of technology is replayed, and this replaying demands that we reconsider the terms of our relation to objects and to other persons. Drawing and not photography; communal song before individual speech; Bakelite phones, not cell phones; mining and manufacturing, not service industries and bureaucracy. We could speak of a "return to nature" in Kentridge's work that implies the density and difficulty of what would have to be done to return us to a moment when human needs and technology were on the same scale. The technology represented in his drawings and films alludes to the years just prior to his birth in 1954, not the years of his current production; it is another aspect of the messenger's effort to delineate a chain of causal relations and connections. The wires and cords proliferating in Kentridge's imagery expose a nervous system that now lies concealed. A Faustian dream of flying and transcendence is shown to be the cheap trick it is: here everything binds and pulls the weight of existence groundward.

It is often said that the Truth and Reconciliation Commission effecting the transition to the new South African state is a monumental advance in the history of ethics—a democratically sanctioned assertion that truth is more important than revenge and that universal access to such truth is more important than the particular claims individuals might make with regard to one another. Yet we can see that the Truth and Reconciliation Commission

is as well the fruit of a long struggle toward justice, a dream of justice freed of its embedding in the grounds of injury alone. This struggle is already explored in imaginative form at the end of the *Oresteia* when the jury form is established and the Erinyes must give up their vengeful rage. Kentridge's work analogously replaces representation with deliberation; he is the most local of artists in his narration and the most universal in his sense of closure.

To see Kentridge's work in this context of the long path of justice is to understand why he so continually returns to the necessity of individual fantasy and desire. In his invention of his major autobiographical fictional characters—Soho Eckstein, Mrs. Eckstein, and Felix Teitlebaum—Kentridge takes the central myth of romance in the West, the adultery plot, away from the margins of history and places it at its inception, just as Helen shadows the start of the Trojan War. Shaped by what René Girard has called "mimetic desire," this plot reminds us of the universal persistence of fantasy even in extreme conditions, a persistence just as necessary to the continuity of the self as memory is—and just as central to the feeling of being an individual who is alive in a world of individuals. Without such an imaginative narration, Kentridge's work would lose its capacity for tragedy on

the level of the individual person. It is not that we find catharsis in the consequences of the plot for the three characters so much as that we see the characters as evidence of Kentridge's inner artistic life resisting a terrible pressure to objectify and externalize.

This place for fantasy in an art of public conscience is tied, too, to another important formal dimension of Kentridge's work: his impulse toward animation. Kentridge's animations include a consideration of the long art-historical tradition of the animated statue, as in his 1990 film *Monument*, where a statue of a suffering worker at the moment of its unveiling looks up and speaks, shifting the focus of attention from the donor to the referent. Yet animation is a formal problem that suffuses all of his work, including his individual drawings and objects that are not filmed. His drawings often show flags, paper, leaves, pieces of cloth and clothing, hair, and limbs under the force of motion and wind. His figures seem steeled against the very air itself, stooped and blown about or grasping for a handhold. Here he has invented another device for making time and change internal to the work: the theme flows from the temporal gestures of his drawing hand.

Violence disrupts our relation to the dead, not simply our relation to the living. In Kentridge's depiction of the real world, the dead have become

anonymous, their bodies blown to bits or experimented upon, their ordeals erased from view. The victims of violence are not buried with rites or reintegrated into the human community as bodies dedicated and commemorated. Rather, they lie facedown with newspapers covering them in a terrible allegory of their ephemerality and vulnerability; they are wrapped in newspaper like any wasted thing, including the news the newspaper brings. Kentridge's response is steadfastly to show the erasure and animate the sequence so that it can be literally re-membered. He has gathered the blown pages and put them back into their proper sequence with all the solemnity of ritual, and then he has filmed them, offering them again to view, so that we might ourselves begin to draw conclusions and form judgments. His art is a haven from the winds of mere contingency—those winds that blow everywhere over all the earth.

II. Resistance and Ground

Printmaking is a public art of a particular kind in the way it yokes an individual vision and an individual hand to the multiple and mechanical reproduction of images. In this regard, mechanically reproduced images acquire some of the fluidity and engagement of speech. The masterpieces of the form reach their afterlife in museum and gallery contexts or in the holdings of private collectors. Yet at their moment of inception, prints also might be received in public spaces with the diurnal quality of newspapers and journals. Such disseminated images, which are truly as well impressions, thereby can be a way of making the fleeting experience of historical events permanent through collective memory and collective aspirations. Something of this public audience haunts the private viewing of any print, as something private about the maker haunts the public display of any work of art.

Like other polymathic artists, William Kentridge works in a variety of media. But where a Picasso might work in painting, ceramics, and graphic works as a way of thinking about the material differences between forms, Kentridge has chosen the more unusual combination of working in theater and mime, sculpture, and drawing. Drawing continues to be at the core of all of his works—drawing to create singular works on paper, drawing for printmaking, and drawing for filmed projection. His drawings appear in his theatrical productions, and scenes from those productions enter into his drawings;[1] his sculptures are often three-dimensional realizations of drawn forms,

and his drawings can question and critique the monumentality of sculptural forms. A constant interplay between two and three dimensions thus characterizes the totality of his practices as an artist—two-dimensionality frames and mirrors reflections upon processes and invites erasure and revision; three-dimensionality tests the limits of realization and sends the artist back to the gestures of drawing and redrawing.

Moving between individual and social forms of work, Kentridge works alone or with assistants. His studio is in his home, and at times he has asked small children to stamp on his drawing surfaces to produce particular marks and effects of wear. For some of his recent animation, *Journey to the Moon*, his collaborators were an infestation of ants in his house; the ants traced lines Kentridge set down on the floor by spilling sugar in looping patterns. His work in theater involves collaborating with assemblages of others, and he has himself variously served as actor, performer, director, and designer. In all these modes, Kentridge is well aware of the political implications of divisions of labor and of the temporality of his works in the surrounding spheres of universal and local history. His theater projects have involved reconceiving Greek tragedy, the baroque classicism of Monteverdi's *Il Ritorno d'Ulisse*, and modernist works by Samuel Beckett, Alfred Jarry, and Georg Büchner. These reconceptions forcefully speak to the contemporary history of his native country. In his recent *Ubu* productions he has brought the absurdity of Jarry's vision to the efforts of the Truth and Reconciliation Commission, asking about the meanings of power, language, and the pursuit of truth and justice within situations that are at once theatrical and juridical.

Kentridge's art bears witness, not merely to history as the unfolding of external events, but also to the unfolding of his own inner experience. His work records and celebrates the universal human needs to desire, regret, sleep, dance, swim, think, and dream. By these means he conveys testimony that is of great interest to audiences in Johannesburg or anywhere else. Moreover, context appears as both medium and theme in his art. His characters Felix Teitlebaum the poet-dreamer and Soho Eckstein the melancholy industrialist, from his Soho/Felix series of 1989–96, resemble self-portraits, yet exist only in his imagination and work. One of his prints from his *Industry and Idleness* series bears the caption "London is a suburb of Johannesburg." In his 1999 film *Stereoscope* he used images of police beating students in Jakarta, riots outside banks in Moscow, rebels being thrown over a bridge and then shot in the river below in Kinshasa, someone throwing rubble at the American Embassy in Nairobi: all drawn from television

broadcasts and newspapers appearing while he was working on the film; he concludes, "of course the images are all of Johannesburg." More recently, Kentridge has explained that in his two *Atlas Procession* prints of 2000, he is envisioning people in flight in Rwanda, Mozambique, central Europe, and elsewhere—any of those places where populations are in motion under conditions of emergency, as they have been through history and are now throughout the world.

Kentridge has studied printmaking formally since adolescence, and he has also briefly taught printmaking techniques. Over the course of his career he has made between two hundred and three hundred prints—monoprints, etchings, engravings, aquatints, silk screens, linocuts, and lithographs; at least twenty of these are large-scale works. Kentridge prefers etching to all other printing processes, and uses a range of techniques that include hard ground, soft ground, photogravure, and sugar lift. He has worked innovatively to combine printing techniques and to explore and discover means of altering plates and images—often drawing over, handcoloring, and in various ways reimagining the work at each stage. In this sense his printmaking is underlain, as is all his work in every form, by his passion for drawing as revision.

Printmaking has also been an opportunity for Kentridge to explore various grounds and papers. His *Portage* of 2000 is a collage work, featuring black Canson paper that he used for silhouetted figures who appear on a background of a 1906 Larousse. The Larousse pages are in turn supported by cream Arches paper, and the whole work is accordion folded. In a recent collaboration with the Dieu Donné Papermill in New York City, *Thinking in Water*, he created translucent watermark and pulp paint images that can be viewed through a light box. His first prints, made in high school, were linocuts; in 2000 he completed several large works by this process, first printing them on strong Japanese paper and then on canvas. These large prints are bold, life-sized evocations of Ovidian transformations: a man turning into a tree, a woman turning into a telephone.

Although printmaking is only one aspect of Kentridge's art, he has an acute sense of the long tradition of this form as a means of social change, particularly in the way prints literally aggregate and restructure social relations. As handbills and broadsides, prints circulate from one person to another, becoming the focus of discussion and bringing news as, by intention and accident, they are distributed far and wide. Or prints can be made as posters, assembling audiences in preparation for later assemblages at public events, with viewers walking toward them and past them and observing them, commenting, or in the end, papering over them with other

posters. Kentridge's 1978 poster for a trade union play with the Zulu title "Ilanga le zo Phumela Abasebenzi" (The sun will rise upon the workers) is an example of the power of anonymous pronouncement that such an art form can have. After the poster was printed, information about each performance was filled in by hand. The figures familiar from many of Kentridge's drawings, the white industrialist and black miner, roped together in a mutual destiny, serve here as the counterpoint and complication of this aphorism.

In 1986, Kentridge commented on how irony always becomes an ingredient of propagandistic art. In his silk screen triptych of 1988, he alludes to the utopian dream of Vladimir Tatlin's 1919–20 *Monument to the Third International* and Max Beckmann's *Death* as works that exemplify an art "where optimism is kept in check and nihilism is kept at bay." The first of the triptych images, *Art in a State of Grace*, evokes a utopian situation he finds "inadmissible"—and with its imagery of fishes it recalls the adulterous idyll of Felix Teitlebaum and Mrs. Eckstein as it speaks to an idea of true utopia as a reconciliation of social and private needs.

Walter Benjamin's classic essay on the mechanical reproduction of artworks contended that techniques of reproduction disseminate and break up the aura of singularity associated with sacred art and are tied to processes of secularization and democratization. Yet what is less often noticed about Benjamin's argument is that he saw in the development of printing, woodcuts, engraving, etching, and then, dramatically, lithography and photography an endeavor dedicated to speeding the creation of visual images. "Not only in large numbers . . . but also in daily changing forms . . . since the eye perceives more swiftly than the hand can draw, the process of pictorial reproduction was accelerated so enormously that it could keep pace with speech." [2]

But as is the case with Kentridge's productions in film, with their "Stone Age" technology of drawing, filming, erasing, and refilming, Kentridge slows down the graphic process; it is precisely this quality of waiting and reworking that draws him to the medium. When he is creating prints, he makes a mark, sees the mark, transforms the mark. He has said that what he values most about these various ways of altering time in printmaking is the element of surprise—when the image comes back from the press, the initial effort returns with a life it has taken on of its own. The process that Kentridge uses in his drawings for projection results in a layered animation and the flowering of metaphorical associations. A coffee press becomes a mineshaft, a landscape becomes a blanket for the invalid Soho Eckstein, Soho's cigar turns into a bell. Each "new" object bears the shadowy impress of its

earlier life. In Kentridge's printmaking this shadow history of the work's own making is also present, but it is not animation that is emphasized so much as seriality. Printmaking is implicitly a narrative or story-telling medium, whether the prints are in formal series or not. And such narratives, no matter their theme or sphere, are in dialogue with, or juxtaposition to, the particular and inescapable realities of competing versions of history.

In his classic work on iconology, Pavel Florensky describes engraving as a deliberative and rational practice—a northern, Protestant art that stands in vivid contrast with the fluid, sensual art of southern, Catholic oil painting. He suggests that engraving

> manifests the intellectual construction of images from elements wholly unlike the elements in the object being depicted; i.e. from the rational intellect's combining of various affirmations and negations. The engraving is therefore a schematic image constructed on the axioms of logic (identity, contradiction, the excluded third, and so on); and, in this sense, engraving has a profound connection to German philosophy, for, in both, the essential and definitive act is the deductive determination of reality solely through the logic of affirmation and negation, a logic with neither sensuous nor spiritual connections—in short, the task in both is to create everything from nothing."[3]

Florensky goes on to point out that on a piece of paper, an ephemeral surface that is "crumpled or torn easily, absorbs water, burns instantly, grows moldy, cannot even be cleaned," lines appear that have been made on a "very hard surface, one attacked and torn and deeply cut by the engraver's sharp knife." Hence the hard engraved strokes constantly contradict the fragile printed surface. Furthermore, by "arbitrarily choosing a surface," he contends, the engraver works with individualism and freedom: "in proclaiming its own law, [the engraver] thinks it unnecessary to attend to that law whereby all things in creation become authentically real."[4]

These rather negative remarks about printmaking paradoxically shed some positive light on Kentridge's attraction to the form. Under the situation of apartheid, where the system of justice is an inscribed system of *injustice* and cannot be resorted to for moral authority, an art framed by metaphors of "resistance" and "ground" and offering this kind of fluidity, individuality, and freedom guided by universal principles has a particular power and appeal. And there is a phenomenological resonance between mining and plowing/agricultural labor on the one hand and the tapering, scratching, and pushing of a hard mineral surface on the other. In drypoint,

the accumulation of metallic dust left by the burin is the residue of a repet-itive labor. Further, Kentridge's two main materials for marking—the char-coal of his drawings and the lampblack that is the key ingredient of printer's ink—both have a direct relation to his native landscape with its charcoal fires burning in the townships around the city and the resulting soot that comes from home fires and industry. The ephemerality of paper, too, is a recurring theme in his work as he depicts newspapers flying as detritus through the urban landscape and at times covering the faces and the bodies of those killed by state violence.

Just as Kentridge's theater work has been concerned with reviving and juxtaposing early and contemporary art, so does his printmaking turn back and renew many dimensions of the traditions of the form, including its re-lation to theater, chronicle, and moral reflection. Specifically, many of his works follow in the tradition of Jacques Callot's *Les Misères et les Malheurs de la Guerre* (1633); Hogarth's allegorical picture stories, such as *A Har-lot's Progress* (1732), *A Rake's Progress* (1735), and, in a direct allusion, *Industry and Idleness* (1747); and Francisco Goya's monumental record of the suffering brought by war, most likely made between 1799 and 1815 and first printed in 1863, thirty-five years after his death, under the posthumous title *Los Desastres de la Guerra*. These seminal prints, varied in their sensi-bility and concerns, are nevertheless inseparable from agendas of secular and humanist reform. They offer first-person testimony to historical events, a fact perhaps most vividly expressed in the simple, wrenching captions to what were printed as scenes 44 and 45 of Goya's *Desastres*. The first is a chaotic scene of a priest, an elderly man, and women, babies, and children hurrying on foot and horseback to the foreground of the picture, their faces contorted by terror and tears. The second is a silhouette view of two women carrying children and a figure carrying a large, toppling bundle that could be a corpse—with other figures carrying other bodies sketched behind them just above the horizon line. They travel across a desolate ground under a threatening black cloud, with a small pig running before them. Below the first print appears the caption "Yo lo vi" [I saw it] and below the second "Y esto tambien" [And this too].[5] Similarly, Kentridge's prints often document disaster and temper their realism with shifts of perspective that lead the reader toward moral reflection. Like Goya, who famously said, "give me a crayon and I will *paint* you," Kentridge usually eschews color. The excep-tion is his moving use of blue—associated throughout his films, drawings, and prints with water and a state of grace or bliss.

All around Johannesburg, what initially appear to be mountains are in fact heaps of debris left by mining companies, and the ground underlying

the periphery is subject to frequent collapse. A contemporary Web site for the city's real estate development explains without irony that in the 1960s, the gold mines surrounding Johannesburg were depleted and that "the mining company looked to further value in the land and in 1968 a Properties arm was established within Rand Mines [the overall owner] to plan, proclaim, and market the now disused mining land." Kentridge's landscape prints directly address this process of stripping, depleting, and commercializing the space of nature. He engraves the landscape over the pages of the Rand Mines ledger book from 1910 and inscribes other landscapes with superimposed surveyor's marks.

As with the ruined landscape, Kentridge employs euphemism to characterize human suffering. In several works of this type, he opens the image of the casspir, the armored vehicle used by the security forces against riots and demonstrations, to reveal decapitated heads arranged in its interior compartments. Kentridge had heard a message on state radio from a mother to her son in uniform "from Mum, with casspirs full of love." In *Casspirs Full of Love* (1989), we seem to be looking down into this interior, but it can also be read as a failed ladder, a distorted emblem of progress, for Kentridge has scrawled NOT A STEP, the inscription we usually find on the top plank of a ladder, above the lowest divider of the casspir's compartments. A drawing for the film *Mine* of 1991 is resonant to these casspir images. It depicts within a receding diagonal view what seem at first to be miners sleeping in their compartmentlike bunks, with only their heads visible above their blankets; on closer view what we see are trunkless heads laid like objects on shelves.

The necessity of a second look, and a third, and more is one way that Kentridge's printmaking practice descends from Hogarth's. The two artists share an affinity for theater and printmaking and a sharp interest in character. Hogarth wrote in his *Autobiographical Notes* of the ways his images evoked drama and mime: "my Picture was my Stage and men and women my actors who were, by Means of certain Actions and expressions, to Exhibit a dumb Shew."[6] And in his well-known print–self-portrait of 1764 depicting himself at work on a canvas, there is a striking combination of simple chalked line drawing with very finely worked etching-engraving—a combination we find in many of Kentridge's works, particularly in the *Ubu* prints. Yet Kentridge's pairing of drawings of a photographic realism with simple cartoons, as well as his use of imagery from CAT scans, MRIs, and x-rays, moves toward and back from realization, thus disrupting the historical convention of an image's progress from drawing to painting to printed reproduction.

A more specific connection between the two printmakers can be seen in Kentridge's *Industry and Idleness* series, which follows and reflects upon Hogarth's allegory by the same name. Hogarth's work tells the story of two apprentices—one, industrious and well-behaved, rises to the position of Lord Mayor of London; the other, drowsy and indolent, falls into a life of crime and eventually is sentenced to death at the gallows. Often shown within proscenium arches, the scenes of Hogarth's allegory are full of by-standers and complex details that undermine the simple dichotomy of the work's moral lessons. In Kentridge's series, made when apartheid laws were still strictly enforced, an idle South African businessman goes to London and becomes rich while an industrious man refuses to emigrate and becomes destitute. In the last part of the sequence, the destitute man becomes the Lord Mayor of a slum. The second plate, *Temporary Absence,* shows the shadow of the industrious man with the words "endorsed out." A person "endorsed out" under apartheid laws was someone who had been physically removed from a particular space because he or she would have been caught without a group areas pass. In the final image, *Coda/Inside Trading/Death on the Outers,* the industrious man has poisoned himself with methylated spirits and the idle man, caught for insider trading, has thrown himself out of his office window.

These prints, like Hogarth's, reveal a multifaceted and layered morality and a complex pattern of allusions and self-reference. Kentridge applies Hogarth's aphoristic caption, "A foolish son is the heaviness of his mother," to the doomed industrious figure, while he has the industrialist say, "I'll buy the whole fucking dump." The print titled *Responsible Hedonism/Temporary Absence* depicts, among other images, a couple who resemble Mrs. Eckstein and Soho making love in a swimming pool. The initial print, *Double Shift on Weekends, Too,* shows the industrious figure bowed under a load of cattails that appear in the *Ubu* series and in a number of Kentridge's domestic and erotic prints. This figure also carries a box labeled Sun, evoking Kentridge's recurring theme of Aeneas fleeing from Troy—with his son, his father, and the *lares,* his household gods—as a figure of emigration. He has evoked Aeneas as well in his print *Staying Home* in the *Sleeping on Glass* series. Here an image of trees in a formal garden is superimposed on pages from book 9 of the *Aeneid.* This work suggests both the tragedy that ensued when Aeneas leaves his fellow Trojans to search for allies and the miracle of the wood of Cybele that cannot be destroyed, protecting the Trojan ships against the force of Turnus by turning them into mermaids. Fleeing violence or persisting in the face of it, deciding to emigrate or not, resolving to begin anew at home or abroad are

Virgilian themes that endure in the lives of every South African of the past and current century. The situation of emigration has created distances between and within many families, including Kentridge's own.

Any genuine moral thinking involves simultaneously embracing mutually contradictory ideas, and Kentridge has often sought out visual equivalents for this truth. He has described how after his *Pit* monoprints of 1979, he wanted to open up theatrical space, and Cartesian single-point perspective more generally, to more complex uses of point of view. In ensuing years he turned to the reversed perspectives, frames within frames, rearview mirrors, and mutually negating views for which his work is known. He has said that such complicated contradictory feelings are common in South African predicaments that involve split or binocular attitudes, like wanting to emigrate and deciding to renovate a house at the same time.

Here, too, the history of printmaking has offered Kentridge a number of devices for complicating point of view. Printmaking is an art of reversals requiring the printer constantly to picture images reappearing as negations or transformations, often through the use of a large mirror. Printers have turned as well to the pantograph for reducing and enlarging images and to the zograscope, a device that reverses and magnifies an image so that the background of the picture will seem to be situated at a considerable distance from the foreground.[7] Kentridge, too, has experimented with various mechanical devices for viewing prints. His *Phenakistascope* (2000) uses two vinyl records mounted on a rotating device to turn a cylinder pasted with the image—a lithograph on atlas pages. His *Medusa* (2001), an anamorphic lithographic image on Larousse pages, calls for the viewer to use a mirror-finished steel cylinder to correct the distortion. Some of Kentridge's small drypoint landscapes have been made via the techniques of the "claude glass"—a device named for the seventeenth-century French painter Claude Lorrain that was especially popular during the eighteenth-century enthusiasm for the picturesque. The "glass" was a small, slightly convex and tinted mirror that the artist would hold before him with his back to the landscape. The device would frame the subject from its surroundings and simplify the range of tones. Kentridge, too, stands with his back to the landscape he wants to depict and holds up the copper plate before him, then draws directly with the drypoint needle on the copper. He records that "every slight shift of the plate, or movement of the head, would make a difference in what was seen in the reflection." By holding the plate before him and at the same same time registering these slight shifts of movement, he thereby can make these drypoints records of unfolding gestures of marking and transformation—that process for which his films are also known.

And of course one of the strongest means for presenting complex perspectives in a print is using captions, titles, and "remarques" or marginal images to comment on, or reflect against, the action or scope of other images in the work. From the *Iconologia* of Cesare Ripa at the turn of the seventeenth century to Kentridge's own practice, the tension between image and caption in emblem tradition and in printmaking opens perspective to contradiction and multiplicity.

To characterize William Kentridge's printmaking as a whole is to acknowledge its tremendous variety and complexity. There are prints of the Umbrian countryside, of Russian writers, of the nude artist in self-portrait dancing joyfully with his wife; and there are the prints of the future as he has turned to the exhilarating and overwhelming question of what it means to be an artist in post-apartheid South Africa. A person of Kentridge's background and education may have become a politician, a lawyer, or a social theorist, and one of the most interesting questions we might bring to his work is one that asks what means of expression visual art has offered in the context of his world—a world wracked by violent injustice and now, in conditions of peace marred by intermittent violence, offering the opportunity to explore the social transformations at the vanguard of thinking about justice and participatory democracy. Kentridge's work directly addresses questions of spectatorship, surveillance, witnessing, and catharsis. By choosing to be a genuinely universal artist, he has been able to be a genuinely local one, one who thinks about the private apprehension of public trauma and reminds the public to acknowledge the resources of the private as well. In his work, history calls out not merely for judgment but also, above all, for imagination.

ARMANDO REVERÓN

Paintings and Objects

It is of course something of a cliché of impressionist criticism to speak of impressionist and postimpressionist paintings as paintings of effects of light. In the work of the Venezuelan painter Armando Reverón (1889–1954), light is that universal phenomenon enveloping all things, and creating all color and perception; and it is also that phenomenon by means of which we can and cannot see. Thickness and transparency as qualities of light are linked to thickness and transparency of paint itself. When Reverón makes the weave of the canvas the dominant overall effect rather than that of luminescence, or when he saturates the canvas or builds up from it, he refuses techniques that would treat light as the mere vehicle of perception or make the analogy between paint and light unproblematic. His paintings pose conceptual issues of emergence and recession, like Michelangelo's *ignudi*; the images are suspended forever between earlier and later, retreating and taking form at once. Some of this is simply a matter of the ambiguity of outline and form. But there is also a brilliant use of the very substance of the canvas: in his *Luz tras mi enramada* of 1926, the grain of the canvas is in the foreground, as if the image were caught somehow within its weave. And we could not say that there is a light source or that objects cast shadows; rather, light is the end of representation as well as the source, and its shadows shape objects; his nudes, for example, in a kind of reversal of the convention of the nimbus, each seem enveloped in a total halo of darkness, as if they had acquired their form in a subterranean world and kept the darkness about them like another skin.

Reverón's monochromism centers not on "naturalistic" external effects of time of day or season, but rather uses the intense blue we associate with a range of melancholy emotions and the sepia that inevitably alludes to his-

torical decay and the distances of memory. These paintings are broadly contemporary to the intense emotional color effects Rafael Alberti developed in poems like "Blu" and "Rojo" or those Federico García Lorca used in his *Romance Sonambulo*. Color of course, like fire, is unquantifiable and has a life independent of its appearance as a quality of objects or, more properly, of the relationships between light and objects: the life of its historical and social association, including those associations between the heights and depths of the color spectrum and the heights and depths of sound. If Reverón's blue paintings have the quality of imaginary worlds glimpsed underwater, his sepia-and-white landscapes look like representations of the powerful invisible force of wind itself.

In the white landscapes, the *Paisaje Blanco* of 1934 especially, the white light produces effects of erasure and misrecognition, evoking the ability of the sun to cancel our vision of the specificity of things and their outlines. In a number of paintings, his use of a white brushstroke becomes more and more evident as the shape of the moving brush, for example as it is in the *Cocoteros* of 1931. This is not a matter of increasing artifice or self-consciousness. Instead, it produces an increasing realization that the conventions of depiction are a barrier to insight. It might be said that this development toward literal materialization in Reverón's work is a vehicle of spiritualization in that the brute facticity of the world is placed in a diminished relation to the desires of the seeing subject.

This is why I believe it is possible to read his objects as well as the inevitable outcome of this acknowledgment of visual limits. The limit to visualization, like the hope to evoke but not delineate the god, in fact affirms human desire and makes it of consequence. If the painter could enter into an unmediated relation to all that he sees, if he could create a representation that would be the instrument of such an unmediated relation, he would be erased; he would no longer be that resistance to what he perceives and makes, just as an eye that succumbs to the sun no longer functions as an eye and a face that retreats to the tautologies of self-founding becomes a death mask.

It is indeed this problem, a knowledge of what resists anthropomorphization, that haunts Reverón's portraits, self-portraits, masks, and objects. His *Juanita* of 1922 looks at us through all-over strokes and marks that create a veil or effect of weather intruding between the face and the viewer. It resembles those acheiropoietic images like the shroud of Turin that seem to appear by miraculous means. Like his images embedded in the weave of the canvas, such as the *Rostro de Mujer* of 1932, the face here is as fixed as a mask by whatever is impeding the relation between the image and the

viewer. There is literally canvas and literally paint between the face and the receiver; Reverón paints the static blocking reciprocity and refuses to create an illusion of eyes locking eyes, that illusion of the meeting between two living persons that is at the heart of all portraiture. He is "superficial out of profundity," as Nietzsche put it in his praise of the Greeks in his introduction to *The Gay Science*, where he wrote: "what is required for that [for knowing how to live] is to stop courageously at the surface, the fold, the skin, to adore appearance, to believe in form, tunes, words, in the whole Olympus of appearance. Those Greeks were superficial—out of profundity." [1] Reverón's masks in fact bear a strong resemblance to the beaten gold death masks of Schliemann's hoard. When art has a status beyond nature, as it does for the Greeks and for Hegel, then the divine is brought nearer. In writing of these very Greek masks, the philosopher-novelist Michel Tournier has described them as the "impersonal and intemporal masks of the gods themselves." [2]

Plastic works are materially finite, made of something yielded by nature and weighed by a conscience toward finitude that language does not suffer. The presentation of this finitude, of the link it creates between artworks and

persons as substances vulnerable to decay and dissolution, and of the non-reciprocity between the material and the human is continued in Reverón's turn toward his objects. His objects are characterized by an obdurate silence: the silence of birds that do not sing, a telephone that does not ring, a shotgun that cannot be shot, guitars and mandolins whose strings do not vibrate, pedals to a piano that soften a music of no sound, an accordion that mutely opens and shuts, mannequins without mouths. Their visual expressiveness is at the expense of aurality, just as many of the sepia-and-white paintings seem to be filled with a wind that is both present and still. When we say that these objects are like toys, we mean that they are not real in terms of use: something about them does not work, or they do not work at all. These works are strikingly reminiscent of the passage on idols in Psalm 115:5–8 (KJV):

> The work of men's hands,
> They have mouths, but they speak not:
> eyes have they, but they see not;
> They have ears, but they hear not:
> noses have they, but they smell not;
> They have hands, but they handle not;
> feet have they, but they walk not:
> neither speak they through their throat
> They that make them are like unto them;

In these facts of nonfunctioning, nonanimate existence resides the aesthetic power of such objects: they are exemplary instances of a prohibition on use and appetite. Yet their very obduracy is somehow poignant. Their maker, too, is "like unto them" and like unto us in his strangely moving stillness.

His objects refuse illusionism as relentlessly as the paintings do; and they, too, take up issues of withdrawal and emergence, here in three-dimensional forms. Are they objects not yet awakened, or the petrified remains of something that once was animated by living hands? Although they feature such conventionally fetishistic accoutrements as feathers and hair, they seem to prohibit touch: the fetishist lives in a fevered dream of animation, but this stillness of Reverón's objects is a tremendous impediment to such animation. Poverty of means and poverty of execution lead to elegance. The objects are consonant with the account of toys Charles Baudelaire gives in his essay on the "Morale du Joujou"—that the immense imaginative world of childhood is built from the most approximate and simple elements: for example, a horse and his rider can come in three parts, or the

little plume of one toy horseman can give him an air of great luxury.[3] Reverón shows us the seams, stitches, fraying edges of this homemade world.

The *muñecas*, or dolls, seem to be the rigorous outcome of a line of thinking in his work that begins with the monochromism, continues through the emergence of the white brushstroke and the grain of the canvas, and then emerges into three dimensions with the objects. It is of course obvious that these dolls are related to the death of his mother and his depression in 1942. But there is no reason to assume that they are somehow compensatory when in fact they so vividly reveal the issues of blocked reciprocity and the limits of human understanding that have been present throughout the work. Rilke wrote, in his famous essay on dolls: "Are we not strange creatures to let ourselves go and indeed to place our earliest affections where they remain hopeless? So that everywhere there was imparted to that most spontaneous tenderness the bitterness of knowing that it was in vain? Who knows if such memories have not caused many a man afterwards, out there in life, to suspect that he is not lovable?"[4] The brilliance of Rilke's comments on dolls lies in their refusal of anthropomorphization; for Rilke it is the doll's inability to reciprocate, its stony denial of our love, that is its meaning.

The kohl-circled eyes and painted lips of the *muñecas* are both vivid and frozen; they uncannily resemble Fayum funerary portraits in fixed expression and ornament. If realistic dolls are made with eyes that close and lips that speak, these dolls have eyes forever snapped open and lips painted shut. The gaze that was blocked in the self-portraits and portraits of the paintings is now completely clear of any impediment of paint or canvas; but the world that gaze looks upon is not our world, and there is not the slightest chance of reciprocity. Real flesh can be wounded, opened, or gaped, as a tear can appear in fabric or canvas. Thus when painters paint wounds, they open up the illusion of depth, just as painters who paint snow or effects of rain open up illusions of supplemental surfaces. The patched and mended flesh of Reverón's dolls is all a matter of surfaces. There is no blood or other bodily fluid that will escape, no scars will form; all will forever remain stitched and patched together. The predominant quality of this flesh is that it is not flesh. If the hair is real, it only emphasizes that the hair of the dead and the hair of the living are the same.

The dolls rely not only upon devices of visual blockage and fragmentation but also upon a sense of tactile deprivation. The famous surrealist and cubist analogy between the body of a stringed instrument and the body of a woman is brought under a devastating critique in Reverón's work with objects, just as in his landscape paintings the lovely illusions of impression-

ist light are both alluded to and revealed for what they truly are. As those paintings showed the relation to the horizon to be thick with light and contingencies of weather, so this same thickness now materializes literally in the inert being of these objects. They project their inertness, their unworkability, their refusal of magic. We could say that these objects are in fact paintings of death; that is, they constantly state the two-dimensionality of their three-dimensional form. It is intriguing that in Reverón's self-portraits with the dolls or in the 1935 photograph of himself between two dolls, he either stands behind or before them, in relations of nonequivalence and nonreciprocity. The face-to-face relation is made impossible.

Reverón's work might be said to resemble that of other modernists, particularly the work of van Gogh in its expression of suffering and attention to the temporal aspects of form. He was not part of any movement—indeed, he lived in a state of marginality akin to madness. Bathed in the dense, obliterating light of his work, perhaps we can glimpse an art that will take on the representation of human finitude as a truly unfinished task.

CHAPTER 7

TACITA DEAN

I. The Coincidence Keeper

Tacita Dean's decade of work centering on issues of time and sound reveals the myriad ways in which aesthetic experience is a resource or, to take one of her own recurring images, a bulwark against the irreducible fact that human beings must suffer time as they suffer within a time that is of their own making. Like all works of art, her films and photographs and objects exist at the place where the inner time consciousness of the maker encounters the external world—that world known through spatial extension and coordination with the lives of others.

Time itself is a made or given feature of consciousness: it is not nature, but rather is one of the aspects of mind by which we are able to know nature. This problem of time as a derived order of being and of the multiplicity of various realms of time is a recurring theme, often expressed as a matter of geometrical or nautical coordinates, in everything the artist has created. Whether she is considering the birth of a wave, a mariner's doomed obsession with a chronometer, the accelerated ruin of the twentieth-century built environment, the persistence of legend, the short life of technologies of representation, the ephemerality of masterpieces, an ordinary sunset at the end of a historical era, or the event of an eclipse on an ordinary day at a farm, she does not merely compare the cycles of natural, historical, and social time. Rather, she constantly brings before us the coincidence of our encounter with her work as part of the larger coincidence of her existence intersecting with the temporal phenomena that are her subjects.

Coincidence preserves experiences and knowledges from the ephemerality of time passing, making them, by their intersection, cohere as events and phenomena of significance. Loss is the counterforce to coincidence; the lost arts of certain crafts and technologies are preserved by the coincidences that are Dean's works themselves intersecting with such gestures in time. No art could be more personal, and yet no art could be less narcissistic. In emphasizing coincidence and the impress of coincidence on her own life, she reminds us that coincidence is the intersection of multiple times within the frame of an individual moment observed from a single point of view. That point of view is both a fiction and a place of departure for the imagination. There is a detached and yet immediate *now* to the event of coincidence—a *punctum*, a point or mark where reality is pierced by an insight that is often a matter of imaginative transposition. Whereas ironic retrospection realigns the relations between causes and consequences and makes rather world-weary claims for the omniscience of the observer, the retrospection involved in noting coincidence is closer to awe—and the more disparate the times conjoined in coincidence, the deeper and more marveling is our observation. In Dean's work nature is full of surprises, and comedy and tragedy come into intermittent, random, and yet profound intersection with each other.

The most basic formal gestures of Dean's projects involve the intersection of circular motion and cyclical time systems with sequential time and narrative development. For example, her two films entitled *Disappearance at Sea* reveal two kinds of images from within a lighthouse: the cyclical figure-eight-like pattern of the lighthouse beam cast into the darkness as seen from the coincidence of the lens of the light meeting the view from the lens of the camera—and then, in the second film, the progression of frames, first in sequence and then in repetition, as the camera, resting on the light's rotating lens, steadily pans the landscape through the windows. On this level, the images are as stately in their formal coherence as a dance of planets or bees. Underlying these patterns, or overlaying them, are narratives of the separate disappearances at sea of the amateur mariner Donald Crowhurst and the conceptual artist Bas Jan Ader. These events may seem to have nothing to do with each other except for the fact that Tacita Dean has made works that take them as preoccupations. And then we learn belatedly, as the artist herself learned belatedly, that in a locker in California opened after his death, Ader had left a book about Donald Crowhurst.

Such a sense of belatedness haunts all of Dean's work. She comes upon a world already made, abandoned, and often decaying, yet she never "ap-

propriates" the things of this world as curiosities or mere objects. Each has a narrative, and that narrative intersects with every other narrative on some plane of knowing yet to be uncovered or revealed in the punctuating process of making art. Coincidence is of course the meeting place of freedom and determination: the artist's endeavor takes up this theme as it intersects with the world, and at the same time shows us the struggle between freedom and determination involved in both its making and reception. Belatedness is in fact what makes determination a source of freedom and, in the end, originality in Dean's work; this very belatedness is the means by which her art speaks to the present. Her early film of the process of building a ship in a bottle demonstrates her aesthetic: the contingent fact of the bottle emptied by the drinking sailor, the patient and long editing of materials that creates the necessary connection between all the elements of the "boat"; the pull of coincidence as the unifying string that lifts all the parts into place. From that moment of lifting, the world can be viewed outside in: the boat is in the bottle, the bottle no longer merely in the boat; bottles contain liquid against leakage into air, boats contain air against leakage into liquid. In this filmed image of boat and bottle now preserved and safe from the elements, fragility is capable of a containing strength.

In the West, the dominant metaphor for time as movement within an unspecified eternity is time as a river or flow. This liquefaction of time aptly indicates the notion of water's eroding power, the force of time in wearing down all things. Near the close of the *Metamorphoses*, Ovid wrote, "Time itself flows on with constant motion, just like a river, for no more than a river can the fleeting hour stand still. As wave is driven on by wave, and, itself pursued, pursues the one before, so the moments of time at once flee and follow, and are ever new." [1] He describes how every minute gives place to another, how night passes into day, morning into night, the sky passes through its colors from red at sunrise to red at sunset, the moon waxes and wanes, the seasons change, human bodies pass from infancy to youth to middle and old age, earth and water are heavy and sink down, fire and air are light and rise up, the earth becomes liquid, water becomes wind, air flashes into the fiery atmosphere of the heavens, fire condenses and thickens into air, air into water, and water, under pressure, turns into earth. Rivers appear and disappear, marshes become deserts and deserts marshes, seashells lie far from the ocean, volcanoes become extinct, bees are born in the rotting carcasses of bulls, hornets in the carcasses of war horses; within the silence of the tomb, the rotting marrow forms into a snake. Ovid realizes that his own account is taking place in time and that as he has seemed

to embrace time within his writing, so will time eventually overcome that inscription: "The day will end, and Phoebus sink his panting horses in the deep, before I recount all the things that have been altered to a different shape. So we see times change, and some nations gain strength, while others sink into obscurity." [2]

In our everyday experience of time, we similarly think of both the past and the future as commensurable infinities. But we have traces of the past, memories and records, and no traces of the future. All of Dean's objects, images, and moving pictures have a memorializing and temporizing function at once. There is a picaresque aspect to her themes. In her films that narrate her wandering toward the usually submerged site of Robert Smithson's *Spiral Jetty* in Utah or her encounter with the wrecked hull of Crowhurst's *Teignmouth Electron* on Cayman Brac in the West Indies, she uncovers evidence of the ruin and disappearance of all made things.

When Dean returns over and over to images of waves and water, she returns the liquefaction of time to a state of eternity—the ceaselessness of the sea and the earth circling beneath the light of the sun. All inscription is abraded back into the earth, and the earth itself will be abraded away into the sea. Her work is an archive of lost voices, extinct words, and vanished practices. What comes into relief will fall back into recession, and there will be considerable beauty in the pulse of that disappearance—a disappearance that in the end acquires endurance through the form-giving work of art in time.

II. The Light of "Banewl"

O dark, dark, dark, amid the blaze of noon,
Irrecoverably dark, total eclipse
Without all hope of day!
O first-created beam, and thou great Word,
'Let there be light, and light was over all';
Why am I thus bereaved thy prime decree?
The sun to me is dark
And silent as the moon,
When she deserts the night,
Hid in her vacant interlunar cave.
Since light so necessary is to life,
And almost life itself, if it be true
That light is in the soul,
She all in every part, why was the sight
To such a tender ball as th'eye confined?

—Milton, *Samson Agonistes*, ll. 80–94

On August 11, 1999, at 11:11 A.M., a total eclipse of the sun was visible above the Cornwall coast. Tacita Dean's *Banewl* records sixty-three minutes of that event at the site of Burnewhall Farm, a dairy farm by the sea; the film's title is a phonetic transcription of the local pronunciation of the farm name. *Banewl* is deeply embedded in concepts of time and universality: it is heavily "dated" and lightly "signed"; the artist's consciousness is evident in the work's conception and in the process of attending and then turning away that puts the human gaze and human behavior more generally within the cycle of nature. The film explores the vast space implied by these famous lines of Milton's blind poet soliloquizing on his blindness in the context of another eclipse: the all-encompassing greatness of the sun's light and the smaller world of our tender-eyed perception.

"We had fallen. It was extinct. There was no color. The earth was dead," wrote Virginia Woolf in her diary after seeing the total solar eclipse of June 29, 1927. If someone wanted to narrate *Banewl*, the account would be something like this: There is the vastness of the sky and then a tree makes a landscape. The barnyard flowers blow in the wind, the stone house stands, and a herd of Holsteins waits behind a broad steel gate, the animals all facing toward the path that will take them to their grazing meadow by

the sea. The herd is led by a man in red overalls. It is followed by a man wearing a cotton shirt. The hooves of the cows make a clopping sound on the earth. The cows bellow deeply; their stride is loping and calm. They switch their tails at the insects worrying their flanks. A bird chirps. The sea crashes in the distance. The barnyard stands empty.

Approaching the open meadow, the cows hesitate and then move off into their individual patterns of grazing. One cow mounts another. A dog bites and gnarls at her fleas, then gazes out to sea. Clouds move swiftly across the sky. The wind makes a great singing hum, and airplanes now and then can be heard offscreen. A crow, or perhaps a jackdaw, suddenly flies by, a black blur across the foreground. Then all is still, a deep gray cloud cover against a nacreous sky, and the cows can be heard chomping on the grass. A clutch of swallows, wood pigeons, and crows roost on telephone wires. The sky darkens. The cows move toward one another and begin to lie down to graze. The swallows assemble and send up an agitated racket. The cows prick their ears, and a breeze stirs the grasses. As the cows become more still, they flick their ears and tails against the onslaught of insects.

Then the darkness descends, and the cows lie down on their sides. A lighthouse beam becomes gradually visible at midhorizon and then the horizon disappears, leaving only the beam.

And then the light begins its slow return. A twitching ear flicks on the horizon, then the whole animal becomes gradually visible. The birds begin to sing as if it were dawn. The wind picks up. The chomping begins again. A cock crows. A cat comes exploring. Gulls circle in the sky. Like a blurred star above deep black clouds, then more diffusely, like light seen through a screen of milk, the sun gradually, partially begins to emerge. The moon is moving away, even though it cannot be seen. Billowing light clouds move swiftly across the sky. The blue-gray sea swells below, then a dark swath of clouds like smoke courses the sky and returns: opaque, then transparent, then broken through by light.

A brood of wood pigeons grazes insects from a corrugated tin roof. A cockerel pecks from behind a wire cage. Other birds, invisible, sing behind the trees. A long branch is filled with sparkling leaves that rustle in the wind like the play of light on water. A cow releases a steaming cowpat beneath her raised and stiffened tail. A plane can be heard far away. The dark clouds pass before the sun breaks through again. A hawk flies past. A cow walks off into the distance. The clouds continue; the sun, the complete round radiance of the sun, has returned. The screen turns blank and black and the credits appear.

What "happens" in *Banewl* the film is the articulation of memory—the

memory of the action of photographers and crews of assistants working four cameras with anamorphic lenses during the two hours and forty minutes of the solar eclipse. The footage is later shaped by Dean's complex artisanal process of editing that carefully preserves the exact temporal sequence of the filming. At the close of the film, the sun is in place in ordinary time and space, and as we leave the screening room, we, too, return to the world of everyday existence where we are objects of the sun living under the sun. The cows, who most often graze in crepuscular light, at dawn or dusk, are first stimulated by the change in light and then quieted by it. The swallows go wild and other birds recede from the scene, often roosting for the night— that time when they must avoid predators. The film can be considered an intended and original work of art by its maker and at the same time one of the responses of our own species to the extraordinary event of the eclipse.

Our hearing delights in the subtle buzzes, chomps, clomps, and clops of the animal world, in the differences between the distanced sounds of the sea and the wind, in the mechanical hum of the planes and perhaps motorboats in the even farther distance. Our sense of touch delights in the film's variegated surfaces: the stone crest of the wall in the foreground; the bony backs of the receding cows; the tough silken whorls of the blazons on the cows' foreheads; the fragile fur of the cat and the waving petals of the summer flowers; the gnarled bark and smooth steel gate. Our sense of color delights in the flinty earth, red with iron, and the red overalls of the cowherd; the many gradations of gray and smoke in the passing clouds; the stark black-on-white and white-on-black cloudlike patterns of the Holsteins' pelts; the overwhelming green of the meadow. The film does not mark its artifice, but within its artifice are the direct associations of lived experiences in the world.

All life depends on the sun, and this is a masterpiece made of light and sounds sustained and diminished by the light of the sun. Our entire sense of the cycle of nature depends on the sun as the epicenter of our world. Yet an eclipse of the sun is an opening to the idea of a gap or break in the universe, an idea almost impossible to bear. When we hear the rustling of the leaves in the tree, it is each individual leaf that is rustling, but we hear only the sound of the whole. In the modes of patient attention followed in *Banewl*, each flower, each leaf, each individual animal and bird and insect is suggested as a particular and universal at once. We see the heifers reacting subtly to the camera; we see the empty space of the barnyard as a space that had once been occupied. We remember that King Arthur is said by legend to be buried nearby, that the lighthouse is like the one, or perhaps *is* the one, that Virginia Woolf's Mrs. Ramsay promises upon, that Turner painted this landscape with such sublime attention that its light is now inseparable from

the "Turneresque." The cows themselves, with stars marked on their foreheads and clouds emblazoned on their torsos, seem like the somber priests of a charming solar religion. We "people" the scene with meaning.

Nevertheless, the fact of the eclipse remains: the fact that as we can never look at the sun, this one gap, this one break could also give us a disarming illusion of accessibility that readily could blind us. We cannot see this event, indeed any event, from a noumenal point of view. And the certainty of the eventual disappearance of the sun—something that will happen irrevocably and irreversibly just a few million years from now—haunts our pleasure in the transitory aspect of this eclipse, as it haunts our pleasure in all human making. *Banewl* could not be more intensely tied to a moment in time and place, and yet it is truly a work of art on the threshold of eternity—that very eternity that, in lighting our world, bestows on us the temporary gift of blindness to its end.

National Archaeological Museum

Schliemann's treasures from Mycenae: (final phase of Bronze Age 1600-1100)
 influence of Minoans
gold death masks, fine sheets of beaten gold over the bodies' corpses
 to draw the mask up to make the beaten
 metal seem more human, figure'd capture
 the cold grim look of the face - mistakenly
 believed to be Agamemnon / his rigidity

 ostrich-egg rhyton with
 gold base + throne lip
 dolphins cavorting round it

findings from shaft graves

At breakfast we experienced a new dawn to our table
not into the lady in Durham's
travelling C. Durham's
"lighths like a snail" -
he'd want to have found
a snail in Black Park morn
Lewis a London + hope
adrift - he's wrong
the power is
March for a
high island
plougheram
over a
picture total!

floating branches of
coral

 octopus as a Vase (amphora)
 from the Mycenaean cemetery
 at Prosymna, Argos
 15th c. B.C.

Mycenaean pictorial
style - workshop Naxos
12th c. B.C.

Clay tablets with Linear B script
from palace of Pylos 13 c. B.C.
nature of documents - inventories accounts.
oldest form of Greek script, deciphered
by M. Ventris in 1952

Tablet TA 641 (1258c) - inventory

ti-ri-po-de tripod
ti-pa qe-to-ro-we 4- handled cup
di-pa ti-ri jo-we 3- handled cup
di-pa a-no-we handless cup

CHAPTER 8

THE *EIDOS* IN THE HAND

I would like to address some of the relations between facing and touching in aesthetic experience in general and at the same time turn to some specific implications of these two senses for this exhibition of portrait miniatures. My theme stems from the description Nicholas Hilliard, the foremost Renaissance maker of miniatures, left of his works in his *Treatise Concerning the Arte of Limning* as "viewed of necessity in hand near unto the eye." [1] Portrait miniatures give us an occasion to think about issues of publicity, privacy, even secrecy, and issues of the representation of persons and the apprehension of artworks beyond our usual paradigms of novelty and display.

The Greek verb *eido* or Latin *video* means both "to see" and "to know": a seeing that is also a kind of recognition. *Eidos* and its derivative *eidolon* are words for an image in the mind, a shape, specter or phantom, and a portrait—particularly a portrait of a god. The verb can also be translated as "behold" and used in the imperative. The presentation of a portrait is analogous to face-to-face meetings between persons. In portraiture, there is a constant interplay between expression, gesture, and the anticipation of reception as the maker creates a mediating image of the person that will confront the beholder.

Such an interplay is perhaps especially evident where emotion is under a strong mandate from public morality, as in the examples of collective mourning we see in the many works created in response to the death of George Washington. In a portrait of Eliza Jane Fay by Ruth Henshaw Bascom, the eight-year-old girl wears a pendant inscribed in memory of George Washington with its language facing outward toward the viewer. The work is complicated by several reversals: the side view and typically stiff posture

give Eliza Fay a heroic or stoical appearance that we associate with portrait medallions. And the pendant itself memorializes or inscribes what is inevitable: that the memory of the dead can be carried forward only partially or tangentially by an eight-year-old. Consider two other examples of individuals wearing their hearts or obligations on their public sleeves: the well-known 1465 portrait by Sandro Botticelli of a young man with a medal of Cosimo de'Medici from the Uffizi and Charles Bird King's miniature of "Chief No-Cush" wearing a large silver medal inscribed with a message of goodwill and national trust. The relations between medals as reproductions and processes of memorializing, patronage, and contract were also important themes in the *Medici Slot Machine* works of Joseph Cornell: his *Medici Slot Machine* of 1942 and his *Medici Princess* of 1952. Cornell, too, built his works out of the dynamics of miniaturization and containment. Yet here we also see how one generation "mints" another; how images of persons are sent into circulation bearing the impress of their makers.

The works of *Love and Loss*, however, complicate any distinction between the expression and reception of emotion. For these works are rarely expressions of the emotion of their makers. Instead, they acquire their highly individuated or artistic emotional valence in their use. The very ineffability and privacy of such uses gives the works a charge beyond whatever socially structured rhetoric is available for encountering them.

Face-to-face forms of art always involve experiences of individual presence. The power these forms have for changing or moving us has a great deal to do with their nearness to us and the reciprocity such close conditions imply. If the spectacle is the point of the most abstract generality—compelling us to identify with concepts of power or the state—the portrait miniature is a work taking place, making meaning, on a scale of privacy and individuation that approaches unintelligibility. Robin Jaffee Frank's comprehensive guide to the exhibition makes it clear that the portrait miniature has a history that can be viewed in terms of changes particular to the internal conditions of the form itself. The private history of each piece in the exhibition—each piece's true ungraspability—becomes an important aspect of our own belated apprehension.

We can think of any form of portraiture as involving the affects of the face to face, but portrait miniatures recapitulate in their themes the very intimacy of nurturing and the erotic that lies behind the development of face-to-face aesthetic experiences. Crossing the boundary between being hidden and being displayed, being closed and being opened, these works are caught up in a process of repetition that is structurally analogous to erotic transport or the ritualistic aspects of mourning. The portrait miniature bears the

frontality of all portraiture and implies at the same time constant pronoun shifts between *I* and *you*. John Donne's verse letter "The Storm," addressed to his friend Christopher Brooke, begins with a tribute to Nicholas Hilliard and the "I/You" frame of the miniature portrait:

> Thou which art I, ('tis nothing to be so)
> Thou which art still thyself, by these shalt know
> Part of our passage; and, a hand, or eye
> By Hilliard drawn, is worth an history,
> By a worse painter made.

Donne will go on to condense the larger history of the 1597 Azores Expedition (under Essex, Raleigh, and Howard) into the miniature of his lines. The opening of the letter puns on art as making and art as a state of being; his letter will need his friend's dignifying judgment as the I/thou relation sustains the dignity of being itself. Louis Marin has described in his reading of Poussin's *Arcadian Shepherds* how "the sitter of the portrait appears only to be the represented enunciative ego who nonetheless defines the viewer's position as a 'tu' he addresses. The sitter portrayed in the painting is the representative of enunciation in the utterance, its inscription on the canvas screen, as if the sitter here and now were speaking by looking at the viewer: looking at me, you look at me looking at you. Here and now [he writes], from the painting locus, I posit you as the viewer of the painting." [2] Considered in deictic terms, the portrait miniature varies in important ways from the portrait on canvas as Marin describes it, with such a fixed standpoint for the viewer.

The portability of the miniature, its attachment to a person or persons, the necessity of removing it from a cabinet in order to view it or otherwise taking it up in the hand or moving close to it, all imply a certain circulation that is both the circulation or evocation of memory and the drawing of others into its implicit economy. It vividly partakes of the gift economy with which all works of art are involved and in this sense is a kind of token or coin that is particularly precious. The portraits of the miniature painter William Dunlap and his wife, or the portraits of Ebeneezer and Elizabeth Storer, embedded in identical hair bracelets, display a perfectly symmetrical gift exchange. There is a neatness and containment to the exchange that speaks to both the volitional and democratic sense of modern marriage and the social sanction and strictness of bourgeois convention. They are not two halves of a broken thing; they are, rather, mirror images of each other that inevitably invite the articulation of differences and the necessity of separa-

tion. But the miniature portrait, unlike portraits on canvas, involves an accessible reverse side and often, when it is encased in a locket or other jeweled enclosure, it has an inside and outside that provide strong contrasts between public and private views, or perhaps more properly, degrees of privacy in viewing.

Seeing is associated with control as well as loss of presence, and to observe or view someone without their knowledge or reciprocity is to have a kind of power over them or independent of them. The complex and ancient folklore of the evil eye is rooted in this aspect of visuality, and images encased in precious metals kept near the body necessarily are related to amulets. The ancient Greeks and Romans believed such objects brought good luck and protected against hostile wills—especially such negative uses of the gaze. The Romans, particularly, used amulets called *bullas* as protection for children of both sexes. The bulla was enclosed in a capsule, often of gold, which was itself believed to possess powers of protection against evil forces and illness, and the capsule was then worn around the neck. The Romans contended that prepubescent children especially needed such protection.[3] In the miniatures included here, children are the objects of the gaze of loved ones, especially when they have in fact come to early harm or death. Mary Way's *Portrait of a Child of the Briggs Family* memorializes the child's living face. In an unidentified artist's *Memorial for Solomon and Joseph Hays*, representation is eschewed for metonymy as the hair of the two infants is set into a circular locket; an image of dual tombs uses the blond hair of one child and the brown hair of the other, and the two kinds are plaited into a pattern, with beadwork and the monogram *H* above *J* and *S* on the back.

We also can see those miniatures bearing the image of a single eye as particularly reminiscent of these practices involving the protection and secrecy of amulets. And the erotic image of Sarah Goodridge's breasts may have a classical antecedent, too, for it is strikingly reminiscent of the story of Baubo that Freud also wrote about as "A Mythological Parallel to a Visual Obsession."[4] This legend tells how Demeter comes to Eleusis in search of Persephone after she has been abducted by Pluto. Demeter is taken in and housed by Dysaules and his wife Baubo; in her great sorrow, Demeter refuses to touch food or drink. But by suddenly lifting up her clothes and exposing her body, the hostess was able to make Demeter laugh and bring her out of her depression. In terracottas found at excavations in Priene, a headless figure with a body that uses nipples for eyes, a navel as nose, and genitals as mouth represents the figure of Baubo. This image was also popular

among the surrealists, as in René Magritte's 1927 *L'homme au journal (Now You Don't)*, now at the Tate Gallery. The image is suggestive as well —in inverse—of Percy Shelley's famous vision on the night of the instigation of *Frankenstein*, of Mary Shelley as a Christabel-like figure whose breasts bore eyes instead of nipples. The monster Frankenstein creates is himself compelled to murder when he views a miniature that reminds him of his own exclusion from the world of romantic love. And that miniature later plays a key role in the mourning practices described in the novel. The perfection of the miniature, its quiet repose and exactness, is contrasted to the unbounded horror of the monstrous as parts that will not cohere and cannot reproduce themselves. In the end, Sarah Goodridge's cloth-draped breasts have much of the effect of Baubo's surprise—they startle and at the same time remind us of the cycle of life that is indicated in the miniature form as a whole: the sexual, the maternal, and the melancholy; love, birth, and death in turn.

In addition to their protective function, oriented toward the present and future, such objects evoke issues of fetishism and serve as erotic trophies. The analogy Patricia Fumerton has drawn between miniatures and sonnets circulated within the coterie culture of scribal publication in the late sixteenth and early seventeenth centuries is particularly apt here.[5] In Hilliard's 1595 "Man Against a Background of Flames," the lover wears a miniature that is not revealed to us, though he clearly points to its existence; and the owner of the miniature would possess both the image of the lover and the image of herself or himself within an abyss of mutual erotic reference. The relation between sitter and viewer is not always reciprocal, for there are implications of secrecy, display, and voyeurism that introduce a third point of view, and there is an imbalance between the genders in the way the miniature is either secreted or revealed. As the third, interdictory term develops the erotic "plot," so does the third-person viewpoint of the reader of erotic works act as an impediment to the perfect duality of the relation between lovers.

As Fumerton explains, in the coterie culture of sonnet and miniature production, miniatures and handwritten "little poems of love" were produced scribally and received and circulated in private, yet this privacy was always shadowed and shaped by the publicity of the court. During the 1560s, the miniature began to make its appearance in public in the sense that cabinet miniatures, previously secreted in bedrooms and studies, began to be worn. They appeared encased in lockets and then gradually were displayed in the open-faced style we see in many of the miniatures in this collection. In his *Anatomy of Melancholy* of 1621, Robert Burton wrote of

lovers that "her dog, picture, and everything she wears, they adore it as a relic" and if a lover "get any remnant of hers, a busk-point, a feather of her fan, a shoo-tye, a lace, a ring, a bracelet of hair, he wears it for a favor on his arm, in his hat, finger, or next his heart." [6] The first French novel, Madame de Lafayette's *La Princesse de Clèves* of 1678 depicts the Duc de Nemours stealing a miniature of the princess for this very reason. And John Donne's early poems are replete with images of erotic mementos of this type. The opening lines of his eighteen-line sonnet "The Token" give us some insight into this form of exchange between lovers:

Send me some token, that my hope may live,
 Or that my easeless thoughts may sleep and rest;
Send me some honey to make sweet my hive,
 that in my passions I may hope the best.
I beg no riband wrought with thine own hands,
 To knit our loves in the fantastic strain
Of new-touched youth; nor ring to show the stands
 Of our affection, that as that's round and plain,
So should our loves meet in simplicity;
 No, nor the corals which thy wrist enfold,
Laced up together in congruity,
 To show our thoughts should rest in the same hold;
No, nor thy picture, though most gracious,

And most desired, because best like the best;
 (lines 1–14)

"Best like the best" is the picture or miniature, yet it is not enough, as witty lines are not enough; and what the lover wants in the end is for the lover to swear that she in fact thinks that he loves her. In "Witchcraft by a Picture," Donne shows us in his first stanza the ambivalent affects that can ensue from gazing on the miniature:

> I fix mine eye on thine, and there
> Pity my picture burning in thine eye,
> My picture drowned in a transparent tear,
> When I look lower I espy;
> Hadst thou the wicked skill
> By pictures made and marred, to kill,
> How many ways mightst thou perform thy will?

In addition to this imagery of miniature portraits, Donne also frequently makes mention of the exchange of hair jewelry or relics. His beautiful meditation "The Relic" describes hair after death—not the hair of the buried body, but rather the hair that binds him to his love eternally: her red hair worn as "a bracelet of bright hair about the bone." In another work, Elegy 11, titled "The Bracelet," he begins by describing the loss of a metal chain and how "not that in colour it was like thy hair, / For armlets of that thou mayst let me wear" (lines 1–2), indicating the connection between the binding of hair jewelry, the lover's erotic access to his love's unbound hair, and the mixture of hairs of the self and the lover that follows from wearing such jewelry.

Elegy 10, "The Dream," uses the imagery of coins to describe the *impresa*, or impression, of the *eidos* of the loved one:

> Image of her whom I love, more than she,
> Whose fair impression in my faithful heart,
> Makes me her medal and makes her love me,
> As kings do coins, to which their stamps impart
> The value, go, and take my heart from hence,
> Which now is grown too great and good for me;
> honours oppress weak spirits, and our sense
> Strong objects dull; the more, the less we see
> (lines 1–8)

It is typical of Donne's sophistication not to record the conventional senti-ments associated with the use of such objects, but rather to explore the complexity and ambiguity of erotic emotions. Once private feelings are put into circulation and hence once impressions are truly like coins, they may bear the impress of their original emotional force, but they acquire a life of their own. The original emotion is inevitably diminished, for its impression or representation can be undervalued or overvalued all too easily, and the more, the less, we will see.

George Cushman painted a miniature of his future wife, Susan Wether-ill, in the 1840s, accompanying it with sincere professions of his love that she at first rejected. But in Flaubert's *Madame Bovary*, Emma Bovary's feck-less lover, Rodolphe, keeps a Rheims biscuit tin full of mementos of love affairs: "stubbed at the corners was a miniature of her that she had given him; he thought her dress showy and her ogling look quite deplorable. As he concentrated on the portrait, trying to visualize the original, Emma's fea-tures blurred in his memory, as though the living and the painted face were rubbing together and obliterating each other." As he looks through his col-lection, he discovers "a black mask, pins, and hair . . . lots of hair! Some dark, some fair, some, catching in the hinges of the box, even broke when he opened it."[7] Meanwhile, Charles Bovary, Emma's faithful and hapless husband, dies holding a long lock of the dead Emma's black hair. There is something horrible about the very size of this lock, which is a kind of *un*-miniature, uncontained and unshaped—in every way out of bounds. This lock of Emma's hair suggests much of the ambivalence of hair in souvenirs and mementos: the popular, though false, belief that hair continues to grow even as the body decays; the efforts to contain hair by repeated gestures of plaiting and twisting; the mournful repeated effort to save a material remain of the other that all the more emphasizes the loss of the body.

By the end of the nineteenth century, the affects associated with an exchange of miniature portraits can seem quite codified. Frank Tousey's 1890 book *How to Write Letters*, subtitled *Everybody's Friend, Samples of Every Conceivable Type of Letters*, provides sample forms for sending and receiving miniatures. A Boston lady, sending her miniature to her suitor, writes,

> Dear Sir: Accept my very best thanks for your kind inquiries regarding
> my health, which I am happy to say is as good as usual. My thoughts
> often recur to the happy hours which we have passed together—hours
> which I have thought passed like minutes, so full were they of the pleas-
> ure which I ever feel in your company. While I feel that my personal

pretensions are but humble, I believe that you will be pleased with the enclosed miniature, the view of which, in my absence, may call to your mind a remembrance of me. While I feel that the likeness is rather a flattering one, still, should it but serve to bring me to your remembrance, the skill of the artist will not have been exercised in vain. Pray accept it as a friendly memento from, ____

And Tousey provides a sample as well of the suitor's reply from Chicago:

My dear_____

I never thought that any fresh proof of your attachment was needed, nevertheless I have this day received another, and that one of the most acceptable I could have desired, viz: the portrait of [her] whom of all others I am most desirous to keep in recollection. In contemplating this specimen of the artist's skill, I feel that it will ever recall you forcibly to my recollection, and in so doing will be a constant source of delight to my mind, and will afford me some kind of solace during your absence. I need scarcely add that I accept your gift with unspeakable delight, although, at present, I have nothing better to send you in return than a fresh assurance of my most constant attachment, which I trust may prove as welcome to you as your treasured miniature has proved to me, and in this hope I remain, Ever yours, affectionately . . .

As Charles's lock and Rodolph's miniature demonstrate a surplus and deficit of affect, so can it be difficult for us to measure or understand the emotional response such objects can summon. We can see that for the Boston lady, love miniaturizes time, making hours seem like minutes, and therefore it might also miniaturize space, making the distance shrink between lovers when they gaze at each other's portrait. It is somewhat amusing that the Chicago suitor says that the lady will be recalled "forcibly" rather than "forcefully" to his recollection; Tousey seems at least subconsciously aware of the demand for repetition of absence that the object evokes so much as it presents opportunities for a surrogate form of presence.

A miniature that may be real or not plays a different kind of complex and ambiguous role in *The Winter's Tale*. Early on in the drama, Leontes' speeches begin to manifest his precipitous fall into paranoia, and he refers to Polixenes as "he that wears her [that is, Hermione] like her medal, hanging about his neck" (act 1, scene 2, lines 307–8). Of course the stage directions don't tell us whether Polixenes is in truth to be shown wearing such a medal or miniature portrait, and the play indicates that men more often

secreted miniature portraits of their loves on their persons rather than displaying them openly as women usually, if not always, did. Leontes is obsessed with whether or not his son Mamillius is an unbreeched, or miniature, version of himself twenty-three years before, and so the legitimacy in likeness is brought up against the illegitimate invisible image of the lover. Paulina reciprocally says of the baby Perdita, "Although the print be little, the whole matter / And copy of the father—eye, nose, lip / The trick of's frown, his forehead, nay the valley / The pretty dimples of his chin and cheek, his smiles / The very mould and frame of hand, nail, finger" (act 2, scene 3, lines 98–102). The miniature of the living infant and miniature portraits can have legitimate and illegitimate owners or progenitors. Many of the miniatures in this exhibition are authenticated by being carried forward through blood ties or other affective ties of generation. Although the miniature can obviously be an object of beauty and regard for its own sake, a significant dimension of the miniature's meaning continues to be derived from a metonymic connection to the bodies of particular persons.

Portrait miniatures particularly exaggerate the inadequacy of any imagined duality between sitter and beholder. Whether devoted to eroticism or mourning, the portrait miniature emphasizes the differences between scenes of depiction and scenes of viewing, showing the enormity of the distance between the present and the world within the frame. The striking image of Harriet Mackie on her deathbed that Robin Jaffee Frank has so dramatically narrated in the catalogue for this exhibit particularly demonstrates this; the fairy-tale bride, in fact possibly a victim of murder, exists in a world of petrified organicism. Her fertility is literally in a state of suspended animation.

Unlike the frontality of other face-to-face works, the frontality of the portrait miniature is undermined by the ready accessibility of the reverse side, the occluded view that returns us to the diminished scale of the present—the irrefutable materiality of the hair, the insignificant packing material, the blank fact of thingness and refused transcendence following from the realization that the object is an object. But if the scale of the portrait miniature is perfectly suited to representing the distancing of erotic shattering or the loss implicit in mourning, the portrait miniature is also designed to compensate by emphasizing the possibilities of touch.

Whatever distancing happens on the level of visual experience in the apprehension of the miniature is remedied or countered by this tactile immediacy. The portrait miniature thus brings up issues of animation that are particularly complex. The remarkable image called MEMORIAL FOR

S.C. Washington shows a deceased adolescent girl breaking through an obelisk in response to the presence and tears of her mother. The image echoes the many popular ballads that tell how the excessive grief of mourners can awaken a ghost or a coffin-bound corpse—and it particularly reverses the terms of the anonymous ballad of "The Ghost's Warning," where a mother bolts through the marble walls of her tomb in order to respond to the crying of her children. That the power of love might bring life back to another is implicit in many myths and legends of kissing, such as the story of Pygmalion and Galatea or the story of Sleeping Beauty that Harriet Mackie's miniature also suggests.

The miniature's dynamic between visuality and tactility in fact implies a range of sensations. Hegel astutely noted that issues of hardness and softness are involved in the animation that is manifested in all portraiture:

> In the human face *nature*'s drawing is the bone structure or the hard
> parts around which the softer ones are laid, developed into a variety of
> accidental detail; but however important those hard parts are for the
> character drawing of *portraiture*, it consists in other fixed traits, i.e.
> the countenance transformed by the spirit. In this sense we may say of
> a portrait that it not only may but must flatter, because it renounces
> what belongs to the mere chance of nature and accepts only what
> makes a contribution to characterizing the individual himself in his
> most personal inmost being.[8]

For Hegel, the actuality of the flesh is what animates the mere skeleton and at the same time is the very individuality that passes away.

Part of the horror of bones coming alive is that they signify a condition of vivacity without any necessary subjectivity or particularity. In the miniature it is a fleshly and pastel softness that is revealed within the metal casing; and so a subjectivity no longer available in reality seems preserved by artificial means, and relations between interiors and exteriors are reversed or turned inside out. And the miniature's references to the tactile surfaces of lips, hands, and nipples in fact privileges those few parts of the body that have no hair as at the same time it foregrounds the use of hair as a supplement to emotion.

The ground hair making up the paint in *MEMORIAL FOR S.C. Washington* and other works lends it what might be called a tactile vividness, just as early miniaturists used gold as a powdered pigment and, in Hilliard's case, also treated it as a metal, thickly applying it to the edges of his works and then burnishing it, making the soft gold particles merge into a continuous gleaming surface.[9] The profound antinomy between stone and water is recapitulated in the miniature's dynamic between gems and tears. The ivory ground is both soft and warm, and hence evocative of flesh; the hair encased as a souvenir is lustrous like metallic things and potentially springing like organic things.

When we consider the reciprocity and transitivity of touch, we realize that what is being animated in the portrait miniature, which always emphasizes the distance of the sitter, is the beholder himself or herself. Such works animate the dormant emotions of the viewer—they evoke the repetitions or, more accurately, the incessant returns of erotic obsession and

mourning and at the same time literally offer some opportunity of at least temporary closure, for they can be encased in their covers, put away for a time, or turned aside, while they are at the same time kept near. And because they are small and precious, they always threaten loss—their destiny is to arrive eventually, often because of the death of the beholder himself, in what Thomas DeQuincy once described as "that great reservoir of *somewhere*" where all lost things go.

WHAT THOUGHT IS LIKE
The Sea and The Sky

Le silence éternel de ces espaces infinis m'effraie.

"The eternal silence of these infinite spaces terrifies me." Pascal recorded in that famous *pensée* his overwhelmed and overwhelming fear of the stars. He knew that the vast spaces of the heavens evoke none of the possessive confidence we feel in looking out over a "view" of the land. The works in The Sea and The Sky, representations of the night sky, the day sky, and the sea, are deeply familiar as types, yet never quite recognizable as particulars. In motion even when seemingly in stasis, they are ineffably complex; they flood and supersede whatever media might capture or frame them. Such 'scapes, as they were called in the nineteenth century, draw us to looking as they draw us to the limits of our looking. As Marianne Moore's great meditative poem on the sea, "A Grave," explains, "Man looking into the sea, / taking the view from those who have as much right to it as you have to it yourself, / it is human nature to stand in the middle of a thing, / but you cannot stand in the middle of this;" [1]

Moore is only one of the many writers who have considered the sea and the day and night skies as phenomena we know primarily through this puzzle: offering themselves as visual experiences, the sky and the sea cannot be encompassed as visual experiences. Perhaps it is this very challenge that makes us long to view, to seek out, such prospects which, in their vast scale and ever-constant motion, are paradigms of the problem of imitating life. Melville, with his usual humor, describes at the opening to *Moby Dick* the pull of the sea for human lookers: "Circumambulate the city of a dreamy Sabbath afternoon. Go from Corlears Hook to Coenties slip, and from

thence, by Whitehall, northward. What do you see?—Posted like silent sentinels all around the town stand thousands upon thousands of mortal men fixed in ocean reveries." He concludes that, like Narcissus, we viewers of the sea "see ourselves in all rivers and oceans. It is the image of the ungraspable phantom of life; and this is the key to it all."[2] Thoreau's journal in January of 1852 explicitly draws a connection between sea looking and sky looking: "The drifting white downy clouds are to the landsmen what sails on the sea are to him that dwells by the shore—objects of a large, diffusive interest. When the laborer lies on the grass or in the shade for rest, they do not too much tax or weary his attention. They are unobtrusive. I have not heard that white clouds, like white houses, made any one's eyes ache. They are the flitting sails in that ocean whose bounds no man has visited."[3] Thoreau considered this interest so vital that he suggested a change in the American working day so laborers could take afternoon siestas devoted to this form of cloud-gazing.

Grounds without figures, extensions without coordinates, the views in this exhibit are nevertheless engaged in a drama whose protagonist is the viewer—and precisely because of the absence of coordinates, the viewer faces a vertiginous loss of position or location. In his monumental study of the significance of J. M. W. Turner's innovations, *Modern Painters*, John Ruskin got to the heart of this risk as a kind of formal problem. Writing "Of Truth of Skies," and describing the liquid quality of the sky, he accounts for the quality of *plunging* in Turner's paintings; "the sky is something into which you can see through the parts that are near you into those which are far off, something which has no surface and through which we can plunge far and farther and without stop or end, into the profundity of space."[4] The viewer, like Icarus, is a creature more of fall than flight; to enter the space of the painting is to recede behind a boundary between sky and sea, taking the boundary itself along. In contrast, when Keats apostrophizes his "Bright Star," he immediately expresses "Would I were stedfast as thou art"—it is his own viewing that he hopes to make analogous to the steadfast, still unchangeable aspect of the star that watches from its fixed vantage point "the moving waters at their priestlike task of pure ablution round earth's human shores."[5] Above the flux of the world, Keats's star is at once permanent, constant, and capable of reversing time.

But Keats's human desire is founded upon a deep error—for the stars have a history that is as irreversible as that of human evolution, and their perfect silence is an illusion created by our own distance from them. The disparities between our views of the seas and the heavens and whatever is their actuality is a constant challenge to our efforts at representation. In

Cape Cod, Thoreau wittily comments on the purely physiological problem of taking in vast distances by sight alone: "We discerned vessels so far off, when once we began to look, that only the tops of their masts in the horizon were visible, and it took a strong intention of the eye, and its most favorable side, to see them all, and sometimes we doubted if we were not counting our eyelashes." [6] Nevertheless, as he champions idle cloud-gazing, Thoreau also links more profound forms of thought to the contemplative viewing of the sky itself. He wrote in his journal on January 17, 1852,

> In proportion as I have celestial thoughts, is the necessity for me to be
> out and behold the western sky before sunset these winter days. That
> is the symbol of the unclouded mind that knows neither winter nor
> summer. What is your thought like? That is the hue, that the purity,
> and transparency, and distance from earthly taint of my inmost mind,
> for whatever we see without is a symbol of something within, and that
> which is farthest off is the symbol of what is deepest within. The lover
> of contemplation, accordingly, will gaze much into the sky. [7]

We have, in the philosophical discourse on the sublime, a helpful commentary on the problem of "taking in" and representing such vast and powerful natural forces. Path-breaking eighteenth-century writers on the sublime such as Joseph Addison and Edmund Burke wrote of the feelings of terror and grandeur that accompany our encounter with nature's powers. But it was Immanuel Kant who developed the most subtle and extensive account of our response to sublimity. He described the agitation of the mind that follows from experiences of the tremendous dynamism of nature and from our staggering sense of the concept of infinity. His significant innovation in the *Critique of Judgment* was to explain that in the end it is not nature herself that is "absolutely great" but rather the workings of our mind as we are able to intuit such greatness—even, or especially, when we *cannot* encompass natural phenomena with our senses. Kant wrote,

> Hence sublimity is contained not in any thing of nature, but only in our
> mind, insofar as we can become conscious of our superiority to nature
> within us, and thereby also to nature outside us (as far as it influences
> us). Whatever arouses this feeling in us, and this includes the might of
> nature that challenges our forces, is then (although improperly) called
> sublime. And it is only by presupposing this idea within us, and by re-
> ferring to it, that we can arrive at the idea of the sublimity of that being
> who arouses deep respect in us, not just by his might as demonstrated in

nature, but even more by the ability, with which we have been endowed, to judge nature without fear and to think of our vocation as being sublimely above nature.[8]

Kant eventually collapsed the initial distinction he had made between the dynamic and mathematical sublime; the vast power and extension of nature, which we cannot totalize through any objective empirical means, but which we can intuit subjectively by means of the pure operation of our reason.

Kant in fact specifically wrote on the phenomena represented here. It is worth following at length what he had to say about them:

> When we call the starry sky *sublime*, we must not base our judgment
> upon any concepts of worlds that are inhabited by rational beings, and
> then conceive of the bright dots that we see occupying the space above
> us as being these worlds' suns, moved in orbits prescribed for them with
> great purposiveness; but we must base our judgment regarding it merely
> on how we see it, as a vast vault encompassing everything. . . . In the
> same way, when we judge the sight of the ocean we must not do so on
> the basis of how we *think* it, enriched with all sorts of knowledge which
> we possess (but which is not contained in the direct intuition), e.g., as a
> vast realm of aquatic creatures, or as the great reservoir supplying the
> water for the vapors that impregnate the air with clouds for the benefit
> of the land, or again as an element that, while separating continents
> from one another, yet makes possible the greatest communication
> among them; for all such judgments will be teleological. Instead we
> must be able to view the ocean as poets do, merely in terms of what
> manifests itself to the eye, e.g., if we observe it while it is calm, as a
> clear mirror of water bounded only by the sky; or, if it is turbulent,
> as being like an abyss threatening to engulf everything and yet find it
> sublime.[9]

Whether we are viewing the heavens or viewing the sea, Kant urges us to pursue the purely aesthetic experience of viewing without preconception — we should not project our own interest upon those vast spaces nor imagine them in terms of their teleology or use to us. To see them "as poets do," that is, in purely aesthetic terms, is the way to follow them as processes at one with a natural history of which we ourselves are a part. Such Kantian aesthetics played a role, too, in Ruskin's thinking. Ruskin claims, as he carefully describes the painterly devices for representing clouds and waves, "perhaps the very first thing we should look for, whether in one thing or

another—foliage, or clouds or waves—should be the expression of infinity always and everywhere, in all parts and division of parts. For we may be quite sure that what is not infinite, cannot be true." [10] It is the task of the painter to express an infinity that cannot be represented; hence truth is rooted in expression, yet, for Ruskin, expression itself is rooted in a dedication to the particulars of natural forms.

Philosophers have not taken up the view of the heavens and the sea only with regard to sublimity, however; they also have been compelled to consider the phenomenon of the horizon, particularly the horizon as a kind of temporal hinge between immediate apprehension and a constant postponement of closure. It is the project of any work of understanding or interpretation to move beyond such apprehension and toward the limit of intelligibility, the ever-receding limit of what can be thought and known. The horizon we observe as we look out to sea exists in some untouchable, unrealizable place between the constant mutations and motions of the water and the air. Is it the horizon that was there yesterday—and is it the horizon that will be there tomorrow? The very *fact* of the horizon is what is immutable; it is an infinite dividing line between infinite entities, a place toward which the mind journeys and yet a place that appears as a continuous, productive deferral of place. There is a deep connection between those real horizons particular to these kinds of 'scapes and the interpretive horizon of works of art. As Hans-Georg Gadamer wrote in his 1964 essay on "Aesthetics and Hermeneutics," "the reality of the work of art and its expressive power cannot be restricted to its original historical horizon, in which the beholder was actually the contemporary of the creator. It seems instead to belong to the experience of art that the work of art always has its own present." [11] The point of view of the work of art carries such a present with it as an ever-receding, ever-promising edge of language or communication.

Water is our element; we imagine entering back into it, coming home to it, immersing ourselves totally as we immerse ourselves in knowledge, and moving toward that far place where water joins the air and we might transcend our physical selves. This progression is one of the vital central myths of Romanticism—a myth of individuality so deep that it seems to be an aspect of our nature. Melville's Ahab, bent on the tautology of revenge, struggles precisely against this possibility of transcendence when he rants, "cursed be all the things that cast man's eyes aloft to that heaven, whose live vividness but scorches him, as these old eyes are even now scorched with thy light, O sun! Level by nature to this earth's horizon are the glances of men's eyes, not shot from the crown of his head, as if God had meant him to gaze on his firmament." [12] One way of looking at these works is to give

careful consideration to what the artist does with the horizon—moving it up or down, splicing it and reversing its direction, erasing it, working it asymmetrically into the "formlessness" that was Caspar David Friedrich's great departure from the "framed" views of earlier Romantic paintings. Each artist calls forward a change in the viewer's perceptual horizon, a movement between immersion and elevation, contingent to the representation of horizon in the work.

And in the case of the sea, Ruskin explains that the "irreconcilable mixture of fury and formalism" of breakers leads us to perceive each one individually—to apprehend or approach an expression "necessarily of mathematical purity and precision: yet at the top of this curve, when it nods over, there is a sudden laxity and giving way, the water swings and jumps along the ridge like a shaken chain, and the motion runs from part to part as it does through a serpent's body."[13] Then, when we are afloat offshore amid the waves, we have a quite different perspective—"not wave after wave, as it appears from the shore, but the recklessness of the very same water rising and falling . . . it is when we perceive that it is no (individual) succession of wave, but the same water constantly rising, and crashing, and recoiling and rolling in again in new forms and with fresh fury, that we perceive the perturbed spirit, and feel the intensity of its unwearied rage."[14] Each view of the sea has thereby at least two sides—a front and a back that contrast confrontation and surrender in a context of unending forceful transformation between parts and wholes. There is in this something of our experience of subjectivity: the contrast between the face-to-face sphere within which individuality is constructed and subjects are the manifestation of their unique experience of time and the complex, ungraspable sphere of the social as a whole. If following an individual wave is like following a person, being caught up in the "same water constantly rising, and crashing, and recoiling" is like being caught up in the swell of a crowd or the swirling circumstances of our historical moment.

In works of art representing the sea or the sky, there is always an infinite reach or recession—behind the heavens is the unending vastness of space; behind the breakers, the extent of the main; under the surface, the depths; behind the clouds, the stars; behind the stars, more stars; and behind our consciousness of these views, a vast inarticulate and untranslatable consciousness. Every gesture indicating surface and depth in these works is an index to the profundity of profundity itself. As watchers of the sea and heavens at least from Amerigo Vespucci onward gathered their observations in notebooks and bound manuscripts, they speak to our need to find some legible and encompassing form for such vastness. Melville's Ishmael describes

the laborious transmutation of the whale into "Bible leaves! Bible leaves!" Proust watched the sea reflected in the glass of a bookcase. To frame enormity within the covers of a book, to register the infinite through a series of patient, exacting marks on sheets of paper, brings the scale of such phenomena back to hand and eye and thought—the vehicles of human intelligibility.

Nevertheless, if the "content" of such sublime spaces can only be marked by the horizon and not articulated, we arrive again at the paradox of the impossibility of representing the sky and sea in these representations of the sky and sea. There is no question that there have been technical "improvements" in our knowledge of the waves and clouds, for example, improvements both shaping and shaped by corresponding technical improvements in our devices of representation. In John Constable's famous cloud studies of 1821, he undertook what he called "skying," dating the cloud formations and at times correlating his observations with the recently completed cloud taxonomy of Luke Howard—a classification scheme that had been acclaimed by Goethe. For the first time cloud types were linked to variations in elevation and moisture. But Constable's aims in his cloud studies were far more searching. In an 1821 letter to Archdeacon John Fisher, he wrote, "It will be difficult to name a class of Landscape, in which the sky is not the 'key note,' the standard of 'Scale,' and the chief 'Organ of sentiment.' . . . The sky is the source of light in nature—and governs everything." [15] Fifty years later, Gerard Manley Hopkins's 1870 journal entries also date his cloud observations and reveal his discovery of a whole new language for describing them. An early spring entry describes how

> in March when long streamers were rising from over Kemble End one large flake loop-shaped, not a streamer but belonging to the string, moving too slowly to be seen, seemed to cap and fill the zenith with a white shire of cloud. I looked long up at it till the tall height and the beauty of the scaping—regularly curled knots springing if I remember from fine stems, like foliation in wood or stone, had strongly grown on me. It changed beautiful changes, growing more into ribs and one stretch of running into branching like coral. Unless you refresh the mind from time to time you cannot always remember or believe how deep the inscape in things is. [16]

Hopkins carefully distinguishes morning clouds from afternoon clouds and the movement of "great rafts" of clouds from the movement of cross-

hatched clouds. And he gives, in August of that same year, a similarly careful account of wave motion:

> [T]he breakers always are parallel to the coast and shape themselves to
> it except where the curve is sharp however the wind blows. They are
> rolled out by the shallowing shore just as a piece of putty between the
> palms whatever its shape runs into a long roll. The slant ruck or crease
> one sees in them shows the way of the wind. The regularity of the bar-
> rels surprised and charmed the eye; the edge behind the comb or crest
> was as smooth and bright as glass. It may be noticed to be green behind
> and silver white in front; the silver marks where the air begins, the pure
> white is foam, the green, solid water. Then looked at to the right or left
> they are scrolled over like mouldboards or feathers or jibsails seen by
> the edge. It is pretty to see the hollow of the barrel disappearing as the
> white combs on each side run along the wave gaining ground till the
> two meet at a pitch and crush and overlap each other.[17]

We could say that these nineteenth-century efforts to engage the reality of clouds and stars and seas by means of observation and precise description anticipate the tremendous change that photography brought to such representations. But photographic realism is of no more interest—in fact, one could argue, is of considerably less interest—than the direct experience of nature. In the history of such representations, photography becomes a handmaiden to the more subjective forms of expression made possible through the touch of painting, the temporal unfolding of drawing, and the assemblage and shaping of three-dimensional representations. And, just as significantly, photography gradually draws forward, as in the "purely" photographic views of this exhibit, its repertory of signs of its own subjectivity, reminding us at every turn that we are looking at an intended view, one tied to the emotions and sensibility of the photographer.

What is the subject of our viewing here if not the process, the temporality, of viewing itself? Such representations are what Vija Celmins calls in her seminal early work on the subject, her pencil drawings of waves and stars, "a record of mindfulness."[18] We are looking at an afterimage of the artist's purposeful activity, a reframing of a visual experience as an experience of thinking. Therefore this work is often permeated by a set of themes and formal problems particular to thinking itself—the relation between agitation and stasis, sound and silence, activity and repose. Ruskin developed a symbology in which the sky was "most profound when it does not summon new attitudes" and contrasted the sky as a scene of calm and majesty to the sea

as a scene of great activity.[19] Yet in fact the terms can be readily reversed, as Ruskin himself must have remembered when he asked in a nearby passage, "Who saw the dance of the dead clouds when the sunlight left them last night, and the west wind blew them before it like withered leaves?"[20]

The dynamic between stasis and movement has a deep historical importance in the development of astronomical thought as well. In fear of the church, Tycho Brahe cannily hedged his discovery in 1572 of what he thought was a new star (but which was in fact a stellar explosion) by saying that since "all philosophers agree, and facts clearly prove it to be the case, that in the ethereal regions of the celestial world no change either by way of generation or corruption takes place; but that the heavens and celestial bodies in the heavens are without increase or diminution, and that they undergo no alteration . . . that they always remain the same, like unto themselves in all respects, no years wearing them away," the "new star" he discovered had to be a miracle.[21] Thoreau's *Cape Cod* describes the sea's occasional appearance as a glassy smoothness, adding that sailors ascribe this quality to a moment when land and sea breezes meet and annul each other or to the oily slickness arising from the depths when blue fish are attacking their prey. "Yet," he wrote, "this same placid Ocean, as civil now as a city's

harbor, a place for ships and commerce, will erelong be lashed into a sudden fury, and all its caves and cliffs will resound with tumult. . . . This gentle Ocean will toss and tear the rag of a man's body like the father of mad bulls, and his relatives may be seeking the remnants for weeks along the strand." [22] The sky and sea may present an illusion of calm beneath or behind which explosions, fires, and great eruptions are ready to roil to the surface. If, as a consequence of the ruin we have brought to the natural world, we now see the sea as finite, we also imagine its depths as infinitely teeming with complex, as yet unknown forms. And if we see the sky as infinite, we also separate our firmament, the nourishing and knowable sphere of our own atmosphere, from the violent and teeming worlds beyond it.

Although we think of the sea's vast and silent depths, we also at seaside will know the great crashing music of the sea. Perhaps no one has described these sounds more exactly than Henry Beston in his classic book on shore life, *The Outermost House*:

> The sea has many voices. Listen to the surf, really lend it your ears, and you will hear in it a world of sounds: hollow boomings and heavy roarings, great water tumblings and tramplings, long hissing seethes, sharp, rifle-shot reports, splashes, whispers, the grinding undertone of stones, and sometimes vocal sounds that might be the half-heard talk of people in the sea . . . sound of endless charging, endless incoming and gathering, endless fulfilment and dissolution, endless fecundity, and endless death . . . the spilling crash . . . the wild seething cataract roar of the wave's dissolution . . . the endless dissolving hiss of the inmost slides of foam . . . above the tumult, like birds, fly wisps of watery noise, splashes and counter splashes, whispers, seethings, slaps and chucklings.[23]

Behind the silence of the painting or drawing or installation here, as behind the silence of the telescope, this organic flow of noise and activity seethes and bursts. Yet as we take it in through visual means we have access to a stillness of which the phenomena themselves are not a part. This stillness returns us to the ever-presentness of the work of art. In such works geological time, astronomical time, historical and social time, and the phenomenological time of our lived experience of the body are all of consequence. Moving toward these moving images, we find vast ages simultaneously emerging toward, receding from, deferring or halting appearance. We might remember the close of Walt Whitman's "On the Beach at Night." This beautiful poem addressed to a child merges the sea and sky gods on the path to some other ineffability, what Whitman calls the "something there is":

Jupiter shall emerge, be patient, watch again another night,
 the Pleiades shall emerge,
They are immortal, all those stars both silvery and golden
 shall shine out again,
The great stars and the little ones shall shine out again, they
 endure,
The vast immortal suns and the long-enduring pensive moons
 shall again shine.

.

Something that shall endure longer even than lustrous Jupiter,
Longer than sun or any revolving satellite,
Or the radiant sisters the Pleiades.[24]

Through works of art about the sea and sky, we search in our vision of forces of nature for some record of the force of our own thought. The majestic cumulus procession, the race of cirrus, the sequential spill of foam at the edge of the wave, the roiling clusters of the stars: in the end whatever forms, whatever vivid images of life, arise out of our encounter with these natural forces are made possible by means of the great gift of nature's mutability.

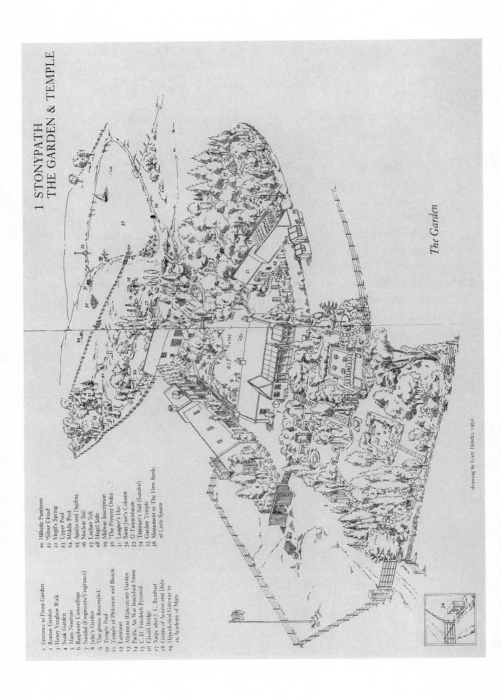

1 STONYPATH
THE GARDEN & TEMPLE

The Garden

1 Entrance to Front Garden
2 Roman Garden
3 Henry Vaughan Walk
4 Sunk Garden
5 Marc Nostrum
6 Raspberry Camouflage
7 Sundial (Fragments/Fragrance)
8 Julie's Garden
9 'Das grosse Rasenstück'
10 Temple Pool
11 Temple of Philemon and Baucis
12 Lararium
13 Allotment (Epicurean) Garden
14 Pacific War War Inscribed Stone
15 C.D. Friedrich Pyramid
16 Claudi Bridge
17 Xaïpe after J.C. Reinhart
18 Grotto of Aeneas and Dido
19 Hypothetical Gateways to an Academy of Mars

20 Hillside Pantheon
21 'Silver Cloud'
22 Virgil's Spring
23 Upper Pool
24 Middle Pool
25 Apollo and Daphne
26 Nuclear Sail
27 Lochan Eck
28 Hegel Stile
29 Midway Inscription
30 'The Present Order . . .'
31 Laugier's Hut
32 Saint-Just's Column
33 O Tannenbaum
34 Tristran's Sail (Sundial)
35 Garden Temple
36 Monument to The First Battle of Little Sparta

drawing by Gary Hincks, 1992

GARDEN AGON

Ian Hamilton Finlay's Little Sparta, 1993–97

He who makes a garden, his own unmaking makes.

A garden is the wresting of form from nature. In this sense, making a gar-
den is synonymous with work, in that it intervenes in nature, and more
particularly with art as a kind of work, in that it produces form. Making
a garden, like making other works of art and unlike practicing agriculture,
involves producing form for its own sake. One might harvest the garden,
but to do so or not to do so will not determine the status of the space as a
garden. In making a garden one composes with living things, intervening in
and contextualizing, and thus changing, their form without determining all
aspects of their development or end. The garden thereby is linked to other
means of ordering life: codifying and ritualizing social time and space, cre-
ating political orders and social hierarchies—including the organization of
military order, or structures of force. In this latter feature resides the long-
standing connection between making gardens and making war. The garden
has, by definition, an articulated boundary. That boundary must be held or
defended against wilderness on one side and interiority or an excess of sub-
jective will on the other. The garden can only be used to pursue an agenda
of organic growth by maintaining a posture of defense.[1] Yet war is as well
the antithesis of the garden, for the ends of war are the destruction of life
and undoing of order. Gardens and war share a teleology of death, but the
garden promises cyclical time in which living things might extend beyond
their makers and death remains in its season. In the garden, death becomes
the seedbed of birth. If natural history repeats itself, then that is the nature
of more than human history. War short-circuits nature; it is the outcome of

acts of human will that risk the destruction of human time and, increasingly in this century, the destruction of Nature herself. The harvest of war is early death; the garden as "lachrymae musarum" is dedicated to the shepherd, hunter, and poet stricken by war.

Any work, including the work of art, is subject to contingency; in the garden contingency is dominated by the indeterminacy of weather. A garden involves composition with living things; it can also involve composition with inert matter—walls, rocks, stones, bricks, gravel, walkways, statues, urns, and other material artifacts. But such inert matter is thereby made meaningful by its juxtaposition to living forms. When we find the encroachment of moss on a brick or thyme on a rock appealing, we are pleased by the contrast between the fixity of the inert and the mutability of its natural frame. When we find an obelisk in a field of weeds or, as with Wallace Stevens's jar in Tennessee, we place a fixed form in a wilderness, an analogous pleasure arises from the opposite relation of figure to ground. Stone will endure; the sundial will orient us in time and space—this is the sensibility of the Enlightenment and the cult of order. Water will wear stone away; all the fixed world will decay—this is the sensibility of the Romantic and the cult of ruin.

Such issues of work, form, mutability, and contingency have been for almost thirty years the focus of the Scottish poet Ian Hamilton Finlay. Born in 1925 in the Bahamas, Finlay served from 1944 to 1947 with the Royal Army Supply Corps and was sent to Germany, where he was witness to the fighting at the end of the war. On his return he worked for a period as a shepherd on the Orkney Islands. Since 1966 he has made his garden an important aspect of his life and work—a garden he has built around himself with the help of his wife, Sue Finlay, and many collaborators.[2] Extending across a four-and-a-half-acre site in the Pentland foothills at Dunsyre, Lanarkshire, approximately twenty-five miles southwest of Edinburgh, the garden stands where there was originally a farm croft called Stonypath that was part of a larger estate belonging to Sue Finlay's family.

The garden was renamed Little Sparta in 1983, when it was twice the scene of struggles with the Strathclyde regional government over the status of a building at the site called the Garden Temple. Since 1978 the artist has wanted the building rated as a religious building; the local authorities considered it a gallery and decided to seize a number of Finlay's artworks on February 4, 1983, as payment for back taxes. Finlay and his supporters staged a resistance to the seizure that was both symbolic and real. Armed with water pistols, garden hoses, Finlay's old horse,[3] and what has been described as the world's longest string-and-tin-can telephone system, the

group, calling themselves the Saint Juste Vigilantes, met the police and authorities while members of the press served as witnesses.[4] Finlay's group flew a flag of Apollo's lyre (for inwardness) juxtaposed with an oerlikon gun (for action)—the gun substituting for the god's usual bow.[5] The sheriff officer was not successful in confiscating works. Finlay struck a commemorative medal of the battle and installed a monument at the entrance to "the battlefield." On March 15 the sheriff officer returned and removed works from the Garden Temple. Some of these belonged to Finlay, but many had been commissioned by or sold to other individuals and institutions. The works were placed in a bank vault, and most were never recovered. Finlay closed Little Sparta for a year. In 1984 the Vigilantes removed two of Finlay's neoclassical stone reliefs from Scottish Arts Council headquarters and installed them in the Garden Temple as war spoils; the garden was again opened.[6]

The two "Little Sparta Wars" were only the first of several "battles" Finlay has had with the arts establishment and the state. Before the 1983 wars, Finlay had conducted a mail campaign to discredit the Fulcrum Press after it published one of his works as a first edition; the work had, in fact, already appeared seven years before in a first edition and had been reprinted in a second. The "Follies Battle" of 1987 was another quarrel conducted by pamphleteering and through postcards and posters; in this case, the argument centered on a planned *National Trust Book of Follies* that included an inauthentic description of the garden at Stonypath. The book was criticized by many artists and scholars for its inaccuracies and careless categorization of monuments.[7]

But perhaps the most difficult struggle in which Finlay has been engaged was his loss of a commission he had been given by the French government in April of 1987. This commission was to install a garden commemorating the Declaration of the Rights of Man on the site of the Assembly Hall in Versailles. Finlay was a more likely choice for this commission than might be at first evident, for throughout the 1980s his art had been concerned with issues of neoclassicism and the French Revolution. But within a few months of the culture ministry's announcement, an editor of the Paris magazine *Art Press*, Catherine Millet, led a public campaign to have Finlay denied the commission after she saw that he had used the lightning symbol of the SS—the Nazi Schutzstaffel—in his work *OSSO*. This work was on display in an unrelated exhibition at the gallery ARC in Paris during the same period. The ministry withdrew the commission in March of 1988, announcing that "the detestable climate of opinion created by a campaign led by certain personalities and organs of the press" made it impossible to pursue the Finlay

project. Finlay eventually won a libel suit in the French courts against his detractors and was awarded a symbolic one franc in restitution.[8]

These events, replete with contention and multiple rhetorical frameworks, might be seen not so much as interruptions in Finlay's career but as integral aspects of his dialectical art. We are reminded of all the meanings accruing around the term *agon*—a place of games, lists, courses; a national assembly of contests; a struggle for life and death; a battle; an action at law or trial; the argument of a speech; agony or anguish of the mind; the contest of the rhapsode; the struggle to assert oneself.[9] Finlay has not designed or intended the specific shape such "battles" will take. And certainly the cancellation of the Versailles commission was a catastrophe for him. It has had a long-term effect on his reputation.

As Finlay's body of work has developed, the issue of strife and the pursuit of strife are key elements in his aesthetic. His work explores, in an open-ended and speculative way, the relations between art, thought, law, and war—the garden is quite literally a *defense* of poetry, a memory and vatic exercise at once on the meaning of war and the meaning of making and un-making more generally. There is an element of isolation, defensiveness, and misinterpretation deriving from the circumstances of his method of producing art that would seem to lead inevitably to trouble. The difficult rhetorical task of moving a public audience to ethical action, the inevitable stress involved in collaborative work and the recognition of individual ego, the harsh conditions under which the garden has been built—all are factors that make Finlay's art simultaneously intransigent and sublime.

<center>**The garden is not about nature,
but is rather a transformation of nature.**</center>

The theme of Finlay's garden is not nature. In this Finlay follows closely the worldview of the pre-Socratics: "In front of man stands not Nature, but the power of the gods, and they intervene as easily in the natural world as in the life of men."[10] As Anaximander linked seasonal repetition or periodicity to a law of time, so does Finlay link the reappearance of phenomena in history to the periodicity of the garden. Finlay called a series of works he made with Nicholas Sloan and David Paterson in 1980 *Nature Over Again after Poussin*, inverting Cézanne's dictum "Poussin over again after nature." When Finlay strategically places inscribed stone signatures in the garden landscape—as he has with Dürer's *AD* beside the Temple pool, evoking the

artist's "Great Piece of Turf" (*Das Grosse Rasenstuck*), and the names of Poussin, Claude, Friedrich, and Corot elsewhere in the garden—he reminds us that our sense of landscape is framed by the history of art.[11] Although the garden is bound up with issues of pictorialism and framing more generally, we do not derive from it a picture of, or story about, nature that is separable from an account of human nature. More specifically, we find history presented as both an expression of human nature and the sister of memory. The viewer of the garden is confronted with the realization that all space here has been made *semantic* space—the garden speaks the gardener's intention; there is no "background" or "backdrop" per se; there is the imposition of boundary which is a task constantly reimposed on the viewer.

The Pentland Hills are within the edge of Roman dominion, between the walls of Hadrian and Antoninus,[12] yet they also are a particularly hostile, northern environment for the revival of neoclassical ideals that Finlay proposes. Finlay follows, within an agenda of what might be called "neo" neoclassicism, the project of the Enlightenment's revival of classical order, a revival already both hampered and enabled by its distance from the classical world. The *tone* of Finlay's use of allusion continually fluctuates between fervent idealism and the ironic stance of parody—a layering that results in multiple, yet specific interpretations. In Finlay's account, historical events are simultaneously tragedy and farce; this is not a matter of the relativity of points of view—indeed it is directly opposed to such relativism. Rather, to see both tragedy and farce is an outcome of a sustained and moral meditation on history.

The overall structure of the garden is articulated by the heavily bounded and hedged front garden before the house, the large middle garden behind the house with a pond and water plants and the Garden Temple, and the woodland area beyond there with its many small glades, groves, and eventual vistas over the larger ponds. One's progress through the garden mirrors the historical progress of the making of the garden: with significant exceptions, one moves temporally from older to newer projects, spatially from density to wilderness, and thematically from interiority to public forms. This tripled and dialectical structure appears as well in the architecture of the Garden Temple: a Main Room designed as an homage to the classical and pastoral themes of the French Revolution, the "idyll of Rousseau"; an Intermediary Room of themes of Virtue, Terror, and Revolution; and a Dark Room, used in 1984 to store the stone reliefs conceived as war trophies.[13]

Finlay's garden includes rowans, ash, conifers, wild cherries, yellow elderberry, varieties of *cornus*, and ground plants such as geraniums, strawberries, *lamium, ajuga, alchemilla*, astilbes, *brunnera*, campanulas, hellebores,

hostas, *nepeta*, saxifrages, sedums, and thymes. Among his flowering plants
are lilies, lupins, irises, *astrantia*, foxgloves, verbenas, yellow water iris and
bulrush, soft rush, reeds and king cups, and water lilies.[14] Finlay uses cher-
ries as emblems of Rousseau, citing a famous passage in the philosopher's
autobiography,[15] and he uses birches, which are difficult to grow at the site,
as emblems of both extinction and discipline—Bring back the birch, reads
a stone inscription planted in a little grove of birches. But with these ex-
ceptions, the plants are not allegorical; they are, as Finlay explains, "what-
ever will grow." This philosophy of planting might be compared to a con-
structivist—or, more simply put, abstract—practice in painting, for plants
are chosen on the basis of their horizontal and vertical relation to the over-
all composition, for textural reasons that are not engaged with celebrating
the specificity of site. The plants are employed within patterns of shade and
light, conifer versus perennial, that Finlay associates with a geometry of time.
In the catalogue for a 1984 exhibit, Talismans and Signifiers at the Graeme
Murray Gallery in Edinburgh, he cites Proclus on Euclid: "We should also
accept what the followers of Apollonius say, that we have the idea of line
when we ask only for a measurement of length, as of a road or a wall. And
we can get a visual perception of line if we look at the middle division sep-
arating light from shaded areas, whether on the moon or on the earth." The
"site" of Little Sparta is the descent of Western culture from the classical
world. More specifically, the garden is built upon layers of allusion to the
history of gardens, from the Garden of the Hesperides to Blenheim, in jux-
taposition to the history of revolutions and war.

The garden is a product of mind.
Nature has no interest in the garden.

Underlying the landscape of Finlay's garden is the allusion to Arcady, the
domain of Pan, Apollo, fauns, nymphs, and dryads. Described by Polybius
in his *Historiae* as a "poor bare, rocky, chilly country," Arcady is gradually,
through the writings of Virgil, transfigured from this "bleak and chilly dis-
trict of Greece . . . into an imaginary realm of perfect bliss." [16] Apollo and
Pan rule over Little Sparta as the gods of law and play, as Apollo was the
tutelary god of the Spartan legislator-prince Lycurgus and the object of
worship of the mythical people of a Northern paradise, the Hyperbore-
ans.[17] When Finlay links the lyre of Apollo with a weapon, he is following
Heraclitus, who contended that "they do not apprehend how being at vari-

ance it agrees with itself: there is a connection working in both directions, as in the bow and the lyre." [18] Renato Poggioli explains in his book on pastoral that the qualities of Apollo and Pan are both separate and interwoven: "Apollo is a very human deity, and this explains why he is the patron of shepherds; far more so than Pan, who lives in Arcadia as a symbol rather than as a tutelar god. It is just for being a dreamland that Arcadia cannot be the land of myth. . . . When Arcadia ceases being pastoral, it turns into wild and reckless nature." [19] Virgil's model of the transformation of site through text, through inscription and reading, is an important prototype for Finlay's work at Little Sparta, but Finlay goes on to take up the Apollonian theme in its later manifestations as well: the tradition of Dürer as an Apollo who brought classical light to the North, of Saint-Just as the Apollo of the French Revolution, of Walter Pater's "Apollo in Picardy," [20] and, not least significantly, the contemporary Apollo missile. The inscription over the entrance to the Garden Temple reads, To Apollo, His Music, His Missiles, His Muses. Finlay's Apollo carries an oerlikon gun, the First World War weapon that in fact helped destroy Picardy.[21]

Edinburgh's eighteenth- and nineteenth-century efforts to style itself as the "Athens of the North" culminated in the plans made in the 1820s for a monument to commemorate the Scottish dead of the Napoleonic Wars. The National Monument on Calton Hill was designed to be a reproduction of the Parthenon. The citation to ancient Athens was intended to symbolize the victory of democracy over tyranny, but the monument was never finished and therefore, ironically, appears as a strangely recent ruin, its melancholy aspect gracing many prints and postcards as if it had been a place of worship for ancient Scots. Little Sparta—sited in a geographical relation to the Athens of the North as ancient Sparta was to ancient Athens—corrects the facile allegory of the National Monument by providing the prehistory of Napoleon's rise to power: the garden presses upon us a memory of the violence preceding, underlying, and resulting from the classical ideal.

In his concern with these themes Finlay has many predecessors, and the garden itself becomes a living repository of the history of gardens in their poetic and philosophical aspects. We might consider Hadrian's architectural reconstructions and models at his rural retreat outside Rome when we see Finlay's pyramid, grotto, bridges, pantheon, columns, temple, and model of the Abbé Laugier's hut. And Marvell had described in "Upon Appleton House" how Thomas Fairfax laid out his flower garden like a fortress that would recall his military career: "when retired here to Peace / His warlike Studies could not cease; / But laid these Gardens out in sport / In the just Figure of a Fort" (lines 283–86). Like Pope's "Twickenham,"

Little Sparta gives the poet "a place to stand." [22] Pope's "The First Satire of the Second Book of Horace Imitated," with its celebration of virtue and translation of martial into garden images, provides an additional gloss on Little Sparta: "And HE, whose lightning pierc'd th'Iberian Lines, / Now forms my Quincunx, and now ranks my Vines." [23] The garden's earthworks resemble battlements, yet Peterborough in retirement is seen as pursuing a purer, more virtuous form of action.

The themes of justice and virtue extend from classical literature to seventeenth-century meditation to the great English philosophy gardens of the eighteenth century that, in addition to Twickenham, have so influenced Little Sparta: Shenstone's The Leasowes, Stowe under Lord Cobham and William Kent, and Stourhead as it developed in the mid-eighteenth century. Significant also is the nearby garden of Sir John Clerk at Penicuik, constructed in the 1730s, an early Scottish instance of the use of poetic and historical allusion to shape a landscape. By contrasting a pastoral landscape with the dark, tortuous, and horrid entrance to a grotto, the Cave of Hurley, at Penicuik, Clerk purposely recalled the Cumaean Sibyl's cave near Naples, and by allusion suggested Aeneas's quest for a new country.

In scale Little Sparta follows William Shenstone's *ferme ornée*, The Leasowes. Shenstone ornamented his small grazing farm with views meant to copy the landscapes of Claude, Salvator Rosa, and Poussin. With his use of inscriptions and dedicated statuary, he juxtaposed his own era to the Gothic and classical past. He created a steep, wooded ascent to a Temple of Pan designed to be followed by a descent into Virgil's Grove and a seat dedicated to the memory of James Thomson.[24] Following Shenstone's "Unconnected Thoughts on Gardening," Finlay has put together a series of "Unconnected Sentences on Gardening," "More Detached Sentences on Gardening in the Manner of Shenstone," and several other series of detached sentences on pebbles, stiles, and friendship.[25] Among Finlay's garden aphorisms are "A garden is not an object but a process" and "Certain gardens are described as retreats when they are really attacks."

As the garden at Stourhead in Wiltshire developed over thirty years in the middle of the eighteenth century (circa 1740–70), the River Stour was used to form a series of ponds, including eventually a large lake designed to be seen from a high prospect. Around the lake was placed a sequence of buildings, including a Temple of Flora, a grotto with a circular domed chamber that included springs channeled to cascade beneath a Sleeping Nymph, and a River God's cave that included a copy of the figure of Tiber in Rosa's painting *The Dream of Aeneas*. Inscriptions at the grotto entrance and on the Temple of Flora refer to the *Aeneid*. Other buildings include a

Pantheon built in 1754—a domed rotunda with a recessed portico within which John Michael Rysbrack's *Hercules* is placed, a five-arched bridge, and a Temple of Apollo built in 1765. Henry Hoare's original intention at Stourhead was to honor the source of the river (Stour) in the pagan manner. Pliny the Younger had described such a situation at the River Clitumnus in Umbria, which Hoare may have visited in his travels.[26] One of Finlay's early inscribed works for the garden is a large stone reading HIC JACET PARVULUM QUODDAM EX AQUA LONGIORE EXCERPTUM [This little pool is excerpted from the longer water]. Finlay's inscription marks the consequence of the flow of time rather than its origins. The idea of the pond as "excerpt" links it to the aphoristic and fragmented quality of the garden's "parts," and adds to the elegaic quality of the garden as a whole.

Another important influence upon Little Sparta is the seventeenth-century garden at Stowe in Buckinghamshire, revised by Richard Temple, Lord Cobham (1675–1749) after his alienation from the court of George II and opposition to Walpole resulted in his dismissal from the army.[27] Cobham, with his architect Sir John Vanbrugh, decorated the garden with temples and other architectural furniture, making a pun on the family motto *Templa quam dilecta* [What pretty temples!]. With consequent help from William Kent, Capability Brown, and others, Cobham laid out a little valley called the Elysian Fields, which includes a Temple of Ancient Virtue and a "Grecian valley." The Temple of Ancient Virtue contains four niches with full-length statues of Lycurgus, Socrates, Homer, and Epaminondas, each inscribed with a Latin motto praising its subject's achievements. This temple is contrasted to The Temple of British Worthies, containing busts of sixteen British luminaries. The effect, as John Dixon Hunt has noted, following William Gilpin's contemporary description, is to juxtapose a handsome classical building, representing the antique, with a deliberately ruined structure containing truncated or abbreviated forms, representing the modern.[28]

These philosophy gardens are replete with literary allusions and devices of memory. They are private spaces addressing a public audience; each is designed to lead the visitor through prospects and commentaries as surely as a well-crafted speech uses rhetoric to conduct the listener to right opinions. If the contrast between ancient and contemporary virtue at Stowe borders on the ironic, it nevertheless proposes clear models of conduct. Little Sparta borrows the philosophy garden's techniques of allusion and rhetoric, but it presents a more complex and dialectical picture of reference, questioning assumptions of historical knowledge as a model for virtuous action as it asserts the necessity of historical knowledge as a model for virtuous action.

Nature, as the manifestation of a contingent will
that cannot be known to us, is a source of terror.

If we return to *OSSO*, the work that prompted the campaign for the revo-
cation of Finlay's Versailles commission, we find a stark exploration of this
very point. *Osso*, the Italian word for "bone," out of the Latin *os*, is here in-
scribed on stone fragments emphasizing the palindromic aspect of the word.
The central *S*'s are written in a calligraphy that reproduces the lightning
symbol of the Waffen SS—the Nazi Sturm Abteilung, or storm troopers.
Finlay constructs an allegory in which the long *S*'s of the eighteenth century,
a symbol of civilized script, are transformed into the runic double-lightning
stroke of SS uniforms and banners as culture devolves into barbarism.[29] He
traces the lightning symbol from the pre-Socratics to eighteenth-century
law to twentieth-century terror: fire in the philosophy of Heraclitus is the
"thunderbolt" steering all things and associated with the possibility of hu-
man wisdom; the French word for lightning, *éclair*, is part of the etymology
of Enlightenment; and the Nazi symbolism of lightning evokes the link be-
tween Nazi ideology and German and French Romanticism. Yet, given the
dialectical impulse of his thought, Finlay's allegory reminds us of the syn-
onymity of law and terror in the absence of moral reason.

We find here of course a continuation of the simultaneous promotion
and critique of Enlightenment undertaken by the Frankfurt School. In Fin-
lay's 1989 work with Keith Brookwell and Andrew Townsend, *Adorno's
Hut*, a direct allusion is made to this philosophy and its exposition of the
terrible consequences of technological thought. But Finlay is drawing on a
related iconographical genealogy of lightning as well: lightning appears
throughout the history of Western art and literature as a kind of literal em-
blem of the eruption of contingency—nature and death—against which
human culture is motivated to protect and create itself. Using the calligra-
phy of the SS/lightning image in *OSSO*, as he had used other symbols from
World War II throughout his garden, required a viewer to forego visual
identification in order to begin a dialectical process of retrospection that
would link the development of Nazi symbolism to these strains of Roman-
ticism and to Vico's thought before that.

The relation between lightning and the bones of death may seem fairly
obvious, but Finlay was, I believe, naïve in thinking that his audience, at any
level of historical knowledge, would be able to engage in a form of dialec-
tical retrospection about this connection, let alone be able to link the sym-
bolism to the rest of his work. Yet to ban, as Millet suggested, the use of
such symbols altogether in the context of art would be to suppress them in

such a way that they would be bound to reappear in contexts of forgetting, nostalgia, and illicitness and hence become once again manifestations of a fascist aesthetic.

In the iconography of the French Revolution, the symbol of the law is often the round-headed tablet, and by the time of the Terror, the law is associated with the biblical notion of law as retributive. The guillotine as the "ax of the law" with its diagonal blade comes to be associated with the swiftness of lightning, and a number of revolutionary prints employ lightning imagery. A print by Louis-Jean Allais commemorating the Constitution of 1793 displays a caption that says, "The republican constitution, like the tablets of Moses, comes from the heart of the mountain in the midst of thunder and lightning." A color print by Pierre-Michel Alix shows "a pair of fiery tablets sending down bolts of lightning against the enemies of the Revolution while members of a patriotic crowd dance around a liberty tree." [30]

Aeneas and Dido first consummate their love in a cave as they flee a thunderstorm, an event Finlay commemorates in his Grotto of Aeneas and Dido, with its AD monogram rhyming Dürer's signature at the Temple pond. In the most popular poem in English of the eighteenth century, Thomson's "The Seasons," the spectacular account of a thunderstorm in "Summer" describes "th'unconquerable" lightning that shatters trees and "blasts" cattle as they stand in the open fields. Here we find the "blasted tree" that Wordsworth will use in the Immortality ode to symbolize the Terror's destruction of the liberty tree, and the ancient oak ruined by lightning that serves as a central symbol of doomed technology in Mary Shelley's *Frankenstein*.[31] Thomson's account of the storm builds to the story of the happy lovers Celadon and Amelia caught in its violence. Just as Celadon assures Amelia that "'Tis safety to be near thee sure," Amelia is struck, "a blacken'd corpse" to the ground.[32] The bone turned to ash, the figure turned to stone are found as well in Poussin's *Landscape with Pyramus and Thisbe*, with its prone body of Pyramus, his arms outstretched in death. Here shepherds and herd pursue a line of flight paralleling the bolt of lightning still evident in the sky.[33] And in J. M. W. Turner's well-known painting of Stonehenge in a storm, we witness the devastation of a shepherd and his flock by lightning on Salisbury Plain.

In his use of these allusions, Finlay draws a continuous and cumulative relation between the terror of primitive man in the presence of nature, the terror of the Greeks and Romans in the presence of their gods, the terror of the French Republic in the presence of a self-inflicted violence, and the terror of the victims of the Nazi regime in the presence of its machinery of death. Walter Benjamin's important aphorism on the mutuality of civiliza-

tion and barbarism provides a gloss on this genealogy, as does Vico's cyclical theory of history. Finlay is a master of the serious pun: when he links the regime of the demonic Pan with the German panzer tank, we are meant to remember both terms at once and to consider the historical course of the implication.

The imitation of nature is an attempt to master terror.
Art and war are imitations of nature: the first an imitation
of nature's making; the second an imitation of nature's destruction.

The related defensive methods of containment and reversibility are central to many of the modes of Finlay's art. Finlay's garden is imagined as a kind of island of history in a vast sea of contemporary life and as itself a sea within which objects appear to a viewer on a horizon alternately near and distant. One is constantly aware of the relation between placement, position, and movement. What is rooted is also growing; what is in motion is seen from a position that is itself in motion; what is inscribed will be re-ordered; what is unintelligible will become increasingly clear.

If we trace this iconography, we find it has myriad dimensions. First, Finlay has used, since his early days as a concrete poet, imagery of the inland garden as a sea. A model of the atomic submarine USS *Nautilus* emerges from a stand of firs as if from the ocean. At the edge of the garden a solitary ash tree is inscribed with the name Mare Nostrum, the Roman tag for the Mediterranean, in order to emphasize the sound of wind in the tree in its echo of the sound of wind on the sea.[34] The front garden includes a sequence of diamond-shaped paving stones, each inscribed with the names of kinds and parts of boats, such as brig, keel, schooner, and ketch. In *Silver Cloud*, an homage to sailing ships is inscribed in a marble monument on an island Finlay made in the Top Pond in 1973. The garden as a representation of the sea is not merely a theme, however; this representation takes the most sublime, the most violent and unencompassable, of nature's phenomena and contains it within a knowable boundary. Unlike a painting of the sea, the garden/sea is in motion and is an image of nature made by nature. As Finlay uses the mirror effects of clouds and inscriptions viewed by means of their reflections in water,[35] containment and reversibility are devices of multiplication and difficulty as well as comprehension. And by extension, the garden encompassing an image of the sea is analogous to the garden encompassing an image of war—for war as the harnessing and unleashing of

nature's forces is the only activity within human scale comparable to the dimensions of the sea's power.

After 1971, the contemporary warship began to replace the small boat in Finlay's iconography. Parallel to Finlay's imagery of the sea and World War II is a set of associations he makes with the Field of Mars. These link the Roman Campus Martius and the French Champs de Mars as scenes of festivity and violence. Finlay has placed a *Hypothetical Gateway to an Academy of Mars* at the entrance to the upper area of the garden. The gateway consists of piers topped with grenadelike capitals. The notion of the Field of Mars reminds us that once the Bastille was razed, a field of nature was created in its place.[36] After the "Massacre of the Champs de Mars" of 1791, when a Republican demonstration was broken up,[37] pastoral revolutionary festivals were held there. Parades were held in which "animals of warfare were excluded, with only peaceful cows and doves permitted." As Ronald Paulson has pointed out in his study of revolutionary imagery, "in the depths of the Terror the dream was held by Girondin and Jacobin alike of a peaceful island in the midst of the stormy sea, and the festivals represented places for refreshment and rest in the navigations of life."[38] Finlay has continued this iconography in his references to Rousseau's original burial place, surrounded by poplars, on the "Ile des peupliers" at Ermenonville.[39] Close to the bank of the garden's Lochan Eck, he has made a small island with a stone memorial to Rousseau, and he would have emphasized this connection with an homage to Rousseau in plantings of poplars and cherries in the Versailles project.

The sudden terror of lightning spurred, according to Vico, the creation of metaphors of explanation and so the beginning of cultural work on the part of early forest dwellers. In Little Sparta, the answer or response to terror is the creation of shelters—the grotto, cave, or hut that is the site of creative rebirth: the cave where Aeneas receives advice from the Cumaean Sibyl, the grotto where Aeneas and Dido hide from the storm, and the hut where society begins to take form. Following Vitruvius and Rousseau in constructing a genealogy of dwellings, Abbé Laugier wrote that men were driven from caves and compelled to make dwellings because of their need for sight: "man wishes to make himself a dwelling that covers him without burying him."[40] The amalgam of buildings and spaces at Little Sparta reminds us of this cycle of architectural history: early man, frightened by tempests, seeks shelter in the forest; when the forest does not offer adequate protection, he retreats to the cave; when the cave proves dark and unhealthy, he builds a roofed structure; when this structure proves vulnerable to the elements, he builds a hut within which the family and, eventually, ex-

tended social relations develop; as society takes shape, buildings become institutional and monumental. Gradually, structures to differentiate and contain social elements are created; these institutional structures become imprisoning—created under the implied threat of force, they themselves evoke violence in response. They are torn down, as in the case of the Bastille; the garden on the site of the destroyed prison becomes a return to nature, but one now deeply inflected by human history.[41]

Containment and reversibility are also implicit in Finlay's use of anagrams, puns, and rhymes. Here alternatives to a given form of order are concealed within the order itself; this Hegelian idea shows that the outcome of reading or interpretation will be both preservation and cancellation. Perhaps nowhere is this point made more vividly than in Finlay's monumental stone inscription made with Nicholas Sloan of the words of Saint-Just: "The present order is the disorder of the future." The words, including the name of Saint-Just, are inscribed individually on stones, each weighing approximately a ton. Anagrams reveal a concealed interpretation. Puns and rhymes show semantic and aural simultaneity in both conflict and harmony. Finlay's inscription "curfew/curlew" on a sea boulder placed in the moorland by the upper pond links the bird's evening song with the transformation of light at day's end.[42] A shell inscribed "goddess" and "caddis" hides a hose that animates the water at Temple Pond. The shell commemorates both the birth of Aphrodite and the shell of the larva of the caddis fly who lives in the pond. The caddis shell is composed of tiny pieces of stone and grit and seems to glisten like gold in the water.[43] Carp within and models of submarines around the Temple Pool remind the viewer that both are bottom feeders. The drum of the martyred boy revolutionary Joseph Barra, commemorated by David, reappears in allusions to neoclassical column drums. The shell of a tortoise is visually and verbally linked to the helmet of the German panzer, in turn linking Pan to both pansy and *pensée*. The French Revolutionary calendar month Arrosoir reappears as a literal watering can and as the flight of Apollo's arrow at evening.

The genres of the pastoral, the eclogue and idyll, are created as well through articulating a boundary and reordering time. Poggioli explains that Virgil's *Eclogues* are "excerpts, in the original sense," and Theocritus's *Idylls* are "little pictures." The idyll is *eidos*'s diminutive.[44] The diminutive appears constantly as a rhetorical form in Finlay's work. His correspondence, his drawings, and his writings make frequent use of the Scottish adjective *wee*, for example, and he makes extensive use of models and toys. One of his earliest exhibitions was a display of toys, and he has often made models of World War II airplanes and ships from the stock available at

Woolworth's.[45] When we play at war, war counts in a different way; the boundary between the game and the world is absolute. But as time passes we might recreate, in order to contain, what was once real, and in the future the reapplication of the game may turn serious: what seemed to be only a game might turn out to be a form of practice, as it is when real armies play war games.[46] Temporality and an exaggeration of scale can create transformations both desired and unwanted. By an ongoing practice of modeling war, Finlay constantly reminds us of the permeability of event and memory.

> Garden-making, an activity of art and war, is a kind of work.
> Yet because such work is not subsumed by utility,
> it is as well a transformative process of play.
> The work of the garden is the cultural work of the trope.

The Temple of British Worthies at Stowe divides its venerable figures into those who followed a life of contemplation, who "sought Virtue in her Retirement"; and those who followed a life of action, "who left Retirement to the cool Philosopher, entered into the Bustle of Mankind and pursued Virtue in the dazzling Light in which she appears to Patriots and Heroes. Inspired by every generous Sentiment, these gallant Spirits founded Constitutions, stemmed the Torrent of Corruption, battled for the State, ventured their Lives in the Defence of their Country, and gloriously bled in the Cause of Liberty."[47] This separation between the active and contemplative life that formed such an important part of Renaissance, baroque, and Enlightenment aesthetics finds its resolution in the garden form. The garden as retirement from the field of war proposes contemplation as both the consequence of action and as the prerequisite of virtuous action in the public realm. And the experience of the garden visitor, who must traverse the "work," both moving and thinking at the same time, recapitulates this dialectic. Contemplative gardens have a theatrical aspect, requiring the viewer to see them as an intended *scene*, yet this aspect as well is characterized by the scene as site of future action. The viewer is asked to both reflect upon and project human action.[48]

Finlay's Little Sparta specifically evokes the relation between contemplation and action by placing inscriptions within scenes of organic transformation. Gavin Keeney insightfully has described this tension in Finlay's proposal for the Versailles project as "the vegetative veil of sorts covering and softening the 'gravitas' of the more assertive (emphatic) mineral forms."[49]

The garden uses *grotesque* in its original sense deriving from *grotto*. As Paulson has described the use of the grotesque in the imagery of the French Revolution: "[the grotesque] was a perfect revolutionary paradigm in that, based on the decorative patterns of metamorphosing plant and human forms, it showed either the human emerging triumphantly from nature or the human subsiding or regressing into nature—or ambiguously doing both. Similar transitions or sequences involve the movement from dark to light, but as the grotesque is all in all the dominant aesthetic mode of the period the movement tends to be cyclic and repetitive, toward undifferentiation." [50] Yet the grotesque as mutation is the counterpart of the inscribed stasis of the law. As the organic moves toward lack of differentiation, the mineral inscription moves toward clarity and universality.

Finlay's inscriptions are for the most part in English, with some use of Latin, German, and French. Although over his career many forms of calligraphy have been used, the recent work emphasizes Roman lettering style, recalling not just eighteenth-century classicism but a particular static quality in the Latin style itself. He draws on this tradition of nature-inscription descended from the votive or commemorative epigram. It is a tradition long linked to burial inscription, but by the eighteenth century the graveyard is as well a major scene of nature sentiment, and Nature is herself a kind of graveyard [51]—aphorisms stemming from pastoral themes such as those of Gray's *Elegy*, the flowering of archaeology, and a new awareness of the transitory fortunes of civilizations.

The inscription is fixed; one must go to it and one must leave it. It speaks with the authority of the universal, the aphoristic, or the genius of place and not with the particularity of subjective voice. When Finlay quotes a particular source, as in the allusions to Saint-Just, it is the ideology of Saint-Just that bears his name, not his person: Saint-Just, who proclaimed, "La nature est le point de justesse et de verité dans les rapports des choses, ou leur moralité" and "La nature finit où la convention commence," [52] is for Finlay, as he was for his contemporaries, the embodiment of Apollo. Finlay's statuary images of the revolutionary cite with heavy irony the romanticized picture presented by the British fascist Nesta Webster's notoriously xenophobic and anti-Semitic narrative, *The French Revolution: A Study in Democracy*: "St. Just [sic] alone retained his habitual calm. The voluminous cravat was gone, leaving his neck bare for execution, but the delicate chamois-coloured coat still remained unspotted, the wide expanse of white waistcoat still fresh and uncrumpled, whilst in his buttonhole there glowed a red carnation. So with head erect St. Just, that strange enigma of the Terror, passed to his death, a marble statue to the last." [53] By citing Webster, a

so-called enthusiast of "democracy" who also promoted a form of paranoia throughout the 1920s, Finlay undermines any idealization of the Apollonian. And Finlay recounts how Saint-Just himself embodies as well the Terror's paradoxical adaptation of Rousseau. Saint-Just's Virgilian motto *Une charrue, un champ, une chaumière . . . voilà le bonheur* envisages a pastoral Republic, yet one where every dimension of life is under state control. The brutal contradictions inherent in the name Saint-Just, in the ideas attached to Saint-Just, in the images under which the figure is made visible, invite his words as laws to be reviewed and not simply absorbed.

This hermeneutic of suspicion, rooted in Enlightenment rationality, is here applied *to* Enlightenment rationality. In order to create such a hermeneutic Finlay has reached back to the didactic, yet unresolvable form of the emblem.[54] For example, he has constructed several emblematic works based on the Battle of the Midway of June 1942. In a 1977 exhibition on the subject, fruit trees were meant to represent the Pacific, and seven Renaissance-style beehives represented aircraft carriers as an "actual emblem." In the historical Battle of the Midway, the fleets never saw each other. The fighting was done by Japanese carrier-based flights and American land- and carrier-based flights. The American ships, the *Hornet*, the *Enterprise*, and the *Yorktown*, are contrasted with the Japanese carriers, *Akagi, Kaga, Soryu*, and *Hiryu*. Finlay envisaged honey spilling out of the hive doors as representing the spilling gasoline—just as smoke drives bees from the hive, so do the ships in flames send out their planes. The history of emblems has displayed the bee as a symbol of industriousness and enterprise; the hornet is a warrior bee, but industriousness here also plays on the linking of industry, technology, and the horror of war.

These connections are already complex, but further meanings can be read in Finlay's Midway emblem. The *Midway Inscription*, a large slate medallion made with Michael Harvey at Little Sparta, reads, Through A Dark Wood / Midway. Finlay thereby links the Battle of the Midway to the famous "middle" theme of the opening of Dante's *Divine Comedy*, where midway in life the poet finds himself in a dark wood with Virgil as his guide. The Horatian imperative of "in medias res" also holds: a dialectical art would have to begin in the middle. But further, the *Enterprise*'s nickname, the "Big E," comes into full play as well. Plutarch's *Moralia* contains in its fifth volume a discussion of "The E at Delphi." Among the inscriptions at Delphi there was a representation of the fifth letter of the Greek alphabet, epsilon (E), which in its written form denotes the number five and is also both the word for "if" and the word for the second person singular of the verb "to be": "Thou art." Plutarch explores the meaning of these three ref-

erents (*five, if,* and *thou art*) and concludes that the letter became associ-
ated with the rites of Apollo at Delphi: one approached the god, using "if"
to ask what might happen and, at the same time, addressing the god in
terms of the certainty of his being: "thou art." He traces the number five to
Pythagorean symbolism: "Five is a 'Marriage' on the ground that it was
produced by the association of the first male number and the first female
number [and] there is also a sense in which it has been called 'Nature,' since
by being multiplied into itself it ends in itself again." As the E compels the
pilgrim to Delphi to address Apollo "Thou art," so does another inscrip-
tion compel the god to welcome the pilgrim with the message "Know Thy-
self." Plutarch wrote that "everything of a mortal nature is at some stage
between coming into existence and passing away and presents only a dim
and uncertain semblance and appearance of itself,"[55] continuing, "And if
Nature, when it is measured, is subject to the same processes as is the agent
that measures it, then there is nothing in Nature that has permanence or
even existence, but all things are in the process of creation or destruction
according to their relative distribution with respect to time."[56] We of course
by now remember that IF is the monogram as well of Ian Finlay.

Against the fixity of the inscription and the material stasis of the emblem
form is the play and transformation of interpretation—the work of the
trope. The trope is celebrated in Finlay's ongoing homage to Ovid, whom
he calls the poet of camouflage. In a 1989 letter to Mary Ann Caws, Finlay
wrote, "Dryads are traditionally represented in terms of metamorphosis,
leaves for fingers, skin turning into tree-bark and so on. For our time (age)
it seems preferable to dress the dryad in a camouflage smock." Finlay
sought to critique the contemporary picture of a benevolent nature with a
view of "nature as something formidable." He quotes Heraclitus: "Nature
loves to hide," an aphorism implying the strategy of concealment, surprise,
and mutability implicit in all his garden works.[57] The garden's most promi-
nent citation to Ovid is the Temple of Philemon and Baucis. Philemon and
Baucis in their old age are rewarded by the gods, who change their small
hut into a temple—marble columns take the place of wooden supports, the
thatch yellows into gold. In Ovid's version of their story, "It is not only their
hospitality but the very purity of their souls that earns for Philemon and
Baucis the grace of the gods. Jupiter and Mercury will grant them their
wish, which is to die at the same time, and will change them into two trees,
with mutually supporting trunks and interwoven branches."[58] The two be-
come one and the one is two, preserved and cancelled by the miracle of si-
multaneity. Nature transformed into culture, culture transformed into na-
ture: this is the Ovidian dialectic, the imaginative reworking of history.

Yet it is typical of Finlay's exhaustive relation to cultural allusion that he does not stop with this version of the story. In part 2 of Goethe's *Faust*, the story is rewritten out of Ovid and eerily resembles the brutality of the Nazi regime: Philemon and Baucis refuse to exchange their poor plot for the rich farm that Faust offers. He wants to remove the old couple from the marsh-land he plans to reclaim for his own sake as well as for what he purports to be the benefit of the human race. When Faust's henchmen try to evict them forcibly, Philemon and Baucis die together in the blaze of their hut, victims of Faust's will to power.[59]

Death Is a Reaper, a folding card Finlay made in 1991 with Gary Hincks, presents images of a scythe with a blade that progressively turns into the Nazi lightning bolt. These images are placed next to a quotation from Abraham a Santa Clara:

> I have seen that Death is a Reaper, who cuts down with his scythe not only the lowly clover, but also the grass that grows tall; I have seen that Death is a Gardener, who does away with the climbing larkspur as well as the violets that creep along the earth; I have seen that Death is a Player, and indeed a naughty one, for he knocks down the skittles and does not set them up again, and he takes the king as well as the pawns; I have seen that Death is a thunderbolt that strikes not only with the tumble-down straw huts, but also the splendid houses of monarchs.[60]

If the Ovidian story changes the pastoral hut into the golden temple and so narrates an account of virtue rewarded, it is contrasted in Finlay's work to Sébastien Chamfort's revolutionary pronouncement of 1789: "guerre aux châteaux, paix aux chaumières!"[61] Wherever there is resolution into law, there is also the seed of the corruption of the law; wherever there is peace, there will inevitably be war, as Heraclitus had claimed in his aphorism "war is father of all and king of all."[62]

Work and death are the objects of memory.

In following Poussin, Finlay practices a particular method of historical reference. As he painted Arcadia, Poussin followed the Roman tradition of Arcadia as an immemorial past, a kind of spiritual landscape derived from ideals rather than any historical antecedents. Yet he emphasized that such scenes are temporally distant.[63] Finlay's most extensive quotation from

Poussin has been his many reworkings of *Et in Arcadia Ego*—Poussin's two
paintings on Arcadia and mortality. These compositions have an important
antecedent in Guercino's two works on the same theme. In Guercino's
paintings, two Arcadian shepherds are halted in their wanderings by the
sight of a human skull on a moldering piece of masonry, accompanied by a
fly and a mouse, popular symbols of mortality. One of the Poussin paint-
ings is in the Devonshire collection at Chatsworth, the other in the Louvre.
Panofsky's famous essay on the paintings, *"Et in Arcadia Ego*: Poussin and
the Elegiac Tradition," explores the tension between two interpretations of
the Latin phrase: "I, too, lived in Arcady," and "I [Death] am as well in Ar-
cady." Panofsky contends that the latter translation, more accurately con-
forming to Latin syntax and made famous by an ad hoc interpretation pro-
vided by George III of a painting with the same inscription by Joshua
Reynolds, was originally what Guercino and Poussin, in his early work, had
in mind. Yet by the time of the meditative classicism of the Louvre version,
Poussin was thinking of the more particular meaning, "the person buried in
this tomb has lived in Arcady," so that "what had been a menace has be-
come a remembrance." [64] Finlay appropriates the images of the shepherds
reading the inscription, but through a series of substitutions and permuta-
tions arrives at a German tank in the place of the tomb, thus placing a men-
ace that is also a remembrance into Arcady.

Finlay plays on Marvell's "mower" as well as the folk theme of "the grim
reaper" in his concrete poem, "Mower is less." The allusion is to the ax of
Robespierre, the guillotine, but it also refers to the theme of lightning, and
the depiction of Cromwell in Marvell's "Horatian Ode": "like the three
fork'd Lightning, first / Breaking the Clouds where it was nurst, / Did thor-
ough his own Side / His fiery way divide" (lines 13–16). As Geoffrey Hart-
man has explained, "a 'bleeding Head' is once again and ironically the pre-
requisite for the body politic's wholeness. . . . The new order is forced to
unify by the sword, by division, by a rape of time." [65] Apollo as musician
sends forth his messages of music; as "far-shooting archer," his messages of
death.[66]

Virtue and justice are the objects of making.

Military metaphors and the rhetoric of moral philosophy, from Laurence
Sterne's Uncle Toby to Samuel Johnson's Stourbridge school poem, "Festina
Lente," were inseparable in the eighteenth century,[67] and Finlay has evoked

in the neo-neoclassicism of Little Sparta many of the connections between
military metaphors and ethics. Among his garden inscriptions, he includes
a 1977 stone plant trough inscribed Semper Festina Lente[68] and accompa-
nied by a relief of a minesweeper. The same warning is translated into Ger-
man, "Achtung Minen," in Finlay's *New Arcadian Dictionary*.[69] Yet the
yoking of a militaristic ethical rhetoric to imagery of the garden has an even
older genealogy. The golden apples of the Hesperides were the ornament
and reward of Hercules' virtue, a virtue made evident not by Hercules's na-
ture but by his actions—his choice of the right path. The Norman invasion
of Sicily produced the tradition of rewarding French kings with orange cut-
tings, the "storied reward of Herculean might." [70] In the sixteenth century,
the Villa D'Este used the story of Hercules' choice at the crossroads to
structure the paths and fountains in their dedication to "honest pleasure,"
and Cosimo de'Medici's Castello showed Hercules subduing Antaeus in an
enclosed garden bounded by the four seasons and lined with emblems of the
virtues of the Medici.[71] Finlay inadvertently, and then markedly, made an
allusion to the Villa D'Este when he inscribed on the bases of stone repre-
sentations of aircraft carriers at Stonypath, Homage to the Villa d'Este.
Later, he learned of the avenue of stone ships at the villa and came to con-
sider this coincidence evidence of the classical tradition as an enduring, if
not always conscious, experience.[72]

Sir Thomas Browne's 1658 treatise, *The Garden of Cyrus, or, the quin-
cuncial lozenge, or network of plantations of the ancients, artificially, nat-
urally, mystically considered*, is another key text for understanding Little
Sparta.[73] Browne, who admits in his opening paragraphs that he is not a
gardener, traces the importance of order in the gardener's art. "Disposing
his trees like his armies in regular ordination," the Persian king Cyrus came
to be known as "the splendid and regular planter" (141). Browne links the
quincuncial form of Cyrus's planting to the Greek letter X, to the anointing
of Hebrew priests in the form of an X, and to the crosses and crucifixion of
Christian iconology (142–43). Although unmentioned, the relation to Her-
cules at the crossroads also emerges.[74] Browne does mention that Aristotle
uses a singular expression concerning the order of vines, delivered by a mil-
itary term representing the orders of soldiers, and that the Roman battalia,
too, was ordered by means of an alternating form of groups of five and four
soldiers horizontally arranged. He concludes with a discussion of the ap-
pearance of quincuncial forms in nature and with "the ancient conceit of
five, surnamed the number of justice, as justly dividing between the digits,
and hanging in the centre of nine described by square numeration . . . [in]
that common game among us wherein the fifth place is sovereign and car-

rieth the chief intention—the ancients wisely instructing youth, even in their recreations, unto virtue, that is early to drive at the middle point and central seat of justice" (183–84). Browne emphasizes only the order, or what might be called the poetic justice, of the analogy between the garden and war. A relentless structuralist, he sees the quincunx wherever he looks and, like the pre-Socratics, finds nature yoked to laws like those that bind human nature. But the purer and more abstract the rule of law, the more insistently does the particular make itself apparent; what has been unified begins to split. The trope falls back into its elements; the materiality of history asserts itself against the periodicity of history.

He who makes a garden, his own remembering makes.

Finlay's three occupations—soldier, shepherd, and poet—are suggested by the forms of knowledge Little Sparta proposes. Although he finds little value in biographical and autobiographical interpretation, Finlay has written of the particular relation between Little Sparta and World War II. He records that "In wartime the British were encouraged to grow their own food (DIG FOR VICTORY), and the phrase Wartime Garden was almost certainly used to denote the purposes the garden might then serve. My work, then, treats the garden, *not* as an idyll or pastoral, but as a kind of model for the Heraclitean or Hegelian understanding . . . in the same way . . . I have treated the French Revolution as a pastoral or idyll: 'The French Revolution is a pastoral whose Virgil was Rousseau.' "[75] At Little Sparta the family clothesline is called the "Siegfried line," in memory of the British song from World War II: "We're going to hang out our washing on the Siegfried Line / have you any dirty washing, mother dear?"

In a garden of sublime, yet sinister images, the *Nuclear Sail*—a stone monument designed to look like a nuclear conning tower protruding by Little Sparta's Lochan Eck, the large pond named for one of Finlay's children—starkly calls to mind the horrific potential of instruments of war, not simply their past. The U.S. *Polaris* submarine base is at Holy Loch, Scotland, on the other side of Glasgow,[76] and Finlay's garden is in a strategic part of the country frequently crossed by Royal Air Force Phantom jets on maneuvers.[77] In deflating the naive and ultimately narcissistic optimism of evolutionary thought, Finlay asks us to consider the moral framework and potential consequences of any historical idea. In tracing the tension between order and disorder through the pre-Socratics to Nietzsche and Hegel,

he has presented a relentlessly dialectical context for thinking about the relations between human culture and nature. Finlay's garden as a paradise of philosophy constantly reminds us of the agon between forms of thought, the simplemindedness of monumentality, and the fragile boundary between art and war. Little Sparta is a work, both made and evolving, that explores the dangers of facile apprehension and ready enthusiasm. The garden refuses to allow the viewer to identify naively with its individual themes and symbols. Finlay argues that when individuals pursue an unthinking identification with power and sentimental ideals, terror and catastrophe ensue.

In 1995–96, a further conflict with the Strathclyde regional government compelled Finlay to close the garden once again. More recently, the regional government itself was dissolved by the state.

CHAPTER 11

AN AFTER AS BEFORE

"Who doesn't like both locks and keys?" asks Gaston Bachelard in his essay on "drawers, chests and wardrobes" in *The Poetics of Space*.[1] Something hidden away might become something to be opened; something invisible might become something to be touched; something entombed might be brought to life. It is the relation to the past that creates the possibility of anticipation; the present is merely a hinge between these worlds of memory and desire. The work in *Deep Storage* exists in the aura of the "after," an after that in turn lies in wait of an appearance. Such work does not carry on the ready enthusiasm of either the sublime or the avant-garde. Rather, these works offer spaces that are at once open and closed: open in the sense that the processes and conditions preceding, and consequent to, the artwork are taken up for consideration; closed in the sense that the mind apprehends them by delimiting a space and time, organizing and structuring materials assembled for thought. The after thereby attends to the prior— the priority of causes and occasions, intentions and history, including the history of their own making.

The work of the archive is the work of remembering, sifting, evaluating, shepherding, restoring. Here the *vita contemplativa* turns away from the *vita activa*. But what contemplation loses in action, it gains in understanding. Such work renews a hermeneutic project that finds its modernist analogue in the poetic, or language-based, practices of Marcel Duchamp, but which, like the work of Duchamp more generally, stems from an older tradition of *vanitas* and *curiositatem* in the Western tradition. In making his *Boîtes-en-valise*, a suitcase filled with miniature versions of his work, Duchamp projects an image of himself into the future; he attempts to out-

wit history, and yet in doing so he both summons the specter of his own death and disappearance and assumes the response of an enduring public—an audience who will take up his work in his absence. The *Boîtes-en-valise* is a time capsule that anticipates an intelligibility that might be more realistically viewed as a projection.

The *studioli*, curiosity cabinets, and *wunderkammern* of the fifteenth to seventeenth centuries compelled a cognitive activity akin to wandering. Indeed, the word *curious* traveled in meaning throughout the Renaissance, designating at times an attribute of persons and at times an attribute of objects. Between Federico da Montefeltro's mid-fifteenth-century *studioli* at Urbino and Gubbio and John Bargrave's seventeenth-century collections at Canterbury, a world of meditative emblems turns into a world of meaningful things attached to the particular history of the collector.[2] Each intarsia of the Montefeltro *studioli* takes part in a complex allegory of humanist thought. In these most private spaces, objects, inscriptions, the passage of light, paintings, panels, effects of *trompe l'oeil* and anamorphosis all lead the viewer toward a harmonic whole that can only be achieved through the proper progress of a series of acts of interpretation in time. As Mary Carruthers has written of the medieval memory practices out of which such cabinets grew, "the Latin word *res* is not confined to objects of our senses but includes notions, opinions, and feelings—that is, a view based on the principle of decorum" or the proper arrangement and composition of objects of thought and memory.[3] The considered and fully planned allegory of the *studiolo* is therefore quite different from the hermeneutic of the curiosity cabinet as it was later to develop as a collection of odd, unique, or strange objects taken up with a half-theological and half-scientific attitude by the viewer. If Montefeltro worked by analogue and aphorism, Bargrave and other collectors worked by association and accrual.

The arrangement of Bargrave's collection depended on a logic of display, rather than meditation. Stephen Bann has described how Bargrave collected small objects and fragments on trips to Italy, France, and Europe; bits of Roman ruins, antique statuettes, the mummified "finger of a Frenchman," and heart-shaped stones. He organized these fragments in a display cabinet engraved with the neologism *Bargraveana*, which unified these souvenirs of experience under his own proper name.[4] Who was the audience for this neologism, for surely if the collection were merely for private consumption, there would be no need for a label at all? Visitors were invited to come in to observe the cabinets, and so the cabinets themselves became a kind of shrine to complement Canterbury's other sacred objects. Here we find the origins of the museum as a place of galleries and corridors, designed for am-

bulatory viewing—a place of mixing where study, amazement, and aesthetic pleasure are experienced by visitors of various backgrounds and interests; a place where objects might be found, in a curiosity collection, because of their rarity or, in a study collection, because of their typicality.

In the development from the *studiolo* to the curiosity cabinet, the mind comes to move without a continuity of meaning. With the advent of "modern" visuality, what is continuous is space—the knowledge of a perspectival geometrical space that Federico himself was so key in refining. Via perspective, any material can be organized within the visual field; what unifies the space is the single viewer. There is a direct relation between a collection organized only by means of the subjective experience of the collector and the scopic capacity of single-point perspective to organize any view. The linked and cell-like units of meaning characteristic of medieval classifications—the cellae, wax tablets, beehives, pigeon houses, palaces, and imaginary cities of medieval memory devices—are replaced by the grids of the *velo* and the arbitrary, yet objective, categories of scientific taxonomy.

Yet, as the works of *Deep Storage* illustrate, the older form of knowledge does not disappear. Rather, in juxtaposition to new devices of thought, it acquires a transformed meaning. Perhaps no recent artistic project illustrates medieval and Renaissance models of thought more deeply than that of Joseph Cornell. We often view in his work the emblems of medieval thought beneath or behind a gridded surface. Cornell took directly as a theme *The Last Prince of Urbino* (1967) and in his many depictions of caged birds repeated the imagery of a well-known inlay from the Urbino *studiolo*. His frames, compartments, drawers, and cabinets are exemplary of a meticulous craftsmanship. The viewer is invited to meditate upon the ways in which memory is both personal (shaped by subjective, inexplicably private experience) and generational (structured by the constant epochal process of culture as the renewal of forms).

Lest we think that such a mnemonic tradition was ever abandoned, consider the allusions to the Urbino *studiolo* in Cornell's work. In addition to the direct allusion made in *The Last Prince of Urbino*, Cornell also uses his boxes to evoke specific connections to earlier memory practices. As early as the *Theaetetus*, memory is denoted by the metaphor of the pigeonhole, or *peristereon*—of the familiar domestic pigeon, *columba livia*. Plato likens the pigeon to a bit of knowledge; when we are infants, our coops are empty, but as we acquire an item of knowledge we shut it up in its enclosure. The metaphor is taken up as well by the first-century Roman writer, Junius Moderatus Columella, who calls the dovecote a *cella, cellula,* or *loculamenta*—the word as well for "bookcase." Virgil uses another word for a

Roman bookcase, *forulus*, a diminutive of *forus*, the word signifying the tiers of cells making up a beehive. Papyrus rolls were kept by the Romans in shelving against the wall, subdivided into *nidi*, *foruli*, or *loculamenta*—pigeonholes, as in our use of the word to describe the compartments of a desk where we "pigeonhole" papers into their proper categories.[5]

In such practices, *cella* are boxes or stalls for birds and bees, which as flying things are allegories for the flight of memory and the wings of thought, as they are in Cornell's boxes *The Hotel Eden* and *Cockatoo: Keepsake Parakeet*. There is, Carruthers notes, a long tradition likening the placement of memory-images in a trained memory to the keeping of birds. Cornell's work recalls the ways in which the tiers of pigeonholes are places to keep memories—the word *nidus* also signifies the place where the bookseller kept copies of his work in Roman times. Cornell's boxes use such grids and niches as emblems of memories both recovered and lost.[6]

Cornell's 1940–48 work, *Beehive*, shows thimbles mirrored in endless reproduction within a Shaker-style circular wooden sewing box. The bee as a medieval emblem of ceaseless activity and industry is both evoked and claimed here as a stillness or absence, especially when we remember that the Shakers, unable to reproduce themselves because of their ban on sex, "died out" like a generation of bees. Cornell's 1952 work, *Dovecote*, with its blocked and open cells, presents an image of memory in a process of disappearance. White balls roll along strips of wood that have been placed behind the grid of cells. This track for balls resembles a popular early American toy—a zigzagging ramp of painted wood down which a marble or small ball could be rolled before it disappeared into a hidden trough where it would await its next "roll."

Cornell developed a large collection of documents about dovecotes and pigeons, clipping photographs and articles from magazines, postcards, and other printed images, and he often spoke to visitors about the decline of pigeon-keeping in New York.[7] *Dovecote* appears as a bleached ruin, a forgotten function, a device with instructions no one remembers. So much of Cornell's work hovers in this way at the edge of animation: his white cockatoos, like Joseph Wright of Derby's white cockatoo in *An Experiment on a Bird in an Air Pump*, perch on the boundary between life and death; his music boxes with tiny ballerinas, his film stars displayed as "stills"—each figure might be brought to life by the animating capacity of memory.

Cornell, perhaps no less than Duchamp, had a tremendous influence on the continuation of the poetic, discursive apprehension of things in postmodern art forms. Robert Rauschenberg's *Rebus* of 1955 or his "combine" paintings of the late 1950s and early 1960s yoked heterogeneous objects on

a flat surface in such a way that Leo Steinberg and others found the most apt description of the work to be "a dump, reservoir, or switching center."[8] What links such work to earlier mnemonic practices is the use of an image that is also a word or allusion. But Rauschenberg's work abandons the kind of charm and precision we find as Cornell privately reforms public images. Rather, Rauschenberg turns us toward the chaotic and noisy plethora of cultural forms that surrounds us. His repeated images—in both painted and "real" manifestations, such as his white oxford shoes in *Untitled*, circa 1954—seem to leap forward in significance, emerging from the skin of the paint. They too arouse the issue of animation. Rauschenberg's open, spilling surfaces function like *pentimenti*; the "reader" of his work rifles through images and shapes like a clerk desperately searching a misplaced file. Nevertheless, in much of the work of Cornell and in most of the work of Rauschenberg, the appearance of the image is destined to be impeded by the passage of time, the hermetic or unintelligible experience of individual subjects, and the decay of materials and traditions.

Hannelore Baron's delicate and mysterious collages, boxes, and books center upon these issues of fragility and opacity as well, but in forms characterized by reticence and withdrawal. With its small, torn flags, damaged flower specimens, remnants of lost children's games and rituals, Baron's work is a concerted critique of nationalism and its consequences: war and environmental degradation. She is deeply involved in the conservation and preservation of the subjective view—a view that her syncretic imagery, borrowed from Taoist, Native American, Muslim, and Florentine Neoplatonist traditions, also claims to be universal. Often wrapped or tied with strings, her assemblages evoke the reciprocal realm of gift-giving. Whereas the famous bundled magazines and wrapped buildings of Christo allude to the finite dimensions of form and issues of aesthetic closure and access, Baron's wrapping is an invitation on the level of a handheld apprehension. The bound blanket around an infant or the shroud wound around the corpse are gestures of care that maintain the integrity of the body and outline its singular identity.

For many years, Christian Boltanski and Annette Messager, in both their collaborative and individual work, have also explored the problem of lost meaning and lost traditions, creating ethnographies of everyday experience and at the same time questioning the authority of received modes of representation. In their "souvenir" album of "pictures of Venice" taken elsewhere and in other work, they have explored the issue of authenticity in photography, showing how labels and captions for photographs lend them a reality they may not otherwise possess. In Messager's use of fetish and reliquary

imagery, in Boltanski's archive of photographs of anonymous ordinary activities of anonymous ordinary people who later became victims of the Holocaust, objects are made replete with meaning as an effect of their assembly in relation to other objects and language.

In Messager's 1971–72 *Le Repos des pensionnaires (Boarders at Rest)*, a display of small birds in garments she knit for them, her drawings from photographs and photographs from drawings juxtapose the frozen labor of taxidermy to the warm sentimentality of the "petite feminine," the temporal unfolding of a line to the instantaneous occurrence of the photograph.[9] By accompanying her "albums" (bound volumes) with "collections" (loose sheaves of writings, drawings, and images), Messager contrasts fixed temporal order with sorting and assortment; the reception of the work of art as completed form and the reception of the work of art as open assemblage. Copying, an artistic task historically assigned to students, apprentices, and "lady artists," becomes for Messager an obsessive and transformative act. In her bedroom, the most private space of her house, Messager as "collectioneuse" wrote, "I seek to possess and appropriate for myself life and its events: I constantly inspect, collect, order, sort and reduce everything to numerous album collections."[10] Embroidery, signature, portraiture—all arts of the individual sign or hand become so elaborated and singular as to be nearly indecipherable.

In Boltanski's archive of *Le Lycée Chases*, ordinary "class pictures" are reproduced and enlarged until the images are obscure and ghostly shadows of themselves. Once the individual identities of subjects are lost to the interpreter of Boltanski's photograph albums, he or she must move through the ambiguity of loss to some form of communal recognition.[11] Even so, the work returns to the uncomfortable position of an interpretation caught within shifting concepts of authenticity. What is the "reference" of the *Vitrines de références* if the subject cannot be found? How can the tragedy of the Holocaust be addressed if the individual person cannot be identified and so, branded by murder, becomes an "example" of a more general category of humanity? Are transformed faces and carefully framed objects emblems of their disappearance or of the artist's fierce and abstracting attention?

Jason Rhoades hyperbolically brings forward a quite contrasting notion of interpretive blockage. Following Rauschenberg's combines and the infamous hoarding of Andy Warhol, Rhoades renews the inherently renewable structure of "the dump"—in his case, the space of the California "garage inventor." But his work wittily accelerates time in such a way that there is no possibility of meditation. By accumulating "trash" piles of newly pur-

chased consumer goods, he makes nostalgia absurd. He sets the viewer in orbit around the work and reintroduces the issue of sublimity and anticipatory time into an art of things. His work is an intense display of vital energy and distraction, a kind of phallic revenge of the active life on the interpretive aura of objects. No tears in the maker, no tears in the taker of this art.

Rhoades's "bachelor machines" allude to Frankenstein as much as to Duchamp; such invention is mad because it is absorbed in process rather than aftermath, but it is valued as unimpeded will and free expression. This work stands in stark contrast with the ethic of care manifested in Jeanne Silverthorne's art.[12] Silverthorne has described her studio as "a space known intimately as a cell creating a physically isomorphic prisoner" and as "a blueprint of the artist's body . . . an instrument for copying, for generating images of itself."[13] Her account of the studio directly mirrors the activity of interpreting the *studioli* of the Renaissance. But whereas Federico and others used their private cells to manifest their power and transcendence, Silverthorne patiently explores every aspect of negative capability within the studio as a site and a device of knowledge.

Recognizing that "cast sculpture leaves behind more mass than it displaces,"[14] Silverthorne draws our attention toward the remainder, the shadow, the after-effects of thought and making. Her casts of the debris in her studio and its lamps, picture hooks, and exit signs; her wires and cords dangling like unfinished marks or disrupted events; her vivid imaginings of the emptiness lying beneath and behind all ready claims of presence speak movingly to the fleeting experiences of making and communication. Silverthorne's work critiques monumentality as surely as Baron's critiques narcissistic identification.

There is a human presence in the shadow of the monument; there is an inexplicable remainder to every insight. Archives bring artworks into scale with memory and as well seal them from further change. A panel behind the panel, a door behind the door; lagoon or mine; lacuna or symbol—tomb or stars as tomb and stars.

FRAMING ABSTRACTION

Museum-going has always been central to my critical and creative work—and this museum especially has always represented a pathway into the thought of the present. Yet in concert with its request that these lectures rethink the paradigm of modernism, I would like to suggest an alternative reading of what kind of "present" this museum represents.

Several weeks ago, I visited the new Museum of Modern Art in San Francisco and noticed the following announcement at the entrance to the permanent collection there: "Modernism [was] a broad movement that crystallized in the early years of this century. Modernism defied conventions long associated with Western art, as modern artists abandoned figurative representation and the illusion of depth, creating wholly abstract images, and incorporated a range of materials and mediums never before used to make art." This story, which is the story of most art history pedagogy and the story of most museums of modern art, is one of diremption and novelty. Modernism developed, according to this account, by freeing itself from past practices of art-making, particularly in painting. By means of new techniques and by breaking up the hegemony of the unified field of single-point perspective, modernism burst onto the scene of the twentieth century. The San Francisco Museum's claim is that through heroic effort and by overthrowing the existing law, modern artists freed themselves from the chains of all that came before.

This narrative is, in fascinating ways, at odds with history. To argue that modernism is the culmination of a Hegelian teleology wherein art evolves toward the freedom of pure abstraction ignores the actual practices of modernism and all that has come after it, if indeed the modernist movement is

over.[1] At San Francisco, the pronouncement, for example, that figurative representation is abandoned at the end point of modernism is particularly puzzling, for that museum makes a great deal of de Kooning's return to figuration and suggests that Bay Area figurative art is the West Coast parallel to the innovations of the New York School. And of course the claim that a range of materials and mediums never before used to make art appear only thanks to modernism ignores the span of world art practices, those practices that in fact played a shaping role in transforming twentieth-century Western art. It ignores as well what passes for art in the domestic interiors, garages, and home workshops of our own native land.

If it is easy to debunk the myths of heroic modernism, it is not so easy, however, to consider alternative histories. First of all, the story of the heroic makes perfectly compelling narrative sense. Narrative histories depend upon the singularity and novelty of events, placing them within chains of causes and consequences.[2] Narrative histories bear the laurels of uniqueness to the artworks they feature. And narrative histories compel identification on the part of their audiences. The Museums of Modern Art at Rome and Torino narrate modernism as a development inseparable from the rise of the Italian nation-state and, ultimately, the technologies of fascism. At the Musée D'Orsay the twentieth century begins far earlier, in the antecedents to French impressionism. Thus when we tell of the Museum of Modern Art's birth in 1929, where should we begin? With symbolism, surrealism, and the works from the 1913 Armory Show that gradually made their way into the collection? With the powerful effects of Russian constructivism on the taste of Alfred Barr?

When we say of abstract expressionism after World War II that, for the first time, an artistic movement originating in America was recognized on the international scene, we are narrating the birth of a nation as a maker, and not simply a receiver, of culture. As the Pennsylvania Academy opened in 1807, Charles Willson Peale, his sons, and other founding members often could not name the "old master paintings" and plaster casts they had sent from Europe.[3] For Peale and other figures of the American Enlightenment, taxidermic specimens of American nature and portraits of the heroes of the American Revolution would come to seem the homegrown equivalents of the Laocoön and the Apollo Belvedere. Throughout the nineteenth century as well, the uniqueness of American art depended upon a uniqueness of American nature—the specificity of its subjects guaranteeing an originality and at the same time inhibiting translation.

Thus when we think of the contribution of abstract expressionism, it is a contribution made on the level of technique rather than theme, one that

marks the severing of artistic practice from the determining conditions of a local nature. Much has been made in recent years of the political uses to which this story of American art was put during the cold war.[4] But I do not believe we should so relentlessly identify artistic movements with the framing statements of their makers or with the use and abuse of artworks in political narratives.[5] Rather, it is only in the dynamic and ongoing inferences of art reception, inferences developed in relation to the evidence of intention in the material of the work itself, that we can practice a critical art history. Once we turn away from an insistence upon absolute novelty as the frame we create for twentieth-century art, we can consider abstraction a continuation of a dialectic between painting and vision with far deeper roots than those attached to nationalism and the demands of periodization as it is conceived at any given moment.

If we abandon the heroic and nationalistic narrative of modernism, or the heroic and fragmenting narrative of the avant-garde,[6] what alternative histories can be constructed for the works in this space? I propose we construct at least one such alternative out of the very conditions underlying the tensions between painting and vision—that is, the conditions under which a dialectic between the senses and abstraction emerges. In this way, we might see the modernist turn to abstraction as not a break with the past but rather a continuation of a certain set of problems regarding the representation of visual phenomena. Indeed, one can never claim that sensual particulars and abstraction exist in separate visual spheres. When we look at an iconic representation, such as the Duccio *Madonna di Crevole* at Siena,[7] we find the image constitutes an object of desire and an occasion for personal submission to the object's power. The material contents of the composition, the use of gold and ultramarine, are transformed by devotion—the market value of the minerals and pigments is merged with the intensity and skill of the application of the paint into a nonobjective eternity.[8] The flat surface prohibits the worshipful subject from confusing the work's materiality with the everyday visual space of this world.

Yet out of this alienation from tangible space, the humanizing perspective of the High Renaissance emerges—that humanizing of the image anticipated in Giotto's emphasis upon gesture and, consequently, touch. In turn, a consequent work like the *Città Ideale* from the Palazzo Ducale in Urbino[9] may seem at first glance to be empty of human figuration, but in fact such a painting marks the triumph of Albertian perspective. In the ideal city the human perceptual grid fills the field; the monocular view of single-point perspective reifies the position of the individual perceiving subject. This well-ordered, completely accounted-for view of nature depicts a hu-

man dream of mastery—the utopian city's depiction is made possible by the utopian desires of perspective itself.

An abstraction of the subjective view, one dependent upon the viewpoint of the individual subject and at the same time making a claim for the universality of that viewpoint, overcomes the alienation of iconic materialism. Yet perspective theory's comprehensibility, its total, yet static mastery of the visual field, led in mannerism to a return to the material aspects of the form. Here the painter's skill is demonstrated in the transporting realism of detail. When we look at the perspective of Bronzino's portrait from the Uffizi of Eleanora of Toledo and her son Giovanni,[10] we are looking at a space that collapses back into the detail's materiality. The Eleanora portrait has more in common with the iconography of the *Madonna di Crevole* than with the geometry of the Urbino court. Here we see a portrait of a dress, or perhaps more accurately a panorama of the ever dissolving and merging details of a dress. This is a panorama in which the material dissolves into the abstractions of line and plane just as abstractions in turn take form as emerging details. In such a work subjectivism is even more faithful to the particulars of viewing; the model here is not the fixity of single-point perspective but the mobility of the desiring subject.

Mannerism, with its play between hyperbolic volumes and enameled surfaces; anamorphism, with its acknowledgment of the arbitrary position of the vanishing point; and *trompe l'oeil*, with its witty articulation of the incommensurability between sight and touch all proceed toward realism via a heightened self-consciousness of realism's claims. If we are looking at an image of seeing in time, rather than an image of a unified field of vision, we no longer have any way of stopping the incessant turn of the mind between sensual particulars and abstraction and back—nor would we in fact want to stop that turning. By this point the mobility of perspective is as highly valued as the universality of perspective. In baroque works, such as Caravaggio's 1600–1601 *Conversion of St. Paul* at Santa Maria del Popolo, this mobility is dramatically brought forward and at the same time constrained by the controlled motion of the spectator; the theatrical space of the painting is inseparable from the viewer's sensual engagement with its details. And that engagement occurs within the narrow corridor of viewing offered by the Cerasi Chapel's architecture. *Istoria*, in Alberti's sense, cannot simply be applied to the scene; Caravaggio stages with immediacy and intensity the contact of the viewer and the sensual hierarchies of the depiction.

I've taken this rather well-worn tour through the origins of Western perspectival representation in painting in order to point to the recurrence of is-

sues of sense impression and abstraction in these forms. And I would suggest that such a dialectic between sense impression and abstraction characterizes all modes of artistic making. Simply seeing twentieth-century abstraction and the breaking up of the space of single-point perspective as a continuation of mannerist and baroque innovation is, in the end, not adequate to the particulars of any period. Yet we would be equally misguided to link the innovations of twentieth-century art merely to the overthrowing of the *plein air* and genre conventions of the nineteenth century. At the risk of distortion, I would like to pursue more closely a problem of seeing that extends from the break modernism makes with the history of realism. The assumption of sensory realism in painting is based upon Cartesianism: Descartes associates the self-identity of human reason with sunlight and rejects temporality in favor of instant certitude.[11] In Cartesianism, resemblance and difference are the grounds for authority and error. Hence the Cartesian tradition of realism—one might say anachronistically even before Descartes—is analogous to the stable monocular conventions of single-point perspective. Under the light of reason, gesture is stopped and reveals in the stable conditions of the view the truth of the material category.

Consider, however, an alternative history whereby we might pursue not the sunlit progression of perspectivalism but rather the ways in which such perspectivalism is compensatory to our awareness of blocked perception and the deprivations of seeing brought on by temporal contingency. Correlatively, consider that the inability of perspectivalism to account for the perceptual fields of memory and, in Romantic terms, imagination led to alternative accounts of visual space—accounts that would not emphasize the readiness of the world to hand so much as the capacity of visual experience to engage in perpetual and unresolved activity. In recent work I have argued that the nocturne conventions of Western art present one of our most sustained meditations upon this problem: the problem of going beyond the confines of material experience and the necessity to express in visual terms the endless play between the senses and abstraction. As organisms of diminished vision, human beings in the night rely upon kinesthesia, touch, and imagination in order to proceed. An absence of clarity and distinctness of phenomena, an inability to organize the visual field, and a problematic relation to depth perception are managed by means of heightened senses of tactility and hearing. In the night we rely upon connotation; we gather information in time; we tolerate ambiguity; and we proceed by means of subjective judgment. The nocturne in all its artistic forms is an alternative to the sunlit world of perspectival realism. In the visual arts, nocturnal works

pose possibilities for synesthesia and synesthetic allusion; they bring forward the potentials for seeing beyond single-point perspective's present-centered conditions.

Since the Neoplatonists, Night is associated with the spiritual contemplation that is part of the Orphic nox—a world of cosmic, Pythagorean harmony, and the lively creativity of the tradition of Saturnian melancholy. In an image such as Dürer's 1514 engraving *Melancholia I*, the Saturnian is linked to memory and is ultimately reconstructive and compensatory. Ever since the pioneering iconological studies of this image by Klibansky, Panofsky, and Saxl, we have come to see Dürer's work as a portrayal of the tragic relation between creative desire and measurement. The shadowed, exhausted anthropomorphic figure as an emblem of human striving and failure; the famished sleeping dog as an emblem of the insatiability of animal appetite; the purse and keys as signs of worldly ambition; the drooping head upon the clenched fist as an illustration of both the fatigue of creative thought and the grasping nature of human intelligence; the compasses, hammer, molding plane, set-square, and writing implements as tools of a geometrically defined optics—these elements of the picture build to an allegory of human creativity wherein the particularity of animal desire and the universality of measure must somehow be mediated.[12]

In nocturnal paintings before the eighteenth century, light is most often an emission of the sacred, a sign of redemption in standard Christian iconology as it had been a sign of transcendent immateriality in Neoplatonism. Following biblical precedent, such works often focus on scenes of adoration, contemplation, and recognition—gestures that depend heavily on visual inference and so emphasize all the more the miraculous qualities of light in the darkness: the Nativity, Christ's calling of Matthew, Nicodemus recognizing Christ, and Saint Jerome in his study, as in Caravaggio's well-known 1606 *St. Jerome Translating Scriptures* at the Galleria Borghese. It is the radiance of the holy that animates the scene from within.[13] In his 1952 survey of Caravaggio's work, Roger Hinks suggested that Caravaggio's use of a concentrated light source focused upon foreground figures against a neutral field of darkness was in fact rooted in many antecedents: Antonello, Bellini, Corregio, Lotto, Bassano, and Tintoretto especially (as well as Caravaggio's immediate masters, Peterzano and the Campi) had all worked in what Hinks calls a "nocturne" form. Even so, he notes that hardly any of Caravaggio's pictures do in fact represent lamplight or torchlight scenes: the *Seven Works of Mercy* forms the solitary exception before the last works, where the lighting is more miraculous than rational.[14] Caravaggio's emphasis upon interior experience and his corollary restriction of

the light source give us further insight into why so many of his paintings use sound—music, a moment of significant speech, or a cry—to animate the scene. We know, in fact, that Caravaggio not only painted directly onto the canvas in response to the presence of his model, but would most often begin his compositions by painting the ears of the figures to be represented.[15]

As the nocturne develops in painting and music in the later eighteenth, nineteenth, and early twentieth centuries, the emphasis shifts from interior scenes of contemplation to the experience of hearing and seeing in nature at night. No longer representing figures absorbed in thought and signifying through allegorical forms the possibilities for reading details as abstractions, later nocturnal works present the sensual particulars of night views; particulars that are simultaneously hidden and revealed and thereby provoke speculation and metaphorical transposition. This is perhaps why the aesthetic form of the nocturne, in whatever medium it appears, is not a dreamscape. The nocturne develops on a trajectory of sensory and emotional detail that finds its logical end point in abstraction. We might even suggest that impressionism, with its concern for the conditions under which light is apprehended, is derived as much from the nocturne's preoccupation with issues of depth perception and the mutuality between moonlight and bodies of water as it is derived from a subjective refocusing of perspectival realism.

Although we could use many artists as our example, James A. M. Whistler asserted a particular affinity between the night (where nature sings "in tune") and artistic consciousness, thereby continuing Dürer's meditation on nocturnal creativity. In Whistler's "Ten O'clock Lecture" of 1885, he wrote, "And when the evening mist clothes the riverside with poetry, as with a veil, and the poor buildings lose themselves in the dim sky and the tall chimneys become campanili, and the warehouses are palaces in the night, and the whole city hangs in the heavens, and fairy-land is before us— then the wayfarer hastens home; the working man and the cultured one, the wise man and the one of pleasure, cease to understand, as they have ceased to see, and Nature, who for once has sung in tune, sings her exquisite song to the artist alone."[16] By now the figure of Melancholy awake in his den or cell in the night and contemplating mysteries not available to others is continued and transformed in the image of the artist who sees in the night.

Coleridge in a previous part of the century had come to identify moonlight with the "modifying powers of the imagination" characteristic of poetry itself.[17] For Whistler, moonlit walks along the Thames were the source of a new harmonic technique that would culminate in his famous nocturnes of the 1870s, including his *Nocturne in Black and Gold—The Fire Wheel* [1872–77; Tate Gallery]. These works were, in fact, constructed by a par-

ticular process of impressing the night scene on the mind with the aid of language. Whistler's pupils, the Pennells, wrote in their biography that the artist would go out in the night and stand before the scene he wanted to paint. He would then turn his back on it and review to a companion "the arrangement, the scheme of colour, and as much of the detail as he wanted. The listener corrected errors when they occurred and, after Whistler had looked long enough, he went to bed with 'nothing in his head but his subject.' The next morning, if he could see upon the untouched canvas the completed picture, he painted it; if not, he passed another night looking at the subject." [18] Here Whistler is deliberately estranging himself from the visual field and turning the process of representation into a memory device. He is not painting nature in the moonlight; he is painting his memory of the sense impressions evoked by nature in the moonlight.

Earlier, William Hazlitt had derisively referred to Turner's nocturnes and paintings of extreme weather effects as "pictures of nothing." [19] And in his famous attack on Whistler, John Ruskin claimed that the painter had merely "flung a pot of paint" in the public's face. Whistler stated in reply, "By using the word 'nocturne' I wish to indicate an artistic interest alone, divesting the picture of any outside anecdotal interest which might have been otherwise attached to it. A nocturne is an arrangement of line, form, and color first. The picture is throughout a problem that I attempt to solve. I make use of any means, any incident or object in nature, that will bring about this symmetrical result." [20] The picture as a problem to be solved, rather than a nature to represent, is what links the nocturne tradition throughout history: the impediments to sight, the unresolved dimensions of perception, are of as much interest to the artist as the triumphant application of perspective to the tangible field of reality.

Now that I have introduced the idea of the nocturne as an alternative route to twentieth-century abstraction, I want to turn more carefully to issues of the representation of memory and imagination that nocturnal works particularly evoke. In *The Book of Memory*, her classic study of medieval memory practices, Mary Carruthers analyzes the ways in which the medieval paradigm linking thought and originality intrinsically with memory gives way in early modernism and consequent periods to a paradigm of imagination.[21] Yet when we think of the long history of what we will have to call anachronistically nonperspectival art, we see that memory and imagination both permit the transformation of sense impressions into synthetic and aggregate forms available to consciousness. Memory and imagination bring to mind what is not available to experience. Both partake in the metaphorical representation of nonbeing. And both activities remind us of

the structure of our temporal conventions, conventions wherein the concepts of past and future enable us to make reference to, and use of, the non-being of moments beyond the grasp of the present.

Painting proceeds by means of touch. In the accrual and application of paint via touch, line, color, and volume emerge as vital, yet abstract, consequences of the painter's actions. If language and thought are able to make available what is not present through memory and imagination, painting can perform an analogous work by means of residual marks gathering into apprehensible form. The sense impressions evoked by material works of art are not the same as those sense impressions recreated within their fields of representation. Within the paradigm of realism, we see objects attached to the surface of the canvas as giving testimony to the material; within the paradigm of memory, such objects have receded into the space of contemplation and imaginative transformation. This dynamic of emerging and receding materiality characterizes much of modernist collage and contemporary painting. The dissolving of figure into ground and ground into figure recapitulates the transforming, form-giving work of the imagination in the apprehension of sensual particulars and reintroduces the importance of time. As early as Aristotle, there is a tradition in the West insisting that memorial phantasmata are both representations of things and "re-presentations" of experience no longer present.[22] Time is a dimension of all images in the memory; the painter's investment in the accruing marks of gesture endows the temporality of memory with the material evidence of its being.

We saw that Dürer's *Melancholia* is a picture of creativity halted between the universal claims of geometry and the varieties of immediate sensual apprehension determined by appetite alone. Carruthers gives us contrary evidence of how creativity is often stimulated through the application of formal structures of memory to sensual particulars. Rhyming catalogues; images of caves, chains, and bins; alphabets and number systems; bestiaries; inventories and treasure houses—the finite, yet repeatable frames of these forms make them ideal devices for the storage of memory.[23] Such devices help us denaturalize the status of the frame per se, for the separation of the frame from the architecture of the space of viewing indicates both the individuality of the image and its potential replicability, its possibilities for repositioning and reuse. If the frame indicates the memorability of what is embraced within its borders, it also indicates a problem of detachment and temporal loss. This problem has become quite familiar to us since it was so dramatically outlined by Walter Benjamin's study of works of art in an era of mechanical reproduction, works that undergo the dissolution of the aura of presence.[24]

Roman mnemonics tied the places of memory to architectural settings, but Carruthers explains that "in particular, treating the memory as though it were a flat area divided linearly into columns within a grid seems clearly medieval. Hugh of St. Victor suggests that memory be treated as a 'linea' or line of bins in a numerically-addressed grid."[25] Hence the perspective grid itself marks the transformation of an application to past sense impressions into an application to the present field of perception. In early perspectival works, such as those of Masaccio and Masolino at the Brancacci chapel in Firenze or Piero's *Flagellation* at Urbino, we find the juxtaposition of past and present within a continuous narrative order; therefore we also are witnessing the work of the grid as it organizes past impressions and the present field of vision into one simultaneity. The *studiolo* at Urbino[26] arrays all of the liberal arts within its various constructions, merging the traditions of perspective with those of the memory cabinet. The *studiolo* is designed to promote thought; the continuous dissolve of its *trompe l'oeil* marquetry insists upon the transformation of the material and the graspability of abstraction at once. The *studiolo* is a cell within which memory is put into play, but it is also a model for memory itself.

If, in this tradition, the grid enables the storage and arrangement of sensual and material detail, we find a corollary tradition in which the imagination is able to offer to sensual apprehension the abstractions of projection and fantasy. As early as Aristotle's comparison between the *sensus communis* and the deliberative imagination and Thomas Aquinas's theories of memory, there was a need to establish a distinction between the memories of actual sense experience and the type of memory that calls upon abstractions and objects of thought. As Carruthers explains, Aquinas's position carefully establishes a retrospective analogy between such thinking and sense perception—we come to know mathematical objects, for example, through a process of comparison and contrast with sense objects.[27] Here, in a reversal of Lévi-Strauss's famous claim that the forms of myth are good to think with, we might argue that abstractions are good to sense with.

Steven Polcari's recent book, *Abstract Expressionism and the Modern Experience*, draws a number of telling and fascinating parallels between the innovations of abstract expressionism and the Roman paintings from Boscotrecase and Boscoreale in the collections of the Metropolitan Museum of Art. Polcari argues that the paintings from the Metropolitan's holdings had a strong impact on Baziotes, de Kooning, and, especially, Rothko. In his *Nocturnal Drama* from 1945 and his *Number 22* from 1949,[28] Rothko's surrealism and his abstractions with their use of thin bars and stacked rectangular color panels follow quite closely what we call, follow-

ing the scheme of the nineteenth-century German aesthetician August Mau, the Roman third style, with its rectilinear panels of opaque color, framed by *trompe l'oeil* columns.[29] Although we often celebrate Roman painting for its illusionism alone, the key connection here is the framing of illusionistic scenes within walls broken up into panels of color. The three dimensions of the illusion are juxtaposed to the flat two-dimensional surfaces in a complex interplay that denaturalizes the wall as window, as we can see in details such as those of a portrait medallion from the central panel of the Black Room's north wall.[30]

This interplay emerged, according to Mau's classic account of Pompeiian painting, by means of a gradual evolution. The First Style is characterized by decorative *trompe l'oeil* and particularly the treatment of painted surfaces as images of stone. The Second Style is derived from theater architecture; it goes beyond the wall of the room into imaginary spaces of skies and landscapes. The Third Style closes off the wall again into monochromatic panels flanked by columns. The Fourth Style opens up the panels into various imagined perspective views.[31] The progress of this evolution enables painting to supplement and even replace reality. Roman wall paintings are not realistic in the sense that they are faithful to the unified view of the subjective perceiver alone or to the material features of the visible world; they are realistic as evidence of the human desire to get beyond the wall—to look into spaces only thought can make available.

This is the desire to represent what the imagination cannot accomplish by means of tangible forms and to gain access to what thought can know beyond the intelligibility of received categories. We might recognize this yearning as the desire for sublimity as it is described in the legacy of Western discourse on the sublime from Longinus to Kant. Indeed, in the writings of Barnett Newman, with their earnest pursuit of sublimity in the temporal conditions offered by the making and apprehension of painting, we find a direct attempt to paint into the anticipatory suspension of the sublime experience. In his 1948 essay "The Sublime Is Now," Newman wrote that he was concerned with the sublime as the "here and now," later explaining that it was not the manipulation of space or the image he was pursuing but a sensation of time that might dismantle the conventional structures of consciousness. Newman proposes a break with thought as memory device and an attempt to put into play the very structures of thought. As Newman wrote, "We are freeing ourselves of the impediments of memory, association, nostalgia, legend, myth, or what have you, that have been the devices of Western European painting . . . the image we produce is the self-evident one of revelation, real and concrete."[32]

In such work, Newman seeks the end of any reference anterior to the gesture of the mark. Not only does painting no longer refer to nature; it also no longer refers to anything that can be given form by the imagination or meaning by the understanding. Newman's *Death of Euclid* of 1947 and *Vir Heroicus Sublimus* of 1950–51 [33] attempt to put the static totality of painted space into a series of apprehensive movements. As Jean-François Lyotard has recently written of Newman's work: " 'after one colour, this other colour; after this line, that one' is no longer the case; now we find the ever-present possibility, the anxiety, that nothing and nothingness might happen: the pleasure in welcoming the unknown is described under the rubric of the question 'Is it happening?' " [34] Hence the purity of an abstraction that precedes its referent; and hence a practice of painting necessary to, because preliminary to, the apprehension of the world.

This is a formalism not so much rooted in transcendental categories of mind as in conditions of seeing and in the development of techniques for representing those conditions. Whereas many contemporary critics have associated formalism with a kind of rigor ultimately confused with sensual restraint, such an argument seems in direct contradiction to the progress of aesthetic abstraction, for the progress of abstraction emerges from a deep engagement with sensual particulars and by means of analogical comparisons between sensual particulars and thoughts. In the late twentieth century, much of the monumentality of earthworks and installations approaches issues of the dynamic sublime, just as much conceptual art approaches mathematical sublimity. Artists have sought to evoke through material means the imagination's striving toward the nonfunctional and untotalizable, and they have sought to push the understanding beyond received categories of thought.

Given that the function of the museum is to be representative in various ways—representative of history, representative of power, representative of interest—we can see that this deep history of abstraction in nocturnal experience and devices for remembering and imagining may be by definition at odds with the potential of the museum as a space for comprehension. Yet I believe that museums in fact can promote thought by framing abstraction in unanticipated ways—that is, by constantly pursuing conditions of juxtaposition, analogy, sequence, and articulation that refuse to reify the possibilities for experiencing any individual work. The museum has many means available to promote such intensive and unbounded looking—emphasizing intention by having viewers direct their own steps; emphasizing the manifold of apprehension by allowing works to be examined at various distances and from various angles; emphasizing distinction and analogies

by presenting works of various materials and forms in concert and at odds with each other; emphasizing absorption by minimizing distractions brought on by noise, conversation, and superfluous architectural ornament. At the same time, museums can promote exchange and discursiveness by providing public spaces for response, discussion, and rest.

Modern artists turned to processes of making amid the most vicious historical circumstances of destruction. So much of the art of the twentieth-century has been made as a critique of technology and of the novelty mandated by a consumer society. To tell the story of modern art primarily as a story of technological change and a rejection of the realism of single-point perspective in pursuit of novelty ignores the particulars of the artworks and dulls their truly radical dimension. Yet museums today are under tremendous pressure to capitulate to those very values against which modernist artists have so constantly struggled.

When we look at a recent work such as Enzo Cucchi's painting *Sguardo di Un Quadro Ferito* (the title can be translated "I look out of a wounded frame," although there is also a subtle allusion to *feritoia*, a loophole), an absence of realism is not so relevant as an imperative to apprehension. Within this "wounded frame," we find something of the cosmology of Dürer's woodcut of Eurus, the east wind, where a man's head in flames signifies fire and summer—a cosmology recorded in those volumes that the twentieth century has constantly put into perilous conditions of destruction and loss. And we find something of Turner's use of the legend of Regulus— the moment when the sun is the source of darkness and blindness as much as the source of sight. The issues of Dürer's melancholy, with its tragic depiction of the relations between sensual perception and conceptual knowledge, have hardly been resolved. In the work of Cucchi and others, we turn to an iconography in which the referents may be half remembered or are in the end only partially determined, and so we begin anew with the sensual particulars of symbolic forms.

New Yorkers, and indeed a far wider population, are free to use this museum over time and to reflect on its holdings over time within constantly shifting paradigms of art history—and now perhaps even within a constantly shifting architectural foundation. Yet the deep history of abstraction will continue to be expressed in the engagement of individual viewers with individual works. For this is a practice of art about which it would be trivial to say it lacks a thematic. Out of the long history of abstraction have come modes of expression giving access to what is intangible in experience, to what is unintelligible in thought, and to what is invisible in vision.

ON THE THRESHOLD OF THE VISIBLE

Just like unto a Nest of Boxes round,
Degrees of sizes within each Boxe are found.
So in this World, may many Worlds more be,
Thinner, and lesse, and lesse still by degree;
Although they are not subject to our Sense,
A World may be no bigger then two-pence.
Nature is curious, and such worke may make,
That our dull Sense can never finde, but scape.
For creatures, small as Atomes, may be there,
If every Atome a Creatures Figure beare.
If four Atomes a World can make, then see
What severall Worlds might in an Eare-ring bee.
For Millions of these Atomes may bee in
The Head of one small, little, single Pin.
And if thus small, then Ladies well may weare
A World of Worlds, as Pendents in each Eare.

Margaret Cavendish's "Of Many Worlds in This World" is an appropri-
ately little poem, but it nevertheless bears an "ornament" of an extra cou-
plet—two lines attached to the sonnet like earrings donned at the last mo-
ment of getting dressed to go out.[1] The poem is, like many a Renaissance
microcosm and many a baroque sonnet, as John Donne says of his own
"Holy Sonnet V," "a little world made cunningly." Cavendish's poem
appears in 1653, twelve years before Robert Hooke would publish his
Micrographia; or, Some Physiological Descriptions of Minute Bodes Made

by Magnifying Glasses, with Observations and Inquiries There Upon that "little objects" observed under magnification would enable "a flea, a mite, and a gnat" to be compared to such "greater and more beautiful works of nature" as "a Horse, an Elephant, or a Lyon." [2]

Small things invite us to compare our measures of significance to what is given in nature and in culture. Something small can be great, as precious as a jewel; each world might contain another world, like a nest of boxes that recedes beyond our grasping and, eventually, our seeing. A second look at something small can supersede an immediate impression—the small compels our attention and so is endowed with the worth of *time*, the *worthwhile* which has no necessary relation to spatial magnitude. Although microscopes, telescopes, and Renaissance science more generally brought many of these issues to the fore, the problem is at least as old as Aristotle's speculations on the relation between size and beauty. In *The Poetics*, the philosopher had puzzled over the problem of appropriate scale: "A minute picture cannot be beautiful (for when our vision has almost lost its sense of time it becomes confused); nor can an immense one (for we cannot take it all in together, and so our vision loses its unity and wholeness—imagine a picture a thousand miles long!) . . . there is a proper size for bodies and pictures—a size that can be kept in view." [3] What is this scale? It is the scale of the first-person subject: the scale of single-point perspective, a human body fixed at a point in time and space.

But it is paradoxically from the viewpoint of human scale that we realize the limits of perspective. Small things can be sublime as readily as the grand material phenomena of nature and human making. When Kant listed the infinite as one of the modes of the sublime, he showed that the problem of proportion and relativity is a red herring: " 'Sublime' is the name given to what is absolutely great," [4] he wrote, but added, "telescopes have put within our reach an abundance of material . . . and microscopes the same. . . . Nothing, therefore, which can be an object of the senses is to be termed sublime when treated on this footing." The size of a thought, for Kant, includes the breathtaking capacity to apprehend something beyond the size of thought, "a faculty of mind transcending every standard of sense." [5]

This exhibit of "tiny objects" is in many ways an exhibition of sublimity. As we enter the exhibition space a blank or blinding emptiness becomes a plenitude of detail. There *is* a there there, to reverse Gertrude Stein's axiom, for the mind needs only a point, an aspect, from which to explore indefinitely and to infinity. This mobility of the point of departure is already implicit in Alberti's "Dove a me paia, fermo uno punto" [Wherever I please, I make a point]. [6] By foregrounding an inverse relation between degree of

magnitude and degree of significance, minute works of art provide a critique not of monumentality and gigantism in themselves but rather of the poverty of any naive materialism confusing physical scale with subjective or social importance. Arriving in the interstices of the monumental sublimity of abstract expressionism and the hyperbole of pop art, these pieces explore the minimalist and conceptual possibilities of thought entertaining negation and pleasure at once.

In Gene Davis's acrylic micropaintings, which range from three-eighths of an inch square to an inch square in size, certain qualities of painting are both exaggerated and transformed. They are monochromatic or striped or dotted, and the weave of the canvas can seem enormous. Color is quantified by intensity and not by dimension; hence issues of saturation, which might be linked to the application of color in Byzantine art, are foregrounded in Davis's work. Davis refuses to use painting as a window and insists on making the viewer self-conscious as he or she moves across the gallery space. His work thereby provides a meditation on the site of painting within the site of the museum. These micropaintings are both signs and sign *posts*; positions from which a relation to scale and color is pursued. In this they, like many of the works here, return us to an Aristotelian tradition where space is not so much an extension from the perceiving subject as a receptacle for the perceiving subject.[7]

Tiny works of art may be representative of objects at another scale, as when they function metonymically as fragments or parts; they may function metaphorically in relation to a particular referent, as they do when they are scale models or miniatures; or they may be objects in themselves considered "tiny" or proportionally small in relation to the human body or other works of art. In whatever manner they function, such works historically have been preoccupied with this split between materiality and significance. In this they often have represented the interests of the aesthetic—and the wonder-full—over interests of utility and ideology; yet they are also powerful manifestations of skill for its own sake and thought directed toward the infinite.

Instances of micrographia such as the *Iliad* in a nutshell that Pliny says that Cicero saw or the miniature Bible inscribed by Peter Bale, an Elizabethan writing master, enclosed "within an English walnut no bigger than a hen's egg" are masterpieces juxtaposing perfected skill with an unfathomable or magnificent semantic.[8] Hagop Sandaldjian has carved a grain of rice into the shape of Mount Ararat and inscribed it with a poem by Yeghishé Charents. James Lee Byars's *The Book of One Hundred Questions* is made of microscopic gold text on black linen paper a little larger

than nineteen by fourteen inches. The questions, enigmatic open queries posed by an artist who has called himself a "World Question Center," can be read with effort by means of a magnifying glass. These works suggestively recall the miniature catechisms and tiny hornbooks by which children in the seventeenth and eighteenth centuries could keep religious knowledge in the hand, in the pocket, or under a pillow. Michael Ross's tiny poem-texts, with their gigantic natural themes (clouds, sequoias, whales, the Milky Way, the rings of Saturn), displace micrographia into the landscape. By increasing the space between the writing and the reader, they ritualize the process of seeking out "the word." But they also show a discipline of the body that is another kind of devotion; Mr. Sandaldjian must work between his heartbeats—even his breathing and blinking must be timed so as not to interrupt the progress of his microscopic work.

Miniature books have often been worn as amulets or charms, for just as they often are Bibles or Qur'ans or other powerful texts, they retain the power of the concentrated labor that has formed them. This power is not an accumulation of materiality but rather an accumulation of transformations made in time; the laboriously handmade object results in a representation of *temporal* magnitude. The clumsy viewer, with access to only the most visual dimensions of the work's significance, cannot apprehend, cannot grasp imaginatively, the magnitude of this temporality. He or she is both immobilized and agitated by the view. To see Yoko Ono's *Yes Painting*, the observer must climb a stepladder. He or she is drawn toward an arrival, a location, where a task might be begun or completed, a tool applied, an object retrieved. This trajectory ends in what might be called a happy demonstration of blockage: the viewer uses a magnifying glass to see the small *yes* painted on the canvas in India ink.

Michael Ross and Gene Davis punctuate or choreograph the viewer's picaresque wanderings through space. Other works remind us of the pilgrimages the devout make to witness firsthand miraculous fragments of the bodies of saints. Such objects often have the metonymic power of the souvenir and, more strongly, the fetish. To "possess" them means in fact to come under their possession, and so they raise questions of the relation of size and context to value. This power of the fetish to make something out of nothing and to both attract and repel is explored irreverently in Tom Friedman's *Untitled*, a half-millimeter sphere of his feces on a pedestal. Here the other side of devotion is irreverence and critique. In the gestalt between the artist's feces and the pedestal, the museum—itself the object of pilgrimage—is desecrated, just as its sanctifying power is emphasized. Charles Ledray has made a tiny ladder out of human bone, which he ex-

hibits under a bell jar. He raises troubling ethical issues of permission and the sanctity of human remains that cannot be resolved unless he reveals the provenance and permission for use, or lack or it, of his material.

Chris Burden has often produced "relics" of his own artworks. Cubic zirconium, a relatively worthless substance, acquired significant value through manipulation and process in a 1981 show, Diamonds Are Forever. Originally, the zirconium was a valueless "stand-in" for a ¼-carat diamond Burden had purchased with funds for the show. The zirconium glowed under a spotlight in a vast, dark exhibition space. Burden kept the real diamond safely in his pocket at all times. The arbitrary, but real, value established by socioeconomic convention for the real diamond is juxtaposed to the equally arbitrary and (eventually) real value of the fake once it has been framed or tempered as art. In reversing values and turning expectations upside down, Friedman and Burden link the small to the "witty," a form of thinking that uses brevity and compression to undermine what is inflated. Here what is small has a critical capacity inseparable from its relation to the grandiose.

Small objects bring the viewer into a nearly unbearable, unreadable intimacy. Richard Tuttle's "rope pieces" have a particular power in this regard. Here his *3rd Rope Piece* of 1974 is a length of ordinary woven jute rope nine-sixteenths of an inch by two and three-eighths of an inch, attached to the wall with a single finishing nail. Clothesline, anchor, or noose—for good or ill, these pieces cannot be strung or knotted or wound. Despite the vividness of the allusions they form, they appear as *literal* or exact representations of metonymy itself. The rope is now severed from whatever it yoked or bound or joined; the image is so powerful in such a primal way that it evokes the possibility of the very undoing, unbinding of the subject who views it. A fixation, a separation, a tragedy. With magnificent economy, Tuttle reveals the paradox of temporal being, the nature of a subjectivity bound by its frame and defined by its lack.

It is the viewer who feels small in the presence of the fetish. In contrast, Joel Shapiro's three-inch bronze chair, bereft of any framing device such as a crèche or dollhouse, turns the floor of the museum into a vast desert; refusing our sensual apprehension, seeming to recede at our approach. This chair once placed in the site suggests pity, fear, and absurdity solely on the basis of its scale and typicality. It is not so much lost in the space as absorptive of all the space around it. The chair is an evocation of helplessness, as if, following Rilke's great poem on Jacob wrestling with the angel, we could see how small is our sphere in relation to what surrounds us. The chair is so small and we, who must remain in the being of our own bodies,

are so very far in the distance. In their obdurate, quiet presence, Shapiro's archetypal objects seem both amusing and sad. They appear as keepsakes that have misplaced their owners.

Although we cannot miniaturize what has not had material being in the first place, there are no miniatures in nature. The miniature assumes an anthropocentric context from the outset. Gaston Bachelard has written in his *Poetics of Space* that "values become condensed and enriched" in miniature.[9] Yet these are not values in general. Rather, the miniature historically has emphasized a particular configuration of subjectivity: first-person experience; single-point perspective; spatial extension from the individual perceiving viewer; interiority and domesticity in opposition to the public or social sphere of the monumental; the diminutive, the childlike, the pastoral, and the picturesque as "alternative" or alienated views. Representations of domesticity and interiority abound in diminutive artworks. The flea circus tames the smallest predator of human beings; the wonder cabinet displays the precious and the exotic in a manageable frame; the diorama and the dollhouse stage scenes of animation where history and even trauma can appear within a script contained by the viewer's private imagining.

Thus the miniature and the "tiny" accrue around certain social and historical matrices—the lost worlds of childhood, of hand or craft labor, of aristocratic wealth and ornamentation—and around certain somatic (and hence psychoanalytically significant) paradoxes—the "invisibility" of the mother's sex and the anamorphism of the phallus, the tactile intensity and eclipsed views of sexual experience. Hannah Wilke has written of the "womb/cunts" she made of chewing gum and ceramics, "I take the essence, the skin [to create a three-dimensional layered shape] unlike a cock, the solid phallocentric form."[10] Yet such objects become, in her work, ubiquitous—a kind of reversed phallic law. Ornamenting landscapes, her own face and breasts, postcards, and other images with these little representations, she marks the world as reliant upon the creative and reproductive labor of women's bodies. These small, shell-like forms are themselves the consequence of an organic process; gum "dies" in the mouth, just as the body withers; like a body, the gum must be buried or placed once it is used up—instead, Wilke "plants" it in full view. Like Yoko Ono's *Pea Piece* from 1960 ("Carry a bag of peas. Leave a pea wherever you go.")—or Johnny Appleseed's good deeds—Wilke's small-scale gestures repeated in various contexts plant seeds of causality in the experience of the receiver.

The "of many worlds in this world" dimension of microscopic, tiny, and miniature objects suggests hiding and uncovering at once, a voyeurism where one might be recognized or caught out—even, perhaps in punish-

ment for the pleasure of seeing what cannot or should not be seen, blinded. There is a titillation to the micrographic akin to the titillation of the pornographic—as representations of desire, both emphasize an incommensurability between visual and tactile experience. Like all works of art and imagination, the micrographic and pornographic are compensatory to reality, but what distinguishes them is their exaggeration of nonreciprocity and mastery. When we look through the microscope at Barbara Bloom's presentation of Shunya prints microfiched on grains of rice, we see from a standpoint of heightened exoticism. These are images distant in time (they are based on seventeenth-century images), in space (their Orientalism is itself made fictional by the vitrine and their status as an edition from a larger work on imaginary renditions of the East), and in scale (the outsize sexual organs of the images are even more exaggerated by the distanced microscopic view). If Ono's work says "yes," these images say "no"—the viewer feels manipulated by his or her own dream of transcendent manipulation.

Small works are fragile and reflect the fragility of the human, just as they are themselves instances of human making. One must take care, and yet one can never take enough care—each life will end, human life on earth may end. Nevertheless, as Freud wrote in the shadow of war, in his 1916 essay "On Transience": "the value of all this beauty and perfection is determined only by its significance for our own emotional lives." [11] Perhaps no work in the show exemplifies this dimension of the aesthetic more than Bethan Huws's *Boat*. The boat is one of many Huws has made. Each is shaped from one stem of rush, taken up from the root and then made to stand again by twisting part of the stem into a base. These little boats have the ephemerality and elegance of other things made of grass: the bracelets, necklaces, and chaplets woven on childhood afternoons, the blade-blown whistles perfected and lost. Knotted with patience, cast aside half finished, left behind or trampled; little ornaments, little objects, little instruments made of grass are the least of things and yet perhaps the greatest of all human gestures against the scythe.

ORGANIC FORM AND PERFECTION IN PAINTING

I am pursuing the perfect painting. When in all modesty, and with a measure of self-irony, Peter Flaccus, an American painter now working in Rome, says this, he is describing an aspect of his larger search, throughout most of his adult life, for a harmony between material, technique, and image in the practice of painting. More recently he has been seeking an absolute economy of means and ends, a mode of painting conducted on a small and clear scale that has a deep resonance with the notion of organic form and the relation between made and natural structures. To follow the course of his reasoning in painting is to understand something of the necessary and sufficient conditions of that particular art.

We might begin by asking what a painting is—that is, how is a painting one kind of thing and not another?—before we can begin to consider what perfection in painting might be. Etienne Gilson's classic analysis of the form in his *Forms and Substances in the Arts* quotes the Nabis painter Maurice Denis's 1890 "Manifesto of Symbolism": "a plane surface covered with colors arranged in a certain order." Denis's definition emphasizes the two-dimensionality, formal totality, and shaping human intention distinguishing this art—an art of composed colors. And Gilson adds, "a picture exists from the moment these simple conditions are fulfilled . . . painting by definition is abstract and not representational." The abstraction to which Gilson refers has nothing particularly modern about it: if we trace the genesis of this art to cave paintings of hunters' handprints and running bisons, we find a magic that is abstract in its use of metaphor and analogy as well as in what might be called its deliteralization of three dimensions into two. Or if we look for a less utilitarian origin of painting in the opening up of pictorial

space between the thresholds of the private and public in Roman (and what was likely to have been Greek) wall painting, these "simple conditions" also prevail.

Yet for any painter who came of age in the second half of the twentieth century, this notion of painting as the abstraction of three-dimensional space into two and a medium dominated by the composition of color has the force of a mandate. Painting's separation from the linearity of drawing, and hence the freeing of color from representational form—indeed the freeing of painting from representational demands of all kinds—ensues in the wake of photography and more generally from the secularization of art, and not only as a consequence of the particular aims of modernist art movements after the Fauves.

Those problems of representation once at the forefront of all painting theory seem to be no longer relevant. The problem of the imitation of nature concludes in differences between works of nature and works of art that cannot be breached—nature as given, art as intended; nature as infinite, art as finite; nature renewable in its multiplicity, art perishable in its singularity; nature as animate, art as animated. Perfection in painting therefore cannot be continuous with perfection of imitation. Perfection in painting may remain in the eye of the beholder, but it cannot coincide with perfection of imitation without surrendering its very existence as painting and disappearing back into the realm of natural objects from which it was created.

For the minimalist, painterly abstraction resides in a search for essence and a stripping down of process to the making of geometrical forms. The mathematical seriality and geometrism of minimalism, as early as Mondrian, links Platonic universals to the physiology of visual perception, hence yoking an invisible and visible nature. For the conceptualist, however, painterly abstraction is inseparable from the abstract, language-based, and hence social relations informing the conditions of art's creation and reception. The postmodern transfer of issues of representation from the visual to the social is an aftereffect of conceptual art in this regard. Yet notions of identity and political power can be absorbed readily into the legacy of caricature and its concern with typicality and the inversion or reversal of the status quo. Once we recognize that "successful" representation relies upon conventions of pictorial space and habitual expectations of perception, once the formal and technical qualities of oil painting have been explored through the subjective means of abstract expressionism and the objective means of minimalism, and once the spheres of production and reception have been analyzed through the theoretical means of conceptualism and the

satirical means of much of postmodernism, there remains the underlying question: why make another painting?

For Peter Flaccus the answer to this question has involved a return to a set of unfinished projects in the history of Western art. Most fundamentally, he has chosen to work for the past eight years solely by means of the technique of encaustic, one of the oldest techniques of the tradition, yet one that almost disappeared by the twelfth century and has remained relatively rare. The Greek term *enkaustikos*, or "burning in," refers to the thermal treatment at the end of a process in which molten beeswax is mixed with pigments and at times resins, then kept fluid as it is brushed or otherwise manipulated upon a surface. Pliny the Elder's *Natural History* records the method and mentions the unusual durability of surfaces produced by this technique, noting that paint applied to ships in this way could not be destroyed by the effects of sunlight, brine, or wind. The Fayum funeral portraits of the second century A.D. are perhaps the most famous surviving examples of ancient encaustic art.

Flaccus begins with bleached pellets of French beeswax, which he melts in old pots on hotplates in his studio and mixes with damar resin, a varnish that comes in the form of clear crystals like small rocks. This is the classic recipe for an encaustic base. He then forms small bricklike pieces of this mixture that subsequently are melted again and combined with pigments.

In his early encaustic paintings, he created spaces and marks by using brushes to apply and layer the wax. Often he would then go on to incise and scrape the wax as well, remelting and refilling areas whenever his sense of the emerging composition required it. As the eye moved from trace to trace of the painter's movements in time, certain effects of depth and emergence were created. Beneath the surface of these works, the viewer could traverse areas of opacity and transparency. At times the surface of the wooden base would be visible; at times a wax-filled gash would draw the attention as steadily as a scar. Images from nature and the colors associated with Roman light—sepia, gold, gray, red, and ochre—produced a sense of cultural fossilization, as if ruin had been stayed by the application of wax.

Freud compared the unconscious to a wax tablet on which are inscribed faintly visible traces of experience. In these early encaustics, there was a considerable emphasis upon the ways each gesture the painter makes could "count," or matter—each gesture is an indeterminate trace of human presence in and by means of a substance that has historically symbolized the crafted productions of nature and an ideal substance for human shaping and use. Although Flaccus has always eschewed metaphor for the evocation of

visual form alone, the viewer was tempted to make familiar associations: the pilgrim's scallop shell, the whorl of hair on an infant's skull, the snail's architectural curve—somewhere on the threshold of nature and culture, an animal gesture seemed to become an intended action in this body of work. Between softening and hardening, the material could evoke the mutability of experience and the capacity of memories, too, to endure or harden in time.

Beyond these associations with animal industry and the impressionability of the memory, encaustic painting, however, challenges the definition of painting as three dimensions abstracted to two—a definition that continues to rely upon notions of depiction and reference to nature. One way to address this would be to consider encaustic painting a type of sculpture, particularly a kind of relief—that is, to emphasize that the wax retains its dimensionality and is manipulated in three-dimensional space by the process of layering it. But this would not be adequate as a description of Flaccus's practice, for his recent paintings—at first dominantly a dark blue or rose-like Pompeian red, and more recently yellows, greens, tans, and fuchsias—are meant to be apprehended as plane surfaces. He is making his way around the color wheel and thinking about how two or three colors can be combined like a musical chord. In these works Flaccus does not use a brush at all. He turns to the wooden board that will form the support for the finished painting and pools various amounts of variously colored wax on the surface. All of this happens in a matter of seconds, and he has less than a minute to make small adjustments or changes. Hence these paintings are an event as well as something made. The cooled painting can be scraped and smoothed to reveal a continuous variably colored surface reflecting and absorbing external light.

Variables of heat, speed, interaction of pigments, and other factors also introduce elements of chance and happenstance into a process that at the same time requires a very high degree of technical skill and knowledge. Painterly gestures are involved, but there is no thematic of touch or tactility. There is also not an emphasis on showing the process, or revealing the artifice—there is a quality of reserve about the technology. Since so much of the reaction between wax, pigment, and heat is fortuitous, the painter does not make claims for the process beyond the outcome that is the painting itself. Another person could not follow the method and make an analogous painting any more than he or she could retrace the method and become the same person.

Rather than offering the rising forms and surfaces of reliefs, the "blue" paintings can be compared to the experience of looking into a deep, smooth body of water or the night sky; the "red" paintings suggest gazing at the sun

or into a furnace. In either case, the opacity of white wax functions as a point of terminus—not in the object but in the apparatus of perception. Yet of course these imaginary contexts come laden with a knowledge of their impossibility, given the mutual repulsion of wax and water and given the disastrous effects of excessive heat to wax. The viewer is thereby thrown back into acts of mind that are indeterminate and purely sensual until the next association arises.

These paintings thereby quite specifically evoke the relation between sense knowledge and the continuity of mental states that Descartes explored in his Second Meditation. Placing a ball of wax near a flame, Descartes held that if he could say the substance was the same, then there must be a continuity of perception—a continuity of the perceiving mind and hence of the perceiving subject himself. Throughout this meditation, a malleable ball of wax, in its indeterminate and constantly changing form, is an occasion for the mind to exercise its powers of abstraction. But what is perhaps underestimated in Descartes' argument is the visual and tactile status of such sense impressions. In the alchemy of Flaccus's practice as an abstract encaustic painter, the wax never asserts itself as anything other than wax—than transparency, opacity, color, and shape. There is no *trompe l'oeil*, no illusion of representation to interrupt the direct interplay of sensual apprehension of color, light, and form in relation to the continuity of the abstracting activities of the perceiving mind.

The resulting paintings (see, for example, *Blue* [2003] and *Red* [2003] on the back cover of this book) are luminous records of their own making. This is not merely a metaphor—it is as if their light stays "on" even as the cooled wax hardens. The areas of pure white have an intensity that seems hot, even as they also present areas of opacity, resolved by their cooled state. If after abstract expressionism it has seemed that modern painting is determined by the drips, spatters, blurs, and runs of liquid paint, Flaccus's work makes us rethink the medium of painting, of colors arranged in a certain order on a plane surface, in fundamental ways. Encaustic painting opens up the relation between wet and dry, fresh and hardened, into temperature and another scale of time. The wax medium is in constant transformation, and so the entire process of fabricating the painting evolves in an accelerated temporality. Balancing this acceleration is the longevity and durability of the finished work, which requires relatively little curating and will remain in a stable state so long as the surrounding temperature does not exceed 150 degrees.

Further, Flaccus is pouring his work without a mediating tool. Gravity, atmosphere in the studio, the chemical interaction of materials, and the art-

ist's gestures directly affect the final composition. There is almost no ma-
nipulation of the surface once the wax hits the board—therefore the final
work has a ratio between happenstance and intention in which chance
greatly outweighs the will of the painter's hand. Flaccus does not romanti-
cize this, and he has a strong sense that some works "don't succeed"; he will
melt down a work and begin again and occasionally make small adjust-
ments to the resulting work. But on this scale, mistakes are mistakes of na-
ture as well as bypassed painterly objectives, and every "mistake" yields in-
formation about a largely inarticulate knowledge of harmony and pleasure
that resides in human perception. In other words, the mistaken is taken up
into the next assemblage of works produced and embraced in the open-
ended teleology of the painter's lifelong project.

Flaccus's transformation of the orientation of his making can be com-
pared to Hofmann's use of poured paint, Pollock's turn toward the floor as
his primary working surface, or Carl Andre's switch toward horizontality
in making his sculptures. Flaccus's paintings are made on a table from
above, but viewed in their finished state on a wall. His recent abstractions
employing radiant effects are on the scale of two feet by a foot and a half—
the size of a medicine cabinet mirror, an attic window, or a large open book.
They are most readily apprehended at the distance one person usually stands
from another in conversation—the place where the face is fully visible and
the two speakers cannot quite see each others' shoes. There is a striking co-
incidence between the image and this scale of apprehension. They have a
clarity at a distance and a resolution into surface details and nuances of
shape, line, and color when viewed very closely. When Flaccus has experi-
mented with larger, in some cases doubled, works with this process, they
have an almost burdensome materiality that seems overdone and cannot
readily be taken in. These ventures into grander works seem almost paro-
dying of the features of the style. And smaller versions of this work, viewed
at a distance, would lose some of the striking effects that come from the meet-
ing of colors. Perfection of scale is indeed a quality of these encaustics if per-
fection is what makes a quality seem unalterable and complete in itself.

Because there is no illusion of depiction, the experience of scale is not at
all bound to a comparison between the size of things in reality and the size
of things in the image—rather, as Kant had claimed of aesthetical ideas
more generally, there is a constant interplay between detail of mark, planes
and shapes, and the edge as a place of event or meeting between substances
of varying temperature and unquantifiable color. The final work is literally
sealed, but there is no distinction possible between outer and inner, the sub-

stance of the thing and the substance of the seal. Oil paintings, acrylics, and watercolors involve the constant application of touches on the part of the artist. An encaustic painting also involves the application of gestures, if not touches, to its surfaces, and the final work has a depth that cannot be gauged from the visual information it provides alone. The colors in Flaccus's recent paintings have what might be described as internal edges; they do not conceal or cover something else beneath, yet because of this they seem of an indefinite depth, and locked together, the colors are juxtaposed in an interaction that is both dramatic and indefinite.

Modernism sought perfection in geometry and other eternal or static forms and hence continued a line of Platonism in art. But just as Flaccus's use of encaustic has opened another route to painterly materiality, so has his imagery opened another route to painterly content—that of the Aristotelian tradition of organic form, especially as it was received by the Romantics. This is a practice of abstract painting that does not place its emphasis upon the mechanics of the process in its use of tools, brushes, and the residue of gestures. Nor does it place its emphasis upon the rationality of the process by determining composition in advance. There are no studies or sketches or representations prior to, or independent of, the final work, nor are the elements of the painting and the relations between determined in terms of shapes and forms in the world outside the painting.

Consider August Schlegel's definition of the differences between mechanical and organic form in his 1808 "Course of Lectures on Dramatic Arts and Literature":

> The form is mechanical when through outside influence it is imparted to a material merely as an accidental addition, without relation to its nature (as e.g. when we give an arbitrary shape to a soft mass so that it may retain it after hardening). Organic form, on the other hand, is innate; it unfolds itself from within and acquires its definiteness simultaneously with the total development of the germ. . . . In the fine arts all genuine forms are organic, i.e. determined by the content of the work of art. In a word, form is nothing but a significant exterior, the speaking physiognomy of everything which, undistorted by any disturbing accidents, bears true witness to its hidden nature.

For Schlegel, the arbitrary shape given to a soft mass is mechanical because it is only determined by the need to end its prior state—as when something soft would need to be transported, or fit into a container. Organic form is

in and for itself, following the demands of an inner teleology, just as the bud unfolds into the flower, the mineral or salt becomes a crystal, the infant an adult person. There is nothing in the realized form that is superfluous or dominant.[1] In Flaccus's recent works, there is never a moment of alienation from nature—rather, there is a cycle continuing from the formation of wax and minerals to the remixing of these elements and a continuity between human gestures and human perception and the phenomena of the natural world without any necessary imitative or representative function.

Each painting arises from the conditions of its inner necessity. The works resemble each other, but each is unique, and any imbalance in process or scale destroys the living quality of the final work. The judgment or determination of such an imbalance is in the end an outcome of a physical and cognitive response on the part of the painter or viewer. It is not that Peter Flaccus's paintings are neo-Romantic but that the problem and opportunity of organic form has never receded despite the truly mechanical demands of various art movements. Such demands always function as either retrospective judgments of practices or prior determinations of content. Created within a culture of waste and decay, Peter Flaccus's paintings are paintings of duration, durable and radiant records of human making. To respond to them is to respond to something alive in ourselves as well as to their colors and light.

To let the artist speak for himself, here are some notes he has sent about "the perfect painting" in response to this essay:

1. *The perfect painting is flat. The plain flatness of the support is the foil against which we experience the invented picture space. This is fundamental—a good painter (and thus the perfect painting) proposes a new picture space, one never before invented. An "original" style really means a new picture space, with specific new confines, characteristics, and rules. Only within his own custom-made picture space does the painter find himself, his voice, his freedom. Think: Bacon is free within the Bacon picture-space, Pollock is free within the Pollock picture-space, Warhol is free within the Warhol picture-space, etc.*

2. *I actually believe that the picture space of these new paintings is an original invention. Among its special characteristics are: that the illusion is held in check by the physicality of the wax; the partly transparent paint body suggests an even thicker material layer than really exists; gesture is absent, and instead the images are traces of specific events that took place*

in a determined moment (as happens in photography or the formation of rocks); colors exist as substance, rather than representing something else; the shapes of the paint substance are locked together like pieces of a jigsaw puzzle rather than being overlaid coatings, as in conventional paintings; swelling forms, gently pulsing light, natural asymmetries, the contrast of soft roundness and square format, all contribute to a tension between motion and stasis; the "color space" is not solid, liquid, or gaseous, but a peculiar environment for form that seems to be in the process of becoming, rather than being fixed or rigid. You can't put new forms in an old warmed-over picture space. And new forms are necessary to elicit new emotions. And new emotions are necessary, otherwise: sentimentality.

3. *Color = energy. Color is harnessed by exactly calibrating specific color relationships; this requires special knowledge and experience, and is analogous to a musician's manipulating the structure of chords, but is even more complicated than musical harmony, since colors exist in many independently variable dimensions (for example, light and dark value, "temperature," hue, intensity, transparency, quantity, etc.).*

4. *Order. The structure of a painting is designed to create pictorial tension, which means contradiction, conflict, and drama, which means interesting to look at.*

5. *The perfect painting emanates light, obviously the illusion of light. Traditionally, painters have sought to represent light and manipulate light, to magical effect. However, lots of recent painters, in rejecting illusionism and romanticism, renounce light. Not me.*

6. *The perfect painting is formally elegant. The painting is flat, but it is an object and should be well made. All the parts are visible. No smoke and mirrors. No brushwork "artfully" concealed. Impeccable execution, that is, material execution that is perfectly efficient. This is not virtuosity as a value in itself. Efficiency, on the other hand, is by itself a basic aesthetic value. Getting a lot for a little. Most effect for least effort. For me, art works when it creates magic. The gap between what we experience and what we know is there creates the astonishment, the shivers. The gap is the art. The bigger the gap the better.*

7. *The perfect painting is characterized by an organic wholeness: integrity, Gestalt, the parts subordinated to a whole, a consistent logic from A to Z.*

8. Leggerezza. *The perfect painting pleases, and looks easy.*

9. *Since the perfect painting is not a metaphor for the fragmentary and contingent aspects of life, it will not be left unfinished. The masters (from Leonardo through Cézanne, Matisse, Picasso, et al.) who left works in an unfinished state were obviously after bigger game than mere perfection. "Perfection," when technically possible, means simply fulfilling a very limited set of criteria.*

10. *The perfect painting has no more than two and a half ideas. A painting with three ideas is already a logjam. I tell my (skeptical) students to pare it down to two and a half. A pair of main ideas to establish the governing dialectic, plus a subordinated one to ramify the internal relationships are sufficient.*

11. *The perfect painting has correct scale. While contemporary galleries and museums generally ask for imposing, heroic-scale paintings, the important thing is that the painting have the right scale for its formal content. It should "hold the wall" with authority. It should look alive from far away, and reveal more of itself as the viewer approaches it. With his nose finally practically touching the painting, the viewer will enjoy the fine-grained detail and notice another thing as well: the perfect painting, made from beeswax, smells good!*

12. *The perfect painting is in harmony with the universe! This must be the reason why, if the painter is distracted and lacks the requisite state of relaxed concentration, if there is an unnoticed draft from an open door, or other physical or psychic disturbance, the arrow will fly wide of the mark, and the painting is a dud.*

13. *A painting could satisfy all these criteria, and yet still be boring as hell. Several times in the past, just at that moment in which I was convinced that I had definitively understood my painting method, and thus had the happy prospect of an endless future of carefree productivity, all at once nothing worked anymore. The paintings were suddenly formulaic, dead on arrival. That's the proof that my own creativity depends as much upon not-knowing as upon knowing. Expertise is important up to a point, but the crucial factor is that each individual work be in a real sense an experiment. This is the reason that the unplanned and unplannable aspect of this new pouring process is working well for me now. Each painting is an experiment to see what would happen if I tried this or that little variation,*

and even if I reproduce all the procedures as closely as I can, I never get an identical copy.

14. *As in nature, evolution creates forms. Painting is a progressive growing and learning process. "Perfection" will be a temporary evolutionary state. When one day I know how to make them perfectly, the game will be over.*

15. *This list is getting long, as more things occur to me, late at night. I just realized that the perfect painting, being simple and essential, will probably not be entirely autonomous but rather exist as part of a series. Its meaning will depend in part upon comparison and contrast with other examples. In the end, the perfect painting may be like a subatomic particle as defined in quantum mechanics: we may have the statistical certainty that it has come into existence, but not have any way to locate it individually.*

EGG AND DART

Notes on the Work of Anne and Patrick Poirier

Summer 1995: Santa Monica, every other house damaged by the earthquake. Why are some untouched and others devastated? A question about experience and not only architecture—walking and skating by the polluted sea, at morning the flat, depthless light, at night the Ferris wheel's bright constellation revolving above the pier. Night music, one note at a time. In the library we often work past midnight; the quake had knocked all the books to the floor, but no one was hurt, the building stayed intact.

Visiting the enormous studio by the airport where Anne and Patrick are building their *Ouranopolis,* a model of a utopian city: *heavenly city,* epithet for Rome and Byzantium. The model like a space ship, suspended in the air—a great white horizontal lozenge with openings for peering in—each opening, a separate world. To see them one after another, you must orbit around the sphere. Each unfolds toward the interior that is inaccessible in the distance; the middle is blocked from view, yet also infinite. It is impossible to tell the scale of these receding architectural spaces. Labyrinths, libraries, steps leading up and down to invisible plazas and rooms where a figure would have to be much smaller than even a little finger. But the eye completely forgets the rest of the body once it's glued to the oculus. Thomson's insomniac city, Borges and Calvino, thoughts of flight, glimpse, repetition and retracing. Things that hover both remind and menace.

The utopian as closed to all senses but vision. Obsession yoked to the ungraspable. The utopian—white, cold, pitiless; desire, though, craves tactility. Those who lived in the eighteenth century thought the classical world was pristine, white, because they wanted to project it upon the future.

The "real" Ouranopolis, gate to Mt. Athos, where women are not welcome. Anne *et* Patrick: recognition and coincidence, multiplications of position becoming force, a single will in concert. Authority, authorship, intention as a matter of signature and façade. *Hadrian* is the one who built what says: M*AGRIPPA*L*F*COS*TERTIVM*FECIT. To recognize one's intention as shaped through time by the intentions of others, this, too, is a mode of grounding the artwork, rescuing coincidence from mere narcissism.

(Almost half the scenes on Trajan's column show work in construction, workers carrying dirt to building sites in baskets. At the top, where no one else can see, the stone carvers carve jokes about stone carvers.)

The egg: 1942, their dual birth date, Patrick à Nantes, Anne à Marseille. They dreamed they were twins separated at birth, one sent north, one sent south. "In the beginning every human being was a rounded whole . . . a circular shape with a hooplike progress . . . thus cut in two, each half yearned for the other . . . when they met they threw their arms around each other."

The dart: 1943, Nantes in rubble. Occupations. After the Greeks, Romans, Saracens, the Nazis destroyed the Old Port of Marseille. History as *naufrage*. From the *Georgics*: scilicet et tempus veniet, cum finibus illis / agricola incurvo terram molitus aratro / exesa inveniet scabra robigine pila, / aut gravibus rastris galeas pulsabit inanis, / grandiaque effossis mirabitur ossa sepulchris [and a time will come when in those lands, as the farmer toils at the soil with a twisted plow, he will find javelins decaying with rust and mold, or his heavy hoes will strike on empty helms, and wonder at the giant bones in the opened graves]. Farmers and soldiers, one-way hospitality. In Venasque an old man once told me that after the First World War they replanted the truffle oaks, but after the Second, there didn't seem to be any point.

Inigo Jones thought the Romans had built Stonehenge. Lord Kames asked himself "Whether should a ruin be in Gothic or Grecian form?" and answered, "In the former, I think; because it exhibits the triumph of time over strength; a melancholy, but not unpleasant thought; a Grecian ruin suggests rather the triumph of barbarity over taste; a gloomy and discouraging thought."

Everything the Poiriers do comes from the rhythm of egg and dart/dart and egg: circle and line, return and departure, origin and ending, making as cultivation, heritage, preservation; unmaking as destruction, war, violence of the gods, nature and man's nature: *ipse pater media nimborum in nocte corusca/fulmina molitur dextra* [The Father, enthroned in midnight cloud, hurls from a flashing right hand his lightning]. In the beginning the third sex came from the moon and was part of both sun and earth. Romans in

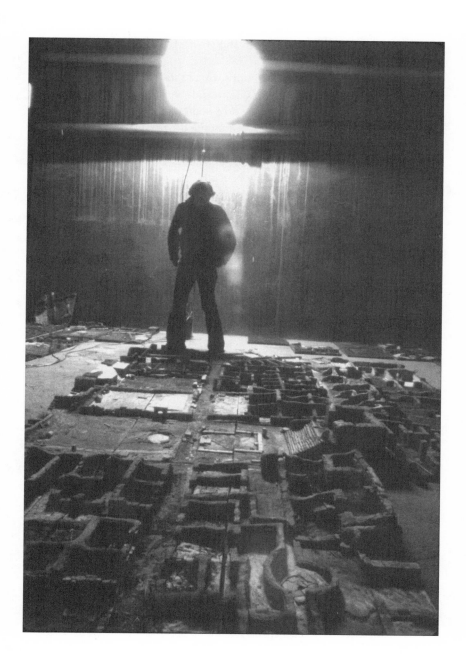

the spell of the Druid moonlight. In the North the Celts, in the South the Phoenician sailors.

At Ostia Antica Corinthian columns, three masks propped on pillars at the theater; genre as taxonomy of emotion. In Anne and Patrick's *Golden mask fountain* of 1984, the mask is propped on a sticklike post, the pool, like the one at the font of Aretusa, surrounded by papyrus. In the *Golden mask with a little bird* of the same year, the face of the mask is in repose, the little red bird rests on the forehead—its landing has occurred in another century. Yet the laurel leaves visible beneath the mask are as fresh as if they had been gathered and woven that very morning, the morning, that is, of the act of seeing.

When Anne and Patrick built their "model of Ostia," they walked outside through the ruin each day and remembered and built inside at night. It is a model of their *memory* of Ostia [Lecoq de Boisbaudran and Whistler]—an art of reconstructed memory as an art of transformed subjective states.

Their materials:

- *black*: charcoal above all, a world frozen by fire, dark forest of ruins. Their model of the Domus Aurea in five scenes built of charcoal, hands and breath at work, stained and systolic, an act of saturation, absorption, strange contrition of the artist building a metaphor of the remembering mind.
- *white*: plaster, patching repairing cementings [the black and white of writing and books, and their own practices of writing, recording, noting, photographing—documentation acknowledges inevitability of decay as conservation does not; and the burnt library at Alexandria, pages turned to charcoal, charcoal turned to pages—the positive and negative fates of trees. George Herbert: "But though the whole world turn to coal / Then chiefly lives . . ."]
- *brick and clay*: as earth emerging into form from earth and crumbling back into earth [in Ostia the bricks are the long rectangular form of the pine bark more or less exactly].
- *bronze*: the corporate aspect of ancient making, bronze arrows protruding from the French countryside like cursors on the undifferentiated fields.
- *stone and water*: natural enemies, hospitality going in only one direction.
- *stone and leaf*: everywhere lichen and leaf sprout from stone, even from the mouth of the head of Ozymandias, travelers from an antique land, the land of cultural memory and not the earth itself. Their trip to

Angkor, the jungle and humidity eroding, torquing the stones. They
built a herbarium from the species at Ostia, the Domus Aurea, and
other Roman sites so that the leaf could be preserved with the stone.
Piranesi wanted to prove the Etruscans were the root.

Time in sculpture is in the viewer who moves from one place to an-
other—Anne and Patrick's half-buried columns by the highway. The tra-
jectory here is in the direction the cars cannot travel, depth and height, the
verticality of memory and meaning, both of which soar and plunge.

Fragility rendered with tensile strength of purpose. Little goats on preci-
pices, shrub oaks and acanthus split the masonry. Archaeology: the science
of where and how the gods descended.

DEATH AND LIFE, IN THAT ORDER,
IN THE WORKS OF CHARLES WILLSON PEALE

Any collection promises totality. The appearance of that totality is made possible by the face-to-face experience of display, the all-at-onceness under which the collection might be apprehended by an observer. This display of course marks the defeat of time, the triumph over the particularity of contexts in which the collected objects first appeared. In display, collected objects are gathered by removing them from one time and space and framing them in another. The arrested life of the displayed collection finds its unity in memory and narrative. From the toys of the dead in Egyptian tombs to the moving statues of Daedalus described in *The Meno* and *De Anima* to the terror of infinite motion in the red shoes or the mechanical toy that will not stop, the dream of animation counters the stasis of display and promises that the collection's total world might speak or come to life—an all-at-onceness might become extension, movement, consequence, and reciprocity.[1] This dream of animation has thereby a kind of social-political claim, for it posits the collection as an intervention, or act of significance, and it compels the consciousness of the observer to enter into the consciousness of the collector. The opaqueness and fixity of the collection on display is transformed into the utopian republic of the fantasy where individual desire finds its fellow dreamer and recognizes itself.

Although collecting objects seems to allow them to endure beyond flux and history, this very transcendence and permanence also links them to the world of the dead, to the end of organic growth, and the onset of inaccessibility to the living. It is not surprising that mechanical toys and objects express a repetitive and infinite action that the everyday world finds impossible: mechanisms do not tire or feel, they simply work or don't work. As

part of the general inversion that the world of the dead represents, the inanimate comes to life in the service of the dead awakened. The theme of animation is itself a kind of allegory of memory and of the role willed memory plays in reawakening the obdurate material world. Thus we might consider the link between the collection and the portrait as devices for recollection— gestures of *countenance* designed to stay oblivion.[2] But rather than continuing in such general terms, I would prefer to focus on a particular historical moment, the end of the Enlightenment, and a set of aesthetic practices, the painting and collecting activities of the early American polymath Charles Willson Peale, where these issues appear, to continue our metaphor, with some vividness. Peale's work takes place in a context of changing religious and political thought that provides a suggestive supplement to any universal theory of collecting.

Charles Willson Peale was born on the Eastern Shore of Maryland in 1741, the son of a schoolteacher who had been in England a convicted felon. The family moved to various small Maryland towns until they settled in Annapolis when Peale was nine. Apprenticed as a saddler when young, Peale practiced various professions throughout his long life: repairer of bells, watches, and saddles, sculptor, miniature painter, portrait painter, Revolutionary soldier, propagandist and civic official, mezzotint engraver, museum keeper, zoologist and botanist, inventor of such mechanisms as a portable steam bath, a fan chair, a velocipede, a physiognotrace for making silhouettes, a polygraph for making multiple copies of documents, a windmill, a stove, a bridge, and false teeth. He studied painting in London with Benjamin West for two years. When he returned, he moved his family to Philadelphia; there at the height of the Revolution he served as both a soldier and maker of banners and posters for the war effort.[3]

Most established artists of the eighteenth century had a painting-room gallery for displaying works for sale or works in the artist's personal collection. In Peale's case this exhibition gallery eventually became the first American museum, embracing both cultural and natural history. During the War for Independence, Peale expanded his display gallery into an exhibition of portraits of Revolutionary heroes. Beginning with his first portrait of Washington in 1772, Peale had established by 1782 a tall and long skylighted chamber for showing full-length and bust-sized portraits. Here he arranged the portraits high on the wall in order to represent the primates, while those lower forms of life he had collected filled the cases and the floor below. A watercolor, delineated by Peale and painted in 1822 by his son, Titian Ramsay Peale II, shows the Long Room of the museum from the time it was located in the Statehouse in Philadelphia. Cases of birds line the left

wall, with the portraits hanging above. At the right are cases displaying insects, minerals, and fossils. On the cases rest busts of Washington, Benjamin Rush, and others. What cannot be seen in the painting are the additional rooms and the table for exhibiting experiments with electricity and perpetual motion.

In addition to the vertical, hierarchical arrangement by principles of evolution, the materials in the museum were also organized according to what Peale knew of the Linnaean system. Peale believed that

> [A]n extensive collection should be found, the various inhabitants of every element, not only of the animal, but also specimens of the vegetable tribe,—and all the brilliant and precious stones, down to the common grit,—all the minerals in their virgin state.—Petrefactions [sic] of the human body, of which two instances are known, and through that immense variety which should grace every well stored Museum. Here should be seen no duplicates, and only the varieties of each species, all placed in the most conspicuous point of light, to be seen to advantage, without being handled.[4]

He proposes that the "gentle intelligent Oran Outang," lacking speech, be placed nearer to the Monkey tribe than to that of humans and that the flying squirrel, ostrich, cassowary, and bat will provide the connecting links between quadrupeds and birds. Further, Peale was an innovator in museum display techniques. Finding that ordinary taxidermy did not produce a lifelike effect, he stretched skins over wooden cores he had carved to indicate musculature,[5] and he offered painted backgrounds of the proper context for each specimen. The museum displayed both live and dead animals. When a live grizzly on display escaped and ran through the Hall, Peale was forced to shoot him.[6]

By 1794, his collections had grown so enormous that the museum had to be moved to Philosophical Hall. Following Rousseauist principles of nature as the proper teacher of mankind and his Deist beliefs in a nonintervening God, Peale saw this enterprise as a "School of Wisdom" designed to teach the public to follow the example of nature. It is clearly the case that Peale's painting and collecting activity served the interests of postwar American society—his portraits memorialized the heroes and patrons of the war, his collections of cultural and natural objects provided in miniature a synopsis of the New World, linking recent historical events to the grand context of nature and providing evidence of a natural providence legitimating those events. To this extent, Peale's collecting activity parallels that of such

Renaissance antiquaries as John Leyland and William Camden, who provided a secular and nationalist narrative for England designed to supplant previous forms of religious authority. Yet if we turn to the particular details of Peale's aesthetic practices at large—his paintings and inventions as well as his collections—we find other interpretations possible that are closer to the psychological history of Peale himself and the religious and intellectual climate of his day.

Peale's Deism and rationalism can be discerned in the very names he gave to his children. Refusing to give them family or biblical appellations, he chose their names from his copy of Matthew Pilkington's *Dictionary of Painters*: Raphaelle, Angelica Kauffman, Rembrandt, Titian, Rubens, and Sybilla after, obviously, the Sybils. And later he expanded to Franklin (after Benjamin), Aldrovand (after Ulisse Aldrovandi, the Renaissance museum keeper of Bologna), and Linnaeus. Moreover, he recorded their births, not in the traditional family Bible, but on the flyleaf of his Pilkington. Like Washington, Jefferson, and Franklin, Peale was attracted to British Deism, with its tenet of God as inventor and first cause, without any particular justification for institutional religion and clericism; its interpretation of Christianity as a moral system akin to civic virtue; and its picture of nature as regular and predictable.[7]

Yet of particular relevance here are several aspects of Deism as it was debated in Britain and the United States. As a legacy of Newtonian physics (and before Hume's *Treatise* of 1739, with its critique of causality, gained popular currency), Deism held the external world to be material and composed of objects now moving, now at rest. Rest is their natural state, not motion; and when such objects move, it is because an active force is moving them. Motion that seems to be initiated by purely material objects is simply transmitted motion, like billiard balls colliding with one another. Genuine autokinesis is found only in human beings. This motion is initiated by the will, and the *feeling* of causing motion is enough to give evidence that one causes it. If all motion originates in the will, then the motion studied by scientists must also originate in the will—eventually one must reach a first cause of motion, which is God.[8] Further, Deist circles were preoccupied with an ongoing conflict regarding life after death. Throughout the eighteenth century, some Deists contended that this world is the only world, while others believed in some afterlife in which moral virtue would be rewarded. Many argued against Calvinist notions of election, and Franklin, for example, came at the end of his life to hold that the soul was immortal.[9] What remained central tenets of Deist thought were the denial of miracles, the denial of supernatural revelation, and the denial of any special redemp-

tive interposition of God in history. These theological arguments are of much consequence in the formal choices Peale made in his art: the material, knowable world can be organized by an empirical and reasoned science; human will is the source of all motion in the physical world, and human motion is caused by divine agency; death is a material fact and the categories "life" and "death" are mutually exclusive; biblical and mythological narrative cannot represent reality.

Peale's only true apprenticeship as a painter came during his stay with West in London in 1767 and 1768. But this influence is remarkable for its absence in Peale's ensuing work. He never chose to imitate the style of history painting and mythological painting practiced by West once West was unable to commission religious paintings from the Church of England.[10] This fact might be best explored by turning to an anomaly in Peale's oeuvre, his copy of West's painting *Elisha Restoring the Shunamite's Son*. The work was one of the first he completed upon arriving at West's London studio; he made a small (16 × 24") watercolor copy of this biblical composition and later took the copy with him when he returned to Maryland, eventually including the work in his exhibition galleries. The story told in 2 Kings 4:8–37 provides the background for the work. It tells of a wealthy childless woman who provided the prophet Elisha with food and rest; in return Elisha predicted the birth of a son to her. The prediction comes true, but the child later dies and when Elisha's servant Gehazi tries to revive the child, he fails. Elisha himself arrives, and putting his mouth on the boy's mouth, his eyes on the boy's eyes, and his hands on his hands, miraculously makes the flesh of the child become warm. The child sneezes seven times and opens his eyes. West, and Peale after him, has depicted the moment of revival; the mother is seen from behind as she bends over the child. The child's limbs are still limp and complete the triangular composition, with both mother and child held within the trajectory of the prophet's open hands. Gehazi is recognizable, holding to the right the staff that failed to revive the boy.

Peale made very few copies of paintings during his career, and this is the only original painting of West's that he copied during his apprenticeship.[11] He preferred to paint "from life," a principle also allied to his Deism, with its rejection of bibliolatry and textual evidence, and in turn to nature and the authority of sensory experience. In a copy of *Émile* owned by one of his heirs, Peale himself probably underlined a passage urging teachers never to substitute representation for reality or shadow for substance, but to teach only from actual objects.[12] This principle meant that, despite some rare exceptions, he always painted from life once his career began. Further, Peale's

museum would be based upon actual samples, not replicas or models. Yet just as Peale had subjected himself to West's prior technical authority in the copy of *Elisha*, so did he chose as his model a subject that would have been an anathema to his beliefs—that is, the evidence of miracles and divine interposition.

This early copy-painting so distant from Peale's religious and aesthetic principles might be contrasted profitably to his painting *Rachel Weeping*, which he worked on intermittently from 1772 to 1776.[13] In contrast with the distanced miracle of the Elisha painting, this work stems directly from an immediate and personal tragic experience. Infant mortality was of course unfortunately common in the eighteenth century, and Charles and Rachel Peale lost their first four children in infancy. This picture records the death of the fourth of these children, Margaret, who was killed by the smallpox epidemic in Annapolis in 1772. Moved by a request from Rachel that he create a memorial portrait of the child, Peale first painted the infant alone, with arms and chin bound down by white satin ribbons, as it is seen in the foreground here. Between 1772 and 1776 he worked on the picture several times, adding his wife and a table of medicines in order to symbolize their futile attempts to save the child's life. Although this is one of the few non-commissioned, and therefore personal, works in Peale's collection, he nevertheless hung it in his painting room. Because Rachel could not bear to look at it, he eventually placed it behind a green curtain and for a time added a note: "Before you draw this curtain / Consider whether you will affect a Mother or Father who has lost a child."[14] The story of Peale's painting is the opposite of West's. It is an account of the stubborn material truth of death itself. Rachel holds herself in a gesture of containment, and the one source of eruption from such stillness—the tears, which seem to bead on the surface of the paint—becomes material there and in the biblical title later given the picture by members of the family.

This picture is only the first instance of Peale's working through, in his painting and collecting practices, an anxiety regarding death. Mastery over anxiety is aided by the establishment of an empirical referent, a bringing to consciousness of the latent understanding and a transforming of that referent into experienced understanding. For Peale, the creation of new knowledge was thereby a stay against death. And taxonomy, the organization of knowledge, served as an antidote to surplus meaning and emotion. His practices are illuminated by the famous passage in Freud's 1916 essay on mourning and transience, where Freud wrote, "We only see that libido clings to its objects and will not renounce those that are lost even when a substitute lies ready to hand. Such then is mourning . . . when it has re-

nounced everything that has been lost, then it has consumed itself, and our libido is once more free . . . to replace the lost objects. . . . It is to be hoped that the same will be true of the losses caused by this war. . . . We shall build up again all that war has destroyed." [15] In common with his contemporaries, Peale lived in an environment of infant mortality, epidemic, and war. But the question becomes for him the meaning of suffering if divine interposition is not possible, and the meaning of nature's lessons when such lessons are unnatural and even monstrous. *Rachel Weeping* is a painting about the limit of nature and about the limit of science's capacity to intervene in

nature. The other side of the Rousseauist doctrine of natural virtue is na-
ture's indifference, ambivalence, and capacity for anachronism and disor-
der. The material representation of death helps to recollect the referent and
bring it to the attention of a formal understanding.

Of all the facts science could provide, one that continued to escape veri-
fiability, and which was the center of much scientific debate at the time, was
the fact of death. For example, Peale's family doctor during his Philadelphia
years, Benjamin Rush, had in his library two pamphlets on the problem of
suspended animation. The first, "An Essay on Vital Suspension: Being an
Attempt to Investigate and to Ascertain Those Diseases, in which the Prin-
ciples of Life are Apparently Extinguished, by a Medical Practitioner,"
printed in London in 1741, explains that the best way to investigate the na-
ture of death is to consider the "inherent properties of life." When this proj-
ect of delineating properties results only in ambiguity, the doctor concludes
that "all bodies in nature are *aut viva aut mortua*, there being no interme-
diate state. The second is that it must be a work of supernatural human art
to recall to vital existence that which is dead." After the expression of fur-
ther doubts and hesitations, the physician suggests that stimulants be ap-
plied to denudated muscle and if any contraction follows, life remains. "It
is proof of the temerity and imbecility of human judgement; that we have
too many instances on record, wherein even the most skilful physicians
have erred in the decisions they have pronounced, respecting the extinction
of life, this should incite the practitioner never to be deterred." [16] A later
pamphlet, by a New York physician, David Hosack, "An Enquiry into the
Causes of Suspended Animation from Drowning with the Means of Re-
storing Life," recommends the application of heat to the body's system
much in the style of Elisha reviving the Shunamite's son. [17]

Given the ambivalent status of signs of life and death and their capacity
for misrepresentation, there were many eighteenth-century folkloric prac-
tices accompanying death. Often in the house of the dead, clocks were
stopped at the hour of decease, mirrors were turned to the wall, and black
cloth was thrown over pictures and over any beehives in the garden. [18] These
gestures of stopping time and stopping the motion of representation can be
connected to the imperative of viewing the corpse. In *Rachel Weeping* the
mother's gaze does not enter the frame of the picture of the dead child. By
placing the work behind a curtain, Peale permanently continued the mourn-
ing practice, and by showing the child and mother withheld from gesture
and motion, he painted the end of human will and autokinesis. This pres-
entation in fact continues, for the viewer of Peale's exhibition gallery, the

experience of display and burial—the mourner's experience of viewing. When Rachel herself died in April of 1790 (either from a lung disorder or from the complications of her eleventh pregnancy), Peale refused to have her buried for three or four days because of his fears about premature burial. Her death was made much more difficult for Peale by the concurrent death of his friend Benjamin Franklin.

A year and a half later, Peale added a relevant set of remarks to his initial address to the Board of Visitors appointed for his new museum. He explains that he plans to follow the Linnaean system and then adds a rather startling suggestion. Explaining that "good and faithful painting" can make the likeness of man available to posterity, he says that nevertheless he would like to find a way to use "powerful antisepticks" to preserve the remains of great men, thereby keeping their bodies from becoming "the food of worms" and making them available for reverence and memory. He continues that he is sorry he did not preserve the remains of Benjamin Franklin in this way.[19] Lillian Miller adds a note to the Peale papers that "although (Peale) never exhibited embalmed people in the museum, his proposal was serious and follows from two central tenets: that as a species in the order of natural history, human beings should be treated like other species, and that moral values could be transmitted to posterity by the physical representations of exemplary men. For Peale death was an event in the economy of nature and no special sanctity was attached to the corpse."[20]

Despite Miller's statement regarding the typicality of Peale's Enlightenment attitude toward death, there remains in his work a persistent theme of anxiety concerning the death of children and the possibility of war as a cause of human extinction. Although natural death is to be expected, the death of a child is of course in a profound sense unnatural, a death that most radically arrests the progress of time. In March 1806 Peale attempted to obtain an embalmed child from a New York church. His request for the child's corpse comes many years after the death of his first children, but echoes as well another moment of trauma when he anguished over a loss of bodily integrity. In the chaotic aftermath of the Revolutionary defeat at the Battle of Trenton, Peale had not been able to recognize his brother James. He wrote in a letter to Thomas Jefferson, "I thought it the most hellish scene I have ever beheld." When a man walked out of the line of soldiers toward Peale, "He had lost all his clothes. He was in an old, dirty, blanket jacket, his beard long and his face so full of sores he could not clean it, which disfigured him in such a manner that he was not known to me at first sight."[21] What war had destroyed here—clothes and face—are those qual-

ities of person making portraiture intelligible.[22] Furthermore, the disfigurement of countenance, of the lineaments of the total person that Peale had so carefully learned to represent in his portraits, presents a severe blow to the possibility of knowledge and recollection key to all of Peale's aesthetic and epistemological values.

After the war and a brief period of public service, Peale suffered a kind of nervous breakdown—the symptoms were an inability to move and an inability to remember—specifically, his memory loss centered on the order and number of his children and the status of death. Toward the close of 1782 he decided to hang the painting of *Rachel Weeping* in his gallery behind the curtain, with the message beginning "Draw not this curtain." He added a poem that he said was anonymous, but that also appeared on the last page of his letter book for 1782–95. The poem warns that the death is "no more than moulded clay," but that the display might evoke an excessive response in anyone viewing the mother's unceasing mourning:

> Draw not the Curtain, if a Tear
> just trembling in a Parent's eye
> Can fill your awful soul with fear,
> or cause your tender Breast to sigh
>
> A child lays dead before your eyes
> and seems no more than moulded clay
> While the affected Mother crys
> and constant mourns from day to day.[23]

A month of so later Peale experienced a breakdown, writing on January 15, 1783, that for more than two years he had been in a kind of lethargy marked by dramatic memory loss: "some short time past," he wrote, "I was sitting by the fireside musing within myself when a thought struck my fancy, i.e. how many children have I. Four, I answers as if it were by Instinct, four! Let me see if I am right and looking round (and) began to name them as they appeared before me, as my not seeing Raphaelle, I was puzzled for some moments to make out my number." He then recounts another instance occurring just the day before, when he "chanced to be looking at the picture of my mother in law and he instantly remembered her person, but could not recollect whether she were dead or not and the circumstances of her will." [24]

It is significant that it is the painting which induces in this latter case the ambiguity of the mother-in-law's life or death. The painting is a kind of presence, a bringing to mind if not to sense, but what kind of presence is it? One of the ways in which a painter can explore the cognitive boundary between displaying death and displaying life is through various devices of *trompe l'oeil*—the kind of fooling the eye that suspended animation, or an exaggeration of the conventions of realistic art, can bring about. *Trompe l'oeil*, itself a kind of material and secular miracle of animation, appealed to Peale in various ways throughout his career and later became the device used by Raphaelle, his most troubled child, in his paintings. Following eighteenth-century aesthetic conventions, the elder Peale ranked the various forms of *nature morte*, which he referred to as "deceptions," low in his hierarchy of painting because they teach no moral values. Yet he sees such work as potentially crowd-pleasing or, more charitably perhaps, as being attractive to afficionadi of painterly technique. Exemplifying this is *The Staircase Group: Raphaelle and Titian Ramsay Peale I*, as it is most often called, which was finished for the "Columbianum, or American Academy of Painting, Sculpture, Architecture, and Engraving" at the Philadelphia Statehouse in 1795. It shows Peale's two sons in life size, climbing a winding stairway. The deception was designed to fool the viewer into believing in its reality. Peale insisted that the picture be hung in a doorway rather than on the wall, and he had an actual step built into the room at the base of the painted step. According to Rembrandt Peale, George Washington, on a later visit to the museum, bowed politely to the figures, for he thought they were "living persons."[25] As early as 1787 Peale had placed a life-sized wax figure of himself in his museum as a way of fooling the public into assuming his presence there. And there are other accounts of Peale traveling through Maryland in a carriage harnessed simultaneously with living horses and stuffed fawns as well as several other taxidermic specimens. This project, he reported in his *Autobiography*, "excited much curiosity along the road."[26]

Peale's "deceptions" may be seen in classic psychoanalytic terms as "derealizations" in that they serve as means of defense, keeping at bay the irreducible fact of a boundary between life and death. The second characteristic of derealizations—their dependence on the past, on the ego's store of memories and earlier painful experiences—is also evident here. The theme of animation centers on issues of the preservation of meaning in the face of its traumatic disturbance.[27] Accordingly, as Peale recovers from his postwar breakdown his first project is an effort to create an exhibition of moving pictures.

Peale decided to invent a spectacle similar to Philippe de Loutherbourg's miniature theater of sound and light in London. He created six pictures, which he advertised in 1785 as "perspective views, with changeable effects, of nature delineated in motion." He chose scenes of dawn rising over a rural landscape, night sinking on Market Street in Philadelphia, a Roman temple battered by a thunderstorm that ended in a rainbow, a view of Satan's fiery palace as described by Milton, and a historical depiction of the September 1779 sea battle between the *Bonhomme Richard* and the *Serapis*.[28]

In such works, Peale experimented with light, painting, sculpture, and the use of natural objects. Carved waves were worked by cranks, while real spray spurted out of concealed pipes. Painted transparencies were passed across one another in front of candles in order to produce airy effects. Foreground objects were either flat cutouts or three-dimensional props, and Peale sustained the phantasmagoric mood with music he played on a specially built organ. He soon discovered, however, that the public wanted perpetually new works—all of which cost a great deal in time, labor, and materials. In a letter to Benjamin West in 1788, Peale told him that for two or three years he had studied and labored to create this exhibition of moving pictures; consequently, he had "injured his health and straitened his circumstances."[29]

It was at this time that he turned fully toward his project of a museum, or, as he called it, a world in miniature. He began by building a landscape out of turf, trees, a thicket, and a pond situated on the gallery floor. On the mound he placed what he referred to as birds that commonly walk on the ground, as well as a stuffed bear, a deer, a leopard, a tiger, a wildcat, a fox, a raccoon, a rabbit, and a squirrel. The boughs of the trees were loaded with birds, and the thicket was full of snakes. On the banks of the pond he placed shells, turtles, frogs, lizards, and water snakes while in the water stuffed fishes swam between the legs of stuffed waterfowl. A hole in the mound displayed minerals and rare soils.

Peale's two major sources for his collection were gifts, largely of curiosities or items that were in some way souvenirs of historical events and famous persons, and those items he and his sons gathered as they traveled in search of specimens. In his search for varieties of every species, with no duplicates, he promulgated Linnaeus's system in the interest of universal laws.[30] Although he would later, as his own dynasty grew, imagine his museum's world as one of paired specimens for reproduction, his wish that there be "no duplicates" is connected to the concepts of uniqueness, individuality, and character that inform his portraiture: the republic of the New World was to be built from the singular actions of singular individuals.

Peale's 1800 *Discourse Introductory to a Course of Lectures* is perhaps the fullest statement of his philosophy of collecting. He links himself in a great chain of largely unrecognized founders of national museums, from the Alexandrian Library and repository of Ptolemy Philadelphus (a kind of historical pun on his own name and location) to contemporary British and European museums. By 1800 his collections were overflowing Philosophical Hall; and Rembrandt's and Raphaelle's museum in Baltimore, begun in 1797, had already failed. Peale's 1800 *Discourse* is in fact a somewhat hysterical document, full of elevated scientific claims and sudden plunges toward dark lyrical effects. In recounting the history of museums, Peale includes a dirge to Aldrovandus before he goes on to tell of the British Museum and how hard it is for the public to view it. A recurring theme of the document is the idea that science is a cure for war. Peale tells how "the chiefs of several nations of Indians," former bitter enemies, met by chance when visiting his museum and were inspired to resolve their differences.[31] But most jarringly, as Peale presents his philosophical and political rationale for the museum, he weaves the lecture into the story of the death of his son Titian in 1798. Titian Ramsay Peale the First's death occurred in September of that year, and two months later Raphaelle Peale's first child died in infancy. In 1799 Charles Peale named a son by his second wife after Titian, thereby connecting the rebirth of the museum with the rebirth of his son. The lecture includes the performance of two musical interludes with words written by Rembrandt Peale. The first is called the "Beauties of Creation" and suggests,

> Mark the beauties of Creation,
> Mark the harmony that reigns!
> Each, supported in its station,
> Age to age unchang'd remains.[32]

The second is an "Ode on the Death of Titian Peale":

> His early loss let Science mourn
> Responsive with our frequent sighs,—
> Sweet flower of genius! That had borne
> The fairest fruit beneath the skies!

Again, taxonomy is seen as an antidote to emotion and surplus meaning. Charles Peale attached a note to his lecture, explaining, "This early devoted and much lamented youth, died with the Yellow Fever in New York in

1798. It might be excused if the fondness of a parent indulged in the eulogium of his son; yet the testimony of numerous friends and acquaintances confirm his worth . . . and the plans which he had commenced, to the prosecution of which his whole soul was devoted, far beyond his years, raised the greatest expectation of his becoming the Linnaeus of America." [33] In ensuing years, as the yellow fever made periodic reappearances, Peale advertised the museum in the *Philadelphia Repository and Weekly Register* as a place where lost children could be kept until called for.[34]

In 1801 Peale heard of the discovery of huge bones by a farmer near Newburgh, New York. He and Rembrandt traveled quickly to the farm, examined the bones, and purchased rights to dig further in the marl pit where they had been found.[35] Cuvier had published the mastodon as an example of an extinct species. The discovery of the Newburgh specimen was dramatic evidence that species could become extinct over geological time. The American Philosophical Society gave the Peales a loan to conduct the excavation, and the family eventually put together two mastodon skeletons that went on to a wide and varied career as exhibitions, from Peale's museum to P. T. Barnum to the American Museum of Natural History in New York to the Peale Museum in Baltimore, where one set is currently on display.[36] In 1807 Peale wrote to Benjamin West of his progress in painting a picture of the site: "Although I have introduced upwards of 50 figures, yet the number of spectators in fine weather amounted to hundreds. Eighteen of my figures are portraits, having taken the advantage of taking most of this number of my family." [37]

This picture is in fact a kind of summary of Peale's career, offering a counterpoint to a copy he made in 1819 of Charles Catton's *Noah's Ark*, just as the realism of *Rachel Weeping* was in counterpoint to the copy of *Elisha Restoring the Shunamite's Son*. The copy of Catton's *Noah* and the picture of the exhumation provide a number of insights into the relations between mourning and taxonomy, memory and animation, I have been pursuing. As Peale continued to add to the canvas of the exhumation through 1808 he delineated more and more family members and friends to be included in the glory of his momentous discovery. Just as Noah's sons, in the face of extinction, would help their father gather members of each species and begin a new world, so would Peale's aesthetic dynasty continue his scientific project. Rembrandt's 1803 pamphlet on the mastodon proclaims, "The bones exist—the animals do not!" He goes on to explain that science has awakened this literally buried fact of "stupendous creation." [38] Science's triumph over death is quite literally demonstrated as Peale includes in his

painting both the living and the dead. The painting dramatizes a critical moment in the excavation when a violent thunderstorm threatened to flood the pit and end the search. The painting forms both a complement to, and inversion of, the Noah's ark theme. Here the dead—extinct species and those of Peale's family and friends who are gone—are awakened and brought back into the light. Yet flooding threatens, just as it did in the picture of the ark, and the family is once again the focus for regeneration and recollection. Of the Noah's ark painting, Peale wrote that he admired very much the innocence of the venerable old man, the sweet idea of parental love, the peacock and other birds whose lines of beauty are so richly tinted. "I can only say," he wrote, "that it is a Museum in itself and a subject in the line of the fine arts and that although I have never liked the copying of pictures, yet should I wish to make a copy of it." [39]

Of course it has long been a convention of the conversation painting, a genre Peale knew well and often practiced, to evoke mourning in a scene by including allusions to, or representations of, the dead in a picture of the living. Mario Praz has pointed out that these conventions frequently rely on portraits accompanied by busts, as is the case in Peale's play on such conventions in his family grouping, which he worked on from 1770 to 1776 and again in 1808.[40] Here the family is gathered around a scene in which Charles, pausing at his easel with face lowered from view, and James, pointing with a small stick, are giving their brother St. George advice as St. George tries to draw a portrait of their mother holding Charles's daughter Eleanor. The family is flanked by busts of Benjamin West, Peale himself, and his early patron Edmund Jennings along with an oil sketch of the Muses on the easel: those customarily in the place of the dead are, in fact, living immortals. And the children, who in such conversation pieces are usually those who receive whatever lessons the dead have to teach, here are infants who died in their first year. This quality of death pushed forward is emphasized by the placement of the still life in the foreground of the picture and by the nonreciprocity of the gazes depicted. One of Peale's last additions to the painting was the dog, Argus, placed in the foreground. At the same time, Peale painted *out* the words *Concordis Anima* (harmony embodied), which had once been written there. Peale wrote in 1808 to Rembrandt that he had erased these words because "the design was sufficient to explain the theme." [41]

But we can also see that time has erased the truth of the legend. Once more the lesson nature has to teach is an unnatural one. By the time the picture was finished, only Charles and James Peale (d. 1831) remained from

the scene. And we cannot help but remember that the dog is named "bright-eyed" after the giant who was put to death by Hermes and whose eyes were then placed in a peacock's tail. Nature's lesson is the production and reproduction of nature, not the production of order and sequence; and nature calls for vigilant observation, not the construction of moral aphorisms.[42]

Further, Peale recognized that he was himself pressed to complete works such as *The Family Group* in preparation for death.[43] Among his last works are his 1822 portrait of James studying a portrait miniature by lamplight and his self-portrait of the same year, *The Artist in His Museum*. Peale had been asked by the museum trustees to paint a life-sized, full-length portrait of himself. He wrote to Rembrandt on July 23, 1822, "I think it is important that I should not only make it a lasting ornament to my art as a painter, but also that the design should be expressive that I bring forth into public view the beauties of nature and art, the rise and progress of the Museum."[44] In his portrait, Peale holds back the curtain so that the collections might be seen, and places in the foreground the giant mastodon jaw and tibia—the mounted skeleton can be discerned to the right just above the set-aside palette. A Quaker woman holds up her hands in astonishment at the mastodon while a father talks with his son, who is holding an open book; another figure looks at the birds. At eighty-one, Peale conducts here an experiment with the relation between artificial and natural light, the latter coming from behind in the museum and the former coming from a mirror that reflects a secondary light onto his head. The light in the painting thus turns back from the foreground of the picture, and the light of nature moves forward from the back, with Peale outlined by their interrelation. Yet the curtain reminds us of the collected and staged qualities of this nature as well as of the curtain hiding a scene of death and extinction in *Rachel Weeping*. And the life-sized "deception" of Peale's figure appears realistically on the most artificial side of the curtain.[45]

I will end with this work, which does little to resolve for us the status of the animated taxonomy and which does perhaps even less to define the boundary where life ends and art begins. There are few pictures of knowledge farther from Platonism than the Enlightenment's skeptical empiricism on the one hand and psychoanalytic concepts of latency and the unconscious on the other. Yet in the case of Peale we see the limit of Enlightenment taxonomy at the threshold of inarticulate emotion. Peale frequently referred to himself as a "memorialist," meaning by this that he was painting the dead in the service of a future memory. Further, just as Freud's theory of mourning is developed around the traumatic consequences of war, so

does Peale develop his museum as an antidote to war's losses and as a gesture against disorder and the extinction of knowledge. In this nexus of motion and emotion, arrested life and animation, loss and memory, that Peale has left for us, we can begin to recollect, with both a sense of difference and a sense of urgency, a central issue regarding representation.

CHAPTER 17

EXPLOSION AT SAN GIOVANNI IN LATERANO,

SUMMER 1993

Notes for Francis Bacon's *Figure with Meat*

Omnium urbis et orbis . . .

The writer's habit is overdetermination; the painter's, obsession.

Francis Bacon felt by 1962 that the more than twenty-five paintings based upon Velázquez's *Portrait of Pope Innocent X* and contemporary photographs of Pius XII he had completed ten years or so before were "silly," and he regretted doing them. It was his practice, throughout the 1950s and 1960s, to destroy much of his work. But he also explained that he had been obsessed not with the Velázquez original at the Galleria Doria Pamphili—which he, though in Rome, in fact had never gone to see—but with reproduction after reproduction of the painting.

In the Art Institute of Chicago's 1954 *Head Surrounded by Sides of Beef*, his obsession is coming to a close, and the elements of the pope series—the monochromatic background; the vitrinelike structure, with its shifting gestalt between solid and plane, inside and outside; the Velázquez citation—are urgently yoked to a self-citation: his *Painting* of 1946, with its opened carcass of meat. And the elements of Bacon's lifelong study of figuration—the head as the locus of the expression of emotion; animal motion and rest; gesture, cry, and action in a frame of contingent circumstances—seem to lie in wait here and open to view.

· 203 ·

When Pope John Paul II visited the site of the explosion, he said that one must pity the miserable creatures who had brought it about.

————

"[W]hen I made the Pope screaming, I didn't want to do it in the way that I did it—I wanted to make the mouth, with the beauty of its colour and everything, look like one of the sunsets or something of Monet."

————

In Soutine's paintings of meat, the pity for an animal and the pity for the human mind that cannot know its animal nature are synonymous. Bacon saw the Crucifixion (picturing Cimabue's strung-up Christ or Caravaggio's inverted Saint Peter) as continuous with butchery, "a way of behaviour to another."

————

Everything hinges on the particular, immediate acknowledgment of death, which for Bacon was expressed in the animal fear of eyes and mouth. Symmetry of the carcass and the Crucifixion as the symmetry between God and animal or the reciprocity of two players in a game.

————

The image of Eisenstein's screaming nanny is etched onto the face of the Velázquez pope; the balled fists of the executed man have taken the place of Innocent's lightly resting hands, the left holding a piece of paper, the right protruding the insignia of the ring.

————

The painting as rebus: the obsession with an image as the obsession with a message. *Slaughter/massacre/innocent/sacre*: the obsession with a message as the obsession with an image—a source of the screaming mouth in Bacon's work can be seen in Poussin's *The Massacre of the Innocents* at Chantilly.

————

In the Doria Pamphili, in the same alcove and immediately at a right angle to the Velázquez, is Bernini's portrait bust of Innocent X. Carved from life: the fragility of the facial bones, the soft spread of the cloth, the eyes looking off into the distance, the shadows on the forehead and eyes, one button slightly undone, the marble in many gradations of polish—so thin at the ear

that the stone is transparent. Bernini's proficient eagerness to please as inseparable from the narcissism of absolute skill.

––––––––

(But Innocent had turned to Borromini for the restoration of San Giovanni in Laterano; his rigorous logic of light and darkness; his laurel leaves, palm leaves, and pomegranates; all "nervous," "crisp," and fundamental. Just as in Sant'Agnese fuori le Mura [an ancient torso was incorporated into a statue of Sant'Agnese], Borromini took fragments of the tombs from the old basilica and put them into new monuments. Manslaughter, 1649: when he found a man tampering with the stonework of the basilica, Borromini and his helpers beat him to death. Innocent intervened to save them from punishment. Geometry as redemption from the clumsy violence of life— Borromini, too, turned against himself.)

––––––––

In Bacon destruction stems from irrevocability—the irrevocability of time. The economy of his practice demands that the painting not go beyond a certain point, or the work is lost; in this economy, excess requires—demands—destruction. To paint beyond the work is to introduce the tyranny of a will that pushes the work over into stasis and death. Hence the aleatory as sacred: in reverence the painter maintains the spinning theater of action, the great wheel driven by fate and contingency, which carries him beyond the merely articulate and intelligible.

––––––––

The Velázquez portrait: the florid face below the red satin camauro and above the red satin mozetta, the lace rochet with *punto in aria* edging, the red velvet sedia with its gold banding and gold finials, the whole enveloped in a heavy red drapery stained by the sedia's tapered shadow. Bacon will take the red from the figure and displace it to the carcass; he will lift the shadow's jointlike shape and splay it symmetrically behind the figure.

––––––––

Velázquez returned the gold chain the pope had offered as a prize for the portrait. He wrote on the sheet of paper, held between the thumb and forefinger of the pope's left hand, Alla San(ta) di N(ro) Sig(re)/Innocencio X(o)/Per/Diego de Silva/Velasquez de la Ca/mera di S.M(ta) Catt(ca).

––––––––

Haunted by an image, obsessed by a face. For Velázquez, the object is to paint seeing; for Bacon, the "deep game" of the feeling of life.

———

Radiographs of artworks and the body. These two uses of the technology appear incongruously in tandem as the turning of the inside out: the radiograph of the painting reveals layers of intentional actions, the history of the painter's will; the radiograph of the body fragments, partitions, pinpoints, frames, and marks the site of decay and dissolution. Bacon's text here is K. C. Clark's 1929 *Positioning in Radiography*. In *Head Surrounded by Sides of Beef*, the radiographic arrow points to the most interior space of the slaughtered body, away from the pope, who seems to spill forward, as if the sedia had been ejected. Despite the influence of Titian's veiling, Bacon's scoured surfaces and striations echo with uncanny precision, as if his portraits were *underneath* the baroque works, radiographs of the Velázquez. In this, and not in any gesture toward immortality, the painter has turned against time.

———

Meaning as a coming forward.

———

Destruction in the basilica of San Giovanni in Laterano: circa 455, 896, 1308, 1360, 1993.

———

There is no natural history of terror.

CHAPTER 18

MUSICAL BOX

Lifelong to be
Seemed the fair colour of the time;
That there was standing shadowed near
A spirit who sang to the gentle chime
Of the self-struck notes . . .

—Thomas Hardy, "The Musical Box"

Things with things, persons with objects,
Ideas with people or ideas.
It hurts, this wanting to give a dimension
To life, when life is precisely that dimension.

—John Ashbery, "Vaucanson"

History

Why does the past not come roaring up behind us like a freight train run by
a drunken brakeman, but rather recedes as a spill of small notes in the dis-
tance—distinct, then eventually inaudible?

The musical box calls us to contemplate the perfection of a little world.
It is charming: at once diminutive and powerful as music, the arrangement
of sound in time, enclosed within a crafted space. Closed, the musical box
is all potential, a temptation to wakening. Opened, it sends forth its spell of
order, melody, and memory, one note at a time.

A chronicle of 1250 from Würzburg mentions a tree made of precious metals upon which mechanical birds flap their wings and sing.[1] Leonardo da Vinci constructed a mechanical spinet and drum set.[2] Yet the origins of mechanical music can be traced more readily to the baroque. The self-playing pipe organ of the Villa d'Este, for example, is described in Montaigne's travel journal on April 3, 1581:

> The music of the organ, which is real music and a natural organ,
> though always playing the same thing, is effected by means of the water,
> which falls with great violence into a round arched cave and agitates
> the air that is in there and forces it, in order to get out, to go through
> the pipes of the organ and supply it with wind. Another stream of wa-
> ter, driving a wheel with certain teeth on it, causes the organ keyboard
> to be struck in a certain order; so you hear an imitation of the sound of
> trumpets. In another place you hear the song of birds, which are little
> bronze flutes that you see at regals; they give a sound like those little
> earthenware pots full of water that little children blow into by the
> spout, this by an artifice like that of the organ; and then by other
> springs they set in motion an owl, which, appearing at the top of the
> rock, makes this harmony cease instantly, for the birds are frightened
> by his presence; and then he leaves the place to them again. This goes
> on alternately as long as you want.[3]

In Montaigne's record we find an account of music as the cultivation of sound; the Villa d'Este or the Frascati villa of Cardinal Pietro Aldobrandi, with their gardens of sound, their staging of aural harmony and dissonance, are engaged in the great baroque project of attending to the *duration* of perception. In a 1618 treatise, the Oxford medical doctor De Fluctibus (Robert Fludd) proposed mechanical instruments, including four types of metal cylinders designed to revolve at a regular tempo as pins, quills or other devices produced sounds, usually by being connected to organ pipes.[4] Caspar Schott, in *Technica Curiosa* (Nurnburg, 1664), and Athanasius Kircher, in *Musurgia Universalis* (Rome, 1650), worked on further inventions of automatic instruments. Kircher published a *Ricercata* by Johann Kaspar Kerll as an example of suitable music for his organ.[5]

The sixteenth-century automatic organs of Augsburg were given forms—a gilded warship with a crew, a miniature building with a flight of front steps, a balcony and stage with gilded sculptures, and a crèche—that juxtaposed the stasis of monumentality with the movement of music.[6] For such an organ, the surrounding architecture forms its box, the limit of its sound.

Of the seventeen works included in The Music Box Project, Aminah Robinson's twelve-part installation of *My Lord What a Morning* and Vito Acconci's musical vest perhaps most clearly exemplify the possibilities of mechanized music in public space. Just beyond human scale in size and intensity, Robinson's construction is made of ten sculptural figures constructed from organ pipes and adorned with individual iron headdresses. The headdresses are based on gate designs slaves forged in the American South. Each pipe plays the title spiritual, and each bears a painted image of an expressive figure and words from the hymn's lyrics. The cascading sound is how we might imagine the singing of choirs of angels, yet each pipe also stands on a dark pediment that reminds us of the involuntary labor from which the spiritual was a reprieve and solace.

As the organ develops it becomes an instrument characteristic of both gigantic ceremonial space and a miniaturized intimacy—the street organ (pierement) in its small serinette or canary organ form, so called because its single voice was used to teach canaries melodies, and the tiny pianolike carillons placed inside watches. Suggestively, Vito Acconci's vest is designed to be worn just as the serinette might be donned by the wandering street musician. It has thirty pockets, each with an eighteen-note movement playing a familiar song Acconci selected from the tune list of the Reuge music box company of Sainte-Croix, Switzerland, sponsors of the project as a whole. The vest transforms its wearer into a one-person jukebox or ambulatory music box shop.

In his classic work, *The Rational and Social Foundations of Music*, Max Weber wrote that "the organ is an instrument strongly bearing the character of a machine. The person who operates it is rigidly bound by the technical aspects of the formation, providing him with little liberty to speak his personal language. The organ followed the machine principle in the fact that in the Middle Ages its manipulation required a number of persons, particularly bellows treaders. Machinelike contrivances increasingly substituted for this physical work."[7] These issues—the preference for the mechanical over the organic; a world of automated universal expression (as opposed to Weber's Romantic notion of a "liberty to speak [a] personal language"); a sound beyond the productive capabilities of instruments miming animal and human sounds—all lead to a cultural world, a made world beyond nature: the giganticized expression of the public orders of church and state or the miniaturized presentation of human emotion.

By the eighteenth century the inventors of mechanical music focused upon two linked associations: the musical clock and the animated figure. The fourteenth-century performing astronomical clocks at Strasbourg Cathe-

dral are predecessors, as are the fifteenth-century "jacks" of Wells Cathedral. At Wells, "Jack Blandifer" strikes the quarter hours with his heels and the hours with a hammer he holds, and two jousting knights strike the quarters with their battle-axes, falling from their horses on the hour. The *android*, or automated figure, and the clock are joined in inventions that celebrate the mechanization of organic form and experience.

If for the Deists the natural world was a clock that God had set ticking, the eighteenth-century makers of automatons and musical clocks imitated this concept of a calibrated creativity. The father-and-son team of Pierre and Henry-Louis Jacquet-Droz in the mideighteenth century created what came to be known as the "Berger" clock—a flute-playing shepherd stood on the top of the mechanism while dolls, a dog, and a bird produced sounds of bells and metal flutes.[8] Their most fantastic creation was the Clavecin Player, a mechanical girl who played the organ with movements of her fingers, head, eyes, shoulder, and bosom. In a career that spanned much of the century, Jacques de Vaucanson, a mathematician and inventor, created many automatons, including a life-sized mechanical duck that could preen, shake its wings, quack, eat, digest, and excrete.[9] His flute-playing models actually blew upon instruments, changing lip and finger movements to play the tunes. Here as in the Jacquet-Droz organist, it is the musician who is animated and not simply the instrument.

In the current show, the architectural firm Coop Himmelblau displays a gangly, inanimate being it calls *The 3D Tattoo: Gimme Shelter*. It has three feet and is a three-dimensional representation of a tattoo the firm's principal, Wolf Prix, wears on his upper-right shoulder blade. A music box mechanism in the object's "top" plays the opening lines of the Rolling Stones song "Gimme Shelter." By being the song, singer, and environment in one, the figure creates a self-contained arena for expression and animation and speaks to the continuing evolution of the automaton. As Wolf Prix explains, "The logical consequence is: architecture begins to move and walk."[10]

The traditional musical box, which emerges as an industrially produced form in the 1820s, is a further development in this drift toward the mechanization of human expression. In contrast with carillons, organs, and string instruments, which can be mechanized as well as played by musicians, the musical box appears to be cut off from human volition and will—a fully automated instrument consisting of a system of vibrating steel teeth moved by a cylinder mechanism so that the teeth are a direct sound source in themselves. The box is not played by us—rather, it plays us; its evocation of emotion comes from a time and space seemingly beyond human agency. Many works in the project capture the mesmerizing effects of the musical

box's circling images and revolving music. Nam June Paik's *I Wrote It in Tokyo in 1954* plays a 144-note transcription of one of the artist's musical compositions while a television screen shows a real-time video image of the turning mechanism for the music as it is projected by a camera. This layered technology gives us the sensation of moving into the future and past at once. Gretchen Bender's work *Solaris* is a slow unveiling of the images from Andrei Tarkovsky's film of that name. John Cage's *Extended Lullaby* is a twelve-part piece played on twelve musical movements that are housed in a long, transparent glass cylinder. The work compels progressive turns from alertness to serenity as we wait for the halting progression of sounds to unfold. In his *Moonlight Sonata*, the Fluxus artist John Armleder has arranged on a flat canvas sixteen green discs of the kind used as bases for twirling figures so that they move counterclockwise and play various selections from the Reuge tune list. They can be played all at once as a spinning orchestra or one by one as samples.

Severed from its origins and working on its own, the musical box continues the dream of a human creativity that could be so powerful as to wake the dead or create an autonomous and reciprocating form of life. In 1796 Antoine Favre introduced his "carillons sans timbre ni marteau" to the Societé des Arts in Geneva. In Favre's invention the little bells and hammers of the miniature carillons in watches were replaced by a simple comb of steel teeth plucked directly at the top by tiny pins on a revolving cylinder. The comb was made of several groups of one to three teeth; as is the case in any musical box, the tooth did not work as a repeatable note; rather, each tooth played one note, so that if identical notes followed each other, the note-tooth had to be replicated with as many teeth as the composition required.

Between 1814 and 1820 a further innovation was made. François Lecoultre created the first comb from a single piece of steel and improved upon the working of the comb as well. He made the teeth at gradually shorter lengths on one end in order to produce a higher register, and he weighted the teeth on the other end with bits of lead in order to produce sonority in the longest teeth.[11] In this exhibit, the lush sonority of John Cale's wedding music, Jan Muller-Wieland's composition to be played out of Raimund Kummer's glass flower, Paik's 1954 composition, and the sounds of Vivaldi emerging from Annette Lemieux's music box of the four seasons all use the 144-note movement made possible by nineteenth-century developments in music box technology.[12] One of the most interesting features of The Music Box Project is that the works taken together might be seen as a kind of museum of music box technologies as they are adapted for varying aesthetic effects.

The production of musical boxes centered in Geneva in the late eighteenth and early nineteenth centuries, but by 1811 much of the activity had shifted to Sainte-Croix, which is still a major location for musical box and automaton manufacture by Reuge and other firms. The Vallée de Jeux in the Jurassic Mountains near the French border has been an important center of craftsmanship since the Enlightenment. Within the Alpine pastoral economy with its long winters, the musical box industry has depended on both cottage industry and an older artisanal social structure that had been continued in the manufacture of lace and watches.

In the midnineteenth century, traders or negotiators supervised the work, carrying the parts from place to place and arranging sales. Even after industrial manufacturing replaced the traders' system toward the end of the nineteenth century, the factory system as well relied on home work.[13] Craftspeople traveled to the factory to pick up workpieces and delivered finished components in long wooden crates. Recorded on the insides of crate lids are messages by the workers—remarks about the weather, local births, marriages, and deaths, observations on current events—all carefully dated and signed.[14] Given that the workers could often have little or no contact with their fellow artisans who were making other components of the piece, and that they often never saw the finished piece, these cartons, with their journal-like writings, recorded the individuality of voices and segmentation of the process that the finished product belied.

Kircher's 1650 *Musurgia Universalis* depicts a satyr playing the flute and a nymph playing the organ; in the musical round they produce, the satyr plays the treble and the nymph the bass.[15] In constructing the musical box, the gendering of labor works in the opposite fashion—as the work becomes finer it is done by women. The base plates are made in foundries by craftsmen who cast and polish them. The combs are made into rough shapes in industrial workshops; then they are tuned in home workshops by other craftsmen using files and lead weights—the weights are used to slow down the vibrations for the lowest notes. A middle register of the scale is determined and the notes adjusted in relation to that mean. Each musical box, therefore, is tuned to a relative rather than an absolute pitch. Next, a transposer adjusts a master cylinder, matching a treble note score to the number of teeth. The cylinder is prepared for drilling, and after this the pins must be inserted. A typical cylinder requires sixteen hundred fine steel pins; this work is done almost entirely by women in their homes. A team of women and men assemble the final components and inspect the movements.[16]

In completing the works for The Music Box Project, Reuge Music has constructed mechanisms "playing" traditional, new, and even what may be

called "nonmusical" sounds. Irene Fortuyn's installation, *Small Sound Library for an Old Village*, expresses the sound arising when the music box's pins are arranged on the cylinder to follow the shapes of leaves: sycamore, horse chestnut, linden, and Lombardy poplar. The "sound" of the visual shape echoes within the material remain—each book-shaped box housing the cylinder is made from the corresponding wood. Kiki Smith's work includes an original composition by Margaret de Wys and a braille translation of a poem she has written, transcribed in pins onto the music box's cylinder. The resulting "music" creates a haunting correspondence between speech and song beyond the capacity of any human "voice."

Animation

Why does the dream of animation recur as the dream of a figure that can move itself? What is the nature of the pleasure underlying divestiture of agency and the creation of a self-perpetuating object? In *The Meno*, Socrates mentions the images of Daedalus and recounts how, if they are not fastened, they will run away, likening them to opinions, which if not tied to a cause by recollection will flee from the human soul.[17] Aristotle's *De Anima* gives another account of these pieces, saying that Daedalus was rumored to have endowed his wooden figure of Aphrodite with movement by pouring quicksilver into it.[18] The earliest baroque mechanical instruments, those proposed by De Fluctibus, Schott, and Kircher, operate by means of keys, cranks, and pulleys, or by water- or wind-driven clockwork.

From the allegories of Daedalus's statues to the animated objects of fairy tales, from Renaissance and baroque automatons to motion picture technology, alternative times and spaces—the times and spaces of dream and fiction—appear severed from their origins in human agency. Of all the parts of the mechanical instrument, the talking doll, and the dancing puppet, it is the key, crank, string, or pedal that is the least obtrusive. Such a device is the umbilical cord linking life to nonlife, a cord that the maker hopes to make obsolete. When the musical boxes here emphasize such an apparatus—as in the prominent crank of Gretchen Bender's *Solaris* picture box, or the sprouting keys of Christian Marclay's *Wind Up Guitar*, or the delightfully slow prancing of the slides of horse images in Jennifer Bolande's music box carousel—the effect is both charming and whimsical, for we are returned to the interface of hand and device where technology remains on a deliberately childlike or amateur scale.

In an Italian folktale, "The Barber's Timepiece," a barber makes a magical clock:

> [A]ll sorts of people came to see this wonderful clock, spoke to it, and received an answer. It could say when fruit trees would bear, when winter and summer would arrive, when the sun would rise and set, and how many years people had lived. . . . Everyone would have liked to have it in his house, but no one could, since it was enchanted: People therefore longed in vain to own it. But everyone, whether he wanted to or not, secretly or openly had to praise the old master barber who had been clever enough to make this unique timepiece and make it run forever and ever, without anyone being able to break it or take possession of it, except for the artist who fashioned it.[19]

To make a clock that will not ever stop is synonymous with making another temporality—one that transcends the limits of organicism and overcomes the inevitability of death by means of possibilities of technique and making.

Once such a figure is created, its freedom is a sign of its bondage to the creator's genius. In fairy tales of magical objects, and in the operation of both sympathetic and contagious magic, possession is the condition of power; the more absolute the possession, the more absolute the power. It therefore is not surprising to find the development of the musical automaton and musical box proper associated with luxury and uniqueness, even as the manufacture of increasingly cheap, imitative, and cruder forms emphasize by contrast the particularity of such luxury items. And yet the desire for an animated object, as any version of the Galatea story shows, always falls tragically short of the reciprocity and erotic force provided by organic life.

Consider two famous automata, one the above-mentioned eighteenth-century Clavecin Player of Pierre and Henry-Louis Jacquet-Droz and the other the Isis figure created by the American Cecil E. Nixon in the early twentieth century. As the Clavecin Player performed, her bosom rose and fell; she looked at her hands, her music, and her audience. Steel pins worked by levers passed through her elbow to her hands and moved them over the keyboard. She bent over her music as if to study it, and bowed as she completed each of the five pieces in her repertoire. Between pieces, she would breathe and drop her eyes shyly.[20] Nixon's *Isis* was a wooden figure of a woman, life-sized, who lay on a high couch decorated with Egyptian motifs of hieroglyphics and leopard skins. She played the zither with both hands, the right hand playing the melody and the left strumming the chords. The fingers plucked the strings by means of electromagnets while the arms were

worked by a strong spring mechanism. As the temperature in the room would rise to 80 degrees Fahrenheit, *Isis* would remove her veil until the temperature fell again.[21] Alexander Buchner, who records the history of these figures, mentions that Isis was a "sensation" in the film studios. In each of these figures, the creator has anticipated the underlying, and un-fulfilled, need of the viewer—the need for a reciprocal gaze: the downcast eyelashes of the Clavecin Player and the removal of Isis's veil promise a par-ticularity of response that is repeated and generalized pathetically. The tau-tological eroticism of the fetish is evident here despite the desperate, much considered, effort toward animation. As musical objects develop, all inani-mate things might possibly burst into song: snuffboxes, jewel boxes, minia-ture chalets, picture albums, cigarette boxes, toilet paper holders, small oil paintings, and landscapes under bell jars where a tiny marquis might play a tiny violin.[22]

Music in a Box

What is the charm of this magical music? It is the charm that lulls us from this world and awakens us to another. The musical box plays a music of du-alities: evocation and fading; an abrupt movement out of and into silence; the truncated and dichotomous relation between theme and refrain; the rigidity of absolute repetition. The music presents a law of form within the vagaries of dream.

Here the musical box's technology finds it source in the Aeolian harp, the music nature plays for us if we contrive the proper instrument for her. If air is drawn at a constant speed on a tightened string, it will produce a friction note. Once the vibrations of the air current are in consonance with the vibration of the string, a tone can be heard. If there is no consonance, partial tones can be heard; those lower than the ninth belong to our con-ventions of musical notes in the West; higher partial tones go beyond this scale and produce a dissonant, unearthly tone.[23] The Hebrew scriptures, commentaries on Homer, Chinese musical history, and of course Romantic poetry all discuss the Aeolian harp, whose music rises and falls beyond hu-man volition.

New music was composed for mechanical instruments from their incep-tion—Kircher, for example, wrote works himself and published pieces by others, including Kerll—and well-known works such as Haydn's and Mozart's fantasies for flute-playing clocks have been adapted to the orches-

tral repertoire. Yet it is the familiarity of music that makes it suitable for the musical box. One listens on the threshold of recognition, gradually or suddenly enveloped in the context of the music's source.[24] Jonathan Borofsky's installation in a black plastic briefcase plays "White Christmas" forward and backward. As this satire indicates, we do not listen to the *music* of the music box—we listen to its evocation. In this the music of the mechanical instrument transports us. But unlike the abstract spirituality of much Romantic and post-Romantic music, this is a music of reference. A form of souvenir, the music here connotes another world to which the listener is attached by a glimmer of recognition. The musical box is playing a song which is both "my" song and "our" song.

The many examples of collaborative work in The Music Box Project explore this metamorphosis between "my" and "our." John Cale and Joseph Kosuth have placed Cale's "wedding music," which is itself a souvenir, inside an exaggeratedly scaled "sacred" book that Kosuth has made and stamped with an aphorism from Balzac on solitude: "Solitude is fine, but you need someone to tell you that solitude is fine." As in the dialogue of sounds in Smith and de Wys's collaboration and Kummer's glass chamber for the music of Muller-Wieland, a kind of synesthesia of hand, ear, and eye maintains at the same time the singular pleasure of each sense. This intersection of the subjective and social is encapsulated in the musical form as well, for the limited amount of musical information that the cylinder can present places the focus on the simplest and most contained part of the theme, often presenting a condensed moment where the solo and tutti parts are adjacent.

Reuge Music's extensive tune list includes what they call "famous composer themes." These works are often the early standards of amateur music lessons: Boccherini's "Minuet," Beethoven's "Für Elise," a Bach gavotte, and familiar compositions from opera and ballet. Other categories include Christmas Tunes, Religious Tunes, Children's Tunes, and selections based on nationality. The Swiss Tunes, including "Emmentalerlied," "Min Vater isch en Appenzeller," and "Niene geits so schön u luschtig," are mostly popular and folk songs tied to regional culture, tourism, and nostalgia. "American tunes" include movie themes, "Hava Nagilia," and "Greensleeves." This is the music of school concerts, amateur nights, campfire sing-alongs, wedding receptions, church recitals—the music of socialization in which individual experience intersects with generational experiences and the lines between desire, nostalgia, and a kitsch materiality are blurred.

Farthest from a universal music, the tunes played by the musical box are more often than not particular and local, limited in space and time. This

very particularity is the source of their evocative power. Yet this particularity is nevertheless an outcome of modernity's uniform modes of production, and the creation of private meaning is indebted to social codes. Max Weber and Jacques Attali each have traced the development of Western music along lines of increasing rationalization; the consequences for music were an emphasis upon performance within the interior spaces of the drawing room and concert hall—a music performed within a surrounding silence; an increasing emphasis upon composition and score as the "scripting" and regulation of individual performance; an emerging link between composition, writing, and an economics of novelty in the commercialization of music and a decline in music's public, ritualistic functions.[25]

The musical box emerges, as do all forms of mechanical music from the baroque automaton to the compact disc, under conditions of professionalization. Mechanical instruments, made by experts and set into motion by unskilled amateurs, make music widely available and increasingly repetitious. The theme played by the musical box has a leveled intensity; there is no *sforzato*, no incursion of the subjective, no fevered eruption or stoical withdrawal of the body. As the solo performer in the concert hall takes on these emotional conditions, producing Romantic catharsis on the one hand and the spectacle of an unapproachable suffering on the other, the mechanical instrument plays on neutrally, objectively, reliably. The musical box's temporality is unconflicted and harmonious—a history unperturbed by event or the disaster of closure. It is a music of perpetual beginning and consequently of *arrested* development—the affinity between theme choices and the standards of the music lesson repertoire is only emphasized by the mechanism's drop back into silence. The dainty constrained repetitions of the musical box stop short of the expression of emotion or sexual striving; they promise the diminution of pain and the regulation of time.

The theme of containment is vividly illustrated by the box itself. Weber wrote that the creation of "resonant bodies" was a "purely Occidental" invention, related to the handling of wood in the form of boards and the development of carpentry and woodworking skills such as inlay among northern European peoples. Weber believed that piano culture developed for climatic reasons in the North. He further claimed that the piano, with its home-based and home-centered production of music, was tied to the triumph of middle-class life as it prevailed over the public outdoor music forms of southern Europe. The free touch of keyboard instruments made them suitable for the reproduction of folk tunes and dances and the amateur world of the home.[26] The musical box's enchantment is in the reproduction of time and sound, the containment, awakening, and diminishment

of a world. The box both conceals and displays the mechanism. It is the site of ornamentation and visual information. As the musical box industry develops after the 1820s the boxes are made of inlays of various woods and mother-of-pearl, materials chosen as well for their ability to promote resonance. Eventually, musical movements were encased within various novelties until the authenticity of the music is elided by the staging of surprise and the proliferation of gimmicky effects.

Several of the artists have made much use of the concept of the box. Christian Marclay's project of course brings forward the slang term *box* for the guitar and produces as well a wonderfully resonant tone out of relatively small-scale movements. The works by Fortuyn-O'Brien, Smith-de Wys, and Kummer–Muller-Wieland play on the interpenetrability of image and sound. Nam June Paik's presentation of the cylinder inside the television cabinet exemplifies the kind of visual hypnotism that can accompany the music's charm. "Glued to the tube," the viewer herself becomes the automated dreamer.

If good things come in small packages, so, as Pandora showed, does trouble arise out of opened boxes. The animation of the mechanical world, so painlessly delivering us from labor, contingency, and emotion, also presents the specter of the resolute and unstoppable: the carousel or merry-go-round that will not be halted; the red shoes that cruelly wear down the dancer; the eighteenth- and nineteenth-century nightmare of the perpetual motion machine so often the panicky theme of the violin or piano exercise. The contained world is often a frozen world, unalterable, as given as the unforeseen consequences of technological change.

In this objective aspect of the animated form is its connection to the concepts of evidence and witnessing. For example, we might think of the recurring use of the musical box in film symbolism. Here the musical box itself is a remnant of early reproductive technology—a primitive metaphor for film form itself, as in the handmade world of Bender's picture show. Borofsky's rather sinister briefcase opens to a stark display of devices; is this the toolbox of a traveling salesman or an international terrorist? The possibilities, like the music itself, seem bound to its principle of exact reversibility. In popular horror, suspense, or dramatic films such as *The Innocents* (based on James's *The Turn of the Screw*), *For a Few Dollars More*, *The Changeling*, *The Silence of the Lambs*, or *The Music Box*, musical boxes provide evidence of crimes, assigning guilt, and mirror the world of the film itself either by interiorizing the soundtrack or by replaying visual details.

The musical box has developed in such a way that it can be seen to exemplify the triumph of repetition and reproduction in musical culture. Yet this elaborate turn to kitsch, reification, and reproduction is addressed and critiqued by The Music Box Project. The curator of the project, Claudia Gould, has, by coordinating the manufacture of such a range of original works, proved that a traditional form can be reinvented and that its very tradition can serve as the material to be taken up by composers and artists. At any given moment of its open hours, the project itself is punctuated by the playing of some works and the silence of others; it has an orchestral structure based in time that is both background and foreground to its visual pleasures. It makes the visitor want to speak when spoken to, sing when sung to, as its closed and open forms recede or come to life.

ANN HAMILTON

I. *tropos*

Since 1986, Ann Hamilton's installations have explored the relations be-
tween the senses, experience, and human work as the transformation and
recognition of nature. These installations are the outcome of a monumental
labor, yet their material existence is nevertheless fleeting—for the works are
at the same time temporary. Therefore the ways in which they are experi-
enced—by those who make, attend, and observe them—is the key to their
aesthetic. The stunning visual impact of recent pieces is only the first of their
remarkable qualities. *accountings* at the Henry Art Gallery in Seattle used
hand-smoked walls, wax heads in vitrines, and thousands of copper tags
nailed to the floors and walls of four large rooms. Hamilton's recent col-
laboration with David Ireland at the Walker Art Center in Minneapolis
used forty thousand pounds of flour to empty and fill adjacent rooms.
aleph, at the MIT List Visual Arts Center, displayed enormous walls of
books about outdated technologies and a stack of mirrors, each with the
tain erased, accumulating to the height of a person. *indigo blue*, her 1991
exhibit at an abandoned garage in Charleston, South Carolina, featured
four thousand blue work uniforms folded and stacked.

Numbers here become merely indexical to a vast sensation of time cre-
ated within the relatively brief period during which the artist has taken on
these works. The literal communities that have arisen from their making
across four continents stand in stark contrast with the intimate level of
hand and eye within which they are apprehended. And yet that sense of
contrast belies the interconnectedness that is part of the political philoso-

phy running through these projects. The interrelation of local and global is not a vague aphorism but the concrete underpinning of each human act and each product of human labor.

As in all of Ann Hamilton's work, *tropos* is connected in specific ways to its site, here a factory building reinscribed by its connection to Dia and the avant-garde of the 1980s. In past works the specificity of site has included the evocation of an invisible or forgotten past—as in the allusions to Native American materials in the piece called *between taxonomy and communion* at the San Diego Museum of Contemporary Art in 1990. At other times the use of site has meant allusion to continuing presences such as trade beads, flower bulbs, and canal travel in Amsterdam or candles and local insect species in Brazil. In *tropos* the site haunts the work in its recapitulation of industrial and handwork technologies. The industrial sounds and traffic of West Chelsea come to us intermittently through the now-opaque glass of the building. The horsehair industries of nineteenth-century Philadelphia and New York are evoked by the pelt and by the history of the piece itself, which was made in those two cities. Two tons of imported horsehair were brought from China, where it had already been collected from slaughterhouses, sorted, and then tied in bundles that uncannily resembled their source—the horses' tails. The assembly of the work itself was replete with connections to the site, including the division of labor and transport of manufactured goods. Eight weeks of twelve-hour days were worked by at least six people at a time. Further, the transformation of the physical space of the room evokes the space of a reverie to which we become irrevocably drawn. We enter it with dramatic immediacy. The skin of the room has been sealed against specific knowledge; instead we are drawn toward the signs of its abstract penetration by sound and light. Whereas many of Hamilton's works have explored the space and experience of daydream brought about by repetitive labor, *tropos*'s connection to factory and piecework gives us a sense of the near claustrophobia brought about by a sealed work environment as well as the freedom offered by aesthetic cognition given such conditions of repetitive work.

Hamilton's installations in the past have also been allusive to the fairy tale's impossible tasks. Work is approached at the level of hand labor—what she calls *lap* work, in a pun on both the lap as body space and the lap as measure of exertion. And the scale of manufacturing and industry is now linked to such hand labor. The cleaning and sorting of thousands of teeth, the knitting of several miles of thread, the washing and arrangement of 750,000 pennies on a skin of honey are previous tasks by which she has evoked such "impossible" transformations. By combining these two forms

of work, hand or lap work and industrial-scale production, Hamilton has reminded us of the human labor that underlies the smooth-talking images of commodity culture. She has emphasized such human tasks, as the work itself is characterized by repetition, permutation, and accumulation. Thereby her installations have avoided any sentimentality or nostalgia that would attach itself to the presentation of the products of such labor alone or to the permanent display of them within a museum or other collecting context. And, in finishing her works, Hamilton has often returned the materials to their sources or to other usable functions. Thousands of wrestling dummies filled with sawdust were recycled as wood pulp. The above-mentioned 750,000 pennies were turned back into usable currency for a public art program. The books from *aleph* were recycled for toilet paper. The flour from the Walker show was donated to a hog farmer to be used as feed.

Such installations often used most of their funding for materials, and the work itself was completed by a shared artisanal community of volunteers—often family or friends—with the artist in the role of coworker and nurturer. *tropos*, however, proceeded in a somewhat different way, shifting the balance between hand and industry toward the latter. The members of the Fabric Workshop of Philadelphia, workers with experience in industrial sewing; members of the Dia staff; and Hamilton herself all completed the piece as paid laborers. When we consider the history of Hamilton's installations, *tropos* marks the passage from a communal to an industrial model of work, and this turn in fact has produced a luxury good—the pelt on the floor below, before, and around you as you walk through the space. Although *tropos* is one of the most spare of her installations, it also investigates and confronts the aesthetic economy's relation to excess. For the earlier pieces were in fact dependent on a larger economy that afforded the leisure of handcraft. In contrast, *tropos* has produced art as a supplement and sign of excess. As funding for art stands in relation to the general economy, so does *tropos* stand in relation to the conditions of its manufacture.

The horsehair here is synecdochal to the material animal; consequently, sewing the hair is synecdochal to animal death. The labor that begins in the agrarian world includes the labor of the dark responsibility of slaughter—the sorting and collecting of remains, their transport, transformation, and use. Of the four principal tropes of classical rhetoric—metaphor as carrying over, metonymy as the transformation of name, irony as the dissembling of speech, synecdoche as the receiving together and reversal of part-whole relations, it is synecdoche that is most emphasized by the material aspects of *tropos*. We might think of the well-known synecdoche of the book of Lamentations—"we gat our bread with the peril of our lives"—where the

enunciation of part only emphasizes the vast implications of whole. The etymology of synecdoche as a *receiving together*, the attachment that all phenomena carry and present, is brought forward by the recovery of their history.

Brought forward also are the communal contexts of weaving and of weaving's relation to early industrialism, for this enormous pelt still has been sewn via lap work and glued and assembled by hand. The relative coarseness, silkiness, and strength of the hair is dependent on the breed of horse and the weather conditions under which it grew and lived. This hair is usually imported for use in brushes, with the finest reserved for the bows of stringed instruments. And like other weavings—that of the dumbstruck Philomel, or the dueling tapestries of Athena and Arachne—what is constructed out of the fibers is a kind of voice, a phenomenon that *speaks* beyond its mere utility as an object.

The materiality of the work thereby turns on its synecdochal relation to a transformed substance. Analogously, the trope of metaphor is employed by carrying allusion, and therefore meaning, from one context to another. Like all of Hamilton's work, *tropos* resists both allegory and theatricality by means of its emphasis on process and its refusal of any framing devices. Fixed reference and spectatorship are the antitheses of the turning, transforming processes of this aesthetic. Consider, for example, some of the meanings carried over by this pelt made of horses' hair. In her use of Baudelaire's prose poem, "A Hemisphere in Your Hair," the artist marks the convergence of hair, ocean imagery, and the erotic sublime of the symbolist tradition. The following is a translation by Marthiel and Jackson Mathews:

> Your hair holds a whole dream of masts and sails; it holds seas whose monsoons waft me toward lovely climes where space is bluer and more profound, where fruits and leaves and human skin perfume the air. In the ocean of your hair I see a harbor teeming with melancholic songs, with lusty men of every nation, and ships of every shape, whose elegant and intricate structures stand out against the enormous sky, home of eternal heat. . . . On the burning hearth of your hair I breathe in the fragrance of tobacco tinged with opium and sugar; in the night of your hair I see the sheen of the tropic's blue infinity; on the shores of your hair I get drunk with the smell of musk and tar and the oil of coconuts. Long, long, let me bite your black and heavy tresses. When I gnaw your elastic and rebellious hair I seem to be eating memories.[1]

The seahorse, the sea of horse tails, mares' tales, nightmares, the mare-mare link in Romance languages. The Trojan horse, that other manufactured horse that played such an important turn in a war fought for beauty and trade. The white horse on the chalk down at Uffington, where the landscape is defined by outline or edge in contrast with here, where it is defined by skin as the lining of an interior. The memento mori of Victorian lockets, the hair wreath; the golden-haired Margaret and ashen-haired Shulamith of Paul Celan's *Totenfuge*; Donne's "bright bracelet around the bone"; Rapunzel, straw into gold; and three hairs from the head of the giant. The associations are not endless—but they are manifold, and each carrying over of meaning opens another sphere of associations and consequences. And such a carrying continually emphasizes the contamination and continuity between the animal, the human, and the god; between the material and spiritual, the senses and abstraction.

The animal pelt of *tropos* situates our feet, placing us immediately in the human world that is both contiguous with nature and built, through work, out of the wresting of form from nature. Meanwhile the tropism of sound and light here pulls our attention toward language and spirit. The hair is played like a lyre, the voice outlines the body, the weaving narrates in silence. One goes toward, is drawn toward these phenomena with the two senses that, since antiquity, have been most elevated by philosophy—seeing and hearing. Yet at the same time we remain tangled in the material, sensual, and made reality of the floor. Like the organic forces imitated by Nathalie Sarraute's *Tropismes*, we are pulled and turned toward light and at the same time rooted and situated within human convention.[2] I have mentioned earlier that *tropos* is one of the starkest of Hamilton's works. It is, I believe, the starkness of this juxtaposition that most affects our experience of it. Plunged into the interiority of this piece, we find that traversal is both imperative and snagged. The subtle change in elevation, the physical rise of the floor as we approach the farthest point from the entrance, gives a sense of vastness. The spread, wave, swirl of the pelts, with their undulating palette close to that of human hair and its temporal changes; the surface textures of hair, cotton, flesh, steel, plaster; the sound of a voice moving in and out of intelligibility and the industrial and traffic sounds intermittently rising—all the senses are summoned but only in a process of constant movement. Spectatorship is turned into *wandering*; visitors surf through the hair, moving like distracted daydreamers, intensely absorbed by the site. One cannot escape immersion; but the two cures for claustrophobia here are permeation by light and permeation by sound.

tropos is illuminated at its edges during the day, and in this, too, it resists the pictorial. It is not defined by outline or frame but by the shifting movement of the sun and the observer's circling and spiraling movement through the space. This use of light recalls the idea of blessedness, the outward sign of holiness or grace as coming into a receiving of the light and a hearing of the voice. It thus presents a meditation on the ideas of illumination and crowning. The speakers for the taped voice are placed outside the windows and work on a disjunctive cycle. The visitor cannot continuously follow this voice, but must constantly turn to it and, in doing so, turn to the light.

But spirit is not redemption here—rather, it throws us back upon the material process by which interiority is constructed—the work of language and knowledge. If one imagines this enigmatic voice as something like an oracle, then one must make the message intelligible to one's self. The modeling of this process upon the tropes of metonymy, or change in name, and irony, dissembling speech, occurs in the use of voice and figure. I would like to consider the uses of voice and reading figure more specifically, because in this case the recovery of the artist's intention can deepen our experience of the work.

"two, too, holy, known and likeness, carved pieces, old rose leaves, leaving wait melt but have." These are the words I wrote in the back of a book I was carrying during my first visit to *tropos*. They are the words I thought I heard coming from outside the windows, but on subsequent visits the words were irrecoverable, as they were discontinuous and barely discernible from the beginning. I do not think it is an accident that the words I imagined—if one can imagine in a completely auditory way—came in mostly pentameter groups and proceeded by moving through the inventory of vowel sounds in English. Here language is known as sound by the body before it is known as meaning by the mind and by memory. The continuum between the sensual and the rational is the site of making and perceiving in this aspect of the work, just as the sensual and rational are in tension in its visual and tactile aspects. Hamilton has emphasized hearing and the human voice in other installations as well. In her recent installation at the Walker she had a tape running from the interior of a desk. On this tape, with what Hamilton has described as a "liquid and sensuous voice," an actress read in Latin from Linnaeus's taxonomy of plant species. *aleph* at MIT used a visual and auditory image of stones being rolled in the interior of the mouth and the consequence sound of stones hitting stones and stones hitting teeth. And more recently in *malediction*, her solo piece at the

Louver Gallery, speakers buried in the wall projected the sound of a voice reading sections of Walt Whitman's "Song of Myself" and "I Sing the Body Electric."

Such commonplaces of loss as "if only these stones could speak" or "these walls have a story to tell"—the stubborn refusal of things to surrender their history—are worked through as productive grounds for making meaning and speaking to others. In refusing the separation of body and mind, this use of voice has maintained the idea of singularity and signature in the concept of "one's own voice." At the same time it emphasizes that the listener's eagerness and anticipation are the necessary condition for the voice as an agent of action. Whereas in earlier installations the use of voice was a kind of complement to a range of sensual effects, in *tropos*, with its more minimal elements, the voice is a key trajectory of the work—one that defines a spatial limit as well as an auditory limit and is responsible for the centrifugal movement of the visitor—the movement to the edges of the piece. As in *tropism*, Newton's concepts of *centrifugus* and *centripetus* can be used to describe their movement. Fleeing from the center and seeking toward the center, which in biology describes the development of certain flower clusters, connect the activity of reception of this piece to two directions of organic growth.

Voice is a force toward exteriority here. It moves from the interior to the exterior in such a way as to recapitulate the evolution from organic life to social meaning. Halting at the edge of intelligibility, voice in all of Hamilton's recent pieces emphasizes the process of that evolution more than its sources or ends. I find what she has done to be a kind of reversal, but echo, of the role of the voice in such a key text as Ovid's *Metamorphoses*. We might remember some examples from that poem's early stanzas—Io, changed into a heifer by Jupiter, tries to complain and is "terrified by her own voice," the lowing sound from her lips; her gaping jaw and strange horns make her flee from herself. Phaeton's sisters are transformed into trees, at last able to move only their lips. They call to their mother until the bark closes over their last words. Juno turns Callisto into a bear and "lest her prayers and imploring words should wake sympathy, deprives her of the power of speech." And Ocyrhoe, the daughter of the centaur Chiron and the nymph Chariclo, loses her sense of prophecy when she is changed completely into a horse: "Now I seem to see my human form stolen away; now meadow grass is my food, to gallop over the broad plain is my delight," she says, but "Even as she spoke, the last part of her lament was barely intelligible, for her words became blurred. Then the sound seemed to be neither

human speech, nor yet the neighing of a horse, but was like someone trying
to imitate a horse. In a little while she gave vent to shrill whinnyings and
drooped her arms toward the grass."³ The slow motion with which Ovid
has let us hear the transformation of the voice is the aural equivalent of
what happens in Hamilton's use of a voice on the edge of articulation, the
voice that moves from random noise to the expression of pain or sensation
to purposeful sound such as that made in animal communication to human
speech, fully given and received.

If it can be put this way, what one "really" hears coming from the speak-
ers outside the windows is the voice of the comic actor Thom Curley,
who has suffered a stroke that has left him with aphasia. At the artist's re-
quest, he is reading from Ivan Illich's treatise on literacy, *ABC: The Alpha-
betization of the Popular Mind* and from T. S. Eliot's "Burnt Norton," the
first section of Eliot's *Four Quartets*. In order to read for this recording,
Mr. Curley had to teach himself how to pronounce the words to read aloud.
Although he knows the words, in an interior sense, articulation is severed
from that knowledge and must be reintroduced as a separate skill.

Aphasia is the loss of functional speech—that is, the loss of the facility
to make meaning and practice cohere in the use of language. In this collab-
oration between the artist and the actor, aphasia becomes a way to inter-
rupt the fluency with which we approach the meaning and use of words. For
Hamilton, this means that difficulty is introduced on the level of the actor's
articulation and so frees us from both theatricality and any quick fix on
meaning. For Curley, this means that his work as an actor might continue—
here in both the heightened focus upon his performance of individual words
and the presentation of the slow pauses in his speech as themselves locations
of significance rather than symptoms of illness or error.

Merleau-Ponty's classic investigation of the phenomenology of percep-
tion discusses aphasia as a way of getting at the interrelations of language,
perception, and action. The aphasic can experience a disorder of voluntary
or purposeful movement; a loss of the sense of the application of objects
that one might otherwise be able to name or imagine using; or an inability
to recognize the form and nature of persons and things. More recent work
by Hanna and Antonio Damasio and Patricia Churchland has specifically
outlined the ways aphasia can affect multiple aspects of language, includ-
ing syntax, lexicon, morphology, and grammatical production and recep-
tion. Interior thought can be fluid even as its application is halted—as it is
in Mr. Curley's illness. Or verbal performance can be fluid but meaningless
because of errors in the application.⁴

In *tropos* the introduction of aphasic speech is the introduction of a certain productive irony or dissembling of the usual modes of speech processes. Mr. Curley's voice is at the edge of our consciousness. Its intention is irrecoverable for us unless we strain at listening and thereby imitate his strained efforts at speech. There is a passage in *The Phenomenology of Perception* that is useful for understanding what has been interrupted here:

> [T]he essence of normal language is that the intention to speak can reside only in an open experience. It makes its appearance like a boiling point of a liquid, when in the density of being, volumes of empty space are built up and move outward. As soon as [a person] uses language to establish a living relation with himself or with his fellow [persons], language is no longer an instrument, no longer a means—it is a manifestation, a revelation of intimate being and of the psychic link which unites us to the world and to our fellow [persons].[5]

In *tropos* as we strain to perceive the voice we become aware of not merely the efficiency and utility of words, but of their materiality as the ground upon which our own subjectivity is born in the recognition of the other.

I have not mentioned the specific texts that Curley is reading in any detail, for they do not appear to us in that specificity. But they are vividly, exaggeratedly specific for the reader. Illich and Eliot have respectively recorded the processes by which a broadly social agenda of transformation can arise from reading and, in Eliot's case, the ways in which an intensely meditative and spiritual agenda can arise as a critique of the social. The voice is speaking, but the speaker is reading—with great effort making the words arise from the body, giving auditory form to what before was silence and thereby moving toward a mutually intelligible sphere of meaning. This in fact is the description of the very nature of the aesthetic in *The Phenomenology of Perception*:

> Aesthetic expression confers on what it expresses an existence in itself, installs it in nature as a thing perceived and accessible to all, or conversely plucks the signs themselves—the person of the actor, or the colours and canvas of the painter—from their empirical existence and bears them off into another world. No one will deny that here the process of expression brings the meaning into being and makes it effective and does not merely translate it. It is no different, despite what may appear to be the case, with the expression of thoughts in speech. (p. 183)

Merleau Ponty goes on to claim that

> thought is no "internal thing" and does not exist independently of the
> world and of words. What misleads us in this connection and causes
> us to believe in thought which exists for itself prior to expression is
> thought already constituted and expressed, which we can silently recall
> to ourselves, and through which one acquires the illusion of an inner
> life. But in reality this supposed silence is alive with words, this inner
> life is an inner language. . . . (p. 183)

> What does language express if it does not express thoughts? It presents
> or rather it *is* the subject's taking up of a position in the world of his
> meanings. (p.193)

But Merleau-Ponty's description is a description of the after-the-fact efficiency and adequacy of so-called normal speech. In the aphasic's speech we are confronted by a breaking down of the relations between thought, language, and subjectivity. The straining here is a straining toward recovery of those three terms in a condition of urgency. That condition makes problematic or puts into question the nature of aesthetic expression. Just as Hamilton's work has previously concerned itself with the mutual labor underlying the production of beauty and aesthetic closure, so does she here remind us of the material effort by which language is used to create interiority and the recognition of such interiority—that recognition which in its mutuality allows us to take up our individuality and position as persons.

I come, therefore, to that aspect of *tropos* that most visitors seem to consider its enigmatic center—the human figure who sits at a rusted metal desk during the hours in which the installation is open to the public. It is in the relation between our bodies and this figure that we determine the enormous scale of the space. For aside from the figure at the desk, we have no experiential referent for a sea of horsehair—it seems as unquantifiable as fire or light or an ocean itself. And this figure counters the centrifugal wandering compelled by the voice, pulling us back in a kind of elliptical movement.

Yet if the voice reaches to us as expression, the figure distances himself or herself from us. Hamilton has for some time explored the use of a figure in her installations. This person, whether the artist herself or another, is always seen in solo form. He or she is a "tender" of the piece—someone engaged in making and unmaking an aspect of the work (knitting, wringing a cloth or hands, modeling dough in the mouth, erasing the tains of mirrors). The figure bears a direct relation to representation; he or she is not miming

an action, but rather is doing an action. The material consequence is evident, apparent to the perceiver—usually in an accumulation that is gathering as the piece gathers time. Gathering, as in the double meaning of *woolgathering*, is in fact a good term for many of these activities—the bringing together of what was scattered before and the process of inference or assemblage of thought. The labor of the attendant is a public labor. Yet its repetitive nature evokes small permutations and increments.

In *tropos* the attendant is engaged in an activity that at first—and perhaps for many viewers always—seems like an abomination: he or she is slowly, letter by letter, word by word, line by line, paragraph by paragraph, page by page, and volume by volume burning books. Using the kind of pyrograph tool employed in woodcut technology, the tender follows his or her reading the way a child follows with an index finger the unfolding words of a primer. The tool is the servant of the eye's mastery of significance and meaning. The words disappear into curls of smoke evident in the light of the room, the smoke disappearing as inexorably as the voices of Ovid's poor mortals. As visitors come and go in the room they often seem to orbit this figure. Able to come very close to the figure physically, they find themselves

nevertheless unable to speak or touch or otherwise engage his or her opaque persona. I have several times seen visitors watch the figure reading as one would watch a person perform a forgotten handcraft in what are called "living history" museums. The figure, absorbed in the activity, remains impervious to movement and sound, even when others are crowding about for a closer look. Soon the visitor moves away and circles outward again. Just as we might think of an aquarium show as a performance in which porpoises have taught human beings to clap on cue, so is the activity of *tropos* one of turns and modifications evoked and displayed in the receiver as dramatically as any evoked or represented within the work.

The reader in *tropos* calls to mind first of all the general figure of a reader as a recurring subject in Western portraiture. In addition to the Cumaean sibyl, who is usually reading leaves that tell the future, there are many annunciations that show the Virgin reading as she is interrupted by the angel messenger. Or we might consider, for example, Piero di Cosimo's portrait of Mary Magdalene at the Palazzo Barberini, Gerard Dou's portrait of Rembrandt's mother, and the many readers in nineteenth-century interiors, such as those of Berthe Morisot. In such paintings the silence of painting and the silence of reading converge. And the relation between the gaze of the depicted figure and the gaze of the viewer is exaggerated by various means. When the figure faces us, it is all the more likely that the text will be hidden. Such frontal images emphasize that whereas speaking is done in the reciprocity of face-to-face communication, reading is a matter of the alignment of gazes, the alignment of time and space such as we find when we read a letter over the shoulder of a character in a film. The side view, such as that in Dou's portrait of Rembrandt's mother, gives us a sense of dramatic conflict between the two-dimensional effect of the profile or silhouette and the perpendicular axis of a text laid out as an object into the illusion of three dimensions. In *tropos*, as we circle around the figure of the reader, something of this tension between the flat world of the text and the orbiting world of the spectator is captured.

But even more specifically, another scene of reading is summoned here—one that has had a central place in the Western construction of subjectivity—that is, the famous passage in book 6 of Augustine's *Confessions* where Augustine mentions that Saint Ambrose read silently. I will quote from the full context of the passage in order to give a better sense of its direction. Addressing God, Augustine explains,

> But although my mind was full of questions and I was restless to argue
> out my problems, I did not pour out my sorrows to you, praying for

your help. I even thought of Ambrose simply as a man who was fortunate, as the world appraises fortune, because he was held in such high esteem by important people. His celibacy seemed to me the only hardship which he had to bear. As for his secret hopes, his struggles against the temptations which must come to one so highly placed, the consolations he found in adversity, and the joy he knew in the depths of his heart when he fed upon your Bread, these were quite beyond my surmise for they lay outside my experience. For his part he did not know how I was tormented or how deeply I was engulfed in danger. I could not ask him the questions I wished to ask in the way that I wished to ask them, because so many people used to keep him busy with their problems that I was prevented from talking to him face to face. When he was not with them, which was never for very long at a time, he was reviving his body with the food that is needed or refreshing his mind with reading. When he read, his eyes scanned the page and his heart explored the meaning, but his voice was silent and his tongue was still. All could approach him freely and it was not usual for visitors to be announced, so that often, when we came to see him, we found him reading like this in silence, for he never read aloud. We would sit there quietly, for no one had the heart to disturb him when he was so engrossed in study. After a time we went away again, guessing that in the short time when he was free from the turmoil of other men's affairs and was able to refresh his own mind, he would not wish to be distracted.

Augustine then goes on to guess why Ambrose might want to read to himself—to avoid questions brought about by obscure passages, for example, or to save his voice for his sermon-giving. He concludes that "whatever his reason, we may be sure it was a good one." [6]

As visitors go toward and around the figure of the reader and then turn back into the room, they have encountered a similar experience of another's interiority. Hamilton has suggested that all of her pieces with figures are intended to happen for the person within the piece—the tender. This person works between the position of subject and object and presents a way of using installation art to interrupt the conventional pictorial frames with which we approach the aesthetic scene. As we come to understand this person's situation, to recapitulate the intensity with which he or she is engaged in a process of work, it is we who are turned or changed. In *tropos*, as in a painting or film, one can read over the tender's shoulder, but the words will disappear according to the temporality of the tender—we must coordinate our perception to a time frame that is given by the other. This time frame is

shared or social, yet it is always known after the fact—and hence becomes an indication of an unfathomable interiority. Like Thom Curley, we must struggle toward articulation and intelligibility. And like Augustine, we must have the good faith to overcome our objections to the burning of books and assume a "good reason" for the activity before us. In this dynamic of rec-

ognition lies, I believe, the politics of this piece, its power to make us consider our relation to nature and to the motivations of others' actions. Private space is not enclosed within static spatial terms for either the speaker or listener, the reader or viewer. Rather, these positions are working into a dynamic of recognition that is ultimately the mutuality of tasks between artist and audience.

Because this mutuality has extension beyond the artist's intention, I have taken the liberty of bringing up a number of texts and allusions that may have significance to only a few people and perhaps not even much meaning for Hamilton herself. Ovid's trope of reversal between the human and the vegetable-animal world reminds us that the compensation for our mortality and perishable form is our voice—that ability to speak what we are. To my mind the other great classical concept of turn is here evoked as well— that capacity for recognition and self-knowledge that Aristotle defined as peripety, the change or turn that transforms a sequence of events. As *The Poetics* explains, peripety is always accompanied by discovery—a change from ignorance to knowledge and hence to judgment and emotion. In Aristotle the latter becomes the hyperbolic terms of love or hate.[7] The stakes in *tropos* have been the possibilities of alienation, theatricality, and monumentality—all posed by the particular circumstances of the work itself. The reward is the recognition of one's self as another in a fleeting word that is heard or seen before it is gone.

II. *between taxonomy and communion*

To experience Ann Hamilton's work is to reexamine what it is to take place, to be in time, to find categories for apprehending nature. In these ways Hamilton returns us with great patience and insight to the very "nature" of sculpture: the interface between bodies, times, and spaces within which objects appear, including ourselves as subjects and objects of knowledge; the hierarchy of the senses employed in the apprehension of any object; the relations between monumentality and intimacy; the articulation of the self at the boundaries-orifices of the body; work as the wresting of form from nature; the cycle of exchange and reciprocity wherein art is produced; and the relation of that cycle to the artist's individual will and imagination.

Hamilton's work is a meditation on our relation to nature and therefore never merely posits that relation. In this sense, her work comments on a world of human action and accountability; she thereby escapes any senti-

mentality or nostalgia that would be attached to views of nature as irremediably other to the human. Asking not merely how we can know nature, but as well how nature enables a knowledge of the world, her work takes apart the "objects" of nature and undermines the "natural" status of the human figure. *between taxonomy and communion*, the work realized by her residency at the San Diego Museum of Contemporary Art in May of 1990, is the culmination of her thinking thus far in this vein.

The work has a vividly ritualistic structure and so gives a certain order to experience. As we approach the work we are asked to remove our shoes and invited to put on a pair of black Chinese slippers from a group placed before the entrance. We enter the work through language—a door inscribed with the titles of animal fables. Stepping into the space of the work, we experience the literal disorientation of a ground that is both brittle and soft. The floor of the room, which slightly slants upward and away from us, has been "paved" with pieces of glass, each the shape, but perhaps four or five times the size, of a microscope slide. This paving shifts and gives above a luxurious, resilient, and musty "carpet" of woolen pelts. Each step into the space gives the unsettled and unsettling feeling that a mistake has been made—for these pavers often in fact break from their human burden. Yet at the same time, and assuaged by the underlying softness, the visitor suspects an intention is at work, that nothing has been an accident or error.

As we cross the floor we can look toward three locations. A large steel table at the "height" of the floor's barely perceptible rise draws us forward. It is bathed in light and seems to hold something. Yet approaching it, we become aware that the "floor" of wool and glass continues up the wall—all the way to a height where a chair rail might be. And more darkly we feel the presence of something behind and to the left: there, attached to the wall, is an enormous black iron birdcage from another century. Its open grill-work, sprung door, and starkly empty state make it seem a souvenir not only of another culture but also of another nature. As we continue toward the table our senses are sharpened: the musty smell of the wool, the odor and dampness of water, the sound of an intermittent, but irregular, dripping, and then, vividly, the surface of the table is revealed: there against a ground of red oxide and close at hand in long and carefully arranged, yet almost undulating, rows like script, lie fourteen thousand teeth. Although each tooth has been cleaned, polished, and placed, we gradually become aware of the ways the human teeth, here interspersed between the teeth of various species, have been worked upon—in other words, how they seem to have a history. At the same time the sound of the water becomes a nearly unbearable anticipation, and we realize that the water is dripping below the

table, that to touch the teeth is to be stained by the oxide, and furthermore that an umber stain is spreading in the wool below the floor of pavers.

This narrative of experiencing the installation may make its end point seem to be a "trick" or surprise, but this is far from the case. For those things that we discover in the piece—what we come to know as an unfolding order—have little to do with what we expect or apprehend. As we "recognize" objects here—wool, glass, oxide, teeth, water—we are returned to the ways in which these objects are themselves. And it is from this point that we can examine our relations to them, from this point that we articulate human marking, making, staining. Characteristically, Hamilton's title is here a description of the experience of the work and not a "caption" or allusion to it: between the human categories by which nature is known and the moment of death in which we are reabsorbed into nature, is the realm of experience itself—the realm of work and knowledge as work. The relation between work and knowledge, then, appears in a trajectory revealing any ritual process as a worked transformation. To "know" materials and to "know" the self is to proceed by a working through of things into their being, their reception, their organization, their use, and, ultimately, their history. Nothing is finished or closed in Hamilton's work, but neither is the work simply random or open to chance. Instead, things and beings are revealed in and by means of the procedures of use giving them meaning and direction.

Between, then, two poles—the taking in of sense impressions and the reabsorption of the body into nature—Hamilton conducts her meditation on experience, figuration, marking, making, and exchange. Her work always begins with the experiences of the physical body, but avoids the dead ends of mere beauty and mere sensation. To take up the objects of her work is only a first step in thinking about where they have come from, what we know about them, what we don't know, how they resist our knowing, and what might be our relation to them—a relation structured by memory and history and a projection into the future so much as by the immediacy of sense impression. By exploring the processes by which sense impressions are organized and by reminding us of the historical "nature" of such impressions, the objects of the senses are made to appear to us within a human landscape already inscribed by human memory. As a sculptor, she summons her "viewers" to use their ears, hands, feet, noses, and mouths as well as their eyes. Although this work is often visually stunning, the visual is always linked to a kind of hand-eye coordination whereby the viewer also enters, uses, traverses the piece. Hearing, sight, touch, taste, and smell waver between immediacy and history. Thus we are shown that our experience is in

fact a matter of intervention. Maker, object, and receiver each take up a place and time, and each has consequences and effects within the work's process.

The consequences of intervention were particularly explored in Hamilton's installation *the capacity of absorption* at the Temporary Contemporary of the Los Angeles Museum of Contemporary Art in the winter of 1988–89. In the first of three rooms constituting the work, Hamilton hung, on small copper brackets, more than a hundred drinking glasses; each spun a vortex of water—the room thereby filled with a kind of watery humming. From the center of the ceiling hung a fiber version of Athanasius Kircher's seventeenth-century speaking horn, an enormous device intended for sending sound across vast distances. On one side of the "horn" a looped video-tape had been installed showing a close-up of water pouring into someone's ear. And hanging from the other side was an instrument like the flared receiver of an early telephone. When visitors spoke into this receiver, the room would suddenly become still—as if the space itself could be called upon to respond and listen at the will of its human inhabitants.

As the visitor proceeded through the remaining two rooms of this piece, she entered farther and farther into worlds of human system and human making. The second room contained a long narrow table that was constantly flooded by a glassy sheet of water. The walls of the room were covered with dried algae, as if the room had been filled and then drained by the sea. Somewhere in the room a cricket chirped. At one end of the table an immobile figure sat; he wore a heavy canvas suit that had a kind of tail extending into a third room, like a large and clumsy umbilical cord or, perhaps, some sad vestigial organ. The figure sat with his hands in finger holes drilled in his end of the table. The opposite end of the long table had an identical set of finger holes that both beckoned and repelled the participation of the visitor. In the final room the walls were covered by a dense layer of graphite. The floor was covered with tons of linotype slugs. The figure's "tail" ended at a giant rusted buoy lying on this floor; upon the buoy's surface were inscribed phrenology notations. A shelf hung from the wall facing the buoy. Placed upon it, a set of mechanized calipers rhythmically jerked wires extending to a small "limberjack" figure—the figure was thereby pulled in one direction and then another by the wires.

As in *between taxonomy and communion*, our path through the installation draws us to an understanding of a relation with nature balanced between reciprocity and control, a relation acquiring meaning only between two deaths—the silence of the inhuman on the one hand and the chaotic noise of a linguistic-visual overload brought about by systems lacking a memory of nature on the other. It is not that the artist distrusts language

per se here, but that language that seems to have lost its common ground in nature and history can also lose its capacity for resonance and integrity. Nature without human agency and intervention can mean nothing to us: such a nature would be an empty point of pure alterity. But language as a fixed and self-referential system would be equally bereft of human agency and intervention. Hamilton points to the relation between nature and language in this piece as a relation that is most useful when it is unfinished and therefore subject to change and reciprocity.

Each of Hamilton's allusions to nature and the world as it is given is thereby also an allusion to culture and the world as it has been made. Even if we consider the recurring elements of her "natural" repertory we find, on second glance, a matter of deep cultural references. Her use of honey and beeswax in many of her pieces emphasizes these substances as made or manufactured by animal work—as she puts it, a kind of "animal money" involving systematization, differentiation of roles, exchange, and storage. Materials such as boxwood, paprika, and gold leaf in her work remind us that nature acquires value by means of an investment of human time: boxwood, that staple of the formal garden, being the most slow-growing of plants; paprika's preciousness tied to its inaccessibility and rare color; gold leaf the "worked" and fragile allusion to the "standard" of value arising where nature is endowed with status as a commodity. The sweetness of beeswax and honey suffused her 1989 work, *privation and excesses*. The sharp odor of eucalyptus, arising from leaves papering the walls and Vicks VapoRub emanating from a steamer, permeated *still life*, her 1988 installation in a Santa Barbara, California, house, and thereby summoned a narrative of deprivation, illness, recovery, and luxury in which the domestication of nature is the foundation for interior space. The interior of childhood, "homework," and the sphere of private emotion all arise from displacements and transformations of a "nature" outside and within us. We are invited to consider what it means to be inside and, if we are inside, how we form this space on the interface between sensation, experience, and nature. We think through the relations between the scale of the body and the scale of objects, the sphere of extension and the sphere of visuality, the near-musical interplay of motion and stillness as inanimate things "come to life," and living things move inexorably toward death.

Like *between taxonomy and communion, the capacity of absorption* was prefaced by language—in this case an external statement described the childhood pleasure Hamilton took in looking up words in the dictionary with her father. If we follow this "clue" regarding method and look up the meaning of the word *room*, the given space in which Hamilton's work ap-

pears, we find a gloss on her project, for these are the word's evolving connotations: "the illustration of forms," "dimensional extent," "to install," "sufficient space," "to clear a space for one's self [by making room]," "to provide space by removing other things," "scope," "to do something," "a short space of time," "a space on an abacus or game board," "a seat or place in a theater," "a space in a series, narration, or logical sequence," "bounds," "a person's position or assigned space," "to board," "a chamber in a building or stall in a barn." They carry forward the ways in which the most simple features of a room, and of being in a room, are brought to bear on her installations. At the interface of the domestic interior and the natural exterior, delimiting the sphere of action and being, establishing relations between figures and objects, the room defines on the one hand a sphere of social interaction (the drawing rooms of Austen and Tolstoy for example) and on the other hand a sphere of meditation and reverie (de Maistre's *Voyage Autour de ma Chambre*, Walter Benjamin unpacking his library, Huysmans, Proust, and others). Experiencing Hamilton's work, we must, as in the rooms of Beckett and Sartre, decide to enter and decide to leave. The full ethical and moral weight of action on the threshold and within the scene comes to bear upon our "reading" of these rooms. It would be inaccurate, however, to think of Hamilton's work as "theatrical" in a traditional sense, for we are not positioned within a passive or voyeuristic theatrical experience here. The visitor takes part in the action and thought of each piece once the threshold is crossed. The room is the given frame or grammar within which action and being take place and acquire resonance—the social emotions, the discourses of privacy, ritual as the public display of private transformations, and the role of domestic labor in the containment of nature are all brought to mind by this framework.

Consequently, nature often seems to "erupt" in or haunt Hamilton's pieces—the cricket chirping in *the capacity of absorption*, the sheep meeting our gaze through an iron grill in *privation and excesses*, a slowly dying tree in *the earth never gets flat*, her 1987–88 work at the Whitney at Philip Morris, or the enormous live eucalyptus branch suspended over a pile of ashes in *still life*. If we do not tend these natural elements, they will turn toward the service of death. Just as her work never makes allusions that are merely "cultural," so do these allusions to nature refuse to be merely natural: it is perhaps not surprising that her work seems replete with literary, aesthetic, and mythological allusions. But to drift into cultural allusion when experiencing her work is to be called back by Hamilton to the realization that all of human making is a transformation of the natural world.

Hamilton's work often presents us therefore with an uncanny sense of

time: the objects in her work, as noted above, are often familiar, even inti-
mate, to us, yet they appear in a time frame that resists conventional peri-
odization. Experiencing her work, we often feel, because of the depth of the
allusions to nature, that we exist in a kind of geological or evolutionary
time—a time of prehistory, enabling history to appear; a time of inhuman
agency before human understanding and its retrospective organization of
history. We also realize that the transformation of nature is worked by a re-
ordering or remaking of time, as if geological time had been ordered within
the space of our everyday lives. Her works have explored especially the re-
lation of the time of the body to the time of the machine: thus we see jux-
taposed the temporality of tools, linked to the time of the body and the di-
urnal cycle, and the temporality of devices, linked to clock or artificial time.
Teeth and hands are contrasted in her work as the most rudimentary tools
of consumption and production. And when teeth are removed from their
bodily context, they acquire another kind of "face value," that borne by
coins and other kinds of "currency." (We find a vestige of such primitive
currencies in the custom from children's folklore of trading in lost teeth for
money.) Inversely, when Hamilton makes use in her installations of a tennis
ball machine firing balls at thirty-second intervals on a ninety-minute cycle,
or of mechanical mortars and pestles pulverizing teeth or pennies, the ma-
chine's cyclical activity is foregrounded as an act of repetition. Yet Hamil-
ton often uses devices that transform or mechanize objects usually manip-
ulated, as the word implies, by hand—pitchforks rhythmically scrape the
walls, rigged to a pulley system in *the earth never gets flat*; the limberjack
is jerked by a wire; the mortar and pestle seem out of control—as night-
marish as a nutcracker, gingerbread man, or, for that matter, a nuclear re-
actor taking off on their own inhuman agendas. Such repetitions, though
set in motion by human agency, seem meaningless precisely because they
have no capacity for memory, causality, and closure.

In several of her early pieces, Hamilton presented figures in silent, im-
mobile, and even resolutely fixed positions. *similar predicaments* of 1984
had as part of its installation a person lying on a shelf projecting from a
wall. Across the room was a toothpick-covered couch painted to resemble
a tropical fish. In *the lids of unknown positions* (1985; Twining Gallery,
New York), a person sat at a table with head and forearms covered by a
mound of sand while another person sat in a lifeguard chair at a height
making it necessary for his head to recede into the ceiling and outside the
room. For these figures, formally clad and bound by their mysterious duties
and responsibilities, time seemed to have stopped. But for the viewer of this
pain and inaccessibility, time became replete and unbearable; the viewer

was the one who assumed the mantle of immobility here, the one who was caught in a refusal of action. From this problem, Hamilton moved to another domain of responsibility—that of the caretaker or tender role central to pastoral tradition. Here the redundant and repetitive qualities of an inactivity are in fact enabling of something else—an intensification of emotion. The figure wringing her hands in a hatful of honey in several of her pieces and the static caretakers and tenders of *the capacity of absorption* and *still life* are imbued with emotional depth because these actions are intended, willed, historical, and of consequence within a human universe, even if that universe is private and inaccessible to the viewer. In the dialogue produced by these ongoing projects regarding figuration, Hamilton thereby reminds us that it is not enough to act, to enable to act, or to explore the consequences of action; we must as well think through the meaning of our actions and assume the possibility that another's actions are meaningful even if incomprehensible. The stillness in Hamilton's work always appears to be apprehensive, on the brink of some decisive and consequential action; and the silence is equally interstitial, an aural space between closure and new forms of articulation.

Part of the power of *between taxonomy and communion*'s ritualistic structure is the way in which the viewer has become a figure of these dimensions. Not incidentally, our experience of the actor's role is deepened by an understanding of the way the behavior of the viewer himself or herself is the end product of Hamilton's thinking-through of the problem of the representation of agency. Here as elsewhere in her work, she has not assumed the mere inversions and playfulness of typical efforts to abscond with artistic agency and place it in the court of the viewer: rather, as her work has developed, she systematically has explored the mutual responsibilities of subjects and objects of action. If it is a commonplace of her work to conclude that the subject is constructed out of the transformation of need into desire and that space is articulated from the transformations of a natural landscape, *between taxonomy and communion* makes these points in quite specific ways. The piece emphasizes such philosophical problems regarding our relation to nature via several issues which are as well central to the history of sculpture: particularly the issues of figuration, relief, and narrativity.

In *between taxonomy and communion* we must decide how long to hesitate at the portal where we can barely discern the animal fable titles and where the scant information provided by the titles alone reminds us not of what we know about these stories but of how we have forgotten them—we have forgotten not merely their contents and characters but, because they

are fables, their morals as well. We must decide whether to go forward or retreat as the glass breaks, or does not break, beneath our feet. We must resolve to ignore the birdcage over our shoulder. As we move toward the table we must turn away from text. We must decide whether or not to touch the teeth: their beautifully polished surfaces invite touch, but we know that to do so will permanently stain our hands and clothes. We must "bear" the slow and irritating anticipation of the water dripping beneath the table; what is unbearable is the emptiness conveyed between these significant aural "marks." We must be willing to stand near the encroaching stain the water makes beneath the table and to feel the wool becoming soaked beneath our feet. And, despite the infinite, indeed sublime, amount of information provided by the spectacle of the teeth, we must decide to return to language, to leave the space and reemerge in the external world once more.

Here as elsewhere in Hamilton's work, exercising the will to enter, the will to continue, and the will to leave are the ultimate acts of the spectator. The issue of figuration in Hamilton's work is therefore not merely a matter of noting whether or not there are people in her work and if so what they are doing or not doing. Rather, human figuration as the notion of "taking place" has to do with a reciprocity between the work's intentions and the reception and action of the participant. As part of this thinking, the piece considers its own site (and thereby its own conditions of possibility): the situation of the La Jolla museum on the boundary between sea and land and on the north–south geopolitical axis that is the boundary of the United States and Mexico; the cultural and temporal boundary between native and nonnative settlements (particularly exemplified by the iron oxide as a reference to sand painting); and La Jolla as a paradigm for a garden by the sea, which evokes both a lost state of nature and the willed human quality of a landscape completely transformed by gardening and the importation of nonnative plants. The work takes on the conditions of expulsion from the Garden of Eden—the conditions of pain, knowledge, and accountability—and constructs from them a kind of Paradise of thought. The spectator must be willing to risk a mutual incomprehensibility nowhere more evident than in the spectacle of the teeth. We must ask: Where is the human in this multitude? How can this display of death present us with such an abundance of life? How are we recognized by our bodies, and the features or elements of our bodies, such as these teeth, at the same time as the physical conceals our true "natures" from ourselves and others?

Hamilton thereby continually links the problems of figuration to the problems of relief, recapitulating the emergence of three-dimensional figuration from the pressures upon the relief and frieze forms. She presents us

with this aspect of the history of sculpture in the West in its profoundly lived, most everyday qualities: that any fullness of identity and being arises from a relation between surfaces. Hamilton herself often refers to such surfaces as "skin." By this she intends to bring forward the permeable, information-laden, and reciprocal qualities of surfaces touching surfaces. As an instrument, the skin is alive and receptive, and thus it is a tool that is also a thing. In Hamilton's early work her elaboration of surface often involved the construction of a human armor: the still figure in *suitably positioned* wearing a suit of painted toothpicks; a figure covered by a dense layer of burdocks and another wearing a catcher's mitt in her 1984 piece *detour*; a figure wearing a suit of flashlights and reflectors in *reciprocal fascinations* (1985); a figure wearing a suit of grass seed in *the earth never gets flat*; the figure in the heavy canvas coat and "tail" in *the capacity of absorption*. These pieces of "armor" elaborate a constructed identity. They point to the work involved, the mediation posed, in any interaction between producer and receiver. Culture *is* the border between nature and human knowledge here. And human signification, ornament, and systems of meaning are shown to be on a continuum with the coats, mails, hides, markings, and colorations of animal existence.

Relief as an issue and object of thought is further emphasized in Hamilton's use of the table in her work. *reciprocal fascinations* of 1985 contained a steel table covered in a surface of vibrating water; a large dining room table in *still life* displayed a stack of eight hundred men's white shirts, each singed and gilded at the edges while a smaller table against a wall displayed empty velvet jewelry forms; *the earth never gets flat* used an autopsy table covered in vibrating water; *the capacity of absorption*'s seventeen-foot wooden table was deliriously, slowly washed by a sheet of water; the hard and damp steel surface of the table in *between taxonomy and communion* contrasts sharply with the soft and powdery quality of the red oxide lining it and forming the bed for the teeth.

The presentational space of the table becomes laden with allusions to production and consumption. The table itself is a three-dimensional object posing a two-dimensional relation to the viewer. Here, as with the microscope slide alluded to in *between taxonomy and communion*, something with depth is "flattened" to appear as something that is faced. But when we truly look, we rediscover the depth and particularity of the object at hand. As in the long tradition of "table painting," the viewer is made aware—in circling the table, looking under it, and standing at various heights in relation to it—that each point of view is circumscribed. Hamilton's tables often are reminiscent of operating or autopsy tables: tables furthering life and

tables exploring death in a dialectic of the restoration and dismantling of identity. Display, arrangement, relief—Hamilton shows us that these artistic conventions regarding articulation are matters of both drawing the viewer forward and keeping him or her at bay.

between taxonomy and communion, as it compels penetration and intervention on the part of the viewer, continues these aspects of "skin" and issues of relief and surface. If the wool gathered here is a transformation of the exterior and the protective coat of the animal, we are invited to enter into the skin—to smell and touch it, to break the glassy shell, to turn the elements of nature inside out and upside down, and, in knowing the boundary, begin to make distinctions. Taxonomy is thereby the vehicle of a communion otherwise inaccessible to us.

Perhaps the most prominent site of elaborated boundary in *between taxonomy and communion* is the mouth. As a site of sexual merger and penetration, of the consumption of nature, and of the production of language and narrative, the mouth becomes emblematic of the most concrete and abstract of boundaries and itself appears on the borders of the private and the public, the silent and the articulated. The mouth, like the skin, is unable to be merely an object. At the mouth, need is transformed into desire; All physical satisfaction is transformed into the infinite and discursive possibilities of language. Hamilton explores in *between taxonomy and communion* the many dualisms of this location of the physical and abstract: its liquidity; the plenitude of the body erupting at its surface; its dual messages of aggression and attraction; its ornamentation by means of staining and marking; its appearance as a two-dimensional outline; the orderly placement of the teeth in this interior of an interior. Most strongly, the mouth is the site of the emergence of language. When we consider the forgotten fabular language of *between taxonomy and communion* and Hamilton's story of her father and the dictionary in *the capacity of absorption*, where the origins of the self are connected to the fluid etymologies of words, we discover an allegory in which language, and desire in language, comes to compensate for the impossible demands of the body. And at the same time, language suppresses the unbearable realization of what remains outside of codification and human systems of knowledge: nature in itself and death. We can begin to see the lined rooms of Hamilton's work as themselves the mouths or interiors of architectural bodies. Her work confronts us with simultaneous desires to fill in space and to empty it.

Hamilton has often posed this problem as a matter of the relations between accumulation or accretion. The monumental scale of labor in her work is assembled by means of minute, yet consequential, actions gathering

effect over time. The systematic aspects of accumulation lead, however, to the seemingly "natural" status of the completed whole: a proverbial whole bigger than its parts, though clearly assembled from parts acquiring significance from their relation and not merely from their individuality. In contrast, accretion takes place within an organic sphere of time and is a matter of the breaking down of form into larger aspects of form. If accumulation is accomplished by means of intention, accretion seems a matter of default or "natural" agency, a growth untended and unintended. But the objects accumulated here—whether pennies, leaves, wool, or teeth—are revealed in their materiality, revealed thereby as organisms or matter. And what is accreted—the stain, the crust, the mold—refers to the monumental time that human labor cannot transcend. Everything "counts" in Hamilton's work, but not everything is subject to human systems of accountability.

A Southern Californian aboriginal sand painting would have involved as many as forty assistants working eight to ten hours each. Hamilton's work—with walls of paprika, beeswax, and dead algae; with a floor made of tons of linotype slugs; with thousands of handwritten slips of memoirs; with thousands of teeth, each cleaned, polished, and carefully arranged; with eight hundred men's shirts, ironed, singed and gilded; with seven hundred and fifty thousand pennies arranged in a pattern and covered with honey—analogously stretches the bounds of individual agency. Her work starts with the fundamental questions regarding artistic production: Who is the artist? What is an artifact? What is the difference between making, tending, and laboring? How do things acquire value? Where do things come from and where do they go?

Just as every natural allusion is a cultural allusion and every cultural allusion is underlain by a natural allusion, so does every "thing" appear here as a made thing and hence as something remembered, storing up a history to be received and reused. If Marx's nightmare was that under capitalism a relation between humans appears to be (merely) a relation between things, Hamilton's work recalls us to the human relation and to the root of the human relation in a transformed or "worked" nature. In this way she draws forward the conflict between an aesthetics based upon triumphing over the limitations nature imposes on form and materials, an aesthetics perhaps best illustrated by the baroque; and an aesthetics based upon an imagined sympathy and cohesion with such natural limitations, an aesthetics perhaps best illustrated by environmental art. Hamilton shows that the struggle to overcome nature is in fact defined by nature and that the struggle to "work with" nature is an impulse defined by human culture and human history. Completely dependent upon and involved with others as makers, care-

takers, and receivers of her work, Hamilton's artistic production includes the social relations and shared histories emerging from the fabrication of her pieces. Each of her works creates a society; it is in fact no accident that she finds that professional museum guards often enjoy her pieces and enjoy taking care of them: they have been witness to, and have often helped with, their manufacture.

Such issues of production were explored systematically in Hamilton's 1989 installation, *privation and excesses*, as the Capp Street Project in San Francisco. Hamilton took the budget for this project and converted it into seven hundred and fifty thousand pennies. These pennies were arranged on a "skin" of honey defining a forty-five-by-thirty-two-foot rectangle on the floor; this extraordinary multitude of copper coins seemed splashed in reptilian waves across the space. Facing the display of pennies, a side room housed three sheep behind an iron grill. And, as mentioned earlier, a person sat dipping and wringing her hands in a felt hat filled with honey while two motorized mortars and pestles were at work, one grinding a bowl of pennies and the other a collection of human teeth. At the conclusion of the project, the pennies were cleaned and counted. Expenses were covered and then the remaining pennies were donated to fund a daylong dialogue on art as process between San Francisco artists and public school teachers.

Hamilton's projects often echo other postmodern efforts to foreground the commodity status of the artwork and to find new relations between the production and reception of art. In his 1982 piece at Documenta 7 in Kassel, *7000 Oaks*, Joseph Beuys piled seven thousand large pieces of basalt in a triangle that pointed to a single oak tree. He intended that this stone "currency" would be bought by the community; each stone would be "cashed in" for an oak tree to be used to restore the trees of Kassel. Here, as in her frequent use of honey (an allusion to the liquid, the sweet, the ripe, the surplus and the crystalline/sculpted) and her use of felt (an allusion to "pressing" as preservation, the transformation of the animal body, the lamb as pet, food, and protection), Hamilton is continuing Beuys's "actions," his radical interrogation of materials and processes. But Hamilton's projects, unlike Beuys's, do not ultimately refer to her own history so much as to the ways in which materials acquire history as they are worked. Noting that pennies in denominations over two hundred dollars are not legal tender because of their sheer weight and numbers, she takes the notion of accumulated or stored wealth to a breaking point—the point where the material's weight and mass, its literal materiality, comes to signify independently of the system of money in which it is generated. Like the decontextualized teeth of *between taxonomy and communion*, the pennies are nei-

ther raw nature, nor symbols of luck, nor true "money" here—they are a made configuration wrested from a prior condition and destined to further transformation.

If Hamilton's projects in this vein seem willful, it is not because the artist has attempted to transcend the scene of artistic production: her work is an attack on spontaneity, originality, and genius to the extent that it always makes evident the historical and causal relations underlying the status of aesthetic artifacts. When we say that her work is "labor intensive," we must recognize that every facet of the work is labored: the labor of thought, the labor of production, the labor of reception. No single person could produce these installations, even given all the time and strength in the world; for in their very formulation these works are designed to make us remember all the reciprocal acts of communication, fabrication, tending, and receiving that are part of any effort of artistic production. Following Hamilton's logic, we would necessarily conclude that a work produced by a single individual would be unintelligible. In order to assemble the eight hundred shirts at the heart of *still life*, Hamilton bought the shirts from a rag dealer and used the shirt-folding machine in a local laundry. In this reflection upon the meaning of domestic labor and accumulation, in which things are "done perfectly" so as to reflect the completeness of the interior world and the private self, Hamilton points to the necessary connection such labor bears to the exterior worlds of culture and nature. To "do" these shirts is both to destroy them as material objects (to singe them) and to revere them as the physical manifestation or projection of her own labor or mark (to gild them).

In order to gather the fourteen thousand teeth needed for *between taxonomy and communion*, Hamilton had friends and associates send her specimens; she contacted all the dentists and oral surgeons in the region; she gathered teeth from taxidermists; she collected animal carcasses from slaughterhouses; she visited osteology laboratories, including those at the Smithsonian Institution, in order to learn how to boil down animal heads and clean and prepare the teeth for exhibition. Although she often relies on friends, associates, and even family members to help with her projects, she has at times had to rely on paid labor to construct special devices or, in the case of the linotype floor in *the capacity of absorption*, to finish an otherwise insurmountable task. The relations between paid and voluntary labor, public works and private patronage, individual and collective work, are thereby never assumed in her installations but rather presented as a problem—something to be put into question, remembered, and considered. The equation of time with money in the public world of paid labor and time as

emptied of value in the private world of domestic, unpaid labor is dramatically brought forward and critiqued in these pieces.

Furthermore, these explorations of the meanings and consequences of systems of production appear as an attack on novelty. Here and elsewhere in Hamilton's work we find contrasted the activities of making and tending. Hamilton emphasizes the creativity and responsibility of the acts of maintaining, caring for, and preserving the world. Such tasks are shown to be necessary for the continuation of a productive relation to nature and of reproduction on a global and environmental scale as well as on the domestic scale that is here posed as a model. Our attention is drawn thereby to the production of art as only a first step in a history of preservation, tending, and even restoration destined to follow that production.

To speak of Hamilton's installations, we must use the past tense: these works, assembled, disassembled, and reused both within and outside themselves, have a dramatic existence in time. Hence arises the dialectic between accumulation, loss, and intervention running throughout Hamilton's oeuvre. Their perpetuity is ensured only by means of memory and the narratives by which memory is expressed.

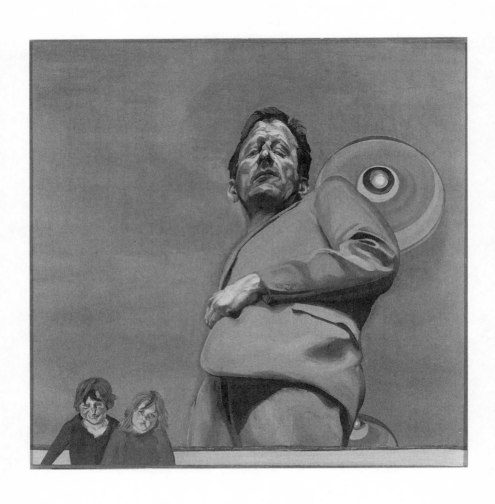

AT THE FREUD SHOW

Aide Memoire—Hirshhorn Museum and Sculpture Garden,
Washington, D.C., Thanksgiving, 1987

I have come on the train with my son to the Freud show. He is just six. All the paintings have been put behind glass: high-glare glass. I ask the guard why I can only see myself and my son in the paintings. She says, for this American show, the painter wanted it that way.

———

I wanted to see the paintings. Am I to see myself as an American, then, as the subject of an intention toward a viewer viewed only as a generality?

———

. . . should be seen, but not heard. It is best to raise them in one continuous place.

———

Behind our reflection, I see a pattern of leaves, a torn couch, a floor skewed up from another floor. That one, the second, is the floor on which we're standing. That is, this we, the we inhabiting our bodies.

———

We were once in one body, but now we are in two. Or, now we are four and whoever is in the paintings. Is the one in the painting the one we are viewing, or is it that viewing that makes us?

———

The pain of childbirth as making's paradigm; the cry, before language, opening the possibility of language, and the child then crying in turn. This, and not syntax, as the origin of utterance.

The guard calls my son away from the paintings. She asks him questions that have no sequence: "How old are you?" "What's your name?" "Did you come here with your Mommy?" He is anxious; he's not to talk to strangers. He looks to me, but her questions are there, in the air, like high-glare glass.

Some find it amusing to frighten children, like to see them nod their heads almost imperceptibly.

How the grandfather remained a child: "Aggressiveness was not created by property . . . it forms the basis of every relation of affection and love among people (with the simple exception, perhaps, of the mother's relation to her male child)."

The gift shop of culture: what is for sale is on display; what is for giving will now be shown. To show is to keep the object tethered to agency. Hence the shown body, the body in pose, is not the body offered to possession.

It is Orpheus who is the fitting subject.

The grandfather's couch was torn in the war.

As in fairy tales and nightmares, could my child be snatched away in the minutes when I turned to look at a painting?

What did Eurydice see when she was turning? Some torn leaves, a stair tumbling down to a floor. Something patterned, but almost imperceptible.

To "withdraw" from the outside world. When the painter looks out his window, he sees another room, furnished by debris. Windows, chimneys, stairs: what is outside as a sign of inside. Jagged glass cemented to the top of a wall: the threshold between being and seeing.

———————

In sleep there is no mother. Watching the child sleep, the mother feels complete; she has made an image and a frame for it in time, and thus she can look upon her death.

———————

"These paintings are too depressing." A living voice said that. But when I turn, I'm unable to find the proper face. I think one person would say that to one person. That is, not just to herself or to a crowd. But there are many pairs here: women with women, women with men, men with men, a woman with child, a woman with a child.

———————

If we were like Isaiah, our mouths would be burned, and then we would bear a perceptible mark of speech.

———————

What is the pleasure of being looked at by a painting? What seems to follow us around the room? The eyes of the nation are upon us. Voyeurism before narcissism; narcissism, then paranoia.

———————

To have license to touch another's face: sable, or bristle.

———————

The girl thinks of the boy as a giant; the boy thinks of the man as a giant; the man thinks of himself—thinks of himself as the dwarf in the mirror. The lamps are not halos, slipping. The children are in the abyss of this world.

———————

For Aristotle, all things being equal, the bigger the work of art, the better. For Kant, the colossal is the presentation of something that cannot be taken in by hand or eye. So what crushes us can in the end, nevertheless, elevate us.

———————

A rat in Tom's house might eat Tom's ice cream. Can Queen Victoria Eat Cold Apple Pie?

———————

Best in one continuous place. Care leads to completion. How, then, to explain beauty as disinterestedness: an interdiction or a kind of joke?

———————

To have license to touch a painting. From the guard's point of view: just doing my job. Then, to whose gaze is the sitter made vulnerable? Superman, for instance, yes, can melt things with his look, but this is the opposite of what we mean by a melting look.

———————

A war is a made thing, i.e., not an accident.

———————

She loves you so, she'll eat you up. Before the birth, a bloody show. They always say, "That's just too pretty to eat."

———————

How we choose to look and otherwise how we cannot bear it. That is what interests the painter—not how we look. The painter is at pains to be seen, while the sitter is sitting to the point of pain.

———————

"The painter remembers his illustrious grandfather by his jokes, and by the gifts of money," says the handbill. It doesn't say the grandfather had a sore mouth and was a phantom.

———————

"If you will recall the tricks of mnemotechnics, you will realize with some surprise that the same chains of association which are deliberately laid down in order to prevent names from being forgotten can also lead to our forgetting them."

———————

My father knew a mnemonic for the entire periodic table of the elements, but he did not—I prefer to think he forgot to—pass it on to us.

———————

A body protecting itself from its own caresses; a body studiously doing nothing. To study nothing in the studio. How to show that one is in—in the nude, in the space—that is, in the ego, "not a surface, but the projection of a surface."

————

How should we behave around a guard? "We may now add, on the lines of the libido theory, that sleep is a state in which all object-cathexes, libidinal as well as egoistic, are given up and withdrawn into the ego. May not this throw a fresh light on the recuperating effect of sleep and on the nature of fatigue in general?"

————

In sleep, there is no mother. Watching the child sleep, she . . .

————

Roy G. Biv. To try to forget colors by making them anthropomorphic.

————

For a year now, my son has asked me, each morning, to brush his hair down flat. He doesn't want any signs of sleep to show; I must always wet the brush.

————

To try to forget color by giving names to color. In this way, we will know we have forgotten something. Oyster gray; fox stain; burnt sienna; Cremnitz white. It is not my imagination that his hair is getting darker.

————

Full term and sleep: an oxymoron. The old self sleeps with its arm about her while she clenches the bed, kept awake by kicks. Body to body; body to stone—a pregnant woman is sublime, like a pyramid.

————

To paint the Caesarean scar and keep it on the surface. A damaged good. To keep things from real damage.

————

Infant, little hand mirror, you used to fit inside my arm. But a body can fall back like an arm flailing.

————

A striped pillow, a mortar and pestle, the father's body, a bathtub, a shutter, a paisley swatch, a scorched palm, a pup, a pattern of leaves: always, between need and desire, always, the gesture of the prop.

———————

I am trying to rest.

———————

A faucet left running, like a cadaver, must be acted upon as a sign of what's missing and as a sign of what refuses to absent itself. Someone rises.

———————

Have I brushed the sleep from the child's fair hair, or brushed the darkness in?

———————

The space of the side and the space behind: the body and the junkyard are situated, therefore, in those dimensions where a painting cannot be.

———————

"And above all the portraits of his mother . . . in 1972 when she began to recover from depression . . . which involved more than a thousand sittings and reached an apogee of grave and measured devotion."

———————

No, not a scar exactly, but a series of bruises, depressions, places where a hand has left its print; where something has been brushed aside, taken up; where there has been a passage of time and gaze.

———————

I am trying not to look like anything.

———————

This train was once involved in a dreadful accident, but tonight things are moving forward as scheduled. I am trying to rest. The catalogues were sold out, but we found a book. The little one is looking. He turns the pages, deciding which pictures were in the show and which were not. Whose gift is the gift of his memory? At six, in language, it must be his own.

———————

Capitoline, Quirinal, Viminal, Esquiline, Caelian, Aventine, Palatine

NOTES

Chapter 1

This essay was written for the workshop "On the History of Collections," held April 2004 and sponsored by the Getty Center for the History of Art and the Humanities and the University of Southern California.

1. Hannah Arendt, *The Life of the Mind* (New York: Harcourt, 1971), p. 20.

2. Immanuel Kant, *Critique of the Power of Judgment*, ed. Paul Guyer, trans. Paul Guyer and Eric Matthews (Cambridge: Cambridge University Press, 2000), pp. 186–87.

3. Ibid., pp. 188–89.

Chapter 2

This essay was written for a conference entitled "The Arts in Question" at the Center for Art Research at the University of California at Berkeley in 2003. My thanks to Alan Singer, Kaja Silverman, Charles Altieri, and Jay Bernstein for their generous comments on this essay, especially in light of each's productive disagreements with many of the points it makes.

1. Bernstein's remarks were made in his paper for the same conference, "The End of Art (Again)."

2. Kierkegaard, for one, posed similarly that in the aesthetical principle no reality is thought or understood until its essence has been resolved into its potential, and in the ethical principle no possibility is understood until each potential has really become an essence. Søren Kierkegaard, *Concluding Unscientific Postscript*, trans. David F. Swenson and Walter Lowrie (Princeton, NJ: Princeton University Press, 1941), p. 288.

3. Charles F. Ascher and Robert Ascher, "The Human Revolution." In *Man in Adaptation*, ed. Yehudi Cohen (Chicago: Aldine, 1968), pp. 315–32; reference is to p. 324. I discuss some of these issues regarding aesthetic experience and the face-to-face

in *Poetry and the Fate of the Senses* (Chicago: University of Chicago Press, 2002), particularly pp. 55–56, 149, and 154–55.

4. Charles Fillmore, *Lectures on Deixis* (Center for the Study of Language and Information. Stanford, CA: Stanford University Press, 1997), pp. 32–36.

5. For relations between animal calls and human emotional expression, see Peter Marler and Christopher Evans, "Animal Sounds and Human Faces: Do They Have Anything in Common?" In *The Psychology of Facial Expression*, ed. James A. Russell and José-Miguel Fernández-Dols (Cambridge: Cambridge University Press, 1997), pp. 133–57; and Nicole Chovil, "Facing Others: A Social Communicative Perspective on Facial Displays," In *The Psychology of Facial Expression*, ed. James A. Russell and José-Miguel Fernández-Dols (Cambridge: Cambridge University Press, 1997), pp. 321–33. See also Ray Birdwhistell, *Kinesics and Context: Essays on Body Motion Communication* (Philadelphia: University of Pennsylvania Press, 1970), pp. 99–120, 163–68.

6. Antonio Damasio, *The Feeling of What Happens* (New York: Harcourt Brace, 1999), pp. 164–65. The philosophical import of this distinction is already noted in Wittgenstein's work on "family resemblance" with its separation of processes of description from those of recognition of perceptual wholes.

7. Immanuel Kant, *Critique of Judgment*, trans. Werner Pluhar (Indianapolis: Hacket, 1987), pp. 182 and 215; and *Critique of the Power of Judgment*, trans. Paul Guyer (Cambridge: Cambridge University Press, 2000), pp. 195, 218. See also Alexander Gottlieb Baumgarten, *Reflections on Poetry*, trans. Karl Aschenbrenner and William Holther (Berkeley and Los Angeles: University of California Press, 1954).

8. Quoted in *Face to Face with Levinas*, ed. Richard A. Cohen (Albany: State University of New York Press, 1986), pp. 23–24.

9. Emmanuel Levinas, "Reality and Its Shadow," in *The Levinas Reader*, ed. Seán Hand and trans. Alphonso Lingis (London: Blackwell, 1989), pp. 139–43; quotation is from p. 137. His thinking here seems influenced by Lessing, but as if Lessing had somehow neglected to mention that the punctum of the "Laocoön" was culled from a series of moments—that the artist chose the most crystallizing, and hence the most dispersing and allusive, of such moments.

10. See Kant, *Critique of the Power of Judgment*, Guyer trans., pp. 227–28.

11. Many of the limitations of a merely reactive art have been set out in Bataille's dismissal of surrealism and all approaches to the "sur": "it is evident at the very least that the implications of surrealism can be pursued only as negation . . . Only the rupture that eliminates the slightest concern for recognition, the slightest respect for persons (not even true contempt, hardly crass derision), allows this moral infantilism to pass to free subversion, the bases subversion" (Georges Bataille, "The 'Old Mole' and the Prefix Sur," in *Visions of Excess: Selected Writings, 1927–1939*, trans. Allan Stoekl [Minneapolis: University of Minnesota Press, 1985], pp. 32–44).

12. Rainer Maria Rilke, "The Rodin-Book: First Part," in *Selected Works*, vol. 1: *Prose*, trans. G. Craig Houston (London: The Hogarth Press, 1954), pp. 95–135; quotation is from pp. 97–98.

13. *Face to Face with Levinas*, p. 21.

14. Emmanuel Levinas, *Alterity and Transcendence*, trans. Michael B. Smith (New York: Columbia University Press, 1999), p. 123.

15. Here in fact we see the coherence of Arthur Danto's position that pop art signals the end of the project of concretization, for pop art, following the contribution of the readymade, presents the point of saturation for materiality—that moment when the concrete realist position finds its solipsistic end. Arthur Danto, *The Transfiguration of the Commonplace* (Cambridge, MA: Harvard University Press, 1981), p. 208.

16. Alain Besançon's discussion of the iconoclastic impulse in modern art can be found in his work *The Forbidden Image: An Intellectual History of Iconoclasm*, trans. Jane Marie Todd (Chicago: University of Chicago Press, 2000), pt. 3, "Iconoclasm: The Modern Cycle," pp. 183–377. See also Christoph Schönborn *God's Human Face: The Christ-Icon*, trans. Lothar Krauth (San Francisco: Ignatius Press, 1994), pp. 18, 21; and Jaroslav Pelikan, *Imago Dei: The Byzantine Apologia for Icons* (Princeton, NJ: Princeton University Press, 1990), p. 73. For other translations and discussions of this material, see Moshe Barasch, *Icon: Studies in the History of an Idea* (New York: New York University Press, 1992), p. 144 ("dead colors and inanimate delineations" vs. "the glistening flashing radiance"); and Edward James Martin, *A History of the Iconoclastic Controversy* (New York: Macmillan, 1930), p.64.

17. Schönborn suggests that the iconic Fayum mummy portraits may have been the first to use a human dot to indicate the liveliness of the eyes (*God's Human Face*, p. 24). See also Annette Michelson, "The Kinetic Icon in the Work of Mourning: Prolegomena to the Analysis of a Textual System," in *October* 52 (Spring 1990): 16–38.

18. We do not have to be Lamarckians to hold to something like an idea of "somatic adaptation" or learning of the kind Gregory Bateson explored in his essay, "The Role of Somatic Change in Evolution" (in *Steps to an Ecology of Mind* [New York: Random House, 1975], pp. 346–63), and to think that the kind of flexibility and reversibility aesthetic experience affords could have far-reaching consequences for human life. Bateson contends (p. 363) that "inheritance of acquired characteristics would be lethal to the evolutionary system because it would *fix* the values of these variables all around the circuits. The organism or species would, however, benefit (in survival terms) by genotypic change which would *simulate* Lamarckian inheritance, *i.e.*, would bring about the adaptive component of somatic homeostasis without involving the whole homeostatic circuit. Such a genotypic change . . . would confer a bonus of somatic flexibility and would therefore have marked survival value."

Chapter 3

This essay was written for the Dia Center for the Arts in 2002 and first appeared in Thomas Schütte, *Thomas Schütte: "Scenewright," "Gloria in Memoria," "In Medias Res,"* ed. Lynne Cooke and Karen Kelly (New York: Dia Art Foundation, 2002, © Dia Art Foundation, 2002; Düsseldorf: Richter Verlag, 2002).

1. Horace, *De Arte Poetica*, ll. 148–50, in Horace, *Satires, Epistles, and Ars Poetica*, trans. H. Rush Fairclough (Cambridge, MA: Harvard University Press, 1926, 1991), pp. 462–63.

2. Plato, *The Symposium*, in *The Works of Plato*, trans. B. Jowett, 4 vols. (New York: Tudor, n.d.), 3:273–358; quotation is from pp. 339–40.

3. Fischer is cited in Nicholas Serota's obituary, *The Independent* (London), December 21, 1996.

4. Ludwig Wittgenstein, *Preliminary Studies for the 'Philosophical Investigations,'* *Generally Known as the Blue and Brown Books* (New York: Harper and Row, 1958), pp. 127–85.

5. Trevor Gould, "It Is Difficult to Arrange an Earthquake: An Interview with Thomas Schütte," *Parachute* (October–December 1992): 38–41; quotation is from p. 41.

6. Horace, *De Arte Poetica*, ll. 295–301; in Fairclough's translation, pp. 474–75.

7. Max Horkheimer and Theodor Adorno, *Dialectic of Enlightenment*, trans. John Cummings (New York: Seabury/Continuum, 1972), p. 154.

Chapter 4

This lecture was written for the Fundació Antoni Tàpies, Barcelona, 2001.

1. Jacques Lacan, *The Four Fundamental Concepts of Psychoanalysis*, ed. Jacques-Alain Miller and trans. Alan Sheridan (New York: W.W. Norton, 1978), p. 103.

2. Marcel Mauss, *Sociology and Psychology: Essays* (London: Routledge, 1979), p.90.

Chapter 5

Part 1 of this essay was written for *Parkett*, no. 69 (2003); reprinted with permission of Parkett Publishers, Zurich/New York. Part 2 was written for the catalogue of the Kentridge prints exhibition at Grinnell College's Faulconer Gallery (2004).

1. For a detailed and helpful analysis of the relationship of the *Ubu Tells the Truth* etchings to the play and film that followed them, see Anne McIlleron, "An Inquiry into Time in Some Prints of William Kentridge" (master's thesis, University of Witwatersrand, 2003), p. 19ff.

2. Walter Benjamin, "The Work of Art in the Age of Mechanical Reproduction," in *Illuminations*, ed. Hannah Arendt and trans. Harry Zohn (New York: Schocken, 1969), pp. 217–51; quotation is from p. 219.

3. Pavel Florensky, *Iconostasis*, trans. Donald Sheehan and Olga Andrejev (Crestwood, NY: St. Vladimir's Seminary, 1996), pp. 106–7.

4. Ibid., p. 109.

5. The captions are thought to have been composed by Goya's friend Ceán Bermúdez from the artist's notes; someone else did the actual inscription of the captions in the 1863 edition. See *The Disasters of War by Francisco Goya y Lucientes*, introduction by Philip Hofer (New York: Dover, 1967), p. 1.

6. Cited in *Engravings by Hogarth*, ed. Sean Shesgreen (New York: Dover, 1973), pp. xxii.

7. See Antony Griffiths, *Prints and Printmaking* (Berkeley and Los Angeles: University of California Press, 1996), pp. 147, 148.

Chapter 6

This essay was written for an international conference on Reverón at the Museum of Modern Art in Caracas (2001) and published in Spanish in the museum's catalogue (ISBN 980-07-8401-2).

1. Friedrich Nietzsche, *The Gay Science*, trans. Walter Kaufmann (New York: Vintage Books, 1974), p. 38.

2. Michel Tournier, *The Four Wise Men*, trans. Ralph Mannheim (Baltimore: Johns Hopkins University Press, 1980) p. 71.

3. Charles Baudelaire, "Morale du Joujou," in *Oeuvres complètes* (Paris: Gallimard, 1961), pp. 524–32; quotation is from p. 527.

4. Rainer Maria Rilke, "Some Reflections on Dolls," in *Selected Works*, vol. 1, *Prose*, trans. G. Craig Houston (London: The Hogarth Press, 1954), pp. 43–50; quotation is from p. 47.

Chapter 7

Part 1 of this essay was written for the Tacita Dean retrospective at the Melbourne Biennial (2001) and published in the subsequent catalogue, *Tacita Dean, Under Above* (Melbourne Festival Visual Arts Program 2001, curated by Juliana Engberg); part 2 was written for a similar retrospective at the Tate Gallery in London the previous year and published in their catalogue, *Tacita Dean* (London: Tate Gallery Publications, 2001).

1. *The Metamorphoses of Ovid*, trans. Mary M. Innes (London: Penguin, 1955), p. 339.

2. Ibid., p. 345.

Chapter 8

This essay was delivered as the Ritchie Lecture in Art History during the exhibition "Love and Loss: American Portrait and Mourning Miniatures" at the Yale University Art Gallery in 2000.

1. Nicholas Hilliard, *A Treatise Concerning the Arte of Limning bound with Edward Norgate, A More Compendious Discourse Concerning ye Art of Liming*, ed. R. K. R. Thornton and T. G. S. Cain (Ashington, Northumberland: Mid-Northumberland Arts Group, 1981), p. 87.

2. Louis Marin, "Towards a Theory of Reading in the Visual Arts: Poussin's 'The Arcadian Shepherds,,'" in *The Reader in the Text*, ed. S. R. Suleiman and I. Crossman (Princeton, NJ: Princeton University Press, 1980), p. 306.

3. H. Ward Fowler, *Religious Experience of the Roman People* (London: Macmillan, 1911), pp 60–61.

4. Sigmund Freud, "A Mythological Parallel to a Visual Obsession," in *Character and Culture* (New York: Collier Books, 1963) p.153.

5. Patricia Fumerton, "'Secret Arts': Elizabethan Miniatures and Sonnets," *Representations* 15 (Summer 1986): 57–97.

6. Robert Burton, *Anatomy of Melancholy*, ed. Holbrook Jackson (New York: Vintage Books, 1977), p. 167.

7. Gustave Flaubert, *Madame Bovary*, ed. and trans. Paul de Man (New York: W. W. Norton, 1965), p. 145.

8. G. W. F. Hegel, *Aesthetics*, trans. T. M. Knox, 2 vols. (Oxford: Clarendon Press, 1998), 2:852–67.

9. Fumerton, "'Secret Arts,'" p. 67.

Chapter 9

This essay was originally titled "What Thought Is Like" and written for the catalogue of The Sea and The Sky exhibit in 2000 at Beaver College Art Gallery, Arcadia University, Glenside, Pennsylvania, and The Royal Hibernian Academy of Art, Dublin: Patrick T. Murphy and Richard Torchia, *The Sea and the Sky* (Glenside, PA: Beaver College Art Gallery; Dublin: Royal Hibernian Academy, 2000).

1. From *The Poems of Marianne Moore*, ed. Grace Schulman (New York: Viking, 2003), p. 145, ll. 1–4.

2. Herman Melville, *Moby Dick*, ed. Harrison Hayford and Hershel Parker (New York: W. W. Norton, 1967), p.12.

3. Henry David Thoreau, *Journals*, 5 vols. (Princeton, NJ: Princeton University Press, 1981), 4:139 (June 23, 1852).

4. John Ruskin, *Modern Painters*, 5 vols., 1873 ed. (Chicago: Hooper, Clarke and Co., n.d.), 1:317.

5. John Keats, *Poetical Works*, ed. H. M. Garrod (Oxford: Oxford University Press, 1982), p. 372.

6. Henry David Thoreau, *A Week on the Concord and Merrimack Rivers; Walden, or, Life in the Woods; The Maine Woods; Cape Cod* (New York: Library of America, 1985), p. 934.

7. Thoreau, *Journals*, 3:200–201 (January 17, 1852).

8. Immanuel Kant, *Critique of Judgment*, trans. Werner S. Pluhar (Indianapolis: Hackett, 1987), p.123.

9. Ibid., p. 130.

10. Ruskin, *Modern Painters*, 1:357–58.

11. Hans-Georg Gadamer, *Philosophical Hermeneutics*, trans. and ed. David E. Linge (Berkeley and Los Angeles: University of California Press, 1977), p. 95.

12. Melville, *Moby Dick*, p. 412.

13. Ruskin, *Modern Painters*, 2:151.

14. Ibid., 2:152.

15. Cited in Basil Taylor, *Constable: Paintings, Drawings, and Watercolours* (London: Phaidon, 1973), p.15. For discussion of the 1821 cloud studies, see also Kurt Badt, *John Constable's Clouds* (London: Routledge and Kegan Paul, 1950); John Walker, *John Constable* (New York: Harry Abrams, 1991), p.86; and Peter Bishop, *An Archetypal Constable* (Madison, NJ: Fairleigh Dickinson Press, 1995), pp. 96–97. In *Forests: The Shadow of Civilization* (Chicago: University of Chicago Press, 1992), Robert Pogue Harrison discusses Constable's clouds in relation to his aesthetic theories, particularly his ideas of "a chiaroscuro of nature" underlying conditions of appearance in general (pp. 202–11). Since the publication of this catalogue essay, Hubert Damisch's *A Theory of /Cloud/:Toward a History of Painting*, trans. Janet Lloyd (Stanford, CA: Stanford University Press, 2002), has appeared as a text congruent with many of my comments on these works. Damisch sees the representations of clouds in Western art as a countertradition to that of linear perspective.

16. *The Note-books and Papers of Gerard Manley Hopkins*, ed. with notes and preface by Humphry House (London: Oxford University Press, 1937), p.140.

17. Ibid., p. 164.

18. Vija Celmins, as quoted by Susan Larsen in her essay "Vija Celmins," in *Vija Celmins: A Survey Exhibition*, by Betty Turnbull and Susan Larsen (Los Angeles: Newport Harbor Art Museum, 1979), p. 29.

19. Ruskin, *Modern Painters*, 1:315.

20. Ibid., 1:316.

21. Tycho Brahe, "On a New Star, Not Previously Seen within the Memory of Any Age since the Beginning of the World," trans. John H. Walden. Reprinted from *Source Book in Astronomy*, ed. Harlow Shapley and Helen Howarth (New York: McGraw Hill, 1929), in *The Book of the Sky*, ed. A. C. Spectorsky (New York: Appleton-Century-Crofts, 1956), pp. 250–51.

22. Thoreau, *A Week on the Concord . . . Cape Cod*, p. 936.

23. Henry Beston, *The Outermost House* (New York: Penguin Books, 1956), pp. 43–45.

24. Walt Whitman, *Complete Poetry and Collected Prose*, ed. Justin Kaplan (New York: Library of America, 1982), p. 399.

Chapter 10

This essay was originally titled "Garden Agon" and published in *Representations*, no. 62 (1998): 111–43. Reprinted by permission of the University of California Press. © 1998 by The Regents of the University of California. It was also reprinted in *Space Site Intervention*, ed. E. Suderberg (Minneapolis: University of Minnesota Press, 2000).

1. For an introduction to these issues, see James Fenton, "War in the Garden," *The New York Review of Books* 40, no. 12 (June 24, 1993): 23–26. James Elkins has provided an overview of the paradigms of garden scholarship in his essay, "On the Conceptual Analysis of Gardens," *Journal of Garden History* 13, no. 4 (Winter 1993): 189–98. Craig Clunas's recent work on Chinese gardens suggests important cultural and historical variations in the tensions between agricultural and aesthetic functions of gardens: *Fruitful Sites: Garden Culture in Ming Dynasty China* (London: Reaktion Books, 1996).

2. In providing an account of the garden, I have noted sources whenever relevant. Any unattributed details are from my notes and sketches made during a visit to Little Sparta on June 20, 1993. Much of the material for this essay was gathered from the Ian Hamilton Finlay archives at the Getty Center for the History of Art and the Humanities, Santa Monica, California. All photographs are courtesy of the Getty Center archives. I am grateful to Mr. Finlay for making possible my tour of the garden and for his ensuing conversation and correspondence, although I do not believe he will concur with every argument I have made here. I also thank the Getty Center for extensive support in May and June 1995, during my tenure there as a Visiting Scholar.

3. In 1962 Finlay founded the journal *Poor. Old. Tired. Horse*, published by the press he had founded with Jessie McGuffie in 1961, Wild Hawthorn Press.

4. See Finlay, "Reflections on the French Revolution," Getty mss. box #18.

5. Although the media coverage of this event emphasized its "mock" quality, Finlay has written that "a very delicate, and dangerous, line was established; it was a case of a

real rather than imaginary garden with very real police. The wonder was that we were not in prison." Correspondence, November 29, 1995.

6. Yves Abrioux, *Ian Hamilton Finlay: A Visual Primer*, with introductory notes and commentaries by Stephen Bann (London: Reaktion Books, 1992), pp. 7–13. This is the second edition, much expanded and revised from a first edition in 1985. Abrioux's work and the essays of Stephen Bann, the latter following Finlay's career closely and providing an ongoing commentary on developments in his art, are the most important and extensive introductions to Finlay's work. Gavin Keeney's "Noble Truths, Beautiful Lies, and Landscape Architecture" (M.A. thesis, Cornell University, 1993), provides an interpretive discussion of Finlay's 1988 *Un jardin revolutionnaire* proposal and locates this recent project within the fuller context of Finlay's work. I am grateful to Mr. Keeney for sending me a copy of his study and for his more general comments on Finlay's work offered in correspondence.

7. Alan Powers, "Neo-Classical Rearmament," *The Spectator*, Sept. 12, 1987, pp. 39–40. For a collection of critiques of the *National Trust Book of Follies*, see "Blast Folly, Bless Arcadia," ed. Patrick Eyres, *New Arcadians' Journal*, no. 24 (Winter 1986).

8. See Patrick Marnham, "Up the Garden Path," in *The Independent Magazine*, August 8, 1992, pp. 19–25; and Peter Day, "Ian Hamilton Finlay: The Bicentennial Proposal: The French War: The War of the Letter" (pamphlet; Toronto: Art Metropole, 1989). The most considered account of Finlay's loss of the Bicentennial Commission is by Yves Abrioux, "Vichy Revisited: The Cancellation of a Public Commission to Celebrate the Bicentenary of the French Revolution and the Declaration of the Rights of Man," photocopy of a talk given at the Sorbonne.

9. In Henry Liddell and Robert Scott, comps., *A Greek-English Lexicon*, 9th ed. (Oxford: Clarendon Press, 1940), vol 1.

10. Quoted from Charles H. Kahn, "Anaximander's Fragment: The Universe Governed by Law," in *The Pre-Socratics: A Collection of Critical Essays*, ed. Alexander P. D. Mourlatos (Garden City, NY: Anchor Press, 1974), pp. 99–117.

11. See the discussion in Claude Gintz, "Neoclassical Rearmament," *Art in America* (February 1987): 110–13.

12. Stephen Bann, "A Description of Stonypath," *Journal of Garden History* 1, no. 2 (April–June 1981): 113–44.

13. Abrioux, *Ian Hamilton Finlay*, p. 13.

14. The plant list is partial, gathered from my notes and from plants listed in Graham Rose, "The Garden of Unrest," *Observer* Colour Supplement, 1986, p. 55 (no further date or pages; see materials in Getty mss. box #21).

15. "L'Idylle des cerises" described in pamphlet from The Wild Hawthorn Press by Finlay and Michael Harvey (Getty mss. box #24): "*gean*, a grove of gean or wild cherry trees. On a small fluted column among the trees is a bronze or stone basket of cherries with the words *l'idylle des cerises*." The phrase is inspired by Finlay's reading of the following passage from Jean-Jacques Rousseau's *Confessions*, as cited in Renato Poggioli, *The Oaten Flute* (Cambridge, MA: Harvard University Press, 1975), pp. 14 and 273: "I climbed into a cherry tree, and threw bunches of cherries down to the girls, who then returned the cherry stones through the branches. Seeing one of the girls holding

out her apron and tilting her head, I took such good aim that I dropped a bunch into her bosom. 'Why are my lips not cherries,' I thought, 'How gladly I would throw them there, too!.'"

16. Quotes from pp. 297–300 of Erwin Panofsky's account of the development of the Arcadian concept in "Et in Arcadia Ego: Poussin and the Elegiac Tradition," in *Meaning in the Visual Arts, Papers in and on Art History by Erwin Panofsky* (Garden City, NY: Doubleday Anchor, 1955), pp. 295–320.

17. The Hyperboreans ("those who carry over") wrapped their offerings in wheat straw and requested their neighbors to pass them from nation to nation until they arrived at Delos. Their home is a region beyond the north wind, a paradise like the Elysian plains, which cannot be reached by land or sea.

18. *Heraclitus: The Cosmic Fragments*, ed. G. S. Kirk. (Cambridge: Cambridge University Press, 1975); quoted on p. 203, discussion on pp. 214–15.

19. Poggioli, *The Oaten Flute*, p. 238.

20. See Stephen Bann, "Ian Hamilton Finlay: An Imaginary Portrait," in *Ian Hamilton Finlay*, catalogue for exhibit at the Serpentine Gallery, London, September 17 to October 16, 1977, n.p.; and Finlay's 1986 card with photography by Marius Alexander, "Apollo in Strathclyde," with its inscription "The wine-dark sea, the turnip-marbled field. / The Hyperborean Apollo of Walter Pater's *Apollo in Picardy*. / In Little Sparta he is identified with Saint-Just," Getty Archive.

21. Bann, "Ian Hamilton Finlay."

22. See Maynard Mack, *The Garden and the City* (Toronto: University of Toronto Press; London: Oxford University Press, 1969), p. 232.

23. Alexander Pope, "The First Satire of the Second Book of Horace Imitated," in *Pope, Poetical Works*, ed. Herbert Davis (Oxford: Oxford University Press, 1978), pp. 340–45. See John Dixon Hunt, *The Figure in the Landscape: Poetry, Painting, and Gardening during the Eighteenth Century* (Baltimore: Johns Hopkins University Press, 1976), pp. 77–78 for a discussion of Pope's grotto at Twickenham in relation to this passage. Dixon Hunt explains that "the grotto at Twickenham was linked to Egeria, wife of a legendary philosopher-king Numa to make this connection explicit: for according to both Livy and Plutarch, Numa and Egeria entertained familiar conversation with the Muses [in their grotto] to whose teaching [Numa] ascribed the greatest part of his revelations" (p. 77). In *Broken Tablets: The Cult of the Law in French Art from David to Delacroix* (Berkeley and Los Angeles: University of California Press, 1993), Jonathan Ribner mentions that the same legend was influential in French Revolutionary thought: "The divinely inspired legislator played a large role in late eighteenth and nineteenth century French culture. That the Spartan Lycurgus enjoyed the blessings of Apollo and that Numa, the legendary second king of Rome, gained legislative wisdom from conversing with the nymph Egeria was known from Plutarch's *Parallel Lives*—a work firmly integrated into the French tradition by Jacques Amyot's classic translation (1559)" (p. 4).

24. See Marjorie Williams, *William Shenstone. A Chapter in Eighteenth Century Taste* (Birmingham, UK: Cornish Brothers, 1935), pp. 37–39; and E. Monro Purkis. *William Shenstone, Poet and Landscape Gardener* (Woverhampton: Whitehead Brothers, 1931).

25. See selections in Abrioux, *Ian Hamilton Finlay*, p. 40.

26. Kenneth Woodbridge, *The Stourhead Landscape* (Plaistow: The National Trust, 1978), p. 5. See also two pamphlets: *Stourhead* (The National Trust, 1971) and *Stourhead/Wiltshire* (London: Country Life Limited, 1952).

27. G. B. Clarke, *Stowe* (St. Ives, UK: Photo Precision, 1971), p. 11.

28. John Dixon Hunt, "Ut pictura poesis, ut pictura hortus, and the picturesque," *Word and Image* 1, no. 1 (January–March 1985): 87–197. "It is as if that Temple of British Worthies, elaborately provided with inscriptions, is offered in only partial competition with its classical counterpart across the river of death" (pp. 92–93). See also William Gilpin, *A Dialogue upon the Gardens at Stowe*, The Augustan Reprint Society, publication no. 176, 1976 (William Andrews Clark Memorial Library. University of California, Los Angeles). For an additional eighteenth-century account of Stowe, see George Bickham, *The Beauties of Stow, 1750*, The Augustan Reprint Society, publication nos. 185–86, 1977 (William Andrews Clark Memorial Library. University of California, Los Angeles).

29. See the booklet titled *SF*, printed at Finlay's Wild Hawthorn Press with George L. Thomson in 1978; and Christopher McIntosh, *Coincidence in the Work of Ian Hamilton Finlay*, n.p.

30. These examples are from Ribner, *Broken Tablets*, pp. 13–15. For further discussion of issues of unusual weather and tempests in Revolutionary iconography, see Ronald Paulson, *Representations of Revolution* (New Haven, CT: Yale University Press, 1983), pp. 5, 8, 44n19, 69, 75.

31. Mary Shelley, *Frankenstein* (New York: Signet, 1965), p. 40: "as the dazzling light vanished, the oak had disappeared, and nothing remained but a blasted stump. . . . It was not splintered by the shock, but entirely reduced to thin ribbons of wood. I never beheld anything so utterly destroyed." See also Victor Frankenstein after the disaster of his experiments: "But I am a blasted tree; the bolt has entered my soul" (p. 153).

32. *The Seasons by James Thomson with The Life of the Author by Dr. Samuel Johnson* (Philadelphia: H. Taylor, 1790), pp. 90–94, lines 1083–1231.

33. See Sheila McTighe, "Nicholas Poussin's Representations of Storms and *Libertinage* in the Mid-Seventeenth Century," *Word and Image* 5, no. 4 (October–December 1989): 333–61; reference is to p. 350. This essay provides an illuminating discussion of Poussin's paintings as representations of his political and moral philosophy, especially his ideas regarding nature and fate. In *Nicolas Poussin, A New Approach* (New York: Harry N. Abrams, 1966), Walter Friedlaender discusses Poussin's stoicism, especially the influence of Seneca regarding the necessity of a resolution to resist accidents of fortune and death.

34. See Bann, "A Description of Stonypath," pp. 123, 126. Finlay's use of vegetative background in light and shade to evoke the sea might also be linked to the "staging" of mythological scenes by means of classical sculptures in a sea of vegetation in the gardens of the Villa Medici, now the French Academy, in Rome.

35. See two of Finlay's pieces in particular: *Cloud Board*, an early work from 1968 in which a bisected tub was set into the ground, with one side reflecting clouds as they passed by and the other planted with aquatic plants such as water lilies, designed to im-

itate the form of the passing clouds; and *Angelique et Medor*, an inscription of the names of the lovers from Ariosto's *Orlando Furioso*, designed to be read in the water of a pond. Their story, set in the context of Charlemagne's wars, includes an account of their honeymoon in the woods; when Orlando, who has been enamored of Angelica, comes upon their retreat by chance and learns she has married the Moor Medoro, he is seized with madness. Orlando runs naked through the country, destroying whatever he encounters, and returns to Charlemagne's camp. As in Finlay's complex recreations of painted landscapes, both following and critiquing eighteenth-century conventions of the recreated picture, here he presents a fictional story in what could be its real setting, but reminds us of our doubled relation to the mutually implicated fictional and real by showing us the names in a mirror.

36. Eventually, in 1793, in the empty space where the prison had been, an enormous statue of Nature in the form of a Sphinx was erected. See Paulson, *Representations of Revolution*, p. 41.

37. See ibid., p. 17.

38. Ibid., p. 75.

39. Rousseau's remains were removed in 1794 to Sainte-Genevieve in Paris. Finlay has also made a series of prints with Gary Hincks, *Tombeau de Rousseau au Panthéon*, which juxtaposes the original neoclassical design with its torch of Truth to an arm holding a machine gun protruding from the tomb door, representing Action or Nature. See Abrioux, *Ian Hamilton Finlay*, p. 297. The Marquis de Girardin's tribute to Rousseau is itself an "island" of English taste in the French gardening tradition. See Day, "Ian Hamilton Finlay: The Bicentennial Proposal": "In successfully blending aesthetics, politics, Arcady and Husbandry, the English created a highly successful and at the same time individual form of garden that had little in common with the mathematical, pleasure and water-gardens of eighteenth-century French court life. As such, the English political garden is as foreign to French eighteenth-century life as the French garden itself differs from the English. The English political garden was alien to the nature and conception of French garden design and thinking, except in the noteworthy case of the Marquis de Girardin, the late eighteenth-century anglophile gardenist" (p. 15).

40. Quoted in Anthony Vidler, *The Writing of the Walls: Architectural Theory in the Late Enlightenment* (Princeton, NJ: Princeton Architectural Press, 1987), p. 18; see also Wolfgang Herrmann, *Laugier and Eighteenth Century French Theory* (London: A. Zwemmer, 1962). Herrmann wrote that "[t]he story of primitive man and his hut may have appealed to the average reader because of the then fashionable interest in the life of the savage, but Laugier had undoubtedly chosen it for a different reason: he thus traced the architectural lineage back as closely as was possible to nature itself. He calls the hut 'a rough sketch which nature offers us'" (from Laugier's *Essai* 2, p. 12 and *Essai* 1, p. 10, quoted in Herrmann on p. 43). See also the discussion of the hut as both picturesque and "a center of concentrated solitude" in Gaston Bachelard, *The Poetics of Space*, trans. Maria Jolas (Boston: Beacon Press, 1969), pp. 31–32.

41. A connection between the neoclassicism of the French Revolution and the destruction of the Bastille is made as well in Finlay's references to the neoclassicism expressed in the pastoral and prison etchings of Piranesi.

42. See Bann, "A Description of Stonypath," p. 138.

43. Ibid., p. 128.

44. Poggioli, *The Oaten Flute*, p. 3. See also Geoffrey Hartman, "'The Nymph Complaining for the Death of Her Faun': A Brief Allegory," in *Beyond Formalism: Literary Essays 1958–1970* (New Haven, CT: Yale University Press, 1970), pp. 173–92: "Those acquainted with the poetry of the Pleiade will remember the impact of the Anacreonta and the Greek Anthology (mediated by the Neo-Latin poets) on Ronsard, Du Bellay, and Belleau, who began to develop an alternate tradition to the high style of the great ode which had been their main object of imitation. Not odes but odelettes, not epics and large elegies but little descriptive domestic or rural poems. . . . A strange riot of diminutives and diminutive forms begins. The word *idyll* in fact was commonly etymologized as a diminutive of *eidos*, a little picture" (p. 177).

45. See Abrioux, *Ian Hamilton Finlay*, p. 2: "Exhibition of toys [in 1963] at the home of the publisher John Calder." Finlay's model-making is discussed in Day, "Ian Hamilton Finlay: The Bicentennial Proposal," p. 19.

46. See, for example, H. G. Wells, *Little Wars: A Game for Boys from Twelve Years of Age to 150 and for That More Intelligent Sort of Girls Who Like Boys' Games and Books; with an Appendix on Kriegspiel* (London: Frank Palmer, 1913). Miles Orvell, in "Poe and the Poetics of Pacific" (in *Ian Hamilton Finlay: Collaborations* [exhibition catalogue; Kettle's Yard Gallery, Cambridge, 13 April–8 May, 1977, Cambridge Poetry Festival 1977], pp. 17–22), describes "Pacific," a war game like draughts that Finlay invented involving the progress of airplane and carrier models across a board. Finlay has also studied, and based a concrete poem ("little fields / long horizons") upon, the prison garden of Albert Speer at Spandau, contending that the Nazi architect's assemblage of concrete, debris, and plants there—far from being a benign hobby—was a recreation of his memories of party rally scenes such as the Zeppelinfeld. See Graham Rose, "The Garden of Unrest" (Getty mss. box #21); and Stephen Bann's commentary on "The Speer Project" in Abrioux, *Ian Hamilton Finlay*, pp. 288–89.

47. Gilpin, *A Dialogue Upon the Gardens at Stowe*, pp. 29–30.

48. See John Dixon Hunt's discussion of theatricality in the perspectival garden scene in "Ut pictura poesis," p. 93.

49. Keeney, "Noble Truths, Beautiful Lies, and Landscape Architecture," p. 163.

50. Paulson, *Representations of Revolution*, p. 7.

51. See Geoffrey Hartman, "Wordsworth, Inscriptions, and Romantic Nature Poetry," in *Beyond Formalism*, pp. 206–30; reference is to pp. 210–11.

52. See Louis-Antoine de Saint-Just, *Théorie politique. Textes établis et commentes par Alain Lienard* (Paris: Editions du Seuil, 1976), pp. 139–40.

53. Nesta H. Webster, *The French Revolution: A Study in Democracy* (New York: E. P. Dutton, 1922); quotation is from p. 473. See also Webster's *Secret Societies and Subversive Movements* (London: Boswell, 1924), *The Socialist Network* (London: Boswell, 1926), and *World Revolution: The Plot against Civilization* (London: Constable, 1921). For a brief discussion of Webster's influence on this "classic paranoid anti-Semitism" as yoked to French modernism, see Louis Menand's review of Anthony Julius's *T. S. Eliot, Anti-Semitism, and Literary Form* (Cambridge: Cambridge University Press, 1995), "Eliot and the Jews," *The New York Review of Books* 43, no. 10

(June 6, 1996): 34–41. In a continuation of the anti-Semitic and anti–Free Mason con-
spiratorial speculations of the eighteenth-century Jesuit Abbé Augustin Barruel, Webster
constantly argues that the Terror is the root of all later anarchic and subversive social
movements. (See the discussion of French anti-Semitism during the Enlightenment by
Leon Poliakov, *The History of Anti-Semitism*, trans. Miriam Kochan [New York:
Vanguard/Routledge, 1975], 3:70–156).

54. In a letter on January 29, 1975, to Michael Harvey on his plans for a Battle of
the Midway emblem, Finlay explains: "Obviously, the emblem or medallion or impresa
form appeals to me because it conjoins words and pictures. It also makes something of
an issue of *brevity*. But perhaps even more relevant is the element of *wit*."

55. Finlay plays on the duality of the Greek word χαίρε, meaning both "hail" and
"farewell" in the sense of a salute to the dead, particularly in his one-word poem
WAVE / ave.

56. See "The E at Delphi" in *Plutarch's Moralia in Sixteen Volumes*, trans. Frank
Cole Babbitt, vol. 5 (Cambridge, MA: Harvard University Press, 1969), pp. 253.

57. Personal letter to Mary Ann Caws, April 30, 1989, p. 3. In Getty mss. box #7.

58. Quoted from Poggioli, *The Oaten Flute*, p. 12. In this theme of a simultaneity
that will reveal the couple as in fact one, we find Finlay's interest in recording the
names of pairs of lovers: Aeneas and Dido, Apollo and Daphne, Angelica and Medoro,
and others who are brought together or torn apart by strife and in their separation are
yet joined by time or dissolved into nature, as Dido is into fire or Daphne is into wood.

59. See Poggioli, *The Oaten Flute*, p. 30.

60. Quoted in Abrioux, *Ian Hamilton Finlay*, p. 291.

61. Maurice Pellisson, *Champfort: Étude sur sa vie, son caractère, et ses écrits*
(Paris, 1895; reprint, Geneva: Slatkine Reprints, 1970), p. 218.

62. Kirk, ed., *Heraclitus: The Cosmic Fragments*, p. 245.

63. See David Carrier, *Poussin's Paintings: A Study in Art-Historical Methodology*
(University Park: Pennsylvania State University Press, 1993), pp. 171–72.

64. Panofsky's final revision of the essay is in *Meaning in the Visual Arts* (Chicago:
University of Chicago Press, 1983), pp. 295–320. See pp. 316–17. The paintings are in
fact a kind of emblem of art history scholarship, posing a number of conflicts in inter-
pretation. See, for example, Carrier, *Poussin's Paintings*, pp. 30–174, which surveys the
competing versions of Panofsky's essay in light of larger considerations of Poussin's
landscapes; Louis Marin, "Towards a Theory of Reading in the Visual Arts: Poussin's
The Arcadian Shepherds," in *Calligrams*, ed. Norman Bryson (Cambridge: Cambridge
University Press, 1988), which uses the deictic aspect of the Louvre painting to propose
a theory of reading in painting; and Jean-Louis Schefer, "Thanatography, Skiagraphy
(from *Espece de chose melancolie*)," trans. Paul Smith, *Word and Image* 1, no. 2
(April–June 1985): 191–96, which sees the painting as a kind of allegory of reading
more generally where the painting represents the onset of interpretation made possible
by the loss of the body as a lived relation.

65. Hartman, "A Brief Allegory," p. 191.

66. Letter from the philosopher Edward Hussey to Finlay in 1977, quoted in Bann,
"A Description of Stonypath," p. 134.

67. See Paul Fussell, *The Rhetorical World of Augustan Humanism, Ethics and Imagery from Swift to Burke* (Oxford: Clarendon Press, 1965), p. 143.

68. Abrioux, *Ian Hamilton Finlay*, p. 224.

69. Excerpts from *A New Arcadian Dictionary* are reprinted in the catalogue *Coincidence in the Work of Ian Hamilton Finlay*, n.p.

70. Terry Comito, *The Idea of the Garden in the Renaissance* (New Brunswick: Rutgers University Press, 1978), pp. 9–12.

71. Ibid., pp. 14–15.

72. See Christopher McIntosh, *Coincidence in the Work of Ian Hamilton Finlay* (exhibition catalogue; Graeme Murray Gallery, 1980, n.p.) p. 3 of text.

73. Sir Thomas Browne, *Religio Medici, Hydriotaphia and The Garden of Cyrus*, ed. R. H. A. Robbins (Oxford: Clarendon Press, 1972). All page references in the text refer to this edition, although I have also consulted *Hydriotaphia, Urne-Buriall, Or A Discourse of the Sepulchrall Urnes lately found in Norfolk. Together with The Garden of Cyrus, or the Quincunciall, Lozenge, or Net-work [p]lantations of the Ancients, Artificially, Naturally, Mystically Considered. With Sundry Observations. By Thomas Browne, D. of Physick* (London: printed for Hen. Brome at the Signe of the Gun in Ivy-lane, 1658).

74. Susan Howe, in an early essay on Finlay's concrete poetry, "The End of Art" (*Archives of American Art Journal* 14, no. 4 [1974]: 2–6) discusses Finlay's use of the cruciform in works like *Fisherman's Cross*, a concrete poem where eight clusters of the word *seas* surround a central *ease*: "again the cruciform, icon of redemption in continuity—. . . a poem whose visible form is identical to its structure." Howe quotes Henry Vaughn: "Death is a Crosse, to which many waies leade, some direct, and others winding, but all meet in one center."

75. Letter of April 30, 1989, to Mary Ann Caws, p. 3.

76. See G. G. Giarchi, *Between McAlpine and Polaris* (London: Routledge, 1984).

77. See Day, "Ian Hamilton Finlay: The Bicentennial Proposal," p. 18.

Chapter 11

This essay was written for the catalogue of the Deep Storage exhibition at Henry Art Gallery, Seattle (1998–99); P.S. 1 Contemporary Art Center, New York (1998); and Haus der Kunst, Munich, 1997: Ingrid Schaffner and Matthias Winzen, eds., *Deep Storage: Collecting, Storing, and Archiving Art* (New York and Munich: Prestel-Verlag, 1998). © Prestel-Verlag, Munich–New York and Siemens Kulturprogramm, Munich, 1998.

1. Gaston Bachelard, *The Poetics of Space*, trans. Maria Jolas (Boston: Beacon Press, 1969), p. 84.

2. See Robert Kirkbride, "On *Wunderkammern*: Curious Collections and Recollections," preliminary paper toward a dissertation on *wunderkammern*, History and Theory of Architecture Program, McGill University, 1996, pp. 9–12; Olga Raggio and Antoine M. Wilmering, *The Liberal Arts Studiolo from the Ducal Palace at Gubbio* (New York: The Metropolitan Museum of Art, 1996); and Luciano Cheles, *The Studiolo of Urbino: An Iconographic Investigation* (University Park: Pennsylvania State University Press, 1986). Curiosity is discussed extensively in Krysztof Pomian, *Collectors and Curiosities: Paris and Venice 1500–1800* (Cambridge, MA: Basil Blackwell, 1990). In a re-

cent essay, Alan Stewart has claimed that Renaissance "closets" were not strictly private spaces, but rather a space of transaction between men—often princes and their secretaries: "The Early Modern Closet Discovered," *Representations*, no. 50 (Spring 1995), pp. 76–100.

3. Mary Carruthers, *The Book of Memory: A Study of Memory in Medieval Culture* (Cambridge: Cambridge University Press, 1990), pp. 24–25.

4. Stephen Bann, "Shrines, Curiosities, and the Rhetoric of Display," in *Visual Display*, ed. Lynne Cooke and Peter Wollen (Seattle: Bay Press; New York: DIA Foundation, 1995), pp. 14–29; reference is to pp. 26–29.

5. Carruthers, *The Book of Memory*, p. 36.

6. Deborah Solomon's recent critical biography of Cornell, *Utopia Parkway: The Life and Work of Joseph Cornell* (New York: Farrar, Straus and Giroux, 1997), mentions several times that the "dovecote boxes" were an important transition in Cornell's work. She writes of how in the 1950s Cornell moved from aviaries to observatories, and then to the dovecotes as "grid-filled nesting places" (see pp. 212, 258, 266, 270, and 337), but does not mention a connection with either memory practices or the *studiolo* tradition.

7. Cf. Diane Waldman, *Joseph Cornell* (New York: George Braziller, 1977), p. 30.

8. Cf. Leo Steinberg, *Other Criteria: Confrontations with Twentieth-Century Art* (New York: Oxford University Press, 1972), pp. 55–91; and Craig Owens, "The Allegorical Impulse: Toward a Theory of Postmodernism," in *Art After Modernism: Rethinking Representation*, ed. Brian Wallis (New York: The New Museum of Contemporary Art, 1984), pp. 203–35.

9. Cf. exhibition catalogue from the Los Angeles County Museum of Art and The Museum of Modern Art, New York: Carol S. Eliel, "'Nourishment You Take,' Annette Messager, Influence, and the Subversion of Images," in *Annette Messager* (New York: Abrams, 1996), pp. 51–64.

10. Quoted in ibid., p. 59.

11. For a discussion of Boltanski's photographs as works in which "it is the artist who creates those images and captions that are imprecise enough to be as communal as possible," see Marjorie Perloff, "What Really Happened: Roland Barthes' Winter Garden/Christian Boltanski's Archives of the Dead," in *Artes* (Stockholm: The Swedish Academy, 1995), pp. 110–25.

12. See Jeanne Silverthorne, "On the Studio's Ruins," *Sculpture* (November–December 1994): 26–29; and Judith Tannenbaum, ed., *Jeanne Silverthorne*, with an essay by Ingrid Schaffner and an interview by JoAnna Isaak (Philadelphia: Institute of Contemporary Art, 1996).

13. Silverthorne, "On the Studio's Ruins," p. 28.

14. Ibid., p. 27.

Chapter 12

This essay was delivered as a lecture for the series Stories of Modernism at the Museum of Modern Art in New York in 1997.

1. For an important discourse on the relation of modernity to Hegel's aesthetic the-

ory and Schiller's "Letters," see Jürgen Habermas, *The Philosophical Discourse of Modernity: Twelve Lectures* (Cambridge, MA: MIT Press, 1990), pp. 23–50.

2. See the discussion of "the claims of narrative" in Alex Callinicos, *Theories and Narratives: Reflections on the Philosophy of History* (Durham, NC: Duke University Press, 1995), pp. 44–53.

3. James Thomas Flexner, *The Light of Distant Skies: History of American Painting 1760–1835* (New York: Dover, 1988), p.161.

4. See Michael Kimmelman's authoritative survey, "Revisiting the Revisionists: The Modern, Its Critics, and the Cold War," *Studies in Modern Art*, no. 4 (1994): 38–55.

5. Michael Leja's helpful survey of the "modern man" discourse—"a matrix of primitive instincts, habits, and unconscious impulses" (p. 270)—that he claims affected the manifesti and reception of the New York School can be found in his *Reframing Abstract Expressionism: Subjectivity and Painting in the 1940s* (New Haven, CT: Yale University Press, 1993).

6. Among the many works that critique the concept of the avant-garde, beginning perhaps with Georges Bataille's critique of surrealism (see "The 'Old Mole' and the Prefix Sur," in *Visions of Excess: Selected Writings, 1927–1939*, trans. Allan Stoekl [Minneapolis: University of Minnesota Press, 1985], pp. 32–44), two of the most central are Rosalind Krauss's essay printed in her collection of the same title, *The Originality of the Avant-Garde and Other Modernist Myths* (Cambridge, MA: MIT Press, 1986), with its discussion of the copy as a central element of avant-garde painting and sculpture, and Peter Bürger's critique of the novelty of the concept of "the new" in modernism in his *Theory of the Avant-Garde* (Minneapolis: University of Minnesota Press, 1984), pp. 59–63. For a discussion of the revival of surrealism in contemporary art, and hence of the ways the avant-garde can by now recycle its own history, see Hal Foster's *Compulsive Beauty* (Cambridge, MA: MIT Press, 1993). Foster wrote, "The outmoded is problematic not because it is now recouped or effaced but because it is too bound up in a singular logic of historical development" (p. 212).

7. Circa 1300; Museo dell'Opera del Duomo, Siena.

8. Michael Baxandall's *Painting and Experience in Fifteenth-Century Italy* (Oxford: Oxford University Press, 1972) traces through contracts and other documents of patron-painter relationships the gradual change in emphasis from the value of materials, gold and ultramarine particularly, to the value of the painter's skill in representation.

9. Anon., late fifteenth century; Palazzo Ducale, Urbino.

10. Circa 1550; Galleria Uffizi, Firenze.

11. See Dalia Judovitz, *Subjectivity and Representation in Descartes: The Origins of Modernity* (Cambridge: Cambridge University Press, 1988), p. 63.

12. Raymond Klibansky, Erwin Panofsky, and Fritz Saxl, *Saturn and Melancholy: Studies in the History of Natural Philosophy, Religion, and Art* (London: Thomas Nelson, 1964).

13. My account of nocturnes in painting here follows my larger description of the nocturne form in *Poetry and the Fate of the Senses* (Chicago: University of Chicago Press, 2002), pp. 256–91. For a discussion of the relation between night and miracles, see Jean-Claude Maire Viguer, "Valenze della notte in alcune esperienze religiose me-

dievali (Italia centrale, XIII-XIV secolo)," *Laboratorio di storia* 3 (1991): 23–29. Regarding light and the nocturnal in painting, see Lucia Corrain, "Raffigurare la notte," pp. 141–61 and "Chiara di luna e pittura di luce," pp. 165–69 in the same issue.

14. Roger Hinks, *Michelangelo Merisi da Caravaggio* (London: Faber and Faber, 1952), p. 51.

15. Caravaggio's relation to sound is briefly discussed in René Jullian, *Caravage* (Paris: Editions IAC, 1961), pp. 128–29. Howard Hibbard's biographical study, *Caravaggio* (New York: Harper and Row, 1983), cites an essay by Cesare Brandi ("L'Episteme caravaggesca," *Colloquio* [1974]: 9–17) recording that x-rays of Caravaggio's paintings show that, in his direct approach to the canvas, "Caravaggio painted heads that almost always begin with the ear." See 29n.

16. Exhibition catalogue, *Notes, Harmonies, and Nocturnes. Small Works by James McNeill Whistler*; introduction by Margaret F. MacDonald, November 30–December 27, 1984 (New York: M. Knoedler and Company, 1984), p.53.

17. Samuel Taylor Coleridge, *Biographia Literaria*, ed. James Engell and W. Jackson Bate, 2 vols. (Princeton, N.J.: Princeton University Press, 1969), 2:5.

18. E. R. and J. Pennell, *The Life of James McNeill Whistler*, 5th rev. ed. (London, 1911), p.113; quoted in Stephen Hackney, "Colour and Tone in Whistler's 'Nocturnes' and 'Harmonies' 1871–1872," *The Burlington Magazine* 136, no. 1099 (October 1994): 695–99; quotation is from p.695. Hackney points out that Whistler's nocturnes are small canvases because he wanted to have the image be the same size it would be when viewed from whatever prospect he had chosen.

19. In *The Collected Works of William Hazlitt*, ed. A. R. Waller and Arnold Glover, 12 vols. (London: J. M. Dent, 1902), 1:76n: "The artist delights to go back to the first chaos of the world, or to that state of things when the waters were separated from the dry land, and light from darkness, but as yet no living thing nor tree bearing fruit was seen upon the face of the earth. All is 'without form and void.' Some one said of his landscapes that they were 'pictures of nothing, and very like.'"

20. Quoted in Linda Merrill, *A Pot of Paint: Aesthetics on Trial in "Whistler v. Ruskin"* (Washington, DC: Smithsonian Institution Press, 1992), p.144.

21. Mary Carruthers, *The Book of Memory: A Study of Memory in Medieval Culture* (Cambridge: Cambridge University Press, 1990), pp. 1–45.

22. Ibid., pp. 52–57.

23. See Carruthers's "Models for Memory" in ibid., pp. 16–45.

24. Walter Benjamin, "The Work of Art in the Era of Mechanical Reproduction," trans. Harry Zohn, in *Illuminations*, ed. Hannah Arendt (New York: Schocken Books, 1976), pp. 217–52.

25. Carruthers, *The Book of Memory*, p.129.

26. See details from the east, south, and west walls in Luciano Cheles, *The Studiolo of Urbino: An Iconographic Investigation* (University Park: Pennsylvania State University Press, 1986).

27. Carruthers, *The Book of Memory*, pp. 51–57.

28. Private collection and Museum of Modern Art, respectively.

29. Stephen Polcari, *Abstract Expressionism and the Modern Experience* (Cambridge: Cambridge University Press, 1991), pp. 132, 141, 146, 228–29, 269–70, 272, 277, 285.

30. See Peter H. v.Blanckenhagen and Christine Alexander, *The Paintings from Boscotrecase* (Heidelberg: F. H. Kerle Verlag, 1962).

31. August Mau, *Pompeii: Its Life and Art*, trans. Francis W. Kelsey (New York: The MacMillan Co., 1899), pp. 446–74. My understanding of this tradition owes a great deal to the lectures of Jan Gadeyne.

32. Barnett Newman, "The Sublime Is Now" (1948), reprinted in Herschel B. Chipp, ed., *Theories of Modern Art* (Berkeley and Los Angeles: University of California Press, 1968), pp. 552–53.

33. Frederick R. Weisman Foundation and Museum of Modern Art, respectively.

34. Jean-Francois Lyotard, *The Inhuman* (Stanford, CA: Stanford University Press, 1991), p. 90.

Chapter 13

This essay, now revised, was originally written for the catalogue of the On the Threshold of the Visible exhibition (Los Angeles and New York, 1997), and subsequently republished as a book entitled *At the Threshold of the Visible: Minuscule and Small-Scale Art, 1964–1996* (New York: Independent Curators Incorporated, 1997).

1. From *Poems, and Fancies: Written by the Right Honourable The Lady Newcastle* (London: J. Maryn and J. Allestrye, 1653), pp. 44–45.

2. Robert Hooke, *Micrographia; or, Some Physiological Descriptions of Minute Bodies Made by Magnifying Glasses, with Observations and Inquiries There Upon* (London: Jo. Maryn and Ja. Allestrye, 1665), preface, final page.

3. Aristotle, *On the Art of Fiction: "The Poetics,"* trans. L. J. Potts (Cambridge: Cambridge University Press, 1968), p. 27.

4. Immanuel Kant, *The Critique of Judgment*, trans. James Creed Meredith (Oxford: Oxford University Press, 1982, p. 94).

5. Ibid., p. 97.

6. See Leon Battista Alberti, *On Painting*, trans. John R. Spencer (New Haven, CT: Yale University Press, 1966) p. 56.

7. See Hubert Damisch, *The Origin of Perspective*, trans. John Goodman (Cambridge, MA: MIT Press, 1995), p. 19.

8. These examples are described in Isaac D'Israeli, *Curiosities of Literature*, 2 vols. (Paris: Baudry's European Library, 1835), 1:231–32. I discuss micrographia and the miniature more generally in *On Longing: Narratives of the Miniature, the Gigantic, the Souvenir, the Collection* (1984; reprint, Durham, NC: Duke University Press, 1995), pp. 37–69 passim.

9. Gaston Bachelard, *The Poetics of Space*, trans. Maria Jolas. Boston: Beacon Press, 1969, p. 150.

10. Exhibition catalogue, *Hannah Wilke: A Retrospective*, April 3–28, 1989 (St. Louis: Gallery 210, 1989), p.20.

11. Sigmund Freud, "On Transience" (1916), in *Character and Culture*, ed. Philip Rieff (New York: Collier Books, 1963), pp. 148–51; quotation is from p. 149.

Chapter 14

This essay was written in response to Peter Flaccus's *Opere a encausto* (Rome, 1996–2003).

1. Augustus Wilhelm von Schlegel, *A Course of Lectures on Dramatic Art and Literature,* trans. John Black (London: Henry Bohn, 1846), p. 340.

Chapter 15

These notes were written in response to the Poirier work *Ouranopolis,* completed at their studio for the Getty Center for the History of Art and the Humanities in Santa Monica, spring 1995, and later exhibited at the Sonnabend Gallery, New York City, autumn 1995.

Chapter 16

This essay was written for a conference entitled "Visual Display" at the Dia Center for the Arts in New York (1995), and subsequently published in the catalogue *Visual Display: Culture beyond Appearances,* ed. Lynne Cook and Peter Wollen (Seattle: Bay Press, in association with Dia Center for the Arts, 1995; New York: New Press, 1998). © Dia Center for the Arts, 1995. Reprinted by permission of The New Press, (800) 233-4830. It was also printed in *The Cultures of Collecting,* ed. John Elsner and Roger Cardinal (London: Reaktion Books Ltd, 1994).

1. See R. S. Buck, ed., *Plato's Meno* (Cambridge: Cambridge University Press, 1961). For discussion of Daedalus, see esp. pp. 408–11. I have discussed the theme of animation more generally in *On Longing: Narratives of the Miniature, the Gigantic, the Souvenir, the Collection* (Baltimore: Johns Hopkins University Press, 1984; reprint, Durham, NC: Duke University Press, 1993). A suggestive parallel to the case considered here is Annette Michelson's study of the iconography of Lenin's death, "The Kinetic Icon in the Work of Mourning: Prolegomena to the Analysis of a Textual System," *October* 52 (Spring 1990): 16–51. I would like to thank the Getty Center for Art History and the Humanities, Los Angeles; the Center for Literary and Cultural Change at the University of Virginia, Charlottesville; and the Dia Center for the Arts, New York, where preliminary versions of this essay were read.

2. The relation between countenance and oblivion is outlined in Emmanuel Levinas, *Totality and Infinity, An Essay on Exteriority,* trans. Alphonso Lingis (The Hague: Martinus Nijhoff, 1961; reprint, Pittsburgh: Duquesne University Press. 1969).

3. The major groups of the Peale family papers are held at the American Philosophical Society and the Historical Society of Pennsylvania in Philadelphia. Additional materials used in this essay are located at the American Philosophical Society Library and the Library Company in Philadelphia. See also Lillian B. Miller, ed., *The Selected Papers of Charles Willson Peale and His Family* (New Haven, CT: Yale University Press, The National Portrait Gallery, and the Smithsonian Institution, 1983–88); Charles Coleman Sellers, *Charles Willson Peale* (New York: Charles Scribner's Sons, 1969); Charles Coleman Sellers, *Mr. Peale's Museum: Charles Willson Peale and the First Popular Museum of Natural Science and Art* (New York: W. W. Norton, 1980); Charles Coleman Sellers, "Charles Willson Peale with Patron and Populace. A Supplement to 'Portraits and Miniatures by Charles Willson Peale' with a Survey of His Work in Other Genres," in *Transactions of the American Philosophical Society,* vol. 59, pt. 3 (Phila-

278 · Notes to Pages 187–189

delphia, 1969); Charles Coleman Sellers, "Portraits and Miniatures by Charles Willson Peale," in *Transactions of the American Philosophical Society*, vol. 42, pt. 1 (Philadelphia, 1952); Pennsylvania Academy of the Fine Arts, *Catalogue of an Exhibition of Portraits by Charles Willson Peale and James Peale and Rembrandt Peale* (Philadelphia, 1923); Edgar P. Richardson, Brooke Hindle, and Lillian B. Miller, eds., *Charles Willson Peale and His World* (New York: Harry N. Abrams, 1983); James Thomas Flexner, *America's Old Masters. First Artists of the New World* (New York: The Viking Press, 1939), pp. 171–244; Lillian B. Miller and David C. Ward, eds., *New Perspectives on Charles Willson Peale, A 250th Anniversary Celebration* (Pittsburgh: University of Pittsburgh Press and the Smithsonian Institution, 1991). I have also relied upon Peale's *Autobiography*, typescript by Horace Wells Sellers (Philadelphia: The American Philosophical Society Library, 1896), p.29.

4. Charles W. Peale, *Discourse Introductory to a Course of Lectures on the Science of Nature with Original Music composed for, and Sung on, the Occasion. Delivered in the Hall of the University of Pennsylvania, November 8, 1800* (Philadelphia: Zachariah Poulson, Junior, 1800), Library Company copy, p. 34.

5. Richardson, Hindle, and Miller, eds., *Charles Willson Peale and His World*, p.101. See C. Sellers, *Mr. Peale's Museum*, p. 19. Peale's skill at mounting skins on woodwork stemmed from his apprenticeship as a saddler.

6. Zebulon Pike had given two grizzly cubs, male and female, to President Jefferson, who in turn gave them to Peale for the museum zoo. One severely injured a monkey and later entered the Peale kitchen in the Hall basement. Peale contained the animal and shot it. He later killed the mate and mounted the two. See C. Sellers, *Mr. Peale's Museum*, pp. 206–7. Peale himself recounts the story in his *Autobiography*, Wells Sellers typescript, p. 373.

7. For surveys of Deism, see J. A. Leo Lemay, ed., *Deism, Masonry, and the Enlightenment* (Newark: University of Delaware Press, 1987); Peter Byrne, *Natural Religion and the Nature of Religion: The Legacy of Deism* (London: Routledge, 1989); Kerry S. Walters, *The American Deists: Voices of Reason and Dissent in the Early Republic* (Lawrence: University of Kansas Press, 1992); and Kerry S. Walters, *Rational Infidels: The American Deists* (Wolfeboro, NH: Longwood, 1992).

8. See Rousseau, "Profession de foi du Vicaire savoyard" (1762), in *Rousseau: Religious Writings*, ed. Ronald Grimsley (Oxford: Clarendon Press, 1970), pp. 107–200; reference is to p. 131. Peale mentions that he is reading Rousseau's *Confessions* in his *Autobiography*, Wells Sellers typescript, p. 12.

9. See Anthony Ashley Cooper, Third Earl of Shaftesbury, *Characteristics of Men, Manners, Opinions, Times* [1711], ed. John M. Robertson, 2 vols. (Indianapolis: Bobbs-Merrill, 1964), 1:268–69, who holds the belief in future rewards and punishments to be immoral; and Benjamin Franklin, letter to Ezra Stiles, March 9, 1790, in Walters, *The American Deists*: "the soul of Man is immortal, and will be treated with Justice in another Life respecting its conduct in this" (p. 105).

10. See James Thomas Flexner, *The Light of Distant Skies: History of American Painting, 1760–1835* (New York: Dover, 1969), p.12.

11. Peale also copied West's copy of Titian's *Venus*. See L. B. Miller, ed., *The Selected Papers*, 1:87n.

12. C. Sellers, *Mr. Peale's Museum*, p. 101.

13. The most important essay on this painting is Phoebe Lloyd's "A Death in the Family," *Philadelphia Museum of Art Bulletin* 78, no. 335 (Spring 1982): 3–13. Lloyd connects the painting to European mourning portraits and the conventions Peale may have drawn from Charles LeBrun's 1649 tract on the depiction of the emotions, *Traité des Passions*. She adds a detail that links the painting back to the artifice of *Elisha Restoring the Shunamite's Son*: "The telltale indication that Peale did not observe his wife from life is to be found in the whites of the eyes visible below the rolled up iris, after the example of LeBrun. This glance is nearly impossible to hold, especially with the head held straight." (pp. 3–5). An interesting parallel to the separation of Rachel's figure from the foreground can be found in Peale's complex *Self-Portrait with Angelica and a Portrait of Rachel* (1782–85), where the portrait of Rachel, slightly larger than the scale of the other two figures, is positioned beyond the picture plane. David Steinberg relates the structure of this work to "images of supernatural aid to the artist in the moment of creation," connecting the pun between *Angelica* and *angel* as the daughter reaches to guide her father's hand. But such an interpretation of divine intervention would seem to be contrary to Peale's Deism, unless perhaps it can be read as a playful allusion or parody. See David Steinberg, "Charles Willson Peale: The Portraitist As Divine," in Miller and Ward, eds., *New Perspectives on Charles Willson Peale*, pp. 131–44; reference is to p. 132. John Adams was "prodigiously" affected by the picture of Rachel mourning when he saw it on August 20, 1776. See L. B. Miller, ed., *The Selected Papers*, 1:382n; and Lyman Butterfield et al., eds., *The Adams Papers, Series II: Adams Family Correspondence*, vol. 2 (June 1776–March 1778) (Cambridge, MA: Belknap Press, Harvard University Press,1963): "Yesterday Morning I took a Walk, into Arch Street, to see Mr. Peele's Painters Rooms. Peele is from Maryland, a tender, soft, affectionate Creature. . . . He showed me one moving Picture. His wife, all bathed in Tears, with a Child about six months old, laid out, upon her Lap. This Picture struck me prodigiously." In the same letter Adams says Peale's head "is not bigger than a large Apple . . . I have not met with any Thing in natural History much more amusing or entertaining than his personal Appearance" (p. 103).

14. Richardson, Hindle, and Miller, eds., *Charles Willson Peale and His World*, p. 66.

15. Sigmund Freud, "On Transience," in *Freud, Character, and Culture*, ed. Philip Rief (New York: Collier, 1963), pp. 148–51; quotation is from pp. 150–51.

16. "An Essay on Vital Suspension" (London, 1741), pp. 7–11.

17. Peale himself records several incidents of ambiguous death in his account of Rachel's death in his autobiography. He wrote,

> "The custom of burying the dead too soon, has often been found a dreadful consequence. There once lived in Maryland a Mr. Chas. Carrol who very narrowly escaped being buried alive. He was supposed to be dead, and was laid out in the usial (sic) manner and persons employed to set up with the corpse—among them was a school master who had lived in the family. At a late hour when they had become inebriated, or as we might say, drunk, the school-master said, our friend there used to love a drop while living, suppose we should now give him some grog, they poured it down his throat and it produced motions of life and he lived some years

after this event. A Dr. Corson revived his daughter with a glass of madeira when she was supposedly dead of yellow fever" (*Autobiography,* Wells Sellers typescript, pp. 135–136).

18. See John McManners, *Death and the Enlightenment* (Oxford: Clarendon Press, 1981), for a survey of French eighteenth-century practices regarding death. Margaret M. Coffin's *Death in Early America* (Nashville: Thomas Nelson, 1976) is an anecdotal account of a variety of folkloric customs regarding death, mourning, and burial; see also David E. Stannard, ed., *Death in America* (Philadelphia: University of Pennsylvania Press, 1975), esp. Philippe Ariés' survey, "The Reversal of Death: Changes in Attitudes toward Death in Western Societies," pp. 135–58, which sees the eighteenth century as the turning point in the historical movement toward the denial of death and the suppression of mourning characteristic of modern society. Yet Peale explicitly rejected common mourning customs of his day. In his *Autobiography* he wrote, "If we are free agents to act as our best reason shall direct, then to [not] follow any custom which we deem absurd or even useless must be laudible [sic]" (Wells Sellers typescript, p. 137). The ambivalent status of the corpse is given much attention in chapters 5–7 of Charles Brockden Brown's 1799 novel on the yellow fever epidemic in Philadelphia: *Arthur Mervyn or Memoirs of the Year 1793* (Philadelphia: H. Maxwell, 1799).

19. L. B. Miller, ed., *The Selected Papers,* vol. 2, pt. 1, pp. 14–15.

20. Ibid., p. 21n4. She continues: "Only one incident of the exhibition of an embalmed body is known, that of the English philosopher Jeremy Bentham (1748–1832), who, toward the end of his life, suggested that people have themselves exhibited after death so that their remains would become a statue, or 'auto-icon.' On his death, Bentham's corpse was mummified, dressed, and placed in a chair for display at the University of London." Among the miscellaneous papers relating to Peale's Museum at the American Philosophical Society Library is a document attesting to the authenticity of two mummies sold to the museum. Dated July 28, 1825, from Trieste and signed "N. Mireoville," the note claims the mummies were collected in Alexandria by the signer, shipped from Trieste on an Austrian vessel, and later sold to a W. B. Hight, from whom Peale may have purchased them.

21. Ibid.

22. Flexner, *America's Old Masters,* pp. 195–96.

23. L. B. Miller, ed., *The Selected Papers,* 1:380.

24. Ibid., 1:382–83. Letter to Joseph Brewer, Philadelphia, January 15, 1783. Peale had four children by this time: Raphaelle, Angelica Kauffman, Rembrandt, and Titian Ramsay. Miller writes that his worries about his mother-in-law's will may stem from financial difficulties. Questions of inheritance in fact haunt Peale all his life, since his early trip to study with West marked his final understanding that he would not be receiving a hoped-for inheritance from England. During the time of that sojourn, he also learned of the true, disgraceful circumstances of his father's emigration to America. Lloyd, in "A Death in the Family," sees this period as a key to the ways in which Peale concentrates on "making the most of a loss," including the altered mourning portrait of Rachel and Margaret, throughout his career. (see p. 5).

25. See Richardson, Hindle, and Miller, eds., *Charles Willson Peale and His World,* p. 88. Issues of *trompe l'oeil* often appear in the discourse around Peale. See, for ex-

ample, William Parker Cutler and Julia Perkins Cutler, eds., *Life, Journals and Correspondence of Reverend Manasseh Cutler* (Cincinnati: Robert Clarke, 1888). In his account of a journey to New York and Philadelphia in 1787, Cutler tells of how he visited Peale with Dr. Gerardus Clarkson. As they entered Peale's studio they saw "a gentleman . . . standing with a pencil in one hand and a small sheet of ivory in the other and his eyes directed to the opposite side of the room, as though he was taking some object on his ivory sheet." They decide that Peale must be busy and they retreat to wait. But in turning around, they meet Peale, who shows them that the "gentleman" is a sculpture of himself, life-sized, in wax. Cutler remarks, "To what perfection is this art capable of being carried? By this method our particular friends and ancestors might be preserved in perfect likeness to the latest generation. We seem to be able in some degree to disappoint the ravages of time, and prevent mortality itself, the common lot of man, from concealing from us in its dreary retreats our dearest connections" (1:259–60). Peale wrote in his *Autobiography*, "If a painter . . . paints a portrait in such perfection as to produce a perfect illusion of sight, in such perfection that the spectator believes the real person is here, that happy painter will deserve to be caressed by the greatest of mortal beings" (Wells Sellers typescript, p. 338).

26. Flexner, *The Light of Distant Skies*, p.140.

27. See Leland E. Hinsie and Robert Jean Campbell, eds., *Psychiatric Dictionary*, 4th ed. (New York: Oxford University Press, 1970), p. 205.

28. Peale describes the moving pictures in his *Autobiography*. See Wells Sellers typescript, pp. 79–83. The presentation of *Pandemonium*, after Milton's description, is accompanied by a note that "Before the scene opened the following words were sung with musick: 'To raise by art the stately pile / we will essay our skill / . . . Yet great the task to make the glow / that burning sulphur does bestow / Yet great the task to make the glow / That burning, that burning sulphur / Does bestow'" (Wells Sellers typescript, p. 81). In the American Philosophical Society copy of the typescript, a 1785 notice of the exhibit of moving pictures is inserted between pp. 79–81.

29. Charles Willson Peale to Benjamin West, Philadelphia, November 17, 1788, in L. B. Miller, ed., *The Selected Papers*, 1:544.

30. Peale, *Discourse Introductory to a Course of Lectures*, Library Company copy, p. 48.

31. Ibid., pp. 39–40.

32. Ibid., pp. 6–7.

33. Ibid., p. 47.

34. C. Sellers, *Charles Willson Peale and His World*, p. 305.

35. Charles Willson Peale to Elizabeth DePeyster Peale, June 28, 1801, New York, in L. B. Miller, ed., *The Selected Papers*, vol. 2, pt. 1, p. 335.

36. Charles Willson Peale to Andrew Ellicott, July 12, 1801, Philadelphia, in ibid., pp. 343–344.

37. Charles Willson Peale to Benjamin West, December 16, 1807, Philadelphia, in ibid., vol. 2, pt. 2, pp. 1052–54. This letter is discussed briefly in an article in the *Pennsylvania Magazine of History and Biography* 9 (1885): 130–32. At the left of the tent, standing with arms folded, is Peale's fellow naturalist Alexander Wilson (author of *American Ornithology*). Climbing a ladder in the foreground is John Masten, the

282 · NOTES TO PAGES 198–200

farm's owner. Peale himself stands with arm extended, holding a large drawing of the bones. Next to him from left to right are Mrs. Hannah Peale in Quaker cap, possibly Mrs. Rembrandt Peale, and members of the Peale family: Rembrandt; Sybilla, who is pointing toward heaven to explain God's plan for the universe and the meaning of the discovery to her little sister, Elizabeth; Rubens (with glasses); and Raphaelle. James Peale stands between the two poles at midpicture. In the group to the right of Wilson, Peale's deceased second wife, Elizabeth DePeyster, scolds her youngest son, Titian Ramsay II; her sister and brother-in-law, Major and Mrs. John Stagg, stand behind her. Other relatives are behind the green umbrella, and the two younger Peale boys, Linnaeus and Franklin, push a log into the pit with a long pole.

38. Rembrandt Peale, *An Historical Disquisition on the Mammoth, or Great American Incognitum, an Extinct, Immense, Carnivorous Animal, Whose Fossil Remains Have Been Found in America* (London, 1803). Reprinted in L. B. Miller, ed., *The Selected Papers*, 2:544–81.

39. Peale's statement is in his *Autobiography*, Wells Sellers typescript, pp. 428–429. See also C. Sellers, *Mr. Peale's Museum*, p. 246. It is interesting to note that Manasseh Cutler's journal of his 1787 visit as well draws an analogy between Peale and Noah. See Cutler and Cutler, eds., *Life, Journals and Correspondence of Rev. Manasseh Cutler*, p. 261.

40. Mario Praz, *Conversation Pieces: A Survey of the Informal Group Portrait in Europe and America* (University Park: Pennsylvania State University Press, 1971), pp. 209–23.

41. Charles Willson Peale to Rembrandt Peale, September 11, 18, 1808, Philadelphia, in L. B. Miller, ed., *The Selected Papers*, vol. 2, pt. 2, p. 1136. By the time the picture was finished, St. George had died in 1778; Peale's mother had died in 1791; his young daughter Eleanor (here on his mother's lap) had died in 1772 in infancy; Rachel had died in 1790; Margaret had died in infancy in 1788; Peale's sister Margaret Jane had died as well in 1788; and Margaret Durgan, the family's old nurse, on the right, had died in 1791.

42. Several times in his career Peale was called upon to paint memorial portraits of dead or dying children. See ibid., 1:415n. It is a theme we see not only in the relation between Titian's death and the museum's establishment but also in the controversies surrounding the life and death of Raphaelle Peale. In his thorough analysis of *The Artist in His Museum*, Roger B. Stein adds a note that poses a somewhat ironic reading of Peale's citation of Luke 15 ("For thy brother was dead, and is alive again, and was lost and is found") in his 1812 "An Essay to Promote Domestic Happiness." Stein sees the quotation as an admonition to Peale's own prodigal son, Raphaelle. Raphaelle died in 1825 after years of physical and mental instability, probably brought on by arsenic poisoning as a result of taxidermic work (See Stein, "Charles Willson Peale's Expressive Design: The Artist in His Museum," in Miller and Ward, eds., *New Perspectives on Charles Willson Peale*, pp. 167–218; reference is to p. 217n95). For an account of Raphaelle's poisoning, see Phoebe Lloyd, "Philadelphia Story," *Art in America* 76 (November 1988): 154–71, 195–203. Further, there is an uncanny echo between the passage from the book of Luke and the 1783 breakdown, for it is *Raphaelle* who cannot be remembered at the time. And it is obviously Raphaelle's drinking and tumultuous

marriage that are the thinly veiled referents of passages on the "hideous form of drunkenness" which makes "the proud form of man . . . degraded below the brutes" described in Peale's *An Essay to Promote Domestic Happiness by Charles W. Peale* (Philadelphia: Philadelphia Museum, 1812), Library Company copy, p.4. The meaning of the Luke passage can also be taken to refer to the position of St. George in *The Family Group*, in which Peale's painting situates him and James in conversation and positions of observation in relation to the dead, but here revived, St. George. And the theme of the lost brother recurs as well, of course, to the traumatic aftermath of the Battle of Trenton—James's disfigurement and Charles's inability to recognize him.

43. See L. B. Miller, ed., *The Selected Papers*, vol. 2, pt. 2, p. 1136.

44. Letter to Rembrandt Peale, July 23, 1822. Microfiche, American Philosophical Society Library.

45. It is suggestive to consider that in his last years Peale in fact seemed to undertake a repetition or review of his earlier work. In January of 1821 he began *Christ Healing the Sick at the Pool of Bethesda*, a large historical work on a theme directly in contrast with the Deist tenets on miracles and revealed religion. The work returned to the issues of miracles and Peale's legacy from West. West had treated the subject, even though Peale was working on an adaptation from a print by Christian Wilhelm Ernest Dietrich. In 1823 Peale made a new version of the *Staircase Group*. In this now-vanished piece, eight feet by six feet, he showed himself full-length, descending a short flight of steps with a palette and maulstick in hand and his saddler's hammer in the foreground. His movement is the opposite of the earlier staircase group, inverting the generations and inverting the direction of movement. His painting room and the museum could be seen behind him. He wrote in his *Autobiography*, "I mean to make the whole piece a deception if I can. . . . The frame is to be a door case with 2 steps and in the painting two other steps, and with my left foot on the lower step and the other behind as coming downstairs. This may be truly emblematical of his desending [sic] in life, with his pallet and pencils in his left hand and the mallstick in his right. Behind an easel with your Mother's portrait and her child asleep, from the idea of a picture which he painted early in his life, and which was much admired, so much that a poet wrote the following verses on it" (See *Autobiography*, Wells Sellers typescript, pp. 452–53). Peale characteristically talks of himself in the third person. In this passage he conflates the two pictures: the now-lost portrait of Rachel holding a sleeping Margaret, finished about 1771 (see Lloyd, "A Death in the Family," p. 3), and the funerary portrait called *Rachel Weeping*, to which he appended his verses. He forgets himself, rather slyly, as he forgets the pictures in time. "The steps will certainly be a true illusion, and why not my figure? It is said that Apelles painted grapes so natural that the birds came to pick them, that he then painted a boy to protect them, but the birds still came to take the grapes" (*Autobiography*, Wells Sellers typescript, p. 453)—Peale recorded in a letter to Rubens of August 25, 1823, that the painter Thomas Sully was fooled by the new *Staircase* painting, thinking the bottom step was a real step, as in the first *Staircase* group. See C. Sellers, *Charles Willson Peale and His World*, pp. 409–11.

Chapter 17

This work was written for *Transforming Vision, Writers on Art*, ed. Edward Hirsch. (Chicago: The Art Institute of Chicago, 1994). © 1994 The Art Institute of Chicago.

Chapter 18

This essay was originally published under the title "The Music Box Project" for the catalogue of the exhibit by the same name, curated by Claudia Gould (New York: On the Table, 1994).

1. Terence E. Crowley, *Discovering Mechanical Music* (Haverfordwest, UK: Shire, 1977), p. 17.

2. Alexander Buchner, *Mechanical Musical Instruments*, trans. Iris Urwin (Westport, CT: Greenwood Press, 1978), p. 16. For further information on the history of mechanical music, see Q. David Bowers, *A Tune for a Token* (Thiensville, WI: The Token and Medal Society, 1975); and Harvey N. Roehl, *Keys to a Musical Past/Player Pianos and Music Boxes* (Vestal, NY: Vestal Press, 1968).

3. *The Complete Works of Montaigne*, trans. Donald Frame (Stanford, CA: Stanford University Press, 1948), p. 963.

4. Arthur W. J. G. Orde-Hume, *Musical Box: A History and Collector's Guide* (London: George Allen and Unwin, 1980), pp. 15–16; and Buchner, *Mechanical Musical Instruments*, pp. 21–23.

5. Buchner, *Mechanical Musical Instruments*, p. 16.

6. Romke DeWaard, *From Music Boxes to Street Organs*, trans. Wade Jenkins (Vestal, NY: Vestal Press, 1967), p. 43.

7. Max Weber, *The Rational and Social Foundations of Music*, trans. and ed. Don Martindale, Johannes Riedel, and Gertrude Neuwirth (Carbondale: Southern Illinois University Press, 1958), p. 117.

8. DeWaard, *From Music Boxes to Street Organs*, pp. 43–44.

9. Crowley, *Discovering Mechanical Music*, p. 8.

10. Coop Himmelblau, *6 Projects for 4 Cities* (Darmstadt: Verlag Jürgen Hausser, 1990), p. 38.

11. DeWaard, *From Music Boxes to Street Organs*, pp. 97–98; and Orde-Hume, *Musical Box*, p. 61.

12. L. G. Jaccard, *Origin and Development of the Music Box* (St. Paul, MN: Musical Box Society International, n.d.), pp. 4–6.

13. Orde-Hume, *Musical Box*, p. 61; and Daniel Troquet, *The Wonderland of Music Boxes and Automata* (Sainte-Croix, Switzerland: Les Editions du Cochet SA, 1989), pp. 20–22.

14. Troquet, *The Wonderland of Music Boxes and Automata*, p. 24.

15. DeWaard, *From Music Boxes to Street Organs*, p. 40.

16. Troquet, *The Wonderland of Music Boxes and Automata*, pp. 26–42.

17. *The Meno*, in *The Works of Plato*, trans. and ed. B. Jowett, 4 vols. (New York: Tudor, n.d.), 3:51–52.

18. *The Basic Works of Aristotle*, ed. Richard McKeon (New York: Random House 1941), p. 544.

19. Calvino, Italo. *Italian Folktales*, trans. George Martin (New York: Pantheon Books, 1980), pp. 599–600.

20. Buchner, *Mechanical Musical Instruments*, p. 87.

21. Ibid., p. 88.

22. DeWaard, *From Music Boxes to Street Organs*, p. 103.

23. Buchner, *Mechanical Musical Instruments*, p. 88; and Arthur W. J. G. Orde-Hume, *Clockwork Music* (New York: Crown Publishers, 1973).

24. For a survey of such issues in the light of information theory, see Leonard B. Meyer, *Emotion and Meaning in Music* (Chicago: University of Chicago Press, 1956).

25. Weber, *The Rational and Social Foundations of Music*, pp. 118–19; and Jacques Attali, *Noise: The Political Economy of Music*, trans. Brian Massumi (Minneapolis: University of Minnesota Press, 1985), pp. 36–86.

26. Weber, *The Rational and Social Foundations of Music*, pp. 118–19, 124.

Chapter 19

Part 1 of this essay was written for *The Robert Lehmann Lectures on Contemporary Art*, vol. 1, ed. Lynne Cooke and Karen Kelly (New York: Dia Center for the Arts, 1996); © Dia Center for the Arts, 1996. Part 2 was originally published under the title "as firmanent a flame" for *between taxonomy and communion*, the catalogue of Hamilton's work by the La Jolla Museum of Art in 1990 (now called the Museum of Contemporary Art, San Diego).

1. Charles Baudelaire, *The Flowers of Evil*, trans. Jackson and Marthiel Mathews (New York: New Directions, 1989).

2. Nathalie Sarraute, *Tropismes,* ed. Sheila M. Bell (London: Methuen, 1972).

3. Ovid [Publius Ovidius Naso], *Metamorphoses*, trans. Mary M. Innes (Harmondsworth: Penguin, 1955): Io, pp. 44–48; Phaeton's sisters, p. 59; Callisto, pp. 61–63; Ocyrhoe, pp. 67–68.

4. See Patricia Churchland, *Neurophilosophy: Toward a Unified Science of the Mind-Brain* (Cambridge, MA: MIT Press, 1986); and Antonio Damasio, Daniel Tranel, and Hanna Damasio, "Face Agnosia and the Neural Substrates of Memory," *Annual Review of Neuroscience*, no. 13 (1990): 89–109.

5. Maurice Merleau-Ponty, *The Phenomenology of Perception*, trans. Colin Smith (London: Routledge, 1962), p. 196.

6. Augustine of Hippo. *Confessions*, trans. R. S. Pine-Coffin (Harmondsworth: Penguin Books, 1961), pp. 113–14.

7. Aristotle, "Poetics, " in *The Basic Works of Aristotle*, ed. Richard McKeon (New York: Random House, 1941), pp. 1455–87.

Chapter 20

This essay was originally published in the journal of the Center for Twentieth-Century Studies, *Discourse* (Fall–Winter 1988–89).

FIGURE CREDITS

Sketch of fragments of pediment at Ostia Antica from museum and travel notebooks. Courtesy of the author. *viii*

Ann Hamilton, *slaughter 1997*. Organza glove embroidered with Susan Stewart's poem "Slaughter." Wood and glass vitrine, $4 \times 18\frac{1}{2} \times 13\frac{3}{4}$ in. Photograph by Thibault Jeanson. Courtesy of Sean Kelly Gallery, New York. *8*

Andy Goldsworthy, *Clu de Barles*, Rainshadow Series. Courtesy of the artist and Michael Hue-Williams Fine Art Ltd., London. *14*

Arakawa and Madeline Gins, *Living Body Museumeum*. Courtesy of Arakawa and Madeline Gins. *27*

Sketch of urns from Thomas Schütte's *In Medias Res*, museum and travel notebooks. Courtesy of the author. *28*

Thomas Schütte, *Urns*, 1999, from *In Medias Res*. © 2004 Artists Rights Society (ARS), New York / VG Bild-Kunst, Bonn. Courtesy of the artist and Marian Goodman Gallery, New York. *32*

Thomas Schütte, *Steel Women*, 1998–99, from *In Medias Res*. © 2004 Artists Rights Society (ARS), New York / VG Bild-Kunst, Bonn. Courtesy of the artist and Marian Goodman Gallery, New York. *33*

Hans-Peter Feldmann, *100 Jahre*. © 2004 Artists Rights Society (ARS), New York / VG Bild-Kunst, Bonn. Courtesy of the artist and Fundació Antoni Tàpies, Barcelona. *44*

William Kentridge, *Act II, Scene 5*, from *Ubu Tells the Truth*, suite of eight etchings, 1996. Mixed intaglio techniques on paper, 250×300 mm. Courtesy of the artist and Goodman Gallery, Johannesburg. *50*

William Kentridge, *Untitled*, drawing for the film *Sobriety, Obesity, and Growing Old*, 1991. Charcoal and pastel on paper. Courtesy of the artist and Goodman Gallery, Johannesburg. *54*

William Kentridge, *Untitled*, drawing for the film *Felix in Exile*, 1994. Charcoal and pastel on paper. Courtesy of the artist and Goodman Gallery, Johannesburg. *55*

Armando Reverón, *Self-Portrait with Dolls*, 1954. Copyright Galería de Arte Nacional. Photograph by Victoriano de los Ríos. Courtesy of Galería de Arte Nacional. 66

Armando Reverón, *Paisaje Blanco*, 1934. Collection of Belen C. Velutini. 69

Tacita Dean, *No Horizon*, 2000. Courtesy of the artist and Marian Goodman Gallery, New York. 74

Tacita Dean, still from *Banewl*, 1999. Courtesy of the artist and Marian Goodman Gallery, New York. 78

Sketches of artifacts at the National Museum of Archaeology, Athens, 1997, from museum and travel notebooks. Courtesy of the author. 84

Nicholas Hillyarde, *Man against a Background of Flames*, 1595. 90

P. R. Vallée, *Harriet Mackie (The Dead Bride) (1788–1804)*, 1804. Courtesy of Yale University Art Gallery, Mabel Brady Garvan Collection. 95

Vija Celmins, *Holding onto the Surface*, 1983. Private collection. Photograph courtesy of McKee Gallery, New York. 98

Vija Celmins, *Untitled (Big Sea #1)*, 1969. Private collection. Photograph courtesy of McKee Gallery, New York. 107

Map of Stonypath/Little Sparta, the Garden and Temple. Drawing by Gary Hincks, 1992. Courtesy of Ian Hamilton Finlay. 110

Photograph of the Temple at Stonypath/Little Sparta. Courtesy of Ian Hamilton Finlay. 117

Joseph Cornell, *Untitled (Dovecote)*, ca. 1950–54. The Dicke Collection. Courtesy of C&M Arts, New York. By permission of Visual Artists and Galleries Association, Inc. © The Joseph and Robert Cornell Memorial Foundation/Licensed by VAGA, New York, NY. 136

Enzo Cucchi, *Sguardo di un Quadro Ferito*, 1983. Centre Georges Pompidou, Paris. Courtesy of the artist. 144

Bethan Huws, *Y Gwch/Rush Boat*, 1983–95. © 2004 Artists Rights Society (ARS), New York / ADAGP, Paris. 158

Peter Flaccus working in his studio, Rome, autumn 2003. Courtesy of the artist. 166

Anne and Patrick Poirier, *Reconstruction of Ostia Antica* (detail), 1972. © 2004 Artists Rights Society (ARS), New York / ADAGP, Paris. Courtesy of the artists. 178

Anne and Patrick Poirier, *Reconstruction of Ostia Antica*, 1972. © 2004 Artists Rights Society (ARS), New York / ADAGP, Paris. Courtesy of the artists. 181

Charles Willson Peale, *The Artist in His Museum*, 1822. Oil on canvas, $103^{3}/_{4} \times 79^{7}/_{8}$ in. (263.5 × 202.9 cm). Courtesy of the Pennsylvania Academy of the Fine Arts, Philadelphia. Gift of Mrs. Sarah Harrison (The Joseph Harrison, Jr. Collection, 1878.1.2). 184

Charles Willson Peale, *Rachel Weeping*, 1772. Courtesy of the Philadelphia Museum of Art. Gift of the Barra Foundation, Inc. (1977-34-1). 191

Francis Bacon, *Figure with Meat*, 1954. © 2004 The Estate of Francis Bacon / ARS, New York / DACS, London. Courtesy of the Art Institute of Chicago (Harriot A. Fox Fund, 1956.1201). 202

Vito Acconci, *Ready-to-Wear Music Box*, 1994. Courtesy of the artist. 208

Ann Hamilton, *tropos*, 1994. Photograph by Thibault Johnson. Courtesy of the artist and Sean Kelly Gallery, New York. *222*

Ann Hamilton, *tropos*, 1994. Photograph by Thibault Johnson. Courtesy of the artist and Sean Kelly Gallery, New York. *233*

Ann Hamilton, *between taxonomy and communion*, 1990. Photograph by Kathryn Clark. Courtesy of the artist and Sean Kelly Gallery, New York. *236*

Lucian Freud, *Reflection with Two Children (Self-Portrait)*, 1965. Copyright Lucian Freud. Photograph © Museo Thyssen-Bornemisza, Madrid. *252*

INDEX

ABC: *The Alphabetization of the Popular Mind* (Illich), 230

Abraham a Santa Clara (Johann Megerle), 130

abstract expressionism, 146, 168; and minute works, 161; and Roman paintings, 154

Abstract Expressionism and the Modern Experience (Polcari), 154

abstraction, 5, 149, 157; as aesthetic, 156; and modernism, 147; and the nocturne, 151, 156; and synesthesia, 25

abstract painting, 173

Acconci, Vito, 211

accountings (Hamilton), 223

Ader, Bas Jan, 76

Addison, Joseph, 101

Adorno, Theodor, 41

Adorno's Hut (Finlay, Brookwell, Townsend), 121

Aeneas, 63, 119; and Dido, 122, 124

Aeneid, 63, 119

Aeolian harp, 217

aesthetic experience, 19, 23, 85, 102; and ethics, 21, 26

aesthetic expression, 231; nature of, 232

aesthetic representation, 19

Aesthetic Studies (Feldmann), 46

aesthetic theory, 27

aesthetics, 17; and aesthesis, 15; and ethics, 5, 17, 18, 24

"Aesthetics and Hermeneutics" (Gadamer), 103

Africa (Feldmann), 47

Akagi (ship), 128

Alberti, Rafael, 68, 148, 160

Aldrovandi, Ulisse, 188, 197

aleph (Hamilton and Ireland), 223, 225, 228

Alexandrian Library, 197

Alix, Pierre-Michel, 122

All of a Woman's Clothes (Feldmann), 47

Allais, Louis-Jean, 122

alterity, 23

Ambrose, Saint, 234, 235

American Enlightenment, 146

American Museum of Natural History (New York), 198

American Ornithology (Wilson), 281n37

American Philosophical Society, 198

amulets: children, protection of, 88; and miniature books, 162

anamorphism: and realism, 148

Anatomy of Melancholy (Burton), 89

Anaximander, 114

Andre, Carl, 172

· 291 ·